MELNIKOV
Solo Architect in a Mass Society

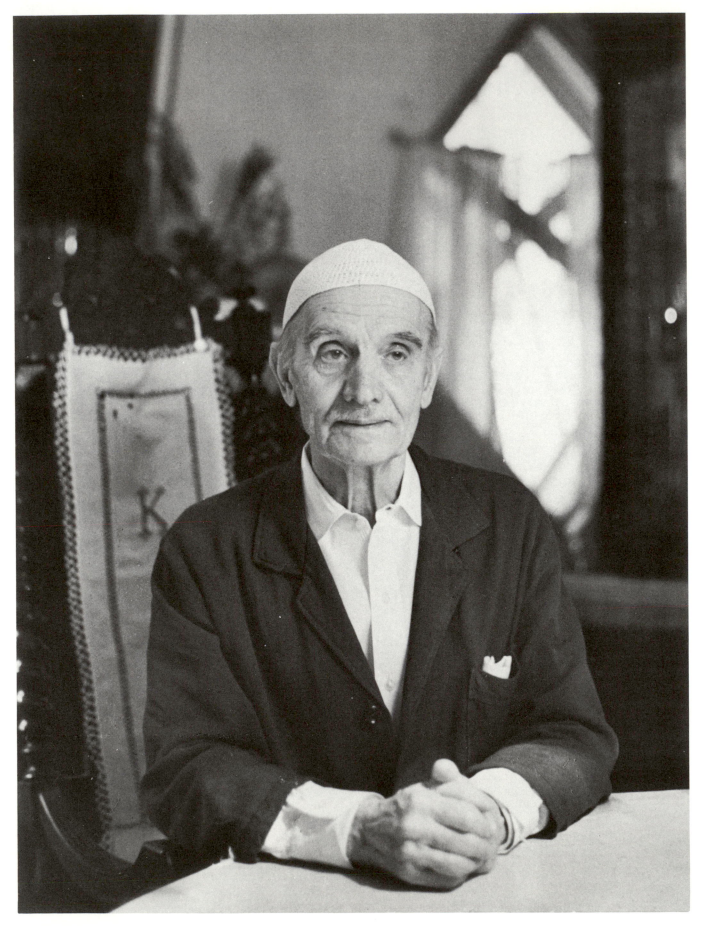

Konstantin Melnikov in 1972 at the age of 82 (Portrait by Henri Cartier-Bresson)

MELNIKOV
Solo Architect in a Mass Society

S. Frederick Starr

Princeton University Press, Princeton, New Jersey

Copyright © 1978 by Princeton University Press

Published by Princeton University Press, Princeton,
New Jersey. In the United Kingdom: Princeton
University Press, Guildford, Surrey

ALL RIGHTS RESERVED

Library of Congress Cataloging in Publication Data
will be found on the last printed page of this book

Printed in the United States of America
by Princeton University Press, Princeton, New Jersey

Table of Contents

Acknowledgments

IT would be hard to conceive of a study of any leading architect of revolutionary Russia that did not bring into play the insights of more than one field. Political science, cultural history, art, and city planning, as well as architecture, are all integral parts of the complex story, to be ignored only at the cost of over-simplification. As one who enters several of these highly developed realms with little but a tourist visa, I, more that most authors, have reason to acknowledge my indebtedness to those specialists who have shared their expertise with me. I am especially grateful to Professor George R. Collins of Columbia University, whose generosity with his time is matched only by his patience with the uninitiated, and to Iurii M. Denisov of Leningrad State University, with whose help the early research for this book was undertaken.

For private instruction they provided on twentieth-century architecture in western Europe I would like to thank Professors Robert Judson Clark of Princeton University, and Kenneth J. Frampton of the Institute for Architecture and Urban Studies, New York. Remmert Koolhaas of Amsterdam has been generous in sharing insights derived from his study of that other pillar of early Soviet architecture, Ivan Leonidov. It is a particular pleasure also to acknowledge the immense benefit this study has derived from materials included in recent general publications on the 1920s by the prominent and justly respected Moscow scholars V. E. Khazanova and S. O. Khan-Magomedov.

The first study in any language devoted specifically to Melnikov was produced in 1965 by V. G. Rodionov, then an undergraduate at Leningrad State University. Though regrettably unpublished, Rodionov's *diplomnaia rabota* still warrants the attention of anyone seriously interested in the subject. Another scholar who took an interest in early Soviet architecture was the late Arthur Sprague of Columbia University. At a time when the entire field was virtually uncharted, Sprague gathered much illustrative material, which he did not live to see in print. I am indebted to his wife and to his academic advisor, Professor George R. Collins, for making these available to me, and I hope that my use of them meets Sprague's high standards.

Some readers may well wish that the quality of the reproductions of plans, drawings, and old photographs were higher. Given the neglect suffered by the modern movement in Russia for a generation, it is astonishing that as many documents survived as did, and that these could be brought together again from forgotten portfolios, locked drawers, scrapbooks kept by friends of the subject, and yellowing journal pages. The above-mentioned Soviet scholars have performed an invaluable service in this re-

gard, but they are not alone. The family of Alexander Rodchenko kindly placed at my disposal certain of the photographs used in the text, pictures that amply deserve a special study in their own right on account of their significance to the history of Soviet photography. Through the sustained efforts of the artist Eva Auer, copies were made of various other photographs and drawings in the possession of the Melnikov family, documents were assembled, and a photographic record was made of surviving buildings. Through this loyal friend of the architect, too, Henri Cartier-Bresson was brought together with Melnikov, to which occasion we owe the sensitive portraits included here. The reproduction of photos from printed sources and the actual preparation of illustrations were capably handled by Barbara Glen, Lucas Collins, and the talented staff of the Smithsonian Institution's photographic laboratory, thanks to whose skills many damaged or faded plans and drawings were rendered clearer without retouching or redrawing.

For their support of various phases of the research and writing I am grateful to the International Research and Exchanges Board, the Research Council of Princeton University, and especially to Dr. Nathan Pusey of the Andrew Mellon Foundation and to the Aspen Institute for Humanistic Studies for their hospitality and encouragement during the summer of 1974.

Finally, I should add a word on the extensive use I have made of documents and materials put at my disposal by the subject of this study, and of information provided by him and by his family in the course of personal interviews in 1966, 1967, and 1976 and through subsequent correspondence. For all of these, and especially for the inspiration and pleasure that such contact afforded, I am deeply grateful to Konstantin Stepanovich and to his unstintingly gracious wife, Anna Gavrilovna, and to his generous son, the artist Viktor Stepanovich Melnikov. At the same time, it should be stressed that this is in no sense an "official" or "authorized" biography. Neither the architect, nor, for that matter, any of the others with whom I have consulted, bears the slightest responsibility for any errors of fact or interpretation that may inadvertently have been committed on the following pages.

A Note on Transliteration

The Library of Congress system has been followed here, with two exceptions. First, the Russian soft sign *(miagkii znak)* has not been indicated in the English; non-Russian readers are not helped in their efforts to pronounce Russian names by the appearance of apostrophes in the middle or at the end of words. Second, where there exists a standard English spelling for a Russian proper name, it has been used, rather than the more precise transliterated form. Thus, Dostoevskii appears as Dostoevsky, Trotskii as Trotsky, and Lisitskii as Lissitzky.

S. Frederick Starr
Princeton, 1974

List of Illustrations

CERTAIN illustrations included in this volume were published during Melnikov's lifetime in professional journals in the Soviet Union or abroad. Due to the poor quality of journal reproductions, however, an effort has been made to locate the original drawing or photograph and to take that, whenever possible, rather than the printed reproduction as the basis for the illustrations here.

The author's debt to Eva Auer and to Arthur Sprague for the use of their illustrative material has been acknowledged in the *Acknowledgments*. It should be noted here that in every case the materials from which they made their copies are preserved in the Melnikov family archive in Moscow. Those illustrations attributed directly to the Melnikovs' private archive in the listing below were all copied by the author, either from the original documents or from the best surviving reproductions.

MELNIKOV
Solo Architect in a Mass Society

I. Introduction

As recently as the nineteen-sixties our picture of world architecture in the twentieth century was like the proverbial New Yorker's map of the United States, depicting the back alleys of Manhattan as equal in scale to whole geographic zones of the Midwest and Far West. Within the known territory—which for architecture meant principally western Europe and North America—the subtlest distinctions among styles were savored, the most arcane data on students or followers of Gropius or Wright exhumed. Out beyond the perimeter of vision lay a vast region known only from random travelers' reports, which were met with the polite condescension with which that same New Yorker might have greeted the revelations of Lewis and Clark. Never mind if that other world included the cubism and functionalism of the inter-war Czech school, the distinctively urbane syntheses of east and west created by the Polish movement, or the prophetic experimentation in the architecture of revolutionary Russia. After all, were not all those East Europeans avowed disciples of the titans of Germany and France?

More recently we have been made aware of how imperfectly such a map describes the architectural terrain of our era. The currents of post-revolutionary architecture in Russia, especially, have been the object of a many sided effort at rehabilitation. Beginning with the materials presented in 1963 by Vittorio de Feo in his *U.R.S.S. Architettura, 1917-1936* and followed by Anatole Kopp's enthusiastic broadside *Ville et révolution* (1967), a stream of books and articles by students in the Netherlands, Italy, France, and especially in the U.S.S.R. have plotted out the main features of building and city planning during the early years of Soviet rule.[2] Thanks to the efforts of these pioneers, the neglected visionary schemes, concrete achievements, and thundering failures of the Soviet Union's heroic age are once more the common property of West Europeans and Americans, as they were in the twenties and thirties, when Frank Lloyd Wright, Mies van der Rohe, and Le Corbusier paid their respects to their collaborators in the common cause that was being furthered in the architectural ateliers of Moscow. The fact that intensive research was going forward at the same time on such well-known aspects of West European modernism as the Rot-

"It is time that we give thought to the scientific history of Soviet architecture, freed from the scum of yesterday's quarrels, so that the objects of our study will be preserved in all their purity and the architectural ideals of our fathers passed on to successive generations."
—IURII GERCHUK, 1966[1]

[1] Iurii Gerchuk, "Arkhitektor Konstantin Melnikov," *Arkhitektura SSSR*, 1966, No. 8, p. 55.

[2] A somewhat dated assessment of this literature is to be found in S. Frederick Starr, "Writings from the 1960s on the Modern Movement in Russia," *Journal of the Society of Architectural Historians*, xxx, No. 2, May, 1971, pp. 171-78. The most comprehensive bibliography is Anatole Senkevitch (ed.), *Soviet Architecture, 1917-1956*, Charlottesville, 1973.

terdam and Amsterdam schools, the German Expressionists, and even the modern movement in Great Britain, only added to the intensity of the enquiry regarding the East Europeans.

With the publication of each new plan or drawing, with the reappearance in print of each long-forgotten polemic, it has become increasingly difficult to maintain, as was done formerly, that the architecture of Russia after 1917 was merely some mutant of the French or German school. For if it was, the child was in many respects more vigorous than the parent. While the Parisians Le Corbusier and Perret had frequently to content themselves with creating an architect's architecture in the form of studio apartments for their friends, while the architects gathered around Walter Gropius at the Bauhaus were suffering from a "hunger for wholeness which Weimar could not satisfy" and Dessau only for a few brief years in the mid-1920s,[3] and while Frank Lloyd Wright was already beginning to devote his days to taking literary pot-shots at a fickle American public, the Russians were busy. Working in groups and as individuals, they labored frantically to turn out projects by the score for the competitions that proliferated after 1922—competitions, incidentally, that at the time were followed closely in the Western architectural press. The main Soviet school for the teaching of modern architecture, the Higher Artistic and Technical Workshops (*Vkhutemas*) in Moscow, was bursting with hundreds of students at a time when the Bauhaus could boast only of its dozens. And if some commentators have justly observed that, for all this, only a small percentage of buildings conceived on paper were actually erected, the number was nonetheless impressive, far more so than has generally been acknowledged, even within the U.S.S.R.

"Architecture," a prominent Soviet cultural official stated in 1927, "is the art of the dictatorship of the proletariat."[4] Disregarding for now the political implications of this bullish assertion, one can scarcely deny its claims as to the centrality of architecture in the cultural life of post-Revolutionary Russia. With its peculiar blend of hardheaded technology, its ambitions to social engineering, and its pervasive symbolic function, modern architecture in the U.S.S.R. claimed a hegemony in the arts to which perhaps only the cinema could also aspire.

Not that other fields of endeavor were stagnant or quiescent. On the contrary, theater flourished as never before following the Russian Revolution, thanks to the heady stimulus of having to address a new proletarian audience with which many able theatrical figures had been seeking contact anyway. Some Jeremiahs decried the "death of painting," pointing to emigré artists and patrons driving taxis in Paris, but their *Te Deum* would have been premature so long as Suprematists were fanning out to instruct in provincial centers, when the *Zorved* group of abstractionists in Leningrad was only beginning to function, and when such first-rate talents as Gustav Klucis and Aristarkh Kliun had their whole careers before them. Symphonic music may have descended to the rough "Get em, Boys" marches popularized during the 1918-1920 Civil War and even to factory-whistle concerti, and leaders of the world of opera and ballet may have yearned for the flush old days, but the musical poverty of the moment can be overstated. And even if these domains of "high culture" faltered, whole new areas of artistic endeavor were opening up. The arresting designs for

[3] Peter Gay, *Weimar Culture: The Outsider as Insider*, New York, 1970, Ch. IV.
[4] Pavel Novitskii, in *Arkhitektura VKhUTEMASa*, Moscow, 1927, p. 1.

factory-made clothes by Natalia Makarova and Nedezhda Lamanova, Vladimir Lebedev's political posters designed for an audience of seventy-million illiterates, or Dziga Vertov's news films that taught about the future by documenting the present, all bore the distinctive stamp of the revolutionary era.

Yet for all this, it was architecture, the one art that could be said to affect all of the people all of the time, that bewitched the builders of Soviet Russia to such an extent as to warrant its being considered the organizing field of cultural endeavor in the 1920s. Architecture appears repeatedly as a symbol of the era in the films of Eisenstein and Vertov; it endowed a school of revolutionary poets with a "Constructivist" aesthetic; and it was taken over by theatrical designers to create a new "revolutionary" form of space in which actors could play out their dramas.

The peculiar circumstances under which the Bolsheviks came to power in Russia made them look to architecture with greater expectations than have any other revolutionaries of the modern world. It is well known that in certain respects late imperial Russia did not fit Marx's template of a nation ripe for proletarian rule. With strong support from the state, its industrial capacity had been growing by leaps and bounds since the 1890s and in overall product Russia already ranked fifth among all nations by 1914. But this industrial side of Russia—including the urban labor force to whose members Bolshevism had the strongest appeal—was juxtaposed to a peasantry comprising seventy-four percent of the total population. Soviet and non-Soviet historians will long argue whether or not the Bolshevik revolution was "premature" according to the Marxist timetable, whether "capitalist" Russia had really gained the upper hand on the backward agrarian world left over from serfdom, and whether it was "ready" in turn to be overtaken by socialism. Suffice it to say that when the Bolsheviks picked up power from the floundering Provisional Government that had replaced the collapsed monarchy, their task was infinitely more formidable than it would have been had the revolution occurred in one of the more industrially advanced nations.

True to it ideology, the October Revolution promised the complete reconstruction of society. To a man, its leaders had a keen utopian sense that manifested itself on one level in works such as Lenin's 1917 *State and Revolution* or Bukharin and Preobrazhenskii's *ABC of Communism* (1918), and on another level in a rhetoric of total transformation of the way of life. At the same time, Bolshevik leaders were notable for their practicality and realism. With conspicuous exceptions, most of them did not really expect their work to be accomplished overnight and they strongly backed Lenin in his repeated warnings that only through prolonged and arduous labor could their backward republic advance toward its ultimate objectives. The result was an agonizing tension between present reality and future ideal that plagued the Bolshevik leadership and pervaded that part of the public to which the revolution most appealed. The policy implications of this tension were especially grave, for the new leaders would not and could not decide to sacrifice the present to the future, nor could they sacrifice the future to the present.

Nothing could have resolved this conundrum, but architecture, more than other fields of endeavor, had the power of softening it, by creating images and models of the new world in the midst of the old. As one Soviet architect tried to explain to the French public in 1925, architecture pro-

vided islands of rationality and order amidst the sea of chaos of old Russia.[5] Or, as a recent student put it, noting the frequency of palm trees in the drawings of Soviet architects in the 1920s, they were creating oases in the desert.[6] In its ability to mediate between the opposites of past and future, death and life, architecture rose to the height of a myth-making enterprise.

A heady assignment, this, but hemmed in on all sides by ideological heresy. As Marxists, the leaders of the new government were bound to insist that society's cultural "superstructure" (of which architecture must be considered a part) changes only after basic transformations have occurred at the level of the economy. Such a notion, followed to its logical conclusion, would have required architects to concentrate fully on tasks related to developing the "fundament," and to allow changes occurring there to have their impact later on the nation's culture. At the same time, as followers of Lenin they asserted the possibility of creatively intervening in the historical process, as they themselves had done by achieving a socialist revolution in a predominantly peasant society. This success encouraged left-wing enthusiasts on the art front to want to transform Russia's cultural life immediately—before, or at least simultaneously with, the construction of a modern economy.

To maintain some kind of equilibrium between these basically different affirmations was the task of Party ideology after 1917. To lay too great stress on Marx's assertions about the proper sequence of development was to condemn the Soviet people to waiting until history's tractor had fully prepared the ground; to move directly to construct the new cultural forms before the economic transformation had occurred would be to deny Marx's all-important distinction between structure and superstructure and, worse, to imply that the core of social life could really be changed by manipulating its outward forms. Either way, it was a fatally unstable compound of elements.

To many of Russia's revolutionaries, architecture seemed a kindred spirit. Like Bolshevism, it epitomized the possibility of taking history into one's own hands and daring to create a new physical environment in which man can live his life. But, also like Bolshevism, the architects could not assume that new housing would make new people unless the rest of the world in which the inhabitants function were also transformed. In a very real sense, then, the theoretical problem facing the Bolshevik Party after 1917 was precisely the great dilemma of all innovative architecture. No wonder that a close affinity developed and flourished between the political and architectural vanguards, in spite of the fact that few Bolsheviks had time to learn much about architecture, and just as few avant-garde architects troubled to learn much about Bolshevism.

How different was this state of affairs from that which prevailed during either the French or the Chinese Revolutions! The upheaval that swept France after 1789 had its economic and social objectives, to be sure, namely, to shift the center of gravity in all aspects of social life to favor the urban middle classes and independent farmer at the expense of the privileged estates that heretofore had so dominated French life. But, unlike the Russian one, this revolution took place before industrialization had gained more than a tentative toehold in France and before it had taken more

[5] *L'art décoratif et industriel de L'U.R.S.S.*, Edition du comité de la section de l'U.R.S.S., a l'exposition internationale des arts décoratifs, Moscow, 1925, p. 85.
[6] Gerret Oorthuys and R. Koolhaas, *Ivan Leonidov*, forthcoming.

than its first steps even in England. This fact of timing meant that both the benefits and problems of the industrial order were as yet beyond the ken of Mirabeau, Robespierre, Marat, and of even the more technically minded Napoleon. Given this, the point toward which French revolutionaries of all shades believed themselves to be striving lay not at the end of a long transitional period of economic development, but in the immediate present. In order to reach that point it was necessary not to reconstruct towns, workshops, and dwellings along radically new lines, but mainly to overturn the political order and reconstitute it according to democratic principles. Thus, the current of utopian building and town planning that had flourished under the *ancien régime* through the efforts of Ledoux, Boullée, and Lequeu found no major champions among the political leaders of 1789-1792. The intermingling of architecture and politics that did occur took place more on the politicians' terms than on terms set down by artists or architects. Doubtless such interaction attracted many artists in other media, among them the painters of the revolutionary *Société populaire et républicaine des arts* and the writers who turned out such propagandistic tracts as the catechistic *Alphabet de sans culottes*.[7] But it left architecture with little to do but to design altars for the new secular religion of Humanity, to create settings for outdoor festivals and civic manifestations, and further to ornament the capital with arches and colonnades in the emerging Roman style.

The situation in China after the 1949 Communist revolution was in certain respects quite the opposite from that in France eight-score years before. Unlike French revolutionaries, Mao Tse-Tung and his comrades foresaw an industrialized future for their country, but, unlike the Russian revolutionaries, they inherited few of the foundations upon which such a future could be built. Hence, they could not delude themselves into thinking that the realization of their goals lay just around the corner. They well realized that the essential tasks before them were long-range and enormous in scope, well beyond the reach of any limited and utopian exercises. Moreover, with the entire twentieth-century experience in architecture and city planning at their disposal, Chinese revolutionaries and their architects were inclined more to adapt foreign experience to their needs than to set about devising totally new solutions. Ready access to Soviet expertise during the early years after 1949 facilitated this. Were official buildings, housing, or factory facilities needed in Peking or Shanghai? Let the Russians provide the plans and perhaps even build them; better yet, let them help pay the bills! For years now, of course, the Chinese themselves have paid the bills, but for all the building that has taken place in China since 1949, architecture has never emerged as more than an earnest toiler—content to take commands from the front lines but claiming no place for itself in the vanguard.[8]

The centrality of architecture to the revolutionary experience in Russia has strongly colored the manner in which it has been approached by recent students of the subject. Forged in alliance with political leaders who themselves took architecture seriously, and divided into groups and factions whose spokesmen welcomed any chance to address the broader public,

[7] James A. Leith, *Media and Revolution: Moulding a New Citizenry in France During the Terror,* Toronto, 1968, pp. 32 ff. Leith's *The Idea of Art Propaganda in France: A Study in the History of Ideas*, Toronto, 1965, makes a good case for the importance but not for the volume of this activity.

[8] Ralph C. Crozier, *China's Cultural Legacy and Communism*, New York, 1970, pp. 256-64. See also *Architectural Design*, 1975, "China."

early Soviet architecture all but entreats us to measure it with the categories and terms of political controversy. This is just as it was intended. When an architect insists that a particular workers' club or community center is designed to serve as a "social condenser," when he invites the approval of leading Party ideologues and even dedicates his work to their theories, as occasionally happened, it would be the greyest pedantry to dwell exclusively on the manner in which he resolved the problems of constructing a flat roof, or on his treatment of cantilevered forms.

Aspects of the architectural enterprise itself make it imperative to pay due notice to the public context. Among all the arts, architecture is quite distinctive in the intimacy that must exist between the practitioner and his patron. This intimacy may assume various forms under different circumstances, but, regardless of whether the patron is a rich Mycenas, a religious foundation, a corporate group, or a revolutionary state, his function will exist. The architect must be told the task of the building he is asked to design, he must know roughly what the building can cost, and he must be informed as to what plot of land he is working with and what limitations, if any, must be observed with regard to surrounding buildings. On each of these points the architect may press forcefully for approaches drastically different from those which the patron has considered and for alternatives that the patron would oppose—in our century such a stance has become the rule for leading innovators in the field. But even these acts of apparent independence stand as evidence of the architect's close engagement with his patron. He must convert the sponsor to his view or at least gain his acquiescence. To be sure, there are moments when the architect designs, as it were, for himself, when he has a completely free hand, thanks to the generosity (or disinterest) of a particular patron, or to the architect's resolve to create a fantasy without regard to whether or not it will actually be built. He may affect a Byronic arrogance towards his patron, assert his differentness by wearing velvet breeches, or claim remoteness by surrounding himself with flunkies who hover like janissaries about their sultan. But such posturing will never alter the fact that architecture is the most social of arts and, *sui generis*, potentially the most political.

By considering architecture in terms of the expectations placed on it by society, it is possible to discern clearly those tasks to which the field as a whole addresses itself. For early Soviet Russia, these assignments were set down with unusual precision in the terms for the various competitions held to select designs for public buildings. These specifications are an invaluable index to the evolving relation of culture and politics after 1917. Yet an approach that lays inordinate stress on the programs of architecture—as opposed to their realizations—has its own limitations.

Take, for example, the program for the competition to select a plan for communal dwelling units, announced by the Constructivists' journal *Contemporary Architecture (Sovremennaia Arkhitektura)* in 1926.[9] It specified that dining and child-rearing functions were to be completely collectivized, which meant that no unit could include its individual kitchen or nursery. It restricted the area allotted to each unit so as to insure that families would make use of communal space and in the process be drawn away from their privatism. A series of further requirements were intended to render it all but impossible for any entrant to stray far from the prevailing consensus on matters of style. So strongly utopian a program is surely a central docu-

[9] *Sovremennaia arkhitektura*, 1926, No. 4, p.111; No. 5-6, p.109 ff.

ment in the history of Soviet architecture. But it does not tell the whole story, because even the most specific programs permit the broadest diversity in their implementation. In this case, the flood of entries astonished the judges with their wealth of varying approaches, among them several that blithely ignored the specifications in an effort to chart out even more boldly utopian schemes. Some were of such brilliance that a half century later they still attract serious study; others were ingenious failures; as a group they spanned the entire spectrum from naïveté to fantasy.

This diversity is precisely the element that a history compounded solely of architecture's successive programs and public tasks fails to grasp. Its existence prompts us to recognize that at no point between 1917 and 1937 did there exist in Soviet Russia a single "typical" architect or architecture. It requires that we acknowledge that in no two years were precisely the same types of competitions announced, and in no two years did architects and judges in the various competitions favor precisely the same type of approach in architecture. Not only was the diversity of styles and impulses within modern architecture in Russia far greater than has been generally appreciated, but not one of the separate components retained the same identity for more than a few years, thanks to the extreme rapidity with which the social and political setting was being transformed.

Even if one takes into account the intentions of the new Soviet patrons, the diversity of architectural tendencies after 1917, and the rapidity with which both were evolving, one will not have touched on all the factors that contributed to the richness and distinctiveness of early Soviet architecture. There was a purely personal element as well. To an extent that seems astonishing in retrospect, the architectural life of revolutionary Russia was dominated by a very few creative personalities. The aesthetic and social views of these few architects delineate the parameters of early Soviet architecture as a whole. The psychological and philosophical cast of each one of them is as much a part of the history of early Soviet architecture as are the predilections of patrons and the progression of competitions.

Normally, these points would be truisms, but normally those who set out to describe the general development of art in a given era can ground their work in the specifics of actual lives and works as set forth in biographical studies. Not to do so would be absurd. It would be unthinkable, for example, to attempt to tell the story of seventeenth-century Dutch art and society without first studying carefully the life and works of Hals, Rembrandt, and a host of other artists. But this has not been possible in the case of early Soviet architecture. Apart from the excellent study of Leonidov published recently by Oorthuys and Koolhaas, and a few brief and incomplete studies published in the U.S.S.R.,[10] there exists not one full biography of any leading architect of the revolutionary era, notwithstanding the fact that there are several—among them Moisei Ginsburg, Ivan Leonidov, the Golosovs, and the Vesnins—whose careers amply justify such attention and who, by right, should occupy niches in the pantheon of modern architecture as a whole. Without such studies, those seeking to describe the overall cause of the development of revolutionary architecture have been placed in the unenviable position of writing about the whole without a thorough understanding of the parts. It is not surprising, therefore, that at various points the prevailing generalizations on the subject are misleading.

[10] A. G. Chiniakov, *Bratia Vesniny,* Moscow, 1970; M. A. Ilin, *Vesniny,* Moscow, 1960; S. O. Khan-Magomedov, *Arkhitektor Ivan Leonidov,* Moscow, 1971.

This, added to the fact that the history of early Soviet architecture has been written with scant reference to the actual social, political, and professional environment in which architects functioned, or worse, on the basis of highly distorted notions about what that environment was like, makes it imperative to pause frequently in the following narrative in order to sketch in the context in which events were set. This does not purport to be either a history of early Soviet culture or of revolutionary architecture in general, but wholly to neglect these subjects would be to ignore factors that were in fact of central importance to the matter at hand.

This is the biography of just one architect, Konstantin Stepanovich Melnikov. Visionary architect to a visionary era, his career began in 1917 and ended in 1937, precisely the two dates by which the rise and fall of revolutionary architecture as a whole can be bracketed. Throughout these two decades after the Russian Revolution, Melnikov figured as one of the most active and visible figures in Soviet architecture. Remarkably catholic in his interests, he turned at one time or another to most of the architectural challenges of the day, with results that invariably generated controversies that themselves became vital parts in the history of Soviet architectural life. By any measure he must be ranked among the leading figures of the revolutionary avant-garde in the arts.

But he was scarcely typical. Who but he would have dared, in 1927—the year in which Soviet architects were embarking on the communal housing competition discussed above—to build for himself a *private* home of unprecedented design in the very heart of Moscow? And after having done so, to label it an "experiment" to be judged under the terms of the same competition? Years later, he was to refer to this structure in his autobiography as ". . . a solo personality sounding forth amidst the roar and thunder of the capital's disorderly vastness as a sovereign unity. . . ."[11] These words could well be applied to the man himself. In contact with all the schools and movements in his own field and sought out by prominent figures from many other areas of the arts, he nonetheless retained a certain distance, a shy aloofness that was readily taken for hauteur. Unlike many of his fellow architects, he showed little interest in developing standardized prototypes, and refused to consider his work—or his style of life—as constituting a pattern after which other buildings or architects might be modeled.

However distinctive Melnikov's creative achievement, it was certainly far from being an unqualified success. Under any circumstances, "success" is a highly relative term. If for an architect it includes designing buildings that are hailed as symbols of one's era and nation, then Melnikov was a success. Or if it means being selected by the jury of the 1933 Milan Trienalle as one of the twelve great architects of the contemporary world,[12] and if it means being the only Soviet architect to be given his own section at the landmark Machine Age Exposition of 1927 in New York, then, too, Melnikov must be counted as a success. On the other hand, if being successful is incompatible with drafting over eighty projects and seeing only twenty actually built, if it precludes having one's last building erected be-

[11] K. S. Melnikov, "Arkhitektura moei zhizni," unpub. MS, Melnikov archive, p. 1.

[12] The others being Sant 'Elia; Le Corbusier and Jeanneret; Loos; Mendelsohn; Mies van der Rohe; Gropius; Dudok; Hofman; Wright; Lurçat; and Perret.

fore reaching the age of forty-five, and if it conflicts with being driven from one's profession by a congress of eight hundred assembled colleagues and then sitting in involuntary idleness for nearly forty years thereafter, then Melnikov can scarcely be counted. For this was his fate. From being the ambassador of Soviet avant-garde architecture to the entire world in 1925, he descended within scarcely more than a decade to the level of whipping boy for his profession and finally its leading martyr during the Stalinist era.

Down to his eighty-fifth year, Konstantin Melnikov was a rare living link with the revolutionary era in Soviet architecture. In spite of ill health and waning vigor, he was a tolerant host to an endless parade of people from the cultural elite of Moscow and, more important, to young Soviet architects from all over the country seeking inspiration at the start of their careers. They came to him in order to make contact with one of the most brilliant and at the same time most problematic periods in their nation's history through a person whose life was an intimate part of that era. They came, also, because sitting in the stark living room of his cylindrical house in Moscow, and surrounded by the creations of several decades at the drawing board and easel, they sensed correctly that the life and work of Konstantin Melnikov is a part of their own era as well.

II. Training Years

MORE than literary convention requires that the biography of Konstantin Melnikov treat in some detail the years before his professional debut in 1917. Not that he was unaffected by the revolutionary events of his graduation year, or that everything he did during the 1920s and 1930s was somehow anticipated by works of his youth—far from it! But his formative years coincided with a whirlwind of change and renovation that swept every area of Russia's cultural life, and he passed those years at the eye of the storm, Moscow. Melnikov's very existence as an artist was the direct result of factors that were part of that turmoil, and his mature art and outlook always retained the imprint of the education he received during the closing years of the *ancien régime*.

Turgenev once noted that during a storm the highest and lowest leaves of a tree touch one another. It is a measure of the state of flux in late imperial Russian society, as well as of Melnikov's talent, that he, a peasant by birth, could have made his way so quickly to the most prestigious centers of his country's artistic life. True to Turgenev's prescription, however, and, unlike our own Horatio Alger legend, Melnikov never threw off that special set of attitudes he inherited from his peasant forebears. Like the small-town immigrant to Paris, Fourier, whose utopian visions of the 1830s Melnikov's work so often calls to mind, Melnikov took all the impressions gained from contact with the sophisticated world of the metropolis and grafted them onto that with which he began. His contribution to early Soviet culture was less the consequence of a single overwhelming confrontation with the new than a synthesis of old and new that was long in the making.

It is paradoxical that the architect who was to be praised and damned for "pure innovationism" should have had deeper roots in traditional Russian life than any other member of the avant-garde. With melodious and wistful phrases that could have rested comfortably among lines by the peasant poet of the revolution, Sergei Esenin (1895-1925), he recalled his origins: "Born in 1890, filled with the naïveté of the nineteenth century, I began life as a specimen of liberty, filled with a neglected independence. The place of my birth was not a hospital, but a worker's cabin, the 'Hay Lodge.' Today, looking back on my works, the source of my individuality is clearly visible . . . in the architecture of that building. Built out of clay and straw, it looked like a foreigner in its own homeland, a foreigner

[1] Igor Stravinsky and Robert Craft, *Conversations with Igor Stravinsky*, Garden City, N.Y., 1959, p. 18

among its civilized kinsmen. But all the magnificence of the carving of the surrounding wooden houses yielded before it."[2]

This aromatic-sounding building stood on the northernmost edge of the city of Moscow, in the Petrovsko-Razumovskoe district, where Beethoven's one-time patrons, the Razumovskii family, once owned an estate. In the nineties the estate was only a memory and the entire area had once more become heavily wooded, except for a few summer *dachas* built for the growing middle-class of Moscow, the Petrovsko-Razumovskaia Academy of forestry and land management, and a tram line that led to the center of the city.

The Hay Lodge was in reality a suburban slum. Here was billeted a band of road-maintenance workers and their families, all sharing in common the scant facilities that subsistence salaries afforded them. It was very much a communal existence, but one based on necessity rather than on choice. Such arrangements were uncommon in Russian towns at the time, especially after appalling rural famines in the early 1890s drove millions of hungry peasants to the cities in search of food and work. After 1900 such wretched housing was to become a *cause célèbre* in liberal and radical circles, and, as we shall see, a debate was to rage for a third of a century as to what best to replace it with. No one consulted the views of Stepan Ilarionovich Melnikov, the architect's father, but as soon as the chance presented itself he indicated his choice by leaving the Hay Lodge.

Stepan Melnikov was himself a part of that anonymous tide of rural migrants who so strained the hospitality of Russian cities at the end of the last century. Nothing is known of him besides a few family recollections that represent him as a very unusual man in many respects. Himself the son of a serf, Stepan had spent his early life in the commune of his forebears, Aleksandrov village, in the Sergachskii district of the upper Volga province of Nizhnii Novgorod. Even after their emancipation in 1861, Russian peasants were legally bound to the village in which they were born and were permitted to leave only with the consent of the village elders. As one who was likely to be able to earn a few rubles to send back home, Stepan Melnikov easily earned that permission and in the late 1880s headed for Moscow, where he rapidly worked his way up to foremen (actually, "elder") on the road crew housed at the Hay Lodge. He married a peasant girl from the Zvenigorod district of Moscow province and in rapid succession fathered five children, of whom Konstantin was the fourth.

At a time when many peasant migrants were discovering that city life could be no less punishing than life in the famine-striken countryside and were, as a consequence, becoming the willing objects of political propaganda from the emerging populist and socialist parties, Stepan Melnikov was forging ahead in life. Availing himself of unused public lands near the suburban Moscow village of Likhobor, he moved his family in 1897 to a three-room log cabin and set up a small dairy to provide milk for the nearby Petrovsko-Razumovskaia Academy. With two cows, geese, chickens, and a wagon, he had become a peasant-entrepreneur (Fig. 1). "My father did not like to be subordinate to anyone," the son recalled, and Konstantin's portrait of this strong, intent man amply supports his judgment (Fig. 2). To prevent any loss of independence, the entire family worked: "We were like a government, strengthening and improving our domain. In such an enter-

[2] Melnikov, "Arkhitektura moei zhizni," p. 2.

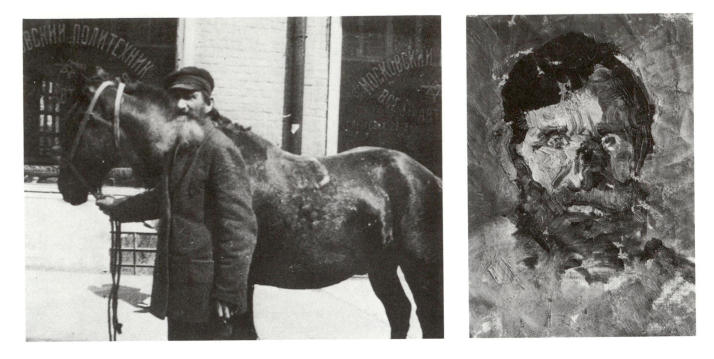

1. Stephan Melnikov, father of the architect, Moscow, ca. 1905

2. Stephan Melnikov, portrait by Konstantin Melnikov, ca. 1916; oil on canvas

prise, we, too, the children, were very real workers and felt personally responsible for our dairy, with our parents."[3]

At best the Melnikov family's existence was marginal, and the sleds built for the children were held together with wooden pegs, not merely out of custom but because money for nails and metal was lacking. Yet for all that, Stepan Melnikov and his family achieved their independence and, thanks to this modest success, Konstantin's childhood was scarcely touched by the suffering that we associate with the Russian peasantry as a whole in those years. Indeed, his recollections of life in their 7 x 7 *arshin* (16 feet x 16 feet) cabin and of his boyhood in the Likhabor forest, which grew to the cabin door, are scarcely less nostalgic in tone than Vladimir Nobokov's fanciful *Speak Memory*, written about his boyhood in the very different world of aristocratic Petersburg. More than once in his later life Melnikov's thoughts as an architect were to return to "the genuine and unfathomed world of Nature" in which he spent his boyhood, to a life regulated by the rising and setting sun and free of the "artificial health" that the flabby, mechanized city offers its denizens.[4]

Whatever the charms of this rural and old-fashioned environment, it was far less auspicious for the development of a young artist than were the boyhood homes of Melnikov's contemporaries in the architectural avant-garde: Moisei Ginsburg (1892-1946), whose father was an architect in Smolensk, and the three Vesnin brothers, born in the 1880s to a middle-class merchant family in which both parents revered the world of art. When the Melnikov family noticed their fourth son's interest in drawing, Stepan Melnikov had to raid wastebaskets at the Petrovsko-Razumovskaia Academy for envelopes and paper for him to sketch on. In the Melnikov cabin there were no representational images at all except for those on the icons, which hung in the corner beside the door at the spot assigned to them by tradition. The best works of art were to found in the latrine behind the house, where torn

[3] K. S. Melnikov, "Arkhitekterskoe slovo v ego arkhitekture." MS, Melnikov archive, n.d., p. 7

[4] *Ibid.*, p. 6.

pages of back issues of *The Moscow Gazette* hung impaled on a nail for the same purpose that old Sears, Roebuck and Co. catalogues once adorned the outhouses of rural America. Melnikov recalled that he regularly culled these for their aesthetic treasures.

By 1900, most young men in Moscow could read, if only haltingly, so it was imperative that the Melnikov family send their son to the parish school on the academy grounds for basic instruction. A good student, Melnikov managed at the same time to spend much time drawing from collections of Russian fairy tales and singing in the Orthodox Church choir, where he was introduced to the music of Tchaikovsky, Borodin, Bortnianskii, and Glinka. The parents could afford nothing beyond this, however, and so they decided in 1902 to apprentice him to a certain Prokhorov, master of an icon painting establishment in nearby Marina Roshcha, as the most suitable means of developing his talents further. But homesickness soon brought an end to this project, and in a short time the boy was back in the family.

Though Melnikov's brief career as an icon painter left no apparent mark on his work, it should not be wholly ignored, if only because it formed a symbolic link between Russia's most ancient traditions of art and the emerging modern movement. About the same time that he was being sent back home, the painter Natalia Goncharova was making her earliest attempts at re-evaluating the work of the medieval Russian masters, and the first national exhibit of icons—few of them yet stripped of centuries of grease and over-painting—was being prepared in the old capital of Moscow. It is a curious coincidence that the only other major figure of the architectural avant-garde drawn from peasant stock, Ivan Leonidov, was also apprenticed for some time to an icon painter in Tver upon completing four years in a parish school.[5]

His brief career as an icon painter having ended in failure, Melnikov at age thirteen (1903) returned to his former work of delivering milk to central Moscow on horseback. Before long, however, his ambitious parents succeeded in placing him as an office boy in the engineering firm of Zalesskii and Chaplin, a post through which he was to gain both an education and a career. The two proprietors had accumulated modest fortunes in the building boom of the 1890s. The senior partner, V. G. Zalesskii, had been the guiding light in the organization of a Moscow branch of the national Society of Civil Engineers in 1899.[6] The other partner, Vladimir Chaplin, a second-generation immigrant from England who had recently achieved some prominence in the field of heat engineering, was a member of the Moscow Architectural Association and the author of occasional articles on central heating that appeared in the technical journals of the day.[7] Chaplin was also a man of progressive aspirations, not of the sort that found expression in actual political activity, but rather of that kind which could be appeased through the "small deeds" that were always the last refuge of well-intentioned liberals in Russia. He was to live on in Moscow after the revolution.

Melnikov's duties in the Zalesskii-Chaplin firm were quite undemanding, and the acute economic slump of 1902-1903 meant that everyone in the office had time to indulge the young boy's interest in drawing. A Ukrainian doorman finally put a series of sketches by "Kostia" on the desk

[5] P. A. Aleksandrov, S. O. Khan-Magomedov, *Ivan Leonidov*, Moscow, 1971, p. 7.

[6] *Nashe zhilishche*, 1899, No. 1-2, p. 44.

[7] V. M. Chaplin, "Ob issledovanii deistviia tsentralnogo otopleniia i ventiliatsii," *Zapiski Moskovoskogo arkhitekturnogo obshchestva*, 1905, pp. 17-31.

of Chaplin, who at once saw in them an opportunity to exercise his largess by sending the lad to art school.

Were there not other fields besides art towards which a person of "progressive" views might direct the boy? There were, of course, but at the turn of the century art exercised a peculiar power over Russia's middle-class merchants and professional people. The economic development fostered by the policies of the Minister of Finances, Count Sergei Witte, had caused new social types to make their appearance in the world of gentility. Merchants, tradesmen, and professionals, most of whom had earlier tended to remain in the middling ranks assigned to them by the official social hierarchy, were not only being vastly enriched but, with the rise of the railwayman Count Witte, they had their own friend and patron in court. With their new money, they—and especially their sons—assaulted the bastions of social prestige. The concocting of fake coats-of-arms and grandiloquent family histories for merchant dynasties became a thriving business, and more than a few architects were to aggrandize themselves by building palaces in the Empire style for the new bourgeoisie. But nothing endowed one more with the gloss of culture than patronage of the arts. To his eternal glory, the great merchant prince Tretiakov in 1894 had bequeathed his entire collection of paintings to the city of Moscow. The railroad magnate Sergei Mamontov two years later stunned the cultural élite when, in imitation of Napoleon III, he had built a private exhibition hall at the Nizhnii Novgorod Fair for the works of his protégé, the painter Vrubel.[8] Such gestures had their effect, not least among the hard-pressed land-holding gentry whose members had heretofore dominated polite society.

In most areas, the manufacturers and professional folk could take on the gentry on their home grounds: they could buy prince so-and-so's Parisian chef from under his nose, hold fancier soirées in Petersburg, and reserve the best suite at the Astoria Hotel in Baden-Baden. It was comparatively easy to score these triumphs, but by 1900 it was no easy matter to assemble a collection of Old Masters that would equal the great aristocratic collections formed during the previous century. Blocked in this direction, the new collectors looked elsewhere in the realm of art. As confirmed risk-takers in their workaday lives, the merchant princes looked with particular sympathy at the emerging lights of art. The astute judgment shown by Ivan Shchukin in buying quantities of the boldest canvasses by the still unknown Cézanne, Matisse, and Picasso is only the best-known example of this phenomenon. The walls of the homes of countless ironmongers, department-store executives, engineers, and lawyers reflected similar efforts on the part of their less well-heeled and less imaginative owners to translate money into cultural success.

It does not reflect badly on Chaplin to record that this motive stood cheek-by-jowl with his progressive social outlook in prompting him to send Melnikov to the Moscow School of Painting, Sculpture, and Architecture. The renowned Smolensk patroness Tenysheva, whose claims to gentility were flawed both by her own illegitimate birth and by her princely husband's keenness for making money in manufacturing, formed a great art collection and sent hundreds of peasants to craft schools that she established. Chaplin's gesture, like Tenysheva's, was part of the times. Like the

[8] G. Iu. Sternin, *Khudozhestvennaia zhizn Rossii na rubezhe XIX-XX-vekov*, Moscow, 1970, pp. 19 ff.

other cases we have touched upon, it bears witness to that peculiar marriage between art and industry, the story of which is in good measure the history of the avant-garde in Russian art.

Admission to the Moscow School was no small honor. Since its foundation in 1843 as the Moscow School of Painting and Sculpture (the Moscow Architectural School was joined with it only in 1865), it had been the organizing center for artistic life in the old capital. Especially after the early 1860s, when the independent Society of Artists began to hold regular meetings there, the school filled the role of both local academy and anti-academy. Because indigenous Russian art had always been more a service industry to the monarchy than something with which the collector could demonstrate his refinement and taste, there was little snobbism connected with the school. Earlier and to a greater extent than the universities, it admitted a fairly democratic student body. Andrei Parshikov, Melnikov's desk-mate in the early years, arrived in Moscow on foot from his native Riazan, clad in a homespun coat and peasant baste shoes. The school's democratic outlook extended to politics as well, the institution being, as the poet-painter Maiakovskii admiringly recalled, "the only place where they took you without proof of your 'reliability.' "[9] Such an admissions policy made it the more important that deficiencies in the students' prior training be corrected through a program of general education, which was instituted in 1898 with the purpose of teaching future artists "to read and write Russian fluently and to know the Shorter Catechism and the first four arithmetical functions."[10]

The existence of this program, in which so distinguished a figure as the historian Vasilii Kliuchevskii at one time taught, added further to the school's attraction for the hundreds of aspirants who showed up annually for the entrance examinations. Pressure for places was intense—with up to twenty-five applicants for each spot—but the stakes were high, as the school was well known to be one of the most lively educational foundations in Russia. Many graduates of the Imperial Academy of Arts in Petersburg came to Moscow for an extra year of training so as to be brought up to date on the most advanced developments in their field. Others transferred from provincial schools in Penza, Odessa, Kiev, or Vitebsk in hopes of being "discovered" by the Moscow art public.

Thanks to this regular immigration of talent from St. Petersburg and the provinces, the school became the chief training ground and mustering point of the emerging modern movement in Russian art: Vladimir Tatlin took a year there, while Ilia Mashkov, Nikolai Sapunov, Sergei Sudeikin, Mikhail Larionov, Pavel Kuznetzov, Robert Falk, and Natalia Goncharova all went right through the program. Among future innovators in architecture—in addition to Melnikov—there were Alexander Vesnin, Ilia and Panteleimon Golosov, and Nikolai Ladovskii. Melnikov himself nearly missed the opportunity of joining this group, having failed the Russian-language examination on his first try. But after a summer spent with the Chaplin family under the supervision of the tutor to the engineer's two daughters, he was sufficiently improved to gain admission in 1904.

For most of his creative life, Melnikov was to have some connection with this institution, first in the general education program to 1910, then as

[9] V. V. Maiakovskii, *Sochineniia v odnom tome*, Moscow, 1940, p. ix.
[10] N. Moleva, E. Beliutin, *Russkaia khudozhestvennaia shkola vtoroi poloviny XIX-nachala XX veka,* Moscow, 1967, p. 257.

a student of painting (1910-1914), then as an architectural trainee (1914-1917), and finally as a professor (1919-1929). Since he received all his formal training at the Moscow School of Painting, Sculpture, and Architecture, and since certain features of that training were to have a profound impact on all of his later work as an architect, the program and atmosphere of the institution is of more than passing interest.

It has been all too easy, on the basis of one incident occurring there in 1910, to cast the school in the role of an arch-reactionary Academie Royale, vigilantly persecuting rebellious students in the name of some unspecified orthodoxy. True enough, a group of boisterous young painters were expelled in that year, among them the "discoverer" of Ray-ism and inveterate prankster Mikhail Larionov, and Robert Falk, a leading follower of Cézanne. Three years later, as if to confirm the school's image as a lair of aesthetic ogres, the Futurist poet-painters Vladimir Maiakovskii and David Burliuk were expelled. There were issues of substance in both cases, for after 1908 the outlook of students and faculty in the painting section began sharply to diverge. But are these sufficient to justify a sweeping judgment against the school?[11]

Granted that the students had legitimate grounds for protesting the assignment of the rather dour portraitist Leonid Pasternak to substitute for the ailing but much beloved Konstantin Korovin; but, besides this, the rebels were impelled by other motives that by no means reflect badly on the school. Actually, the ringleaders were not students at all, in that they were already in their late twenties and had long since established themselves among the fledgling avant-garde. With no money to show for their artistic efforts, they hoped that the *alma mater* that had nurtured them would continue to keep them under her wing. The genial Korovin had allowed them all to continue to work in his studio, but the more businesslike Pasternak denied them this privilege. Hence the revolt.

Korovin's broad and tolerant attitude was typical of the faculty at the time Melnikov studied there. Many of them—and the administration of the school as well—extended this outlook beyond the studio, which made the building at 2 Miasnitskii Boulevard (now 21-23 Ulitsa Kirova) a major gathering place for the cultural élite of Moscow. Melnikov recalled being introduced to the most recent poetry and especially to the works of the symbolist Andrei Belyi in the preparatory division, as well as being among the many young students who gained admission to the musical soirées held at the school in a tradition founded by the elder Pasternak, and meeting the renowned *basso* Chaliapin at the funeral of Korovin's brother, Sergei, in 1908. The auditorium in the school's main building was among the better halls in Moscow for small lectures. In addition to hosting the Moscow Architectural Society, which still met there occasionally even though it had recently built its own headquarters, it was the scene of meetings of the Union of Russian Painters (of which Korovin was president), of the Moscow Society of Lovers of the Arts, of the Literary-Artistic Circle, and of other newly founded groups for the arts and letters.

The desire to see all the arts in their mutual relation with each other, to discern the underlying unity among them, and to elevate that unity to a

[11] Camilla Gray's unfair judgment in this case is supported by references to a nonexistent revolt of 1909 and by including several persons among the renegades who had long since completed their training—at other institutions. *The Great Experiment, Russian Art 1863-1922,* New York, 1962, p. 104. A brief account of the 1910 incident is in D. Kogan, *Konstantin Korovin*, Moscow, 1964, pp. 231-32.

philosophical first principle, is, of course, common to *fin de siècle* culture everywhere, and particularly of the international current of Symbolism. But only a few cities in Europe could boast a center more conducive to the creation of *Gesamtkunstwerke* than Moscow's School of Painting, Sculpture, and Architecture. No Symbolist himself, and little attracted to the work of members of the "Blue Rose" circle of Russian painters and poets, Melnikov nonetheless was thoroughly intrigued by their efforts to combine various media in one work, and he was continually to return to this interest over the next decades.

By chance, the order in which the three departments appear in the school's name reflects their overall quality in the early twentieth century, although not their relative size. The hegemony of painting was nearly absolute, with almost half of the school's students and a half-dozen distinguished masters to teach them. Only two teachers in the tiny sculpture department—Paolo Trubetskoi and Sergei Konenkov—and one in the architecture (where a third of the students worked) stood in the same class with Melnikov's teachers of painting, Sergei Maliutin, Vasilii Baksheev, Nikolai Kasatkin, and Korovin. The latter made a particularly strong impression on him.

Thirty years earlier, Korovin had himself revolted against the training he had received at the school in order to make his way towards Impressionism, of which he became the leading exponent in Russia by 1900. This experience made him less concerned as a pedagogue in passing down a specific method than in generating in his students the highest possible sense of vocation towards art. Beyond that, the young Melnikov was attracted to Korovin because he exuded the cosmopolitanism that was the hallmark of Moscow painting in those years. At a time when Melnikov and his classmates were lining up to see the Cézannes and Matisses in the palatial homes of Shchukin and Morozov, this man brought the latest gossip of Paris right into the classroom. Dressed in Paris-cut suits, smoking his cigar, and full of stories of the cultural *beau monde* which he would relate at great length—even at the expense of more substantive lessons—Korovin would arrive late to classes and generally behave "like a ballerina," in the words of his former student.

However trivial in its externals, such a performance went far towards eliminating whatever parochialism may still have remained in the prewar School of Painting, Sculpture, and Architecture. Moreover, contact with the glittering personality of Korovin, along with the remote and inspired image of Chaliapin and the endless student gossip about the mysterious Symbolist artists and poets of Russia and France, confirmed Melnikov in the belief that the artist in any field is a kind of inspired priest bringing beauty into the life of humanity.

During his four years in the department of painting, Melnikov excelled at the work set for him, twice winning gold medals in the exhibitions of student work sponsored by the Tretiakov brothers and receiving favorable mention in the press. But his canvases of those years show little impact of the new avant-garde that was so rapidly coalescing in the shows of such exhibiting societies as the Donkey's Tail, the Ace of Diamonds, and the Union of Youth. Though in the 1920s he was to paint still lifes that are fully in stride with the experimental art of their day, as a student Melnikov ventured no further than a painted wooden plate in the historicist style of the Russian *art nouveau* (Fig. 3). Since we lack full evidence, it is all but

3. Wooden plate painted in the Russian *art nouveau* style. Konstantin Melnikov, before 1910

impossible to reconstruct precisely why he did not succumb to more advanced influences at this time, but two factors are clear from his reminiscences. First, the main avant-garde painters to whom he was exposed were all considerably older, the gap in age generally being about a decade.[12] Melnikov and several of his contemporaries, including his friend Ilia Golosov, observed the proprietary arrogance with which their immediate elders laid hold of experimental painting, and concluded that they themselves must seek their future in allied fields, especially in architecture.

Second, given Melnikov's keenness to master the classical skills that his entire training in the general department had taught him to respect, his quiet personality, and his *arriviste*'s respect for social conventions, he could not help but be repelled by the more flamboyant and deliberately shocking manifestations of the artistic counter-culture. As we shall see, however, this did not prevent him from borrowing heavily from the ideas championed by two of the movements current in pre-Revolutionary Russian art—Futurism and Suprematism—nor did it prevent him from participating in a movement away from easel painting spearheaded by Cubists and Futurists.

The year 1912 was an important one for the twenty-two-year-old Melnikov. His personal life was altered by his marriage to the sixteen-year-old Anna Gavilovna Iablokova, like himself from a devoutly Orthodox family, but of Moscow's solid middle class, rather than the peasantry (Fig. 4). In the same year his professional life took a new turn with his decision to switch from the painting department to the department of architecture. It proved easier to get married than to change careers. In the eyes of Melnikov's patron, Chaplin, painting partook of that realm of high art with which he, a mere engineer, could make contact only indirectly, through his protégé, if at all. Even if Melnikov had no intention of abandoning that realm as he shifted fields, to Chaplin the move appeared as a denial of everything for which he had groomed the young man. On a more practical level, Chaplin also knew that the great painters of his own generation—Serov, Borisov-Musatov, Levitan, etc.—were highly respected personages whose lives had been rendered comfortable and secure by the goddess Art. He therefore insisted that Melnikov at least complete the program in painting before switching to architecture. With little choice in the matter, Melnikov acceded, completing the work for the diploma in painting in 1914 and truncating the five-year architecture program into three years, enabling him to graduate in the spring of 1917.

Melnikov's change of direction was neither as abrupt nor as idiosyncratic nor even as complete a break as it may at first appear. It was not abrupt, because he had considered the possibility of becoming an architect since his first contact with architectural students during his years in the general department, and, in turning to architecture, he never abandoned the two-dimensional media, as the seventy-two canvasses and numerous sketchbooks preserved in his archive attest. It was not idiosyncratic, because fundamental developments within the field of painting were drawing numerous students and even more mature artists gradually in the direction of architecture. After 1910, architectural themes appear with ever greater

4. Anna Gavrilovna Melnikov, charcoal sketch by Konstantin Melnikov, 1916

[12] Nikolai Sapunov (b. 1880); Martyros Sarian (b. 1880); Petr Konchalovskii (b. 1876); Ilia Mashkov (b. 1881); Aristarkh Lentulov (b. 1882); Alexander Kuprin (b.1880); Mikhail Larionov (b. 1881); Pavel Filonov (b. 1883); Kazimir Malevich (b. 1878); and the more senior Vasilii Kandinskii (b. 1866).

frequency in the works of Russia's painters. Aristarkh Lentulov, for one, prominent in the "Donkey's Tail" group, set to work on a series of canvasses depicting the chunky masses of the cathedrals of the ancient Ivers and Strastnyi Monasteries,[13] while Eleazar Lisitskii, later renowned as El Lissitzky, was abandoning Talmudic themes in favor of more fantastic architectural conceptions, which made their tentative debut in his cover design for Alexei Kruchenykh's "transrational" Futurist libretto, *Victory Over the Sun*, in 1913.[14] Far less reserved in their new infatuation with line and mass (rather than with light and color) were Vladimir Tatlin and Ivan Puni (Pougni), whose hanging wall-sculptures by 1915-1916 assumed the form of site-plans for an architecture that did not yet exist. At precisely the same time, though in a more deliberate and meticulous way, Kasimir Malevich set out on the expedition that was to take him, via his squares and rectangles of 1915-1916, to a new world of architectural forms, which he named *Planity*.[15] This architectural current was not confined to painting; one of its earliest manifestations was in the work of a poet Vasilii Kamenskii, who for a Union of Youth exhibit in St. Petersburg in 1911 attempted to create a "Ferro-Concrete Poem." But it was focused among those innovative young painters who were in the process of retooling themselves to become architects.

In the 1930s, Berthold Lubetkin, a peripheral figure in the Moscow architectural world of the 1920s who later emigrated to England as pressure on the field increased under Stalin, used the pages of *The Architectural Review* to accuse his former colleagues of being mere "paper architects."[16] There was bitterness in Lubetkin's words, but truth as well. Melnikov himself frequently denounced the widespread tendency to neglect the practical aspects of a building and instead to follow the siren of painterly effect. Yet among Melnikov's greatest achievements are his drawing-board renderings. Through them one experiences the utopianism and fantasy of the era in all its purity, uncompromised by scarcities of building materials or by bureaucratic obtuseness. Here, too, the genealogy of his new architecture is loudly proclaimed, with its indebtedness to painting far more clearly evident than in the buildings themselves. And in these same renderings one senses an exuberant disregard for technological reality as it was understood by Russian engineers of the day. And no wonder! Melnikov and the others who "changed trains" were granted the title of "artist-architect" rather than "engineer-architect." They relied on others to do their engineering work—sometimes to their own misfortune—and arrived in the architectural world with a built-in dependence upon, and hostility towards, "mere engineers."

Melnikov and the other Russian artists who turned their backs on the two-dimensionality of the traditional canvas demonstrated an indebtedness to the pan-European currents set in motion by Cubism and Futurism. As with the French Cubists in 1906-1908, Russian painters after 1910 struggled intently to make contact once again with that "solid, tangible reality"[17] with which Courbet had once concerned himself but which had been

[13] V. Kostin, *Aristarkh Vasilevich Lentulov: Katalog Vystavki*, Moscow, 1968.
[14] Only the drawing for this appears in Sophie Lissitzky-Küppers, *El Lissitzky*, Dresden, 1967, pl.6; the final printed version is still more "architectural" than this sketch.
[15] Troels Andersen, *Malevich*, Amsterdam, 1970, Appendix 2.
[16] Berthold Lubetkin, "Soviet Architecture; Notes on Developments from 1917 to 1932," *Architectural Association Journal*, May, 1956, p. 260.
[17] Douglas Cooper, *The Cubist Epoch*, New York, 1917, p. 18.

neglected by two generations of colorists. Like their French mentors, but at a yet more dizzying pace, Tatlin and his co-nationalists progressed quickly from painting to sculpture to architecture—all within the span of only a few years.

Since Futurism was from the outset more explicitly "architectural" than Cubism, and since it affirmed the urban world, which the older generation of Russian painters despised as ugly, it was ideally suited to ease the transition between fields. Under the powerful influence of the Italian Futurists, Russian painters were rapidly torn from any lingering preference for classical repose in favor of the unbalanced, thrusting diagonals and spirals beloved by Boccioni, Carra, and Balla. As has been noted, Melnikov's student painting shows no influence of Futurism as such, but he readily acknowledged that the passion for dynamism and motion that suffused his work as an architect had been nurtured under the influence of his first encounters with the works of the Futurists.[18]

When Melnikov entered the architecture department of the Moscow School in 1914, it was no hotbed of innovationism. One would look in vain among his instructors to find a single person who, in the years 1914 to 1917, stood at or even near the forefront of European architecture of the day. Nor was there any other institutionalized source of training in Russia that could provide the kind of front-line exposure to the most advanced architectural ideas that Frank Lloyd Wright received in the office of Louis Sullivan, or that Mies van der Rohe, Walter Gropius, and Le Corbusier absorbed in the office of Peter Behrens. Yet this is not to say that Melnikov's teachers were ignorant of the latest developments abroad, or that the revival of Romantic Classicism in Russia, which they helped to bring about, was without the greatest significance for the future modernist. Indeed, Melnikov's avant-gardism of the 1920s, far from being a reaction against his pre-revolutionary training as an architect, can fairly be interpreted as its logical culmination.

The architectural world in which Melnikov's teachers and, through them, Melnikov himself functioned was in the midst of turbulent change in 1914. His teachers' generation had entered the field at a time when Russian architecture was dominated by the bombastic pseudo-Moscovite style that can still be seen in the building of the Historical Museum on Red Square in Moscow and the Cathedral on the Blood in Leningrad. Developed largely by transplanted Germans and encouraged by no less an authority than Napoleon III's house architect Eugene Viollet-le-Duc, this tinsel-and-icing attempt at a national idiom had been featured on pavilions for every international fair in which Russia participated down through the St. Louis Fair of 1904. It was only the generation of Melnikov's teachers that succeeded in dislodging it, and then only by importing another West European style, the *Art Nouveau, Jugendstil*, or *Moderne*, as it became known in Russia. For some, like Fedor Schechtel in Moscow or Nikolai Vasiliev in St. Petersburg, this provided liberation by encouraging the designer to conjure wonderful fluid forms instead of assembling dry elements of an atrophied Muscovite canon. For others—among them Melnikov's teacher Illarion Ivanov-Schitz—its geometric and analytic aspects emerged dominant.[19]

[18] Cf. the excellent discussion of the impact of these movements on West European architecture in Reyner Banham, *Theory and Design in the First Machine Age*, 2nd ed., New York, 1970, pp. 202 ff.

[19] Melnikov's two other teachers were F. O. Bogdanovich and the Pole, S. V. Noakowski.

For nearly all of them, however, the *Moderne* was but a way station to be passed on a longer journey. The many buildings that Ivanov-Schitz built after 1900 exhibit muted elements of the *Moderne*, but they are otherwise notable for their emphasis on clean, purely classical forms, on contemporary materials, and on workaday functionality.

A slim volume published on the heels of the Revolution of 1905 by the St. Petersburg engineer, V. Apyshkov, reveals the problem that the *Moderne* had failed to resolve and that continue to plague Ivanov-Schitz and Russian architecture as a whole. In Apyshkov's view, the revolution of 1789 in France had spelled the doom of all "aristocratic architecture" and the beginning of a search for "Rationality in the New Architecture," to cite the title of his book.[20] His clear implication was that Russia reached that same point with the establishment of the semi-constitutional regime in October 1905, and had now to join the world-wide search for a new architecture. Apyshkov did not reveal what that new architecture would be, but he was convinced that the answer was to be found in the experience of Western Europe and America. His study, like virtually the entire architectural press of the day, is a guidebook to the most advanced accomplishments of world architecture, with whole sections devoted to Hermann Muthesius, Henri van der Velde, Otto Wagner, Victor Horta, and others. Its very catholicity attests to the uncertainty of direction experienced by Russian architects after the breakup of the most flamboyant phase of the *Moderne*.

There were as many answers to the questions of new directions as there were architects. Far from being dominated by cheap commercialism and tired nationalism, as several recent writers on the subject have suggested, Russian architecture before 1917 was engrossed in the very serious task of confronting and analyzing the leading international currents of the day. This was made easier by the fact that so many leading West European architects either visited or worked in Russia before World War I. Both Macintosh and Ölbrich came to Moscow in 1903 to show their latest interior design, and, in the process, to meet with Russian architects.[21] The English architect Walcott emigrated to Russia and built a number of buildings in and around Moscow, including the Art-Nouveau Metropole Hotel opposite the Bolshoi Theater. And Peter Behrens designed a new German embassy for St. Petersburg, which was erected under the supervision of site architect Mies van der Rohe during the years that Melnikov was completing his studies. Other leading foreign architects who did not actually work in Russia before 1914 were nonetheless well known there, thanks both to Russians studying abroad and to publication of their work in Russia. Suffice it to say that whole delegations of Russians visited the English garden settlements after 1909, that Moisei Ginsburg was studying the Germans and even the famed Wasmuth edition of Frank Lloyd Wright's works while in Milan before the war,[22] that Ölbrich and the Viennese Secession found a major disciple in the St. Petersburg architect Vasiliev, and that by 1912 the young Pantaleimon Golosov (older brother of Melnikov's friend Ilia) had built near St. Petersburg his own version of Wright's Japanese-influenced Warren Hickox House in Kankakee, Illinois.

Of all the prewar solutions to the problem of architectural style, the only one to come close to gaining a degree of hegemony in Russia was superfi-

[20] V. Apyshkov, *Ratsionalnoe v novoi arkhitekture*, St. Petersburg, 1905.

[21] *Mir iskusstvo*, 1903, No. 3, p. 31.

[22] G. B. Zabelshanskii, "M. Ginsburg kak teoretik funktsionalizma," unpub. *diplomnaia rabota*, Leningrad State University, 1970, p. 11.

cially the most conservative: the revival of classicism. One of Melnikov's teachers, Ivanov-Schitz, became a leading exponent of this current during the decade after 1905. Thanks to him and to several like-minded professors at the Moscow school, this broad movement came to occupy the central place in the architectural education received by Melnikov and most of the other avant-gardists trained in the years before 1917. Since this classicizing trend was to remain the single strongest influence on Melnikov's later avant-garde work as well, it merits our closer attention.

The present-day visitor to Moscow quickly gains a sense of what this classicizing tendency did and did not include. Notwithstanding the effort of the architect R. Klein to evoke antiquity directly in the Pushkin Museum (1911), the classicism in question is not that of Greece or Rome, nor even primarily that of the Renaissance, but rather the freer, more sculptural, and hence more dramatic Romantic Classicism (sometimes known as "Revolutionary Classicism") of the late eighteenth and early nineteenth centuries.[23] This is what Melnikov acquired from Ivanov-Schitz and his colleagues. He was steeped in the ideals of this classicism, and produced numerous early projects based on its canons, not to mention his many later avant-garde works in which the impulse of Romantic Classicism is clearly manifest.

This is not to deny the central pedagogical role played by the architecture of the Renaissance. The major buildings of Bramante, Bernini and Borromini were carefully studied in Moscow, as they were elsewhere in Europe and America at the time. Students were still expected to have mastered the elements of Renaissance style, and to prove their proficiency by submitting projects incorporating those elements. Several prominent Russian architects of the early twentieth century went so far as to advocate a direct return to Renaissance prototypes. The measure of their success is the fact that their influence can be detected even in the works of architects who considered themselves to be working squarely in the later tradition of classicism.

Yet for all of this, Renaissance architecture remained essentially alien to Russians after 1900, even as it had been to Russians in 1500. Instead, they opted for the simpler classicism pioneered in France in the decades immediately preceding the French Revolution. Unlike the Renaissance styles, this current had always been at home in Russia. Thanks both to West European masters patronized by Catherine II and Alexander I, and to their talented native Russian disciples, Moscow was studded with distinguished buildings of this school. Hence, the new interest that it evoked after 1900 had more the character of a local revival than of a fresh discovery.[24] Surrounded by excellent examples of Romantic Classical architecture, and at ease with the knowledge that this was directly a part of their own heritage, Russian architects of the early twentieth century were the more able to reassimilate the movement and eventually to transcend it.[25]

What was this century-old tradition of classicism that Moscow architects revived with such enthusiasm? In its aesthetics, it held that all architecture

[23] See S. Giedion, *Spätbarocker und romantischer Klassizismus*, Munich, 1922.

[24] The revival of broad public interest in Russia's classical architecture dates to the publication of I. Fomin's article "Moskovskii klassitsizm," *Mir iskusstvo*, vol. 12, 1904, pp. 187-98, the founding of the journal *Starye gody*, and to the 1911 "Istoricheskaia vystavka arkhitektury" organized under Fomin's direction in Petersburg.

[25] The best appreciation of the classical revival in Russia by E. A. Borisova, "Neoklassitsizm," in T. P. Kazhdan and E. A. Borisova, *Russkaia arkhitektura kontsa xix-nachala xx veka*, Moscow, 1970, pp. 167-219.

must be based upon the primal elements of geometry, i.e., blocks, pyramids, cylinders, cones, and so forth. These abstract units were seen as the platonic forms without which no true architecture can be created. Their actual composition into buildings could be carried out with a degree of freedom, and each geometric component was permitted to retain its integrity within the whole. Classical canons of composition were not ignored in the assembling of the parts, but they were interpreted with great flexibility, thus enabling the architect to exercise originality and boldness in conceiving the overall plan. The judicious use of classical orders and motifs reinforced the unity of the composition and assured that individual buildings would fit harmoniously with one another. Finally, ornamentation was stripped down to an absolute minimum so as to emphasize the fundamental forms from which the structure derives its beauty.

The idealist strain in Romantic Classicism was fully evident in the work of the late-eighteenth-century founders of the movement, Etienne-Louis Boullée, Claude-Nicolas Ledoux, and Jean-Jacques Lequeu. All three evinced a strongly platonic preoccupation with pure, abstract forms. Pyramidal cenotaphs, spiral beacons, cylindrical castles on the sea, and countless other designs based on elementary forms reflected their authors' unprecedented passion for the beauty and expressiveness to be achieved through the geometer's rule and compass. As Boullée put it, "Tired of the emptiness and sterility of irregular forms, I have passed to the study of the regular. . . .These captivate by simplicity, regularity and reiteration."[26] In such statements one can find the roots of the "formalism" for which Melnikov, Ivan Leonidov, and other visionaries of the 1920s were later attacked.

Stalinist critics of "formalism" assumed that its attention to aesthetics and to psychological impact left no room for social concerns. In this they were quite wrong. Those who revived Romantic Classicism built more than a few private residences, but their best commissions and deepest enthusiasms—like those of their French forebears—were for public buildings. This was the easier since the same austere idiom had been the official style of the Russian government over several decades before and after 1800. In the early twentieth century the government came again to favor Romantic Classicism and used it for many of the monuments and buildings erected to honor the tricentennial of the regime if 1911. At the same time, such architects as Klein, and Melnikov's teacher Ivanov-Schitz, applied it to such diverse edifices as the Shaniavskii Public University of 1913 and the Moscow "Coliseum" movie theater of 1914.

To a far greater extent than the contemporary Schinkel revival in Berlin that it so strongly resembles in other respects, and even more than the American City Beautiful movement of the same years, the Romantic Classical revival in Russia concerned itself with town planning. This was quite natural, since the greatest planning endeavors undertaken in Russia had occurred during the reigns of Catherine II, Alexander I, and Nicholas I—the period when the original style had held sway—while the most grave damage to those plans had occurred at the hands of late-nineteenth-century entrepreneurs who championed the neo-Muscovite style. Partisans

[26] Emil Kaufman, *Three Revolutionary Architects, Boullée, Ledoux, and Lequeu,* in *Transactions of the American Philosophical Society,* New Series, Vol. 42, part 3, Philadelphia, 1952, p. 471. See also Kaufman's earlier volume, *Von Ledoux bis Le Corbusier. Ursprung und Entwickelung der autonomen Architektur*, Vienna, 1933.

of the Romantic Classical revival set up Russia's first modern town-planning courses in 1911 and successfully brought pressure to bear on local authorities in St. Petersburg to regularize that city's further expansion. By stressing the historic precedents for systematic urban development achieved through strong governmental leadership, the revivalists raised Russian city-planning out of the doldrums in which it had been mired since the 1850s.[27]

Beyond this, the French founders of Romantic Classicism had been impelled by a desire to define the ideal community in its most revolutionary and at the same time architecturally specific terms. Hence, Boullée's vast triumphal arches, metropolitan churches, opera houses, and national assembly halls constituted the physical framework in which some perfect society of the future was to fashion its life. Without doubting their own right to do so, these architects dared to usurp the Enlightenment philosophers' work of charting out the course of mankind's development.

The early-twentieth-century Russian followers of Boullée, Ledoux, and Lequeu did not dare to go this far, but they were not unaffected by the vision of the architect's role in society that the French masters held out to them. In turn, the revivalists succeeded in inspiring their students—notably Melnikov—with the hope that architecture could again be raised to that position of preeminence among the learned arts to which it had once aspired.

How did this legacy of the pre-Revolutionary French Enlightenment pass to pre-Revolutionary Russian architects and students of architecture such as Melnikov? With a good knowledge of architectural literature in France, Germany, and the English-speaking world, Emil Kaufman writes: "As late as the 1920's the works of Boullée and Ledoux were discussed only if they had some local interests. Beyond this, their works were referred to very briefly, at best, and the authors commonly disparaged."[28] But this general ignorance did not extend to Russia. The architectural principles of Ledoux and Boullée were well known to Russians indirectly through study of the works of their numerous Russian followers of the Napoleonic era.[29] But direct contact was also re-established during Melnikov's student days, when the distinguished historian of Russian art, Igor Grabar, devoted a section of his 1910 volume on the architecture of St. Petersburg to their ideas. On these pages, part of his landmark *History of Russian Art*, he traced the peculiarly strong impact of the school of Ledoux in early-nineteenth-century Russia. Besides reproducing examples of many of Ledoux's and Boullée's works, he selected from the complete ouvrage of their Russian followers those buildings and projects which best embodied the "constructive idea" he considered to be the essence of St. Petersburg classicism.[30]

Melnikov heard Grabar lecture on these subjects at the Moscow School and eventually formed an acquaintance with him that was frequently to bring the historian to the architect's home. Moreover, Grabar's chief ar-

[27] For details of this aspect of the classical revival, see S. Frederick Starr, "The Revival and Schism of Russian Urbanism," in *The Russian City in History*, Michael Hamm, ed., Lexington, 1976, pp. 222 ff.

[28] Kaufman, p. 433.

[29] For example, Adrian Zakharov (1761-1811); Nikolai Lvov (1781-1803); Nikolai Alferov (1780-1840); and Ivan Starov (1743-1808). Thomas de Thomon (1751-1803), a French engineer who became architect to the Russian court, was an avowed disciple of Ledoux.

[30] Igor Grabar, *Istoriia russkogo iskusstva*, vyp. 15, p. 455; also I. Grabar, "Rannii aleksandrovskii klassitsizm i ego frantsuzskie istochniki," *Starye gody*, Vol. 7-9, 1912, pp. 68-96.

5. Student sketch by Konstantin Melnikov, Moscow School of Painting, Sculpture and Architecture, ca. 1908

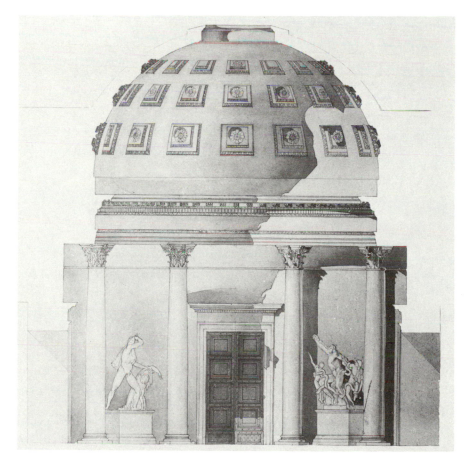

6. Vestibule in the Roman style. Student project, 1914

chitectural consultant on the volume, A. V. Shchusev, himself a lifelong student of Russia's classicism, was later to serve as one of Melnikov's chief protectors in post-Revolutionary Moscow. The requirements of the curriculum at the Moscow School, however, were such as to prevent the impact of Franco-Russian Romantic Classicism from being felt in Melnikov's work until about 1915. His earliest surviving sketches (Fig. 5) all address such standard Beaux Arts problems as floral ornaments, Corinthian capitals, etc. Similarly, the 1914 "Vestibule in the Roman Style" (Fig. 6) employed the Corinthian columns that Grabar's work was to compare unfavorably to the more austere Doric. A "Cafe-Restaurant" of the same year (Fig. 7) presents features intended to recall Bernini and Brunnelleschi, notably the round-arched arcade of the façade, the quoining at the corners,

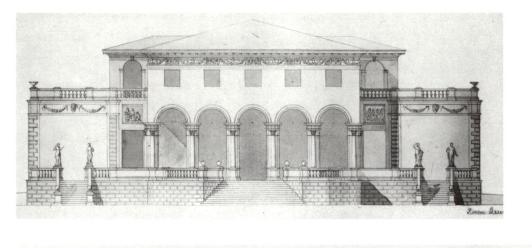

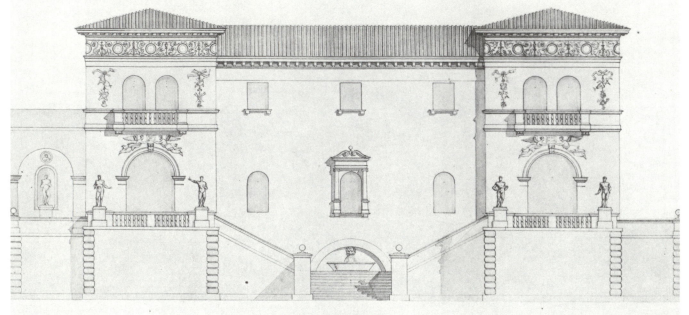

7. Cafe-Restaurant in the Renaissance style. Student project, 1914

8. A house in the Renaissance style. Student project, 1915

and the rusticated foundation. At the same time, the plain walls and unornamented windows of the second story hint at a shift towards the more austere Romantic Classicism.

The following year Melnikov addressed the set theme of a two-storied "Building in the Romanesque Style" in such a way as to present these traits of Romantic Classicism more prominently. The masses are more clearly defined, so as to make the building seem an assemblage of blocks. Melnikov used the same technique effectively in the design of a "House in the Renaissance Style," also of 1915 (Fig.8). Here, a pair of staircases were employed on the Renaissance structure to form diagonals across the façade in a manner that anticipates directly several of Melnikov's more theatrical entrances of the 1920s. This use of diagonal staircases to add relief to an external surface appears yet more prominently in an otherwise routine project of 1916 for a railway station's service building.

A military museum from 1916 (Fig. 9) shows Melnikov moving yet more deliberately to the elemental classicism of the pre-Revolutionary French architects and their Russian followers. Here he presents the façade of the six-columned temple of Paestum, whose importance to Russian clas-

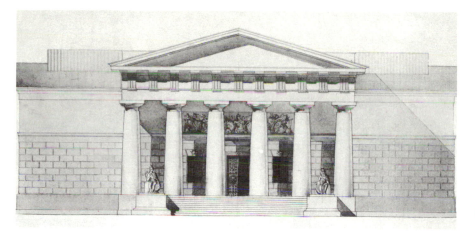

9. A military museum, student project, 1916

sicism had just been explained by Grabar,[31] and combines it with the type of unfenestrated but heavily rusticated front wall employed by Ledoux for his 1788 *Caisse d'Escompte* and by Jacques Gondouin and the early-nineteenth-century Petersburg Hellenist, Stasov, in a number of projects also published by Grabar. An important and propitious detail in the drawing is the use of heavy shadows to create a series of sharp diagonals to cut the severely rectangular façade into triangles, thus adding a restless quality to the whole composition that was to reappear in countless works by Melnikov and avant-garde painters over the following years.

Melnikov's project for the diploma in architecture (Fig. 10) may at first glance strike the modern viewer as an exercise in the purest anti-quarianism, a careful reconstruction of the early-nineteenth-century Russian nobleman's "nest" blown up to accommodate a trade school or large public agency. The central body, with its cupola over a protruding semicircular colonnade, borrows literally from the estate of Elizavetino near Moscow, even down to the paired columns,[32] while antecedents for nearly every other element may be readily found either in works of Romantic Classicism in Russia or in those of its various antecedents back to Palladio. But to stop with this observation would be to undervalue the project and, more broadly, the importance of the Romantic Classical revival as a whole to the modern movement in Russia. For however much attention Melnikov devoted to assembling the elements of a time-worn canon into a single building, that very exercise required him to analyze the constituent cubes and cylinders in terms of a coherent language of forms and to organize them in such a way as to meet the practical needs of a large public building. It gave him a chance to experiment with the architectural means of creating a setting for ceremonial occasions and to explore the use of covered walkways to integrate parts of what might otherwise be separate buildings.

The results in this case have a distinctly, though not decisively, modern cast. In the final variant of the project, Melnikov stretched the horizontal planes out to their extreme limits, thereby disarticulating the geometric components and placing them into a far more sculptural relation to each other than even Romantic Classicism would have allowed. Moreover, that same stress of the horizontal reduced the literally classical elements—columns, colonnades, etc.—to the status of surface ornaments pasted onto

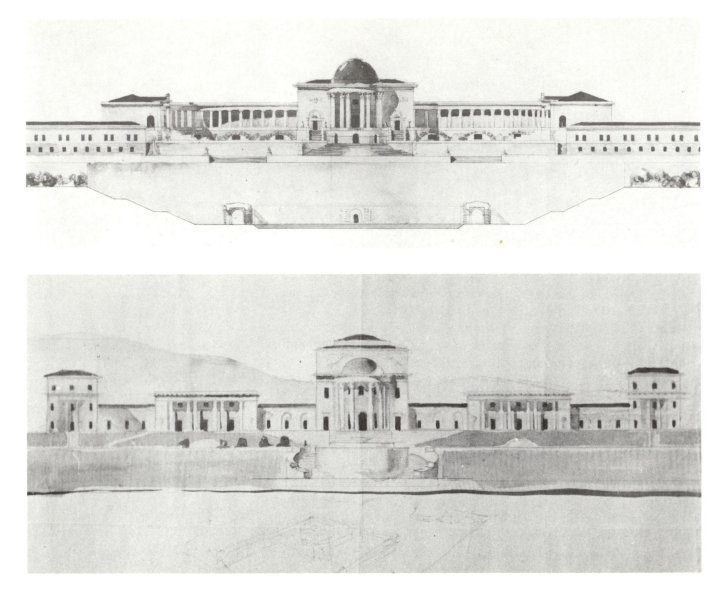

10. Headquarters for a trade school or public agency; project submitted for the Diploma in architecture, 1917. First variant

11. Headquarters for a trade school or public agency, 1917. Second variant

a thoroughly twentieth-century construction of masses. Finally, the circular entryway on the first variant (Fig. 11) was so successfully abstracted from its Romantic Classical sources that it could later be applied virtually without modification at the renowned Kauchuk factory workers' club of 1927. Clearly, Melnikov was transcending Romantic Classicism even as he was mastering it.

Training based on the study of Romantic Classicism by no means sheltered Melnikov and his contemporaries from considering the functional requirements of architecture, but it did tend to immunize some of those who had been exposed to it—including Melnikov—to the most extreme functionalism of the 1920s and it encouraged them to think instead in terms of an equilibrium between practical and aesthetic considerations. Such training provided a legacy that Melnikov neither rejected nor even held up to gentle teasing, as Prokofiev did to the analogous musical heritage in his "Classical Symphony." It is no wonder that when the most radical experiments of the late 1920s were subjected to criticism, Melnikov and many of his fellow modernists reverted in their quest for suitable forms to the precepts of their earliest training.

III. Bearings in a New World

THE spring of 1917 found Melnikov an architect at last, having received a prize along with his diploma from the Moscow School of Painting, Sculpture, and Architecture. Normally, the school would have sent so successful a student abroad for a final year in Paris, but the First World War prevented this, just as it disrupted every other aspect of normal existence in Russia. With all but industrial building at an utter standstill and with a family of four to feed, Melnikov had no choice but to follow the same path that so many other Russian architects were reluctantly taking and to find work designing factories.

His first project, carried out with the Moscow engineer, A. F. Loleit, [2] was to plan Russia's first automobile plant, the AMO factory in Moscow.[3] Working with Loleit, he designed several structures for the factory, in addition to which he singlehandedly planned the façade of the main building. The work brought two very real benefits, besides enabling Melnikov's family to live in its own house on the Moscow River embankment. First, it forced him to rid his architecture of all that was irrelevant to the practical requirements of a factory or excessively costly in terms of building materials or labor. When during these same years his contemporaries, the Vesnins and the Golosovs, also undertook to design factories, the austere requirements of the task had the same refining and simplifying impact on their work. Second, because the plant was established by the prestigious and widely cultured Moscow cotton factors, the Riabushinskii brothers, the young graduate's name came to the attention of numerous prominent cultural figures, both of the tsarist and revolutionary worlds.

However real these benefits, the AMO commission turned out not to reorient Melnikov in the direction of industrial architecture, any more than did similar experiences convert other Russian architects to what had always been and was to remain the realm of the engineer. The façade of the main building (Fig. 12), far from depending on an industrial aesthetic, recalls nothing so much as a stripped-down version of the late-eighteenth-century Moscow estate of Bratsevo designed by A. Voronikhin, or the wings of M. Kazakov's 1802 Pavlovsk Hospital, also in Moscow. The significant innovations in the design—especially the treatment of the arches (Fig. 13) and the doorway—result from pushing the historic prototypes be-

"All Power to the Soviets!"
—*Revolutionary slogan*

"All Power to Architecture!"
—PAVEL NOVITSKII[1]

[1] "Vsia vlast arkhitekture," *Arkhitaktura i VKhUTEIN*, 1929, No. 1, p. 2.

[2] Loleit was a friend of Chaplin's, through whom Melnikov probably received the commission. *Zapiski MAO*, 1905, p. 1 ff.

[3] S. V. Voronkova, "Stroitelstvo avtomobilnikh zavodov v Rossii v gody pervoi mirovoi voiny (1914-1917 gg)," *Istoricheskie zapiski*, No. 75, 1965, p. 159 ff.

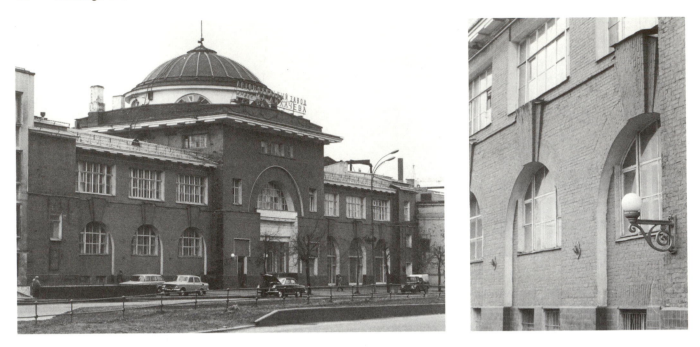

12. Main administration building for the A.M.O. (now Likhachev) automobile factory, Moscow, 1917

13. A.M.O. automobile factory, Moscow. Detail of the facade

yond the limits recognized by the eighteenth-century masters, rather than from introducing wholly new notions from the factory.

There is nothing surprising in this, for, with but few notable exceptions, the modern movement in Russian architecture shunned the assembly line, the workshop, and the refinery, finding its role instead in designing places of residence and recreation for workers and offices for managers and public adminstrators. Melnikov and his peers were by no means ignorant of the factory, but, like the poet Maiakovskii and the Italian Futurists, their contact was just great enough for them to be awed by its rationality and power, yet not so great as to destroy their largely aesthetic appreciation of industrialized production.

Even had such a reorientation occurred as a result of wartime exposure to industrial architecture, neither Melnikov nor his contemporaries would have had the opportunity to follow through on it, for, during the half decade 1917-1921, the country was in a state of spiralling turmoil caused by two revolutions, civil war, and foreign intervention. Rural Russia boiled with peasant seizures of land when it was not in flames from contending Red and White armies—not to mention the Green forces of anarchy. When supplies of wheat and rye were no longer forwarded to feed the hungry cities, Moscow rapidly shrank to half its former population, the dwellings and workshops abandoned by the fleeing and dead left to stand unheated through bitter cold and gradually to be pried apart by frost. Famine followed famine, the dark figures of starving evacuees huddled on platforms at snowbound railroad stations, and amidst it all the ghostly palaces in Petrograd echoed to little more than the footsteps of an immigrant from Odessa helping himself to an evening with the library of a Grand Duke. The Revolutionary period presents one face of an epic tale of contending heroes and villains moving and counter-moving for control of Russia. But its other face, known alike to Bolshevik or Menshevik, Socialist Revolutionary or Constitutional Democrat, scrubwoman or commissar, was haggard and lined with the cares of what the novelist Pilniak termed the "naked years."

These circumstances hit working architects with the particular force re-

served for those lines of endeavor which depend upon the existence of a flourishing economy. The collapse of building activity threw the field into chaos by 1918. With no commissions, the professional associations suspended activity, training schools closed their doors, and former ateliers were in most cases disbanded. Nor did funds exist to aid those out of work, so that many architects simply abandoned the field for whatever work they could find. Even those most enthusiastic over the turn of political events suffered with the rest. As Melnikov recalled, "the word 'new' became equated with cold and hunger, and the word 'activity' with daylight."[4]

Such conditions constituted a significant part of the background against which the renaissance of Russian architecture and the flowering of Melnikov's talent occurred. But they are by no means the whole story, for alongside these grueling circumstances, Russia's social and political drama was unfolding, watched with rapt interest by much of world public opinion at the time.

That the idea of revolution came eventually to fascinate and to a considerable extent inspire the leading architects of the 1920s goes without saying. But to establish the precise steps by which the new architecture became bound up with the new politics is no simple matter. Thus, it is true that hardly a man among the avant-garde architects was a member of the Bolshevik Party in 1917 and very few joined thereafter, with such exceptions as the public administrator and urban planner, N. A. Miliutin, later the author of a famous project for a linear city. Yet until pressure was placed upon leaders of institutes, schools, etc., to join the Party, there was no reason to do so, for party membership was itself a profession that placed extremely heavy demands on anyone who entered it.

It is also true that most future leaders of the architectural avant-garde stood aloof from the political struggles of 1917. The studied vagueness of Melnikov's recollections of the revolutionary year could have come from the pen of more than one of his colleagues: "Should I try to recall now that which is passed? No. Of course, one cannot describe everything because much, probably better than half, is already forgotten, and if not forgotten, it has slipped from sharp memory into a series of complicated and beautiful sensations that can no longer be caught by the pen. I have no diary (which is probably to the good). It seems to me that our memory is built so that it preserves whatever is of value for one's personality. And for the artist its work is not to speak of all events occurring in one's lifetime, but only of one's role in them, and perhaps not even that. . . ."[5]

Melnikov's wife, Anna Gavrilovna, recalled some of the events that might have been recorded in his diary, had he kept one.[6] According to her, the family's first direct contact with the Revolution occurred in the late autumn of 1917, when the workers at the AMO factory overthrew the management. A mob siezed several unpopular foremen and, bundling them into sacks, threw them into the Moscow River and left them to drown. The same crowd of workers came directly to Melnikov's house in order to reassure him that they liked and respected him and would not interfere in any way with his work. In response to their polite request, Melnikov turned over several rooms of his house to workers' families, on the condition that the women would take a hand with the housework and babysitting.

As it became increasingly difficult to obtain provisions in Moscow, Mel-

[4] Melnikov, "Arkhitektorskoe slovo . . . ," p. 19
[5] Melnikov, "Arkhitektura moei zhizni," p. 18.
[6] As recalled in April, 1976.

nikov and his family moved back with his now-ailing parents, with whom they spent the remainder of 1917 and all of 1918. When the family cabin in Petrovsko-Razumovskoe became too crowded, the younger Melnikovs retreated to a rented room in Moscow's Gazetnyi Pereulok, but even this central location brought the architect no closer to the Revolutionary events. Preoccupied with domestic affairs, Melnikov neither fled with the Whites nor threw in with the Reds. Yet however detached he was in 1917, Melnikov and many like him came to support the new order, once it became apparent that that order would be supportive of their activities.

Melnikov's aloofness from the political events of the Russian Revolution was a manifestation of a general antipathy to political controversy that he was to retain all his life, often at considerable cost to himself. Such detachment, maintained with more rigor and consistency by him than by most other avant-garde architects, may well have important psychological dimensions. Against the background of the architect's peasant origins and his experience at the Moscow School of Painting, Sculpture, and Architecture, however, it is by no means surprising. By his own admission, Melnikov arrived at the school with none of the easy familiarity with and practice at partisan controversy that the middle-class city boys possessed; in his youthful pride he thought it best to avoid the entire subject rather than to exhibit his naiveté. Melnikov's contemporary and friend, Boris Pasternak, used his verse memoir *1905* to describe the protest meetings, strikes, and fighting that spread through the Moscow student world during the Revolution of 1905. At the Moscow School these confrontations were particularly sharp, with the consequence that by November 14 the institution was simply closed.[7] Melnikov, then fifteen, took no role in those events, but, for Pasternak and others who did, the ensuing letdown was severe, especially when it became clear that the "seeds of reform" had sprouted nothing more than a crop of professional politicans. Melnikov's student days coincided with this general disenchantment with politics at the school, and he adopted the prevalent view that culture and politics were distinct realms, the former being far superior to the latter.

Though scornful of politics, Melnikov and most of the architects stopped short of the rowdy anarchism that spread among the younger painters with the revival of radical politics during the First World War. Such painters showed great initial enthusiasm for the aesthetics of revolution and even before 1917 lent their talents to numerous adventures that were to take their place in the history of mass communication. But they also produced far more emigrés than did the architects, as the Russian colony in Berlin and the swollen rolls of the "Union des Artistes Russes" in Paris attest.

While most of the political leaders were off fighting the Civil War in 1918, the entire artistic community was asked to participate in the decoration of Moscow and of other major cities in honor of May Day and the first anniversary of the October Revolution. The Vesnin brothers and a handful of other architects participated—more often than not as painters or graphic designers—but the names of such prominent architects as Ginsburg, Ladovskii, Dokuchaev, and Barkhin are notably absent from the record. Melnikov is reported to have attended meetings at the Moscow School to plan the decorations, but no work of his for the occasion has been preserved.[8]

[7] N. Dmitrievna, *Moskovskoe uchilishche zhivopisi, vaianiia i zodchestva*, Moscow, 1951, pp. 152-54.

[8] Reported by N. Kolli, in E. A. Speranskaia, *Agitatsionno-massovoe iskusstvo pervykh let Oktiabria. Materialy i issledovaniia*, Moscow, 1971, p. 82.

He did leave many non-political paintings of this period, however, and a major triptych depicting Leyda the Swan. Apparently, he was waiting to see what assignments the Revolution would bring him as an architect.

The answer was not long in coming, and it took a form appropriate to the apocalyptic mood of the day. Few who followed Bolshevik propaganda in the early days of the Revolution could have failed to realize that the new order would seek to transform human life. It was an obvious corollary to this proposition that death, too, would be transformed, by abolishing the sacramental trappings of the Orthodox Christian funeral and by erecting instead a new Communist ritual. Nor could the practice of burying corpses in the ground be continued in a new world concerned with hygiene and with the need to preserve and carefully utilize urban spaces. Instead, the worker's body would be cremated, a practice that had until then been successfully opposed by the Christian, Jewish, and Muslim communities of the old empire. With the introduction of cremation, family ritual would be revolutionized in a stroke, transcendental beliefs battered down, and the cause of sound health advanced—so ran the Party's reasoning.[9] When a competition to design Moscow's first crematorium-columbarium was announced in February, 1919, some fifty-eight architects came forward with solutions.

This competition marks an important step in the development of early Soviet architecture. A few projects for community centers (narodnye doma) had been built in 1918, but all had reverted to the most hackneyed motifs of Greek and Roman antiquity. Monuments to heroes of the Revolution and to the Soviet Constitution were also being built by 1919, but these were more limited sculptural efforts. Utopian towers by Naum Gabo and Vladimir Tatlin and the more feasible tower-kiosks of Alexander Rodchenko are the most characteristic efforts of that year, but these had purely symbolic functions, Tatlin's claims to the contrary notwithstanding. The crematorium-columbarium, by contrast, called for a building that combined a highly functional program with a high degree of revolutionary elan.

Melnikov's design for a columbarium did not win the competition, but it surpassed all other entrants in boldness. All proposals were required to utilize the foundations of a partially completed chapel in the Donskoi Monastery, but in such a way that the resulting building would not in the least suggest a Christian church. Melnikov proposed to build on the existing foundations but imposed on the ground plan a series of stairways connecting different levels, both inside and outside the building, so as to mark the points along the route of the complex procession that he envisioned the civic funeral to be (Fig. 14). The rather bewildering maze that resulted suggests that he may have taken the project as a whole far more seriously than the formal program required, and that, in fact, the funeral theme may have touched off in him some rather far-reaching speculations. (This possibility will be explored in depth in the concluding chapter of this book.) Returning to the plan, for what would have been the west front of the chapel, Melnikov proposed a large glassed entrance (Fig. 15) that, to one contemporary critic, seemed more appropriate for an exhibition pavilion than a crematorium and that indeed suggests somewhat the façade of Wal-

[9] See Leon Trotsky, "The Family and Ritual," in *Problems of Everyday Life*, New York, 1973, pp. 44-47. Pre-revolutionary advocates of crematoria based their case entirely on hygienic grounds; cf. "Uspekhi krematorii na zapade," *Stroitel*, 1895, No. 29, pp. 4 ff.; cf. also K. N. Afanasiev, *Iz istorii sovetskoi arkhitektury 1917-1925, dokumenty i materialy*, Moscow, 1963, pp. 214-15.

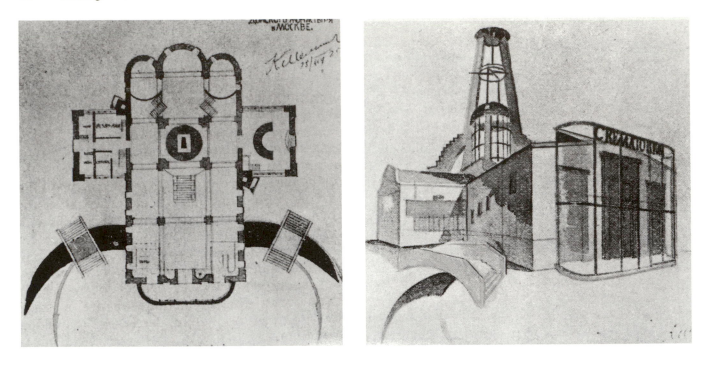

14. Project for a crematorium-columbarium, 1919. Plan

15. Project for a crematorium-columbarium, 1919

ter Gropius and Adolf Meyer's 1914 building at the Deutscher Werkbund Exposition.[10] Then, over the crossing he erected his own addition to the group of Revolutionary towers, this one based on the form of a compass, as if to give the public new bearings to replace those provided formerly by the Orthodox cross (Fig. 16). If the façade alludes to prewar German architecture, the jagged flying buttresses supporting the tower suggest another German source, in this case the radical medievalism of German Expressionism. That Melnikov found all this to be quite exotic and foreign is suggested by his decision to identify the building with Latin letters on his drawings. Evidently the jury agreed, for it rejected the proposal outright, and opted instead for a bland building resembling an office block, its interior lined with austere pews in the manner of a Protestant chapel.[11]

With his project for the Moscow crematorium, Melnikov finally crossed the frontier separating Romantic Classicism from the experimentalism of the 1920s. Though it cannot be said that he had arrived yet at any stable alternative to the styles in which he had been trained, it is worth noting how rapidly his architecture was evolving at this time. A year before, he had submitted a design for the proposed new home of the Alekseev Psychiatric Hospital in Moscow (Fig. 17). The project is not without interest, but in its cautious handling of the received legacy it is far less promising than his diploma project or the AMO factory. Yet within the year, Melnikov was striking out in wholly new directions.

A series of one-family dwellings developed in 1919 began to reveal the sculptural expressiveness for which Melnikov was later to become famous. The first variant calls to mind the resort cottages of the Crimea and marks the beginning of a series of experiments with shed-roofs that would culminate in the celebrated Makhorka pavilion of 1923 (Figs. 18-19). The second variant is far more radical, in that in it for the first time Melnikov

[10] F. Lavrov, "Moskovskii krematorii i ego zhachenie," *Stroitelstvo Moskvy*, 1926, No. 5. The competition as a whole is discussed in *Khudozhestvennaia zhizn,* 1919, No. 1.

[11] S. Nekrasov, "Pervyi moskovskii krematorii," *Kommunalnoe khoziaistvo,* 1927, No. 11-12, p. 16.

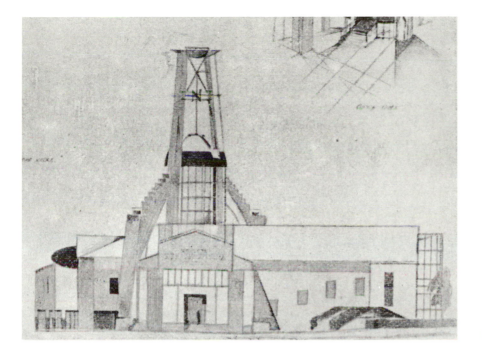

16. Project for a crematorium-columbarium, 1919. Elevation

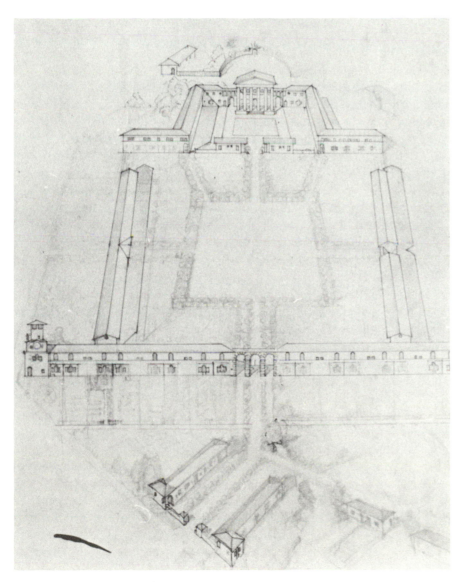

17. Project for the Alekseev Psychiatric Hospital, Moscow, 1919

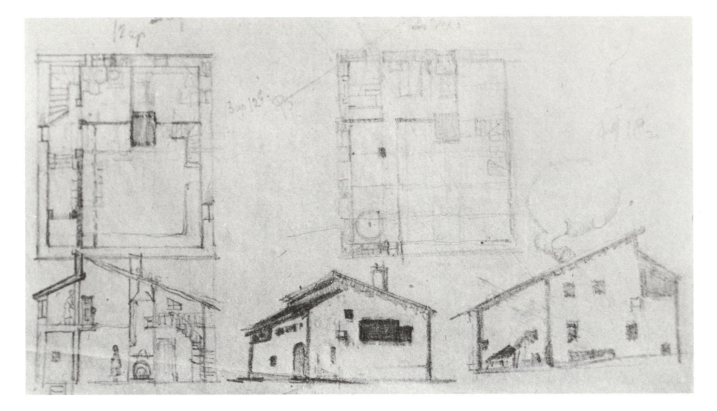

18. Project for a single-family dwelling, 1919. First variants

sought to break a static rectilinear ground plan into more complex and dynamic triangular forms (Fig. 20). The result is a decidedly interesting structure, with the eccentric-shaped rooms contrasting to the regularity of the outer walls, just as the three—and in one variant, four—colliding roof planes provide a lively counterpoint to the stolid rectangle on which they sit (Fig. 21). This transformation of a rectangle into triangles was to appear again soon, first in the crystalline form of Lenin's sarcophagus of 1924 and then in the renowned Soviet pavilion built in Paris in 1925.

By the end of 1919, it was clear that the two successive revolutions had immeasurably broadened the expectations that architects could realistically hold for themselves and their craft. For fifty years prior to 1917, they had been organized into professional associations that had struggled bravely but ineffectually to carve out for themselves a niche in a world dominated by all-powerful but increasingly sluggish and reactive governmental agencies. These organs of state and their forerunners had once overseen the construction of the city of St. Petersburg *ex nihilo* and had planned the reconstruction of the major cities of European Russia—both projects unequalled anywhere at the time for their sheer magnitude. But with the rise of private entrepreneurs in the building industry, the government bureaus had gradually abdicated their innovative function and, by the 1860s, had become impediments to those independent architects who wished to take it up. The Revolution of February, 1917, for all the vacuous rhetoric with which its eventual leader, Alexander Kerensky, surrounded it, had the very positive function of destroying these bureaucratic regulatory bodies and thereby liberating architects and city planners from a major source of frustration. From that moment until the early 1930s, the architects and planners had every reason to believe that they, the designers, would be free to make plans for whatever seemed necessary for the architecture and urban devel-

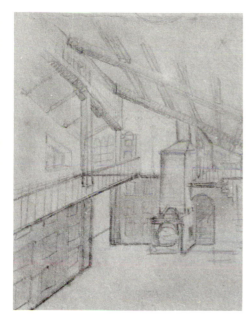

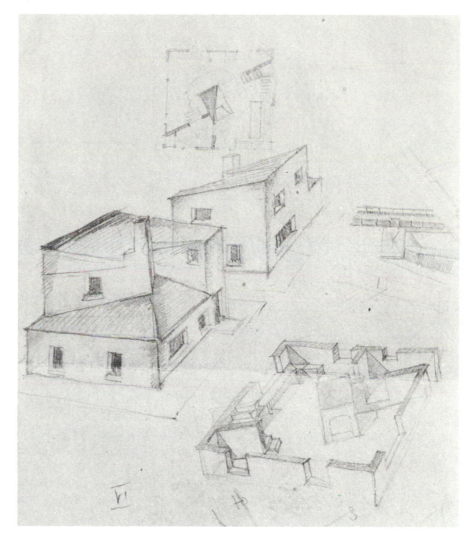

19. Project for a single-family dwelling, 1919. Interior of first variant

20. Project for a single-family dwelling, 1919. Second variants

21. Project for a single-family dwelling, 1919. Second variants

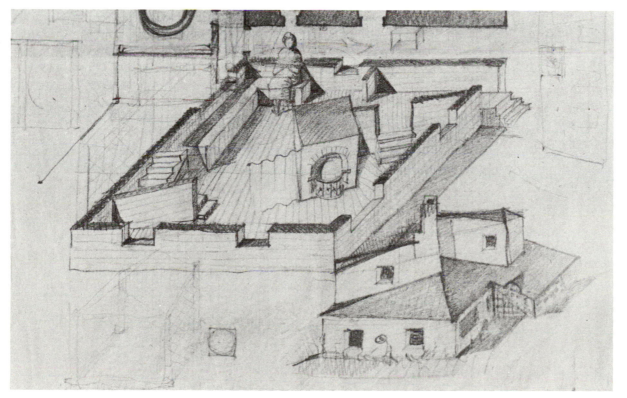

opment of Russia and to present those plans to the government with every expectation that they would be adopted.

The Bolshevik Revolution of October, 1917, added another strong ingredient to this already potent brew. In the decades before the Revolution, an extensive movement to regularize and plan the development of Russian towns and cities had developed, but it was drastically hampered in its efforts by the absence of even the sort of controls over land use that existed in London after the County Council Act of 1909. To advocates of such controls in Russia, most of whom were liberals or moderate socialists in politics, a series of Bolshevik decrees issued before and during the hottest fighting of the Civil War came as a godsend. First, in May-June, 1917, control over all construction by the state and overall town planning was focused in the Committee on State Building of the Supreme Council of the National Economy; next, in February, 1918, the government nationalized all private property in land; six months later this decree was extended to cover all immovable property in the cities; then, in March, 1919, newly formed City Councils *(soviety)* were entrusted with control over all housing matters; and, finally, in a move explicitly patterned after "the newest French legislation," each large- and middle-sized city was charged with preparing a plan covering its growth for twenty-five years into the future.[12] Never mind that few cities actually followed through on preparing such plans either during the Civil War or afterwards. The mere existence on the books of legislation as sweeping as this opened an unprecedented and vast panorama to architect-planners and did more than anything else to win their support for Soviet power.

Melnikov welcomed these developments and at once joined up with eleven other young architects—all of them like himself having only recently completed their studies—for the extravagant purpose of replanning the ancient city that was soon to become the capital of the Soviet republic. The group that accomplished this included some first-rate talents, among them Nikolai Ladovskii, soon to found the Association of New Architects (ASNOVA) and two other of Melnikov's colleagues from the Moscow School, the Golosov brothers, Ilia and Pantaleimon. The twelve were to work at their task until 1922, by which time they had produced the first post-Revolutionary plan for the complete reconstruction of any Russian city. The formidable abilities of Melnikov's colleagues were matched by their equally impressive lack of modesty, as shown by their ready identification with the Apostles in Alexander Blok's recently published symbolic paeon to the Revolution, *The Twelve*.

The unlikely leader of these enthusiasts was Aleksei Viktorovich Shchusev, a forty-seven-year-old former academician in whom talent and modesty were combined in precisely the opposite ratio from his young draftsmen. A painter by training (at the Academy of Arts in St. Petersburg and the Academie Julien in Paris) and archaeologist by avocation, Shchusev had carved out a brilliant career for himself before 1917, restoring ancient Russian cathedrals, designing lordly residences for the Solodovnikovs and other merchant princes, doing lavish pavilions for the Tsar's 1914 exposition in Venice, and building a vast neo-Muscovite railroad station in Moscow.[13]

[12] Texts of these essential legislative acts are reproduced in *Iz istorii sovetskoi arkhitektury 1917-1925*, pp. 13-18.

[13] K. Afanasiev, "Zodchii A. V. Shchusev," *Arkhitektura SSSR*, 1967, No. 8, pp. 29-35; also N. B. Sokolov, *A. V. Shchusev*, Moscow, 1952.

Shchusev's record was scarely such as to endear him to a revolutionary government. But, having received the highest honors of the old regime, he set out with unflinching singlemindedness to adapt himself to the new. No sooner did he indicate his willingness to continue work than leaders of the new government in Moscow received this former academician with open arms. Active, good-natured, and eminently flexible, Shchusev survived for decades all the pressures to which his colleagues were subjected and was eventually to have the national museum of architecture in Moscow renamed in his honor.

Shchusev's early work scarely commands attention today except to the extent that it seems to foreshadow the worst features of the Stalinist rococo. Yet his service to Soviet architecture in general and to Melnikov in particular was immense, for he alone in Moscow enjoyed enough prestige to attract major commissions during and immediately after the Civil War, and at the same time he had the generosity to use those commissions to bring together and encourage the strongest young talent available. Melnikov remembers him as "Papasha" and recalled virtually living at the Shchusev's during work on the "New Moscow" project. Shchusev reciprocated Melnikov's affection and, in the good Russian tradition of *shevstvo* (chef-ism), became the younger man's patron, dropping his name in this office and drawing attention to his work in that committee. Between 1919 and 1925, he did more than any other person to bring Melnikov's work to public notice.[14]

The "New Moscow" city plan upon which Melnikov worked for two and a half years was sponsored by the Moscow City Council, which in turn got the idea from the example of St. Petersburg, where the first twentieth-century plan for rationalizing the development of a Russian city had been developed in 1909 under fear that that city's classical beauty would be irreparably marred by the encroachments of industrial civilization.[15] Moscow's Council, which was to be the single greatest patron of avant-garde architecture during the 1920s, was fortunate to have attracted to its cause several of Russia's leading urbanists and architects. In addition to Shchusev there was Ivan Vladislavovich Zholtovskii, another academician from the old regime whom Melnikov described as "an unbending aristocratic aesthete"[16] but who in 1918 was given his own planning atelier, where he brought his years of study of Renaissance architecture to bear on the design of Russian cities of the future, and G. D. Dubelir, a civil engineer who for a decade had campaigned unsuccessfully to get the pre-Revolutionary City Duma to formulate a thorough plan for Moscow.[17] It was Dubelir who now successfully argued the case for dividing the city into functional zones, surrounding it with garden suburbs, and linking the entirety with a subway system.[18]

If such demands did not go beyond the bounds of widely held planning

[14] *Shevstvo* was quite common in architecture. For another example involving F. Ia. Schechtel and Leonid Vesnin, see Chiniakov, *Bratia Vesniny,* Moscow, 1970, p. 14.

[15] On the Petersburg plan, see F. E. Enakiev, *Zadachi preobrazovaniia S.-Peterburga*, St. Petersburg, 1912.

[16] Melnikov, "Arkhitektura moei zhizni," p. 23.

[17] Dubelir was a moderate socialist who had worked actively in the Russian Garden City movement before 1917. His views are set forth in his introduction to G. P. Kovalevskii's *Bolshoi gorod i goroda-sady,* Kiev, 1916; and in his "Planirovka gorodov," *Gorodskoe delo*, 1910, No. 2, pp. 634-50.

[18] Report of December 20, 1918, reprinted in *Iz istorii sovetskoi arkhitektury 1917-1925*, p. 37. A thorough discussion of New Moscow is in Khazanova, *Sovetskaia arkhitektura perrykh let Oktiabria . . . ,* pp. 77-90.

notions of the day, the means proposed by Shchusev and his disciples for carving out green spaces in the congested capital did. Rather than create wooded islands of parkland throughout the city, as had been suggested in St. Petersburg earlier, the Muscovities proposed to drive three broad wedges of green from the countryside to the very walls of the Kremlin. Something akin to this device had figured in at least one German scheme for a "city of the future,"[19] but Melnikov, who participated actively in this phase of the work, claimed that such an idea had its origin not in the study of German utopian planning but in the verbal and visual symbolism of the Revolution. And indeed it is true that artists working independently in various cities of Russia had conceived the great upheaval as a wedge cleaving apart the old society as a peasant might split a length of limewood. In 1918, Nikolai Kolli, one of Melnikov's fellow "disciples," had proposed a monument for Moscow entitled "The Red Wedge"[20] and, in 1919, El Lissitzky, working independently in Vitebsk, did an abstract street poster with the legend "Beat the Whites with a Red Wedge."[21] Members of Shchusev's team, most of them painters by training and none of them immune to the revolutionary romanticism so widespread in Moscow during the Civil War, simply took over this motif and applied it to the plan of the entire city of Moscow.

It is revealing of the mood of the times that not one commentator remarked critically on the formalism of this device—so striking on paper but problematic from the standpoint of actual planning—but that several did raise their eyebrows indignantly at the young architects' failure to destroy the "temples to superstition" inherited from the Muscovite past: "Miasnitskaia Boulevard doesn't need either churches or hospitals. It needs multi-story buildings made of steel and reflecting glass: as much glass as possible and as little stone. . . . Not only is the church of Saint Hermylus superfluous but so are the churches of Saint Florus and Saint Laurus and the Menshikov tower as well."[22] Evidently, however, the wedges did not provide sufficient green space for the Moscow Soviet, which even before Shchusev's plan was completed commissioned S. S. Shestakov to draft proposals for a "Great Moscow" embracing three times the area of "New Moscow."[23] In the long run, neither Shchusev's nor Shestakov's plan was to serve as a framework to integrate the many building projects of the 1920s, nor in the long run did the Muscovites ever commit themselves absolutely to any static ideal of their city's future. But the Shchusev plan had the distinction of being the most extensive effort at rationalizing and coordinating a city's growth that Russia had ever seen.

The most intensive and enduring work by Shchusev's group was di-

[19] Adolf Rading, "Grundriss einer Grossstadt der Zukunft," *Junge Baukunst in Deutschland*, H. DeFries, ed., Berlin, 1926, p. 11. N. Iszlenof, a Russian architect writing for a German audience, claimed at the time that the "new Moscow" plan derived from medieval Russian towns. "Die Architektur in Russland," in Bruno Taut, *Frühlicht, 1920-1922*, Berlin-Frankfurt/M., 1963, pp. 168-69.

[20] Speranskaia, *Agitatsionnoe-massovoe iskusstvo . . .*, pl. 41-42.

[21] Sophie Lissitzky-Küppers, *El Lissitzky*, Dresden, 1967, pl. 40.

[22] N. F. Popov, "Novaia Moskva—ne muzei stariny," *Izvestiia*, 1925, November 22. Popov was head of the city's Directorate of Immovable Property. Compare to P. A. Lopatin's laudatory *Novaia Moskva, gorod nastaiaschchego i budushchego*, Moscow, 1925. Shchusev's thinking is set forth in "Pereplanirovka Moskvy," *Khudozhestvennaia zhizn*, 1919, No. l; "Moskva budushchego," *Krasnaia niva*, 1925, No. 7; "Problemy Novoi Moskvy," *Stroitelnaia promyshlennost*, 1925, No. 3, pp. 193-200; and in "Novaia Moskva—tsentr novoi kultury," *Izvestiia*, 1926, No. 270, reproduced in *Iz istorii sovetskoi arkhitektury 1917-1925*, pp. 50-51.

[23] *Iz istorii sovetskoi arkhitektury, 1917-1925*, pp. 78 ff.

rected towards replanning the various squares and districts of the city. Initially, the further development of some eleven regions was rationalized, with Leonid Vesnin's low-density housing for the Lenin District and Ilia Golosov's elegant adaptation of classical axial planning for the Dramatic Theater area meriting particular comment.[24] According to Shchusev's program, the next phase would begin with a series of competitions, to be organized by the City Soviet in cooperation with the Moscow Architectural Association (MAO), for designs covering the remaining squares and buildings. These projects went beyond regularizing the existing fabric of streets and buildings to the design of whole new centers on the model of work in progress in Basel and Cologne, and known to Russians through Wasmuth's *Monatshefte für Baukunst*.[25] Melnikov entered several of these competitions and, by the originality and vigor of his proposals, gained for himself a central position in the rapidly emerging constellation of avant-garde architects.

Three housing schemes that Melnikov drafted during 1919 and 1922 were important contributions to this effort. All three projects were exceedingly timely, for the housing problem in Moscow had steadily grown in magnitude since the 1890s, when Stepan Melnikov's generation of peasants began flooding to the urban centers. Well before the First World War, a movement for better housing had grown up in Moscow and pursued its objectives through many of the same tactics employed by Progressive reformers in the United States at the time. The prewar cooperative movement was part of this effort, as were the campaigns of physicians for more hygienic living conditions, the congresses of urban leaders and experts held periodically after 1910, and the formation of an "Urban Group" or bloc in the third State Duma for the purpose of lobbying for state credits to cities so as to enable them to underwrite housing and reconstruction costs.[26] But none of these movements had made more than a few nips at the edges of the problem before 1917, and, with the deterioration of all urban housing stock during the Civil War, the shortage reached crisis proportions.

As the need for housing soared, a heated polemic broke out about the form of housing appropriate to a revolutionary society, a debate that was raging while Melnikov designed all three projects and that defined the elements that he was to employ in them.

The oldest, and by far the most widely publicized, program for solving Russia's housing crisis took its inspiration from the utopian writings of the Englishman Ebenezer Howard. The publication in 1898 of Howard's benign mixture of Sunday School socialism and entrepreneurial tips, *Tomorrow: A Peaceful Path to Real Reform*, immediately attracted notice in Germany and Scandinavia, as well as in his own country. Even before Howard had begun to buy land in Hertfordshire in which to build his ideal "garden city," Russians, too, had taken an interest in his vision of inde-

[24] Khazanova, *Sovetskaia arkhitektura pervykh let Oktiabria . . .* , pp. 76-87.

[25] A. Shchusev, "Problemy Novoi Moskvy," *Stroitelnaia promyshlennost*, 1925, No. 3, p. 196.

[26] On these various currents, see M. G. Dikanskii, "Zhilishchnaia nuzhda," *Zodchii*, 1907, No. 23 (pp. 233-40), No. 31 (pp. 321-24), No. 32 (pp. 333-39); "Organizatsiia predstoiashchego vserossiiskogo sezda gorodskikh deiatelei," *Gorodskoe delo*, 1910, No. 2, pp. 906-10; Z. G. Frenkel, "Zadachi pravilnoi zastroiki naselennykh mest v osveshchenii sovremennoi gigieny," *Obshchestvennyi vrach*, 1912, No. 1, pp.1-7; D. Margolis, "Kooperativnoe domoustroitelstvo," *Izvestiia Kievskoi gorodskoi dumy*, 1914, No 12, pp.11-26.

pendent towns of 30,000 set in the countryside and endowed with their own industrial base. Beginning with reviews in 1902, and culminating in the foundation of a Russian branch of the International Garden City Association in 1913, the Russian movement advanced to the point of being one of the most active in Europe.[27]

To his Russian followers, an essential aspect of Howard's vision was his reliance upon individuated housing units as opposed to large apartment complexes or "jails," as they were referred to.[28] Perhaps because they accepted without debate the notion of a planned series of autonomous satellite towns around major cities, Russian partisans of the "garden city" were able to focus their polemical energy the more singlemindedly on the architectural question of the "English cottage."

The first years after the Revolution saw the planning of a series of cottage towns, or "Red Garden Cities," as they were termed in an effort to paper over their bourgeois origins. Presided over by the head of the People's Commissariat of Public Health, a Cooperative Association of Moscow-Area Garden Cities came into being to promote and coordinate efforts at cottage construction throughout the region.[29] In this manner, a movement that in 1913 had been advertised by an anti-Marxist proponent as "Socialism without Politics"[30] and whose leading Soviet spokesman, Vladimir Semenov, frankly defended it because of the practicality of the individualistic cottage,[31] showed every sign of becoming official policy under the Bolsheviks. Soon it even received the endorsement of Leon Trotsky![32]

When Melnikov designed a model worker's dwelling in 1920, he turned directly to the type of cottage so lauded by enthusiasts of the garden city. His project, intended for three families, was designed so that it could be constructed entirely of wood by peasant craftsmen (Fig. 22). The apartments within were calculated to appeal to the peasant worker's sense of individuality; since the two wings were mirror images of each other and quite different from the two-floored central block, each apartment retained a distinct identity within the single building.

[27] Several articles by V. L. Ruzhzhe have set forth the outlines of this movement: "Arkhitekturnye-planirovochnye idei goroda-sada v Rossii v kontse xix- nachala xx vv.," *Izvestiia vysshikh uchebnykh zavedenii Min. vysshego i srednego obrazovaniia, ser. Stroitelstvo i arkhitektura,* Novosibirsk, 1961, No. 5; and "Goroda-sady: maloizvestnye proekty russkikh zodchikh," *Stroitelstvo i arkhitektura Leningrada*, 1961, No. 2. For English studies of this current, see Eric L. Richard's excellent unpublished senior thesis, "The Garden City in Russian Urbanism, 1904-1933," Princeton University, 1972; and S. Frederick Starr, "The Revival and Schism of Urban Planning in Twentieth Century Russia," *loc. cit.*

[28] This was stressed in P. G. Mizhuev's 1916 study on "Garden Cities and the Housing Question in England" and was picked up after the Revolution in G. B. Barkhin's "The Worker's House and the Working Man's Garden Suburb" (1922), as well as a host of other books and articles appearing in leading journals. P. G. Mizhuev, *Sady-goroda i zhilishchnyi vopros v Anglii*, Petrograd, 1916; G. B. Barkhin, *Rabochii dom i rabochii poselok-sad*, Moscow, 1922.

[29] *Pravda*, 1922, No. 146, July 4. Other relevant documents on the post-revolutionary garden cities are reproduced in *Iz istorii sovetskoi arkhitektury 1917-1925*, pp. 109-28. Regular reports on this movement appeared in the journal *Garden Cities and Town Planning*, of which Dr. J. Guelman's "Garden Cities for Russia" (1923), No. 2, p. 24, marks the beginning.

[30] V. Dadonov, *Sotsializm bez politiki: goroda-sady budushchego v nastoiashchego*, Moscow, 1913.

[31] N. Semenov, "Ocherednye zadachi" (report delivered earlier), *Arkhitektura*, 1923, No. 1, pp. 28-29; compare with his pre-revolutionary defense of the cottage, "not for its beauty but for its practicality," in *Blagoustroistvo gorodov*, Moscow, 1912, p. 1.

[32] Lev Trotskii, *Literatura i revoliutsiia*, Moscow, 1924, p. 189.

22. Wooden dwelling for three workers'
families, 1920. Facade

Opposed to the garden city ideal was a rival current whose spokesmen began as early as 1918 to campaign for the abolition of cottages and other individuated housing and for the utmost collectivization of life.[33] To these planners, Howard's program seemed hopelessly bourgeois and unworthy of serious consideration under the coming system of a Communist Russia. The civil engineer G. D. Dubelir, for example, whom we have met as a pre-Revolutionary urban reformer and advocate of the "New Moscow" plan, came out in October, 1918, for apartments to be built without individual kitchens or laundries but with ready access to these and other collective services to be built into the complex.[34] Such spokesmen for collectivization couched their program in terms of the economies it would achieve, but were not unmindful of what they hoped would be its ideological correctness.

Melnikov was never to figure among the major advocates of the collectivization of housing and everyday life. Nonetheless, in 1919 he drafted a proposal for a communal settlement that embodied important aspects of the collectivizers' program. The entire settlement was to be quartered in a single large ring, with no individuated sub-structures to mar the egalitarian whole. All residents were to have equal access to the central park which would contain playing fields and other collective facilities (Fig. 23).

Perhaps more interesting than the social program of this project, which is scarcely developed in the drawings, is its aesthetic form. The sketches of the façade reveal windows and other elements drawn from medieval Russia (Fig.24), while the large arched entries are used to destroy the sense of scale in much the way that they would have done in works by early Romantic Classicists in France. Indeed, the entire effort bears a surprising resemblance to Bruno Reynard's Le Grand Hornu buildings of 1822.

In his model housing for workers, Melnikov had adopted the principle of Ebenezer Howard, while his communal settlement was resolved in favor of the collectivizers' ideal. In his entry for a 1922 competition of an entire

[33] Khazanova, *Sovetskaia arkhitektura pervykh let Oktiabria* . . . , pp. 106-14.
[34] P. Kerzhentzev, *K novoi kulture,* Petrograd, 1921, pp. 63 ff.

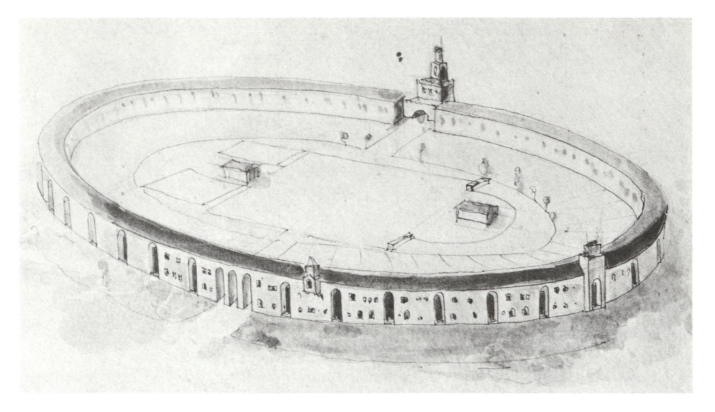

23. A communal settlement for workers, 1919

24. A communal settlement for workers, 1919. Sketch of facade

district of workers' housing, to be built on Serpukhovskaia Ulitsa in Moscow, he achieved a synthesis of the two programs that was so successful that it thrust him to the center of the new architectural life of the new capital (Fig. 25).

The project for Serpukhovskaia Ulitsa incorporates strong elements of the garden city ideal, and particularly its affirmation of separate apartments with full facilities for each family. "As the basis of my project," Melnikov reported, "I took the idea of the maximal isolation of all types of dwellings, both those for families and those for single people."[35] The motto "Atom" under which he submitted the work reflects this concern for individuation, as does the title "The Saw" that he gave the development, referring to the separate entrances for each family dwelling unit that were to be arranged in irregular rows like the teeth of a saw (Figs. 26-27). Each apartment was to consist of two and a half floors with two balconies, kitchen, dining room, etc. (Fig. 28), and, since no vehicular roads crossed this part of the plot (another garden city notion), space was freed for kitchen gardens and an orchard.

These features of "The Saw" bespeak a close relationship with the garden city movement, but they do not fully define the project any more than Howard's folksy small-town ideal embraces the full range of early Soviet urbanism. Equally as prominent a part of the project are elements whose origins trace directly back to the collectivizers' utopian tradition. It is evident that, while Melnikov disliked the regimentation and austerity of the collectivist ideal, he sympathized with the demand for extensive communal facilities and for forging individuals into a harmonious community. Hence, the six "saws" of family apartments were to be oriented around a central park, like splayed ribs of a fan (Fig.29). Commanding the park, Melnikov

[35] K. S. Melnikov, Memorandum of October 30, 1971, MS, Melnikov archive.

placed a community building in which would be housed a restaurant, meeting rooms, facilities for storage, a garage, and—in keeping with a primary concern of the collectivizers—a kindergarten (Fig. 30). Together, these facilities transformed "The Saw" into the first self-sustaining micro-region designed in Russia.

Between the family units and the park were to be erected four towers of four stories each with small apartments for unmarried people. These were to be served by a broader range of public facilities than were called for by nearly all other projects of the day.[36] In one of the most interesting features of "The Saw," these towers were to be connected with each other and with the community center by an enclosed and heated passageway (Fig. 31). Melnikov was not the first Russian to explore the use of closed corridors as a device for integrating individual apartments into a collective whole: S. Serafimov, for one, had tried it in one of the more promising (but never realized) projects for a "house-commune" in 1921. But Melnikov's "Saw" went far beyond any other project to date, in that its gently curving corridor is not merely a long hall off which apartments open, but a link raised one floor above the ground which would provide communication between otherwise separate buildings and serve as a gathering place in its own right.

"The poorest wretch . . . gets from his lodgings to the public halls and workshops by means of street-galleries which are heated in winter and ventilated in summer . . . one can pass through workshops, stables, shops, ballrooms, banquet and assembly halls, etc. in January without knowing

[36] S. Khan-Magomedov, "Kluby segodnia i vchera," *Dekorativnoe iskusstvo,* 1966, No. 9, p. 3.

25. Workers' housing for Serpukhov Ulitsa, Moscow, 1923. "The Saw." Presentation drawing

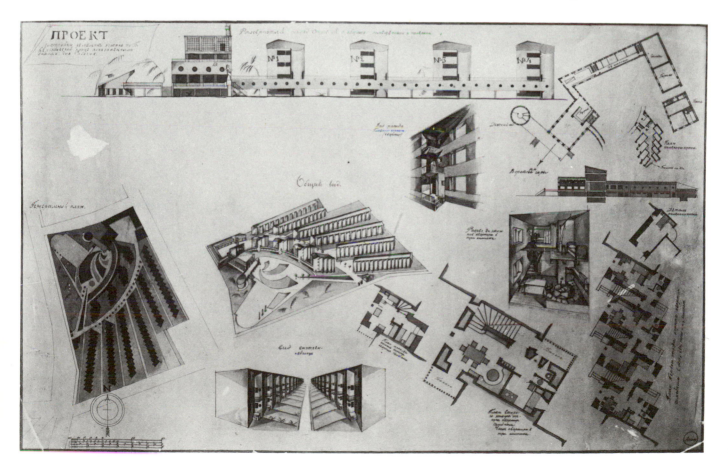

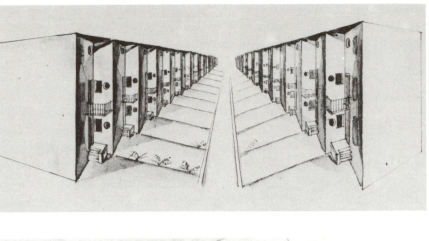

26. Workers' housing, "The Saw." Apartments for families. (Detail of No. 25)

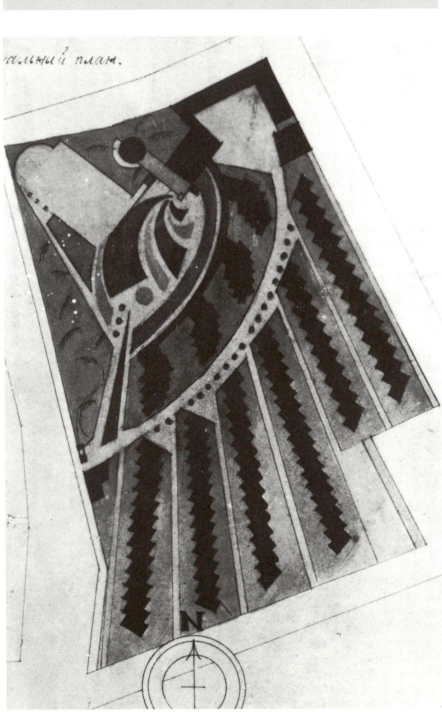

27. Workers' housing, "The Saw." Site plan. (Detail of No. 25)

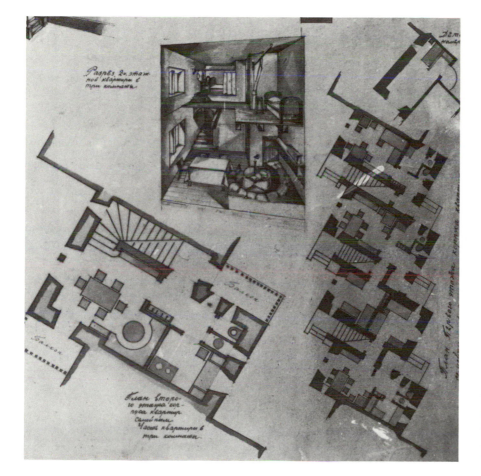

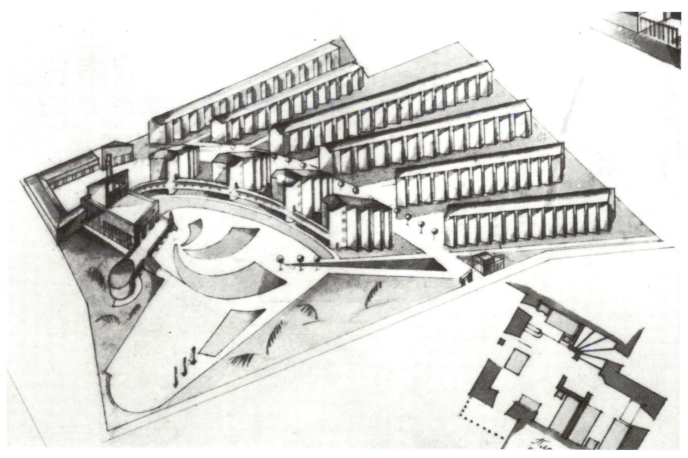

28. Workers' housing, "The Saw." Plan and interior view of apartments for families. (Detail of No. 25)

29. Workers' housing, "The Saw." Aerial view. (Detail of No. 25)

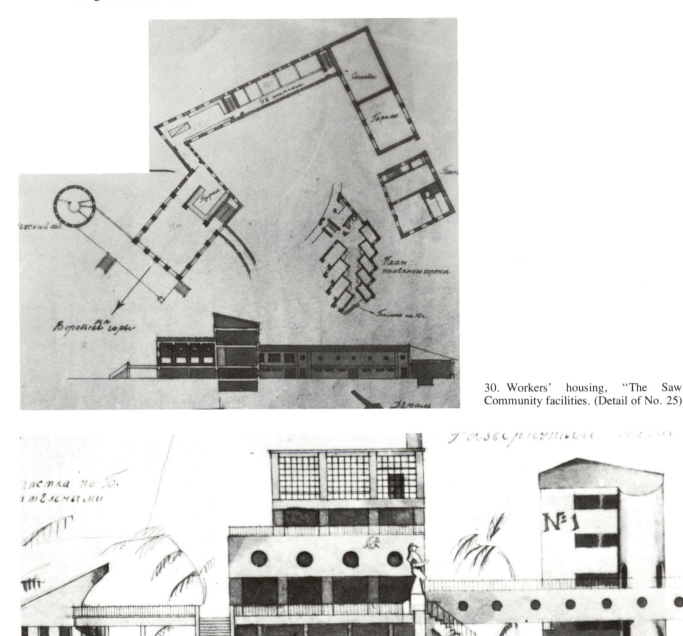

30. Workers' housing, "The Saw."
Community facilities. (Detail of No. 25)

whether it is rainy or windy, hot or cold. . . . At each extremity of this spacious corridor there are elevated passages, supported by columns, and also attractive underground passages which connect all parts of the [central structure] and the adjoining buildings."[37] These are not Melnikov's words, but those of Charles Fourier, visionary and crank-in-residence of Louis Philippe's Paris. So closely do they seem to anticipate Melnikov's still strongly individualistic transposition of the communitarians' program that the question arises whether the architect might not have been inspired directly by Fourier. He certainly had ample opportunity, for in early twentieth-century Russia there occurred a revival of interest in Fourier, which, especially after 1917, led to a fresh series of translations and

[37] Charles Fourier, *The Utopian Vision of Charles Fourier: Selected Texts on Work, Love, and Passionate Attraction,* Jonathan Beecher, Richard Bienvenu, eds., Boston, 1972, p. 243.

analyses.[38] Melnikov did not recall having read either Fourier or his Russian followers, but it would not have been necessary for him to do so in order to learn of them, since by 1922 the details of Fourier's scheme for collective dwelling units were so widely current that several entries in competitions for housing could employ the motto "Phalanstery" as an accepted symbol of communitarianism.[39] Whether as a conscious or unconscious disciple, then, Melnikov in "The Saw" showed his indebtedness to the great French visionary.

A feature that further distinguishes "The Saw" from the other sixty-five entries is the very advanced architectural forms in which Melnikov embodied his conceptions. Here, for practically the first time, appear many of the elements that were to become identified with Soviet progressive architecture of the 1920s: the flat roofs and windows arranged in bands; the use of deliberately austere, almost industrial forms, but on a site planned like a Suprematist painting rather than as a dry exercise in functionalism; the stretching of horizontal planes to create a sense of expansiveness; even the high-handed disregard for the character of the surrounding neighborhood, as if that, too, would soon be reconstructed according to modern principles. In all these respects, the little-known project stands favorable comparison with anything being done in Europe at the time.

The jury, recognizing the vigor of Melnikov's approach to the problems of both aesthetic and social forms, and finding the project to be "original" and warranting "particular attention," singled it out for second prize, and

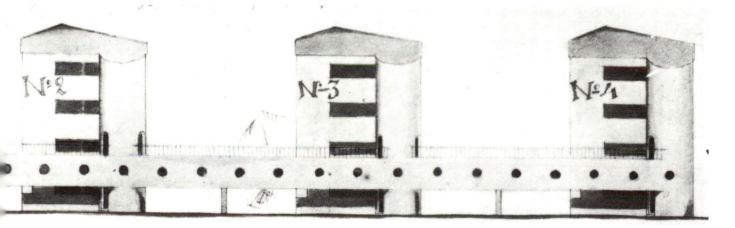

sent its astounded author a warm letter of commendation.[40] Since first prize went to the entry of the more senior Leonid Vesnin and Sergei Chernyshev, this constituted a signal success for Melnikov and marked him in the eyes of Moscow's architectural world as a man to watch.

The Serpukhovskaia Ulitsa housing competition represented a watershed

31. Workers' housing, "The Saw." Elevation of buildings with apartments for unmarried persons, showing elevated passageway connecting them. (Detail of No. 25)

[38] N. E. Kudrin, "Velikii utopist," *Russkoe bogatstvo*, 1905, No. 11-12, pp. 78-101; M. Tugan-Baranovskii, "Sotsialisticheskie obshchiny, posledovateli Ouena i Fure," *Vestnik Evropy*, 1913, No. 2, pp. 179-97; F. Bebel, *Sharl Fure; ego zhizn i uchenie*, V. Lavrov, transl., St. Petersburg, n.d.; Georges Sourine has reviewed the earlier impact of Fourier in Russia in *Le fourierisme en Russie; contribution à l'histoire du socialisme russe*, Paris, 1936. V. Friche, *Kartiny zemnogo raia*, Moscow, 1919, deals not only with Fourier but Cabet, Campanella, and other utopians as well.

[39] As, for instance, D. Buryshkin and L. Tverskoi in 1921; Khazanova, *Sovetskaia arkhitektura perykh let Oktiabria . . .* , p. 110.

[40] Report of the jury to K. S. Melnikov, MS, n.d., Melnikov archive.

both in Melnikov's career and in the development of early Soviet architecture. For him, the second-place showing meant that he could face the future without fear that his lonely pursuit of architecture during the Civil War years, when so many of his colleagues had turned as a group to theater and graphic design, would not prove to have been imprudent. Further, it showed that even in a competition dominated by joint or group entries it was possible for a "solo personality" to make its mark.

The significance of the competition for Soviet architecture was no less decisive, though by no means uniformly positive. On the one hand, as one of the first post-Revolutionary schemes that was clearly intended to be built, it showed that public housing could command material support and hence that Revolutionary architects could gain access to a fitting arena for work. On the other hand, the fate of Melnikov's entry demonstrated clearly that the momentum behind innovative patronage might be lost. There was scant cause for optimism in the fact that a reviewer, writing in the Moscow Architectural Society's own house organ, could find Melnikov's microregion to be "a crime against public ideals" and its architectural style to be "severe, almost ascetic,"[41] nor could one miss the point of the jury's conclusion that "the façades of the buildings are of too dull and monotonous a form."[42] The fact that the first prize went to an entry consisting of plain three-storied row houses grouped around courtyards and walkways according to a convention that was even then well on the way to becoming established as the standard housing type across northern Europe was no less encouraging. Apparently, in a competition designed to produce plans for low-cost and hygienic housing without frills, too obvious a concern for other factors, while respected, was of no help in obtaining the highest honors.[43]

The signs were clear that a post-Revolutionary era was dawning. After a half decade of extreme storm and stress, during which few projects were drafted, even fewer built, and yet the most grandiose schemes conceived for transforming the house and town, Soviet architects and patrons now evinced a readiness to spurn experimentation in favor of more immediately realizable conceptions. Under such circumstances, Melnikov might well have rejected his own early work as youthful folly and turned into one of those earnest but gray architects who, though justly forgotten today, designed most of the buildings erected in Russia during the 1920s. That he did not is due to his peculiar response to the dawning era of the New Economic Policy.

[41] I. Ivanitskii, *Arkhitektura,* 1923, No. 3-4-5, p. 49. The reviewer also found the site plan to be ". . . subordinated to an abstract scheme of an ornamental character alien to the living demands of the situation."

[42] *loc. cit.,* Report of Jury.

[43] A thorough discussion of this competition and of the entries of S. Ridman, M. Parusnikov, A. Fufaev, and A. Belogrud is to be found in Khazanova, *Sovetskaia arkhitektura pervykh let Oktiabria . . .,* pp. 63 ff., while still others are presented in *Iz istorii sovetskoi arkhitektury, 1917-1925 . . . ,* pp. 51 ff., and in Mossovet, *Rabochee zhilishchnoe stroitelstvo,* Moscow, 1924.

IV. Architect-Agitator of the Red Thermidor

AS the tide of revolutionary romanticism receded in the early 1920s, Konstantin Melnikov was engaged by the Moscow Soviet to design a huge bar, to be contructed at the heart of the ancient Sukharevka Market. For centuries the square adjoining the seventeenth-century Sukharevskaia Tower had been the scene of one of those motley and picturesque fairs celebrated in Stravinsky's *Petrushka*. With the revival of economic life after the Civil War, this venerable emporium proved daily more inconvenient, its confused rows of ramshackle booths an impediment to the functioning of what was in actuality Moscow's *Les Halles*. In an effort to prove that revolutionaries could esteem the best monuments of the past more highly than did the old regime, the ancient tower was restored after 1917, only to be pulled down a few years later in order to provide freer circulation for traders. At the same time, the square was swept clean of all structures and Melnikov was brought in to replan the entire area and to design new stalls. The beer hall was added to provide a canteen for peasant vendors and shoppers, as well as to house offices on its second floor (Figs. 32-34).

By any measure the bar was a roaring success. Though the sponsors rejected a first, circular variant with conche-like portals, the triangular structure that the Moscow Soviet eventually approved was an imposing and functional center for the peasant market. The bar and canteen immediately became established as a prime gathering place for the grubby underworld of NEP society. The novelist Ilia Ehrenburg passed by the Sukharevka Market upon his return from Berlin in 1924 and found it ringing with dissolute peddlar's ditties.

> Chicken roasted, chicken steamed, chickens also want to live.
> I'm no Soviet, I'm no Kadet, I'm just a chicken commissar.
> I cheated no one, and I shot no one,
> I only pecked the grain.

Or the meat-pie vendor's refrain:

> My father's a drunkard, he craves for his vodka,
> he lies and he blusters, and my brother's a thief;
> My sister's a trollop, she's gone to the devil,
> My mother's a smoker, oh what a disgrace.[2]

"While we dawdle and quarrel in search of fundamental answers, all things yell: give us new forms!"
—VLADIMIR MAIAKOVSKII, 1921[1]

[1] Vladimir Maiakovskii, "Order No. 2 to the Army of the Arts," in *Vladimir Mayakovsky: The Bedbug and Selected Poetry,* Patricia Blake, ed., Bloomington, 1975, p. 149.

[2] Ilya Ehrenburg, *Memoirs, 1921-1941*, Tatiana Shebunina, transl., New York, 1966, p. 67.

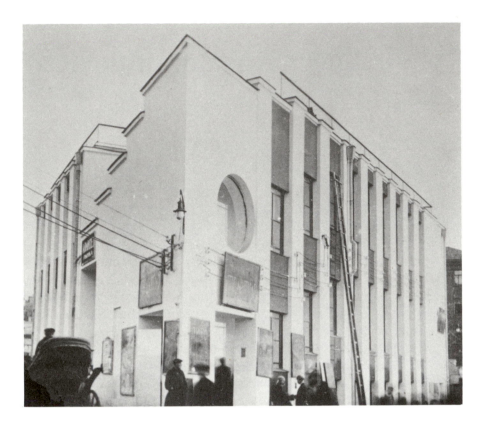

32. Cafe-bar and administration building,
Sukharevka Market, Moscow, 1924. Photo
by Alexander Rodchenko

33. Cafe-bar and administration building,
Sukharevka Market, Moscow, 1924, pre-
liminary drawing

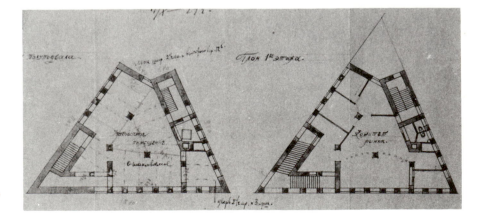

34. Cafe-bar and administration building,
Sukharevka Market, Moscow, 1924. Plan

The trademen's songs, the drunkenness, the individual stalls for private traders, the fur-coated NEP men haggling over each deflated *chervonets*—the new Sukharevka seemed to confirm the truth of the old maxim, *plus ça change, plus c'est la même chose.*

To many on the far right and far left, it indeed seemed as if the Revolution had never occurred. Readers of *Pravda* were treated to advertisements for Singer sewing machines and Ford tractors. At the newly opened Prague Restaurant, women in short skirts danced the two-step to "Yes, We Have No Bananas," while at a bistro named bluntly "The Bar" blasé students and furloughed soldiers elbowed up to hear somber singers moan the latest chants from Odessa's Moldavanka. An American newsman found cocaine and heroin in good supply.[3] Newsreels of Dziga Vertov record fashionable couples riding out in carriages, parasols sheltering madame's outfit by the long-time queen of Russian fashion, Lamanova. And the self-proclaimed "Poet of the Revolution," Vladimir Maiakovskii, laboriously painted tobacco posters proclaiming "The problems of the world are solved—Embassy cigarettes are the best things in life."[4] It was all very lively—or depressing, depending on one's point of view. Ehrenburg aptly summed it up as "a mixture of nineteenth-century gold fever and an exaggerated Dostoevskian moral climate."[5] Pedants compared the mood to that of Paris during the free-wheeling days that followed the Jacobin Terror; Trotsky termed it the "Red Thermidor."[6]

In fact, the New Economic Policy represented a substantial change over Tsarist policy as well as over the temporary "War Communism." Lenin had pushed his New Economic Policy through the Tenth Party Congress in March, 1921, for the limited and practical purpose of rebuilding the economy with the utmost dispatch so as to ward off the threat of counter-revolution that the revolt of peasant seamen at Petrograd's naval base of Kronstadt had just posed. To achieve this end, he posited the need for timely concessions to the peasantry, coupled with a degree of independence for those private traders and entrepreneurs willing to cooperate with the regime. Most important, he made the startling proposal that Communists should adopt wholesale the Imperial German system of state capitalism, only replacing what he called the "Junker-bourgeois imperalists" with the Russian working class.[7] Thousands of enterprises confiscated during the Civil War were rented (but not sold outright) to private individuals and groups, including former owners. Concessions were widely granted to West European and American entrepreneurs, and these were supplemented by a wide range of technical assistance contracts that brought thousands of engineers to Russia from points as diverse as Düsseldorf and Detroit.[8]

What set the NEP apart from tsarist policy was, first, the fact that the Su-

[3] W. Duranty, *I Write as I Please*, New York, 1935, p. 14.

[4] "Maiakovskii v reklame," *Dekorativnoe iskusstvo*, 1970, No. 1, pp. 52-53.

[5] Ehrenburg, p. 68.

[6] Lev Trotsky, *The Worker's State and the Question of Thermidor and Bonapartism*, London, 1973, p. 37.

[7] Economic aspects of this change are reviewed in E. H. Carr, *A History of Soviet Russia*, Vol. II, *The Bolshevik Revolution, 1917-1923*, Baltimore, 1968, Chs. 18-19; the impressions of Alfred Rosmer, a French Communist in Moscow at the time, are also pertinent: *Moscow Under Lenin*, New York and London, 1972, pp. 131 ff.

[8] The nature and extent of these concessions and assistance contracts is exhaustively considered in Antony C. Sutton's *Western Technology and Soviet Economic Development 1917-1930*, Stanford, California, 1968.

preme Council (*Soviet*) of the National Economy exercised unprecedented powers over the various trusts into which production was organized, and, second, the far greater extent to which the state controlled the "commanding heights" of the economy—the banks, large industries, and foreign trading companies. State trading companies played a particularly critical role in the development of NEP. As the sole exporters of raw materials and finished products, they held the keys to Soviet success in acquiring much-needed hard currency. Foreign investors were permitted to hold up to forty-nine percent of their stock, but control remained firmly in Soviet hands. As highly visible manifestations of the regime's new policy, the trading companies made every effort to present themselves as the substantial institutions they were.

Early in 1923, Melnikov proposed a design for the Moscow headquarters for the largest of these agencies operating in England, the All Russian Cooperative Society, Ltd., or ARCOS, as it was known. With ten million gold rubles capital and five hundred employees in London alone, ARCOS amply merited central offices that would reflect its solvency and weight in the world of Mammon.[9] This was scarely a charge to inspire Revolutionary architects, as the results proved. The winning design by the three brothers, Vesnin, was a box-like structure that looked like a warehouse; second prize went to A. Eichenwald and D. Friedman for an equally leaden hybrid of Bolshevik austerity and Wall Street showiness; while third place went to a stern Palladian mastodon by Ivan Fomin submitted under the preposterous motto "Red Doric."[10] Melnikov entered the ranks with two alternatives, neither of them free of the complacent sobriety of the winners but both relieving it somewhat with lively visual effects. The first variant, consisting of rectilinear office blocks flanking three sides of an entry, sports large circular ornaments on the façade and a sign over the entry that anticipates the Art Deco style (Figs. 35-36). The second covers the

35. Arcos Building, Moscow, 1923. First variant

36. Arcos Building, Moscow, 1923. Elevation of first variant

[9] Sutton, *loc.cit.*, pp. 270-71. Several Russian employees of ARCOS were later accused of spying, causing a breach in Anglo-Soviet relations in 1927.

[10] See the discussion in V. Khazanova, *Sovetskaia arkhitektura pervykh let Oktiabria* . . . , pp. 144-46.

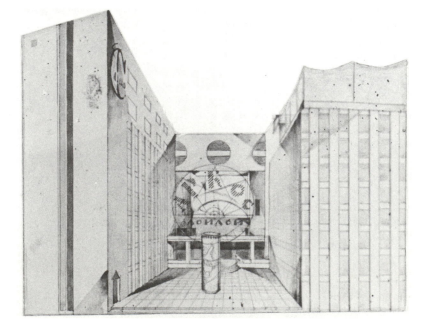

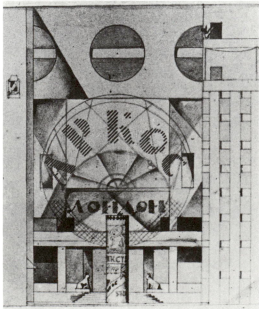

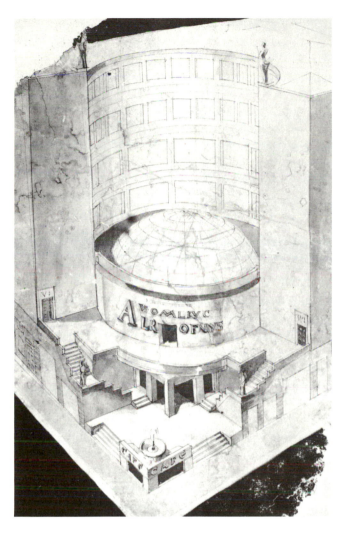

37. Arcos Building, Moscow, 1923. Second variant

38. Arcos Building, Moscow, 1923. Elevation of second variant

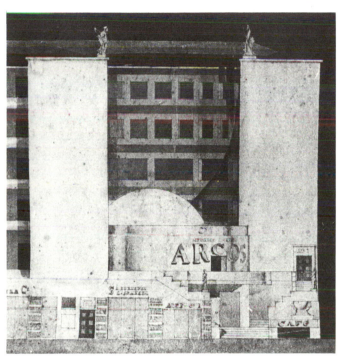

entrance with the circular dome and turns the approach into the focal point of the structure. The visting London banker was to be humbled by having to approach the edifice via a complex system of stairs with four landings, upon which he could pause to reflect upon the substantiality of ARCOS (Figs. 37, 38, 39). More provincial Russian visitors, meanwhile, would be awed by the name in Latin lettering prominently spanning the façade (and appearing in the drawing as gibberish because Melnikov as yet knew no foreign language).

Melnikov's bombast on ARCOS's behalf was somewhat more subtle than that of other entrants, but bombast nonetheless. It revealed him as being for the moment quite willing to make his peace with the new era. Immediately thereafter, a second opportunity to work within the NEP system presented itself, but this time Melnikov's response was far bolder. In 1923, the same year as the ARCOS competition, Moscow witnessed the First Agricultural and Cottage Industries Exhibition of the U.S.S.R., a month-long event that demonstrated vividly just how far the young Soviet Republic was willing to go in order to enter into commercial relations with the bourgeois West, and what impact such a policy would have on avant-garde architecture. Lavish almanacs and profusely illustrated guidebooks for the hundred-acre exposition were printed in English, German, and French; all signs at the fair were bi- or tri-lingual, and the grounds swarmed with interpreters and guides. These had been assembled not for

39. Arcos Building, Moscow, 1923. Plan of second variant

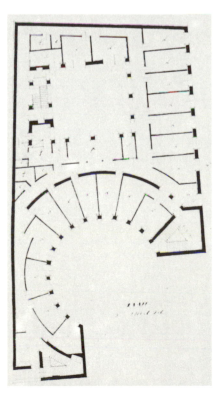

ordinary visitors but for the princes of foreign business—especially Germans—whom the Foreign Department was assiduously courting. Anyone coming to the U.S.S.R. to trade was met at any one of five border points of entry, given complimentary rail tickets, and provided with a chauffeur-driven limousine.[11]

Given the reasons for their presence at the exposition, there was no sense in preaching to such dignitaries about the virtues of proletarian culture. To see that nothing so untoward would occur in the design of the exhibits, the Commissariat of Agriculture invited "the leading architects of Moscow" to elect a planning committee.[12] To the surprise of no one, these "leading architects" produced a facsimile of themselves with a group that included among its eight members two former designers of expositions for the imperial government and three former academicians. The Moscow Architectural Association (MAO), whose members already dominated the committee, was asked to nominate a chairman, and they came up with Melnikov's patron, Aleksei Shchusev. Not one of the group could be mistaken for a member of the architectural avant-garde.

This committee made little headway beyond naming a special commission to design the site. Once again the choice for three of the five positions fell on leaders of pre-Revolutionary architecture, in this case former academicians V. A. Shchuko, I. V. Zholtovskii, and I. A. Fomin.[13] The plan they arrived at, while workable and innocuous, differed little from that for the Nizhnii Novgorod Fair of 1896, or for that matter from the All Russian Art and Industry Exhibition of 1882.[14] Indeed, the only adventuresome measure the group took was to invite the MAO to hold a competition for the design of certain pavilions and exhibit halls. Several of the younger generation were among the winners in this concourse, but for the most they were permitted to participate in the design work only as aides to their more senior colleagues. The open-work classical arch of wood erected at the entrance to the fair by former academician Zholtovskii, with the assistance of Melnikov's fellow "disciples" N. Kolli and V. D. Kokorin, was the fruit of this ill-starred cooperation. Even this was bold by comparison to the same architects' hunting pavilion—a seventeenth-century Muscovite merchant's house on the outside with cast-iron arches spanning the interior gallery—or Fedor Schechtel's Turkestan pavilion in the form of a Central Asian mosque. In all these projects, the old guard called the tune.

The exposition was immense, with over fifty galleries, exhibit halls, demonstration buildings, and kiosks. Under any circumstances, additional designers would have been necessary, the more so because the low construction budgets for all but the main halls made the minor commissions less attractive to the establishment architects on the planning committee. The solution finally arrived at was to throw up a large number of utterly plain wooden-sided sheds and turn their broad exterior surfaces over to young artists for decoration. The flat walls were then decorated by an army

[11] First Agricultural and Home Industries Exhibition of the SSSR (sic.) Foreign Department, *Guide to the Exhibition*, Moscow, 1923; also *Almanac,* Moscow, 1923.

[12] *Pravda*, 1922, No. 157, July 16.

[13] *Iz istorii sovetskoi arkhitektury 1917-1925*, p. 174. A more detailed treatment of the design of the fair grounds is M. Astasiev-Dlugach, "Pervaia selskokhoziaistvennaia," *Arkhitektura, SSSR,* 1974, No. 1, pp. 25-28.

[14] Comparison of the architecture and planning of the 1923 fair with the 1896 Nizhnii Novgorod Fair indicates the extent of the continuity: *Nashe zhilishche*, 1895, No. 18-19, pp. 1-29.

of the most advanced designers of the Revolutionary era, among them
Rodchenko, Udaltsova, Popova, and Lentulov. Alexandra Ekster, in some
of her last and most commanding work in Russia before her departure for
Paris, ornamented the walls of two halls devoted to field crops with gaily
colored counter-reliefs representing windmills, flails, harrows, and carts.

Such ornaments may have impressed foreign businessmen, but they also
carried the fair's message to a second clientele: the Russian worker and
peasant, particularly the latter. The message beamed to the NEP peasant
was not the same one sent out to German investors, however, though it was
no less central to the enterprise as a whole. A quotation from Lenin in-
scribed on a pyramidal monument placed in a bed of flowers near Zhol-
tovskii's entrance arch set forth this second, more political purpose for the
exposition: "Our object is to create a link between the workers and the
peasantry and to show the peasant that we begin with that which he already
knows and understands. . . ."[15] By taking as her subject not the crops but
the straightforward tools with which peasants produced them, Ekster exe-
cuted perfectly the NEP injunction to deal with the peasant as he was and
not as he should be.

Western writers have frequently regretted that Soviet architecture of the
1920s was so hampered by the shortage of materials and funds. But, far
from hindering it, austerity stimulated the modern movement, as the 1923
agricultural exposition clearly demonstrated. The exuberantly avant-garde
newspaper kiosk that the architect Gladkov built with wooden planks and
simple iron stringers made the turreted and gabled machinery palaces that
surrounded it appear to be from another era. Similarly, the simplest barns
and sheds were invariably more interesting than the pavilions whose de-
signers carried out Shchusev's obtuse injunction that exhibit halls be of
stuccoed wood.[16] And for austere boldness, the high point of the entire ex-
position was the smallest pavilion on the site, the wooden structure for the
shag-tobacco combine "Makhorka," designed by Konstantin Melnikov.

Old timers insist that Makhorka was the best-known means of mosquito
prevention—an acrid tobacco quite unsuited for export. Given this, the
pavilion had to be aimed principally at the lower ranks of the Russian pub-
lic. In keeping with the fair's pedagogical objective of bringing the existing
peasant world closer to the workingman and vice versa, Melnikov pro-
posed to show the urban worker each phase of the process by which peas-
ant hands converted a raw crop to his familiar smoke. This called for a
step-by-step presentation, with the viewer following the processional route
through the hall set down for him by the architect (Figs. 40-41). Melnikov
permitted the movement of viewers through the building to define in good
measure the form of the structure. Beyond that, however, he decided to
treat the building's function as the chief means of advertising the product,
by parading the internal procession before passers-by in such a way as to
lure him into becoming part of it himself. This was achieved by opening
long windows along several exposed passageways (Fig. 42) and by placing
a spectacular spiral stairway at the corner of the building down which de-
parting visitors would pour in a kind of Coney Island ending (Figs. 43, 44).
Multi-colored supergraphics on the exterior further proclaimed the product
(Fig. 45), and at several points within were placed exhibit cases that re-

[15] *Krasnaia niva*, 1923, No. 33, p. 15.
[16] *Pravda*, 1922, No. 255, November 11. The text of Shchusev's statement is reproduced
in *Iz istorii sovetskoi arkhitektury 1917-1925*, p. 174, No. 211.

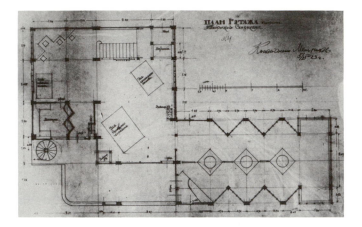

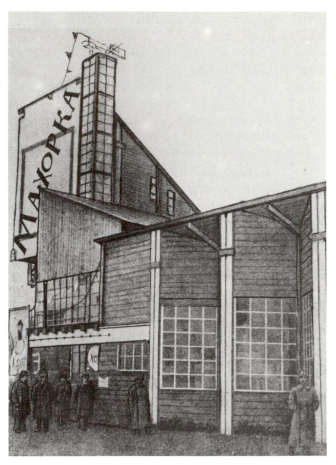

40. Makhorka pavilion; Moscow, 1923. Plan

41. Makhorka pavilion; Moscow, 1923. Contemporary photograph

42. Makhorka pavilion. Contemporary photograph of the building from the rear

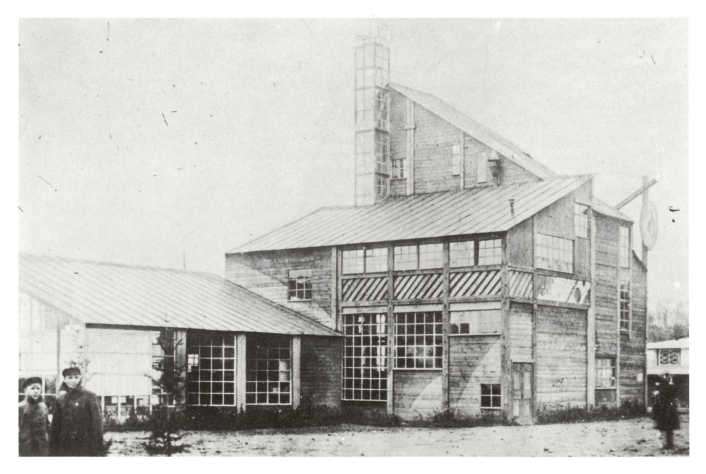

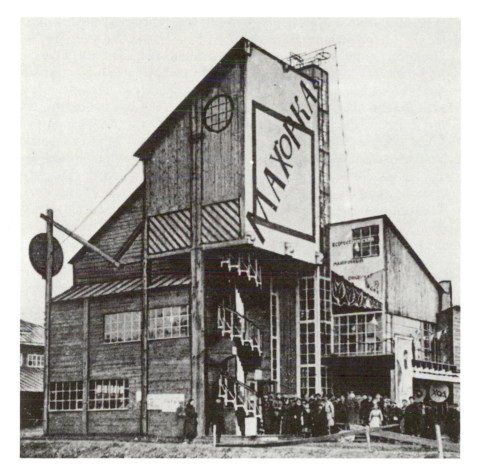

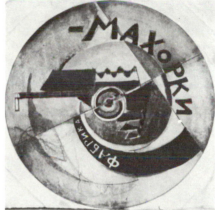

45a-b. Makhorka pavilion. Working drawings of super graphics for exterior (see Ill. 43)

43. Makhorka pavilion. Contemporary photograph showing main exit

44. Makhorka pavilion. Detail drawing of exit stairs

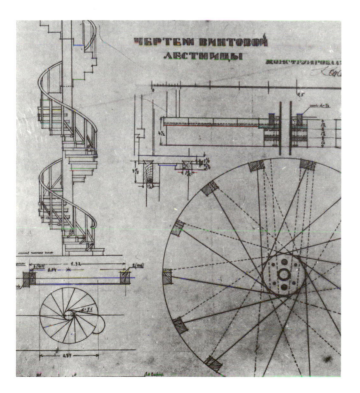

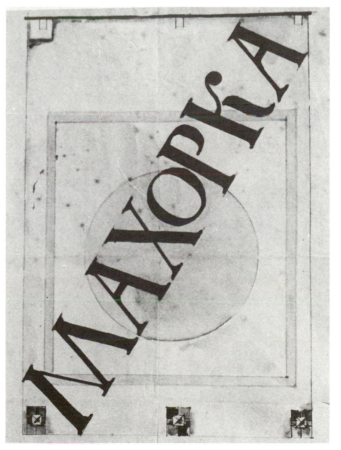

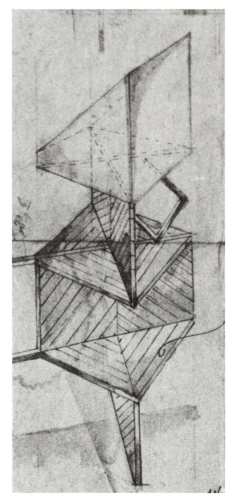

veal, through their sharp juxtapositions of planes and acute angles, an indebtedness to the contemporary sculpture of Tatlin (Fig. 46).

The design of the building as a whole did not emerge at once. Like the more famous pavilion built in Paris in 1925, the Makhorka project passed through a long gestation period during which numerous forms were explored. Several attempted to exploit the round Makhorka trademark, but without success (Fig. 47); in the end the trademark was to appear only in the bold graphics that Melnikov drew for the interior. Others sought to achieve dynamism of form through the use of dramatic external stairways slicing diagonally across the wall of a composition of blocks (Fig. 48); this, too, was passed over.

The shed-roof form of the building that was actually constructed owes a certain debt to the grain elevators of the American Midwest. Even before the turn of the century, the Russian architectural press had featured articles

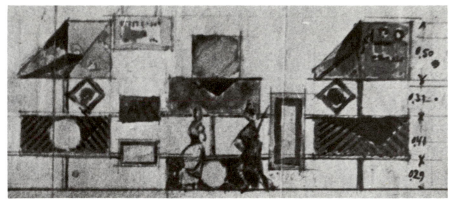

46a-b. Makhorka pavilion. Exhibit units for the interior

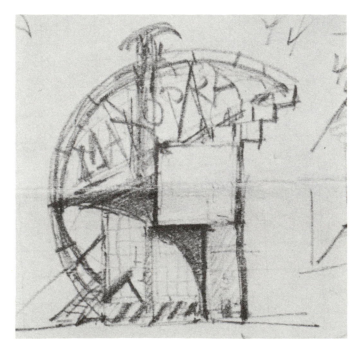

47. Makhorka pavilion. Preliminary sketch

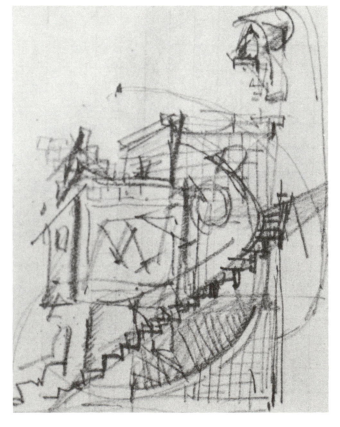

48. Makhorka pavilion. Preliminary sketch

on the aesthetics of the grain elevator,[17] while others appeared during 1923, just as the Makhorka building was emerging from the drawing board.[18] Whether or not Melnikov saw any of these, it is more than likely that he, like Moisei Ginsburg, author of one of the articles in question, had seen Le Corbusier's 1923 polemic, *Vers un Architecture*, in which a number of American grain elevators were held up as a great discovery.[19] But the very large groupings of cylindrical elevators that the Frenchmen presented are a far cry from Melnikov's highly original shed, with its cantilevered second storey, long window panels, helical stairway, and open sculptural elements on the exterior to strengthen the play of masses. In all likelihood, the greater sophistication of Melnikov's scheme is due to the fact that he had experimented with shed roofs on his own since 1919, and by 1923 had passed beyond direct borrowing from any one source. And unlike many other architects who experimented with rural sheds, he accepted and utilized the agrarian referent in a manner that would not have been lost on workers or peasants visiting the pavilion. As in Ekster's counter-reliefs, the Makhorka pavilion proposed to teach the common man about rural industry by first accepting the existing forms and language of the countryside, rather than by forcing it into the mold of Moscow's high culture.[20]

The impressive showing by Melnikov (Fig. 49) and the avant-garde at the First All-Union Agricultural and Cottage Industries Exposition underscores the presence of divergent currents within NEP culture. Conspicuous to all observers was a yearning for stability and order, for the "normalcy" that found expression in the careful but uninspired site plan, in the traditional entry arch, and in the many pavilions that by their stolid design assured foreign businessmen that all was well in Russia. Thanks to this same conservatizing impulse, the Academy of Arts was reconstituted in 1921 after four years in limbo, and the old-fashioned realist painters of the Society of Wandering Exhibitions *(Peredvizhniki)* held their first post-Revolutionary exhibit in 1922, a decidedly non-Revolutionary "Association of Artists of Revolutionary Russia" was formed in the same year,[21] and the leftist Proletarian Culture organization (Proletkult) was suspended in 1923.

Official spokesmen found fault with blatant revolutionism wherever it existed. Thus, the Commissar of Enlightenment, Lunacharskii, criticized one of his own ministry's journals for denying too categorically any worth in the culture of the past.[22] Meanwhile, Lenin, angered by Lunacharskii's decision to print verse by the Futurist Maiakovskii, stormed that his Commissar of Enlightenment "should be flogged for his Futurism."[23] In place

49. Konstantin Melnikov at the Makhorka pavilion, 1923

[17] E. Perrimond, "Kratkoe opisanie naibolee tipichnykh elevatorov severnoi Ameriki, zapadnoi Evropy i Rossii," *Stroitel*, 1897, No. 13-14, pp. 481-511; No. 15-16, pp. 561-85.
[18] The first issue of the Moscow Architectural Association's journal, *Arkhitektura* (No. 1-2, 1923) contains an excellent selection of photographs of grain elevators and a commentary by the editor, Ginsburg, while *Stroitelnaia promyshlennost*, 1923, No. 11, pp. 493-94, included a discussion of "Zernovye elevatory v Amerike."
[19] Le Corbusier, *Towards a New Architecture*, Frederick Etchells, trans., London, New York, 1927, p. 25.
[20] This shift in orientation did not escape Melnikov's friend and patron, Shchusev, who had gotten the Makhorka commission for his younger friend; so incensed was Shchusev by Melnikov's "Constructivism in the grain elevator style" that he took to the pages of a leading Moscow building journal to criticize it. *Stroitelnaia promyshlennost*, 1924, No. 12, p. 762.
[21] I. M. Gronskii, V. M. Perelman, eds., *A. Kh. R.R.: Assotsiatsiia Khudozhnikov Revoliutsionnoi Rossii*, Moscow, 1973.
[22] K. A. Jelenski, "Avant-Garde and Revolution," *Arts*, Vol. 35, October 1960, p. 39.
[23] Quoted by Louis Fischer, *Life of Lenin*, New York, 1964, p. 496.

of militant experimentation, officials advocated a return to more tranquil modes of expression. As Leon Trotsky observed in his 1923 study, *Literature and Revolution:*"If Futurism was attracted towards the chaotic dynamics of the revolution . . . then Neo-Classicism expressed the need of peace, of stable forms. . . ."[24]

Yet the striving for order that Trotsky detected in the revival of older artistic forms failed to attain complete dominance in the world of art and architecture, as the Agricultural Exposition clearly attests. The radical and experimental strain not only continued to exist in architecture after the start of NEP, but it survived and flourished as never before, thanks precisely to governmental patronage. Much as Lenin criticized the avant-gardists, many of the leading exponents of Futurism and other radical tendencies in art were working comfortably in Moscow's newly formed Higher Artistic and Technical Workshops, with salaries from the Commissariat of Enlightenment. This is where Melnikov could be found from the day of its reorganization.

There is no topic more central to the history of early Soviet culture than this school—the *Vkhutemas*, as it was known, according to its graceless acronym.[25] From its original foundation in 1918 as the Free Workshops (*Svomas*) through its reorganization as the *Vkhutemas* in 1922 until its closing in 1930, it was the leading center of Revolutionary architecture and art in the U.S.S.R. At the start of the NEP, when Revolutionary momentum in all spheres appeared to be waning, this school not only kept it alive in the arts, but significantly strengthened it. Staffed with nearly a hundred faculty members, the *Vkhutemas* acted like an autonomous and radical Republic of the Arts within the capital of the Soviet Republic. Its rise and fall is the story of Russian experimental art in the twenties.

The *Vkhutemas* was not the sole school of art and architecture in Moscow, nor was it even the only one with experimentalists on its staff. The faculty of the Moscow Architectural Institute, for example, included several architects whose outlook was so close to Melnikov and his colleagues at the *Vkhutemas* that they frequently did projects there, the same being true for faculty members at the Higher Technical University, formerly the Imperial Technical School.[26] But, like the old Moscow School of Painting, Sculpture, and Architecture, the *Vkhutemas* was unique in the extent to which it served as a general gathering place where one might bump into such foreign visitors as Bruno Taut or Eric Mendelsohn, debate ideas for the latest design competition, or hear Maiakovskii declaim his newest verses.

The resemblance of the *Vkhutemas* to the school at which Melnikov once studied derived from the fact that the new workshops had been formed by merging the Moscow School with another venerable institution, the

[24] Leon Trotsky, *Literature and Revolution*, Rose Strunsky, trans., New York, 1925, p. 113.

[25] The best available study is L. Zhadova, "VKhUTEMAS-VKHUTEIN (stranitsy istorii)," *Dekorativnoe iskusstvo*, 1970, No. 11, pp. 36-43; one should also consult Szymon Bojko's "Le devancement d'une époque," *Democratie nouvelle*, Paris, February 1967, pp. 33-64; L. Marts, "Propedevticheskii kurs Vkhutemasa-Vkhuteina (osnovnoe otdelenie)," *Tekhnicheskaia estetika*, 1968, No. 2, pp. 31-34; No. 4, pp. 27-29; No. 12, pp. 25-27; and A. V. Abramovoi, "Vkhutemas-Vkhutein," in *Moskovskoe vysshee khudozhestvenno-promyshlennoe uchilishche (byvshee stroganovskoe)*, Leningrad, 1965, pp. 37-68. V. Khazanova's brief overview provides an adequate introduction: "Vkhutemas, Vkhutein," *Building in the USSR, 1917-1932*, O. A. Shvidkovsky, ed., London, 1971, pp. 31-34.

[26] These institutions are treated by A. Fisenko in "Razvitie sovetskoi promyshlennoi arkhitektury," *Arkhitektura SSSR*, 1967, No. 7, pp. 14 ff.

Stroganov School. This merger brought dramatic changes as well. The Stroganov School dated from 1825, when the wealthy patron, Count Sergei Stroganov (1794-1882), founded it as a school for drawing. From an early date the school came to stress crafts of all sorts rather than the academic arts taught at the Moscow School.[27] Under the guidance of the Ministry of Finance's Department of Industry and Trade, the Stroganov School had by 1914 begun to train people to fulfill for Russia some of the functions of the *Deutscher Werkbund*, which Hermann Muthesius and the Prussian Board of Trade set up in 1907 to foster collaboration between German industry and design. The infusion of metal and wood-working, textile design, polygraphy, and ceramics into the staid curriculum of the Moscow School—not to mention the addition to its staff of such lights as Alexander Rodchenko, Liubov Popova, and El Lissitzky—transformed the old institution by bringing together the artist and the craftsman. As it merged into the new institution, the Moscow School abandoned its former function as bearer of a specific artistic heritage, just as the Stroganov School dropped its tinge of romantic medievalism that colored the arts and crafts movement. The result was an institutional break with the past more thorough even that which occurred when the Weimar School of Arts and Crafts became the Bauhaus.

No sooner had the two schools merged to form the Free Workshops then most of the old academicians simply withdrew to the sidelines, convinced as they were that the Moscow School as they knew it was dead. This left a deep vacuum on the faculty, which Melnikov and his contemporaries rushed in to fill. "Just up from our school desks," he wrote, "we became professors."[28] This was only a mild exaggeration. Melnikov was thirty when the *Vkhutemas* was organized, as was El Lissitzky; Moisei Ginsburg was thirty-three when he joined the faculty; Ilia Golosov, thirty-seven; and Nikolai Ladovskii, the old man at thirty-nine. Clearly the innovative architects whom Lunacharskii considered to be the "crown" of the *Vkhutemas* were, to a man, part of the generation that made its professional debut just as Russia's new order was emerging.

The architectural section was organized by the end of 1920, some seven years before the Dessau Bauhaus set up a distinct program in architecture. Its faculty was large, with twenty-six members, counting Melnikov (Fig. 50). Demand for qualified architects was enormous at the time, and the percentage of buildings being erected without the benefit of an architect was actually increasing even in Moscow.[29] In the provinces the situation was yet more grim. Unless reversed, Russia would soon have reverted to a land of log cabins hewn and laid up by peasant *desiatniki*. These circumstances required faculty members to fill exceedingly demanding teaching schedules, which in turn caused much internal discussion in the school to turn on questions of pedagogy. Technical and philosophical issues were by no means neglected, nor were politics banned, as at the Bauhaus, but when such debate occurred it was ordinarily set in terms of the teaching program, with the stakes being the control of the curriculum.

In the early years of the *Vkhutemas*, any tendency for one faction to gain a monopoly was held in check by the pluralism that was the school's es-

[27] N. Moleva, E. Beliutin, *Russkaia khudozhestvennaia shkola vtoroi poloviny xix-nachala xx veka*, Moscow, 1967, p. 172.

[28] Melnikov, "Arkhitektura moei zhizni," p. 15.

[29] P. I. Antipov, A. A. Kochetov, "Novoe stroitelstvo," in Iu. Larin and B. Belousov, eds., *Za novoe zhilishche*, Moscow, 1930, pp. 108 ff.

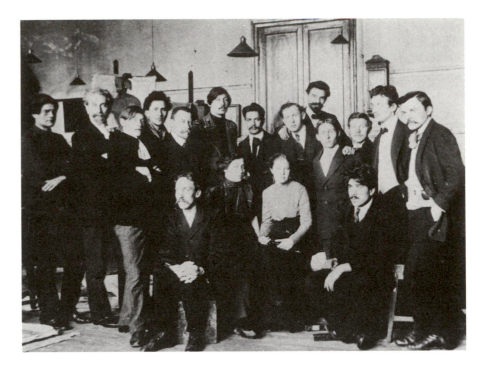

50. The architectural section of the *Vkhutemas* in 1923. Konstantin Melnikov is standing, second from right

sence. Comprised of two very different institutions and staffed by people drawn from yet more diverse intellectual backgrounds, the school, entirely fittingly, was named, in plural form, the Higher Artistic and Technical Workshops. The two-year basic architectural course was worked out by Nikolai Ladovskii, who, as a true alumnus of the Moscow School, stressed the careful analysis of form according to what he termed the "psychoanalytic method." While superficially part of a flirtation with Freud that many Russian Marxists (including Trotsky) were carrying on at the time,[30] Ladovskii's program was in essence an affirmation of aethetics as against the concerns of the craft worker.

Melnikov, as shall be seen, shared most of the Ladovskii's principles, finding them consistent with both his own academic training and his conception of the new architecture. At the same time, he considered the third-year program offered by Ladovskii to be too exclusively theoretical, just as he felt the alternative third-year program offered by the rest of the department to be too narrowly craft-oriented and practical. Accordingly, he and Ilia Golosov, the more introspective and painterly of the two Golosov brothers, proposed that the basic course be followed by a one-year program which they named "The New Academy."

Students choosing this last program were expected to execute renderings for actual projects, as was done in the normal third-year course, but without the craftsman and engineer's presumption that each problem permitted of but one rational solution: "When projects were turned in I would gather all my students into the auditorium and write the names of all present on the board. Then I'd ask each to sign on the board next to his name. 'Look,' I'd say, 'Here are your names written in my hand and all identical; and here you each signed and every signature is individual. This is the way you

[30] A brief introduction to this issue is provided by John Fizer, "The Problem of the Unconscious in the Creative Process as Treated by Soviet Aesthetics," *The Journal of Aesthetics and Art Criticism*, Summer, 1963, pp. 399-406. "The psychoanalytic theory of Freud . . . can be reconciled with materialism," Trotsky, *Literature and Revolution*, p. 220.

should do individual projects on the same theme.' "[31] Like the twelve writers of the Serapion Brotherhood in Petrograd, who declared in 1922 that "We did not want everyone to write alike . . . ,"[32] Melnikov affirmed not only that people *are* different from one another, but, more controversially, that they *should* be.

The key to the New Academy's approach was that architecture was first and last an art. When several students in the program reacted negatively to Melnikov's apparent disinterest in technical matters,[33] he rejected their criticism out of hand. In his rejoinder to them, he argued that architects who worship the idol of building technology end by becoming its slaves. Such architects, he felt, were foolish to work only with those techniques sanctioned by technology's overly cautious high priests, the engineers, and they cheated themselves by being too timid to force the new techniques to evolve in directions relevant to architecture.

Conceiving architecture to be an art, Melnikov and Golosov at the same time took pains to disassociate their position from that of aesthetes who aspire only to create pleasing objects. For both of them, and for Melnikov in particular, the purpose of architecture, and of art in general, is to stir the passions through the manipulation of elements drawn from man's unconscious and semiconscious life. The strongly romantic approach to art taken by the New Academy is epitomized by the language of Melnikov's description of the Makhorka pavilion: "I exhausted myself in the summoning roar of Nature, [coming to me] from somewhere remote and profound as if through a sort of thicket; self-supporting mechanics gave way by themselves, and the masses that reared up on the insignificant magnitude of the pavilion exalted Architecture through a new language, the language of *EXPRESSION*."[34] However much he might disagree with Le Corbusier on other matters, Melnikov would have found little to criticize in the Frenchman's *bon mot* of the early twenties that "The purpose of construction is TO MAKE THINGS HOLD TOGETHER—OF ARCHITECTURE TO MOVE US."[35] Even more than Le Corbusier, however, Melnikov retained his moorings in the world of Romantic Classicism and continued to believe in architecture as a dramatic and emotion-evoking enterprise. Such an attitude, reinforced by the poetic language and naturalistic imagery of German Expressionism, provided him with a fighting credo that could assure the survival of the Revolutionary impulse in architecture amidst the sober pragmatism of NEP.

Several of Melnikov's projects of 1923 and 1924 embody this perspective, so typical of the bolder spirits at the *Vkhutemas* but so out of step with the dominant political mood of the nation. Thus, when he was called upon to replan the Sukharevka Market, Melnikov rejected the rectilinear and static configurations preferred by most early NEP designers and placed the files of stalls in curving rows so as to generate a dynamic, swirling motion as in paintings by the Italian Futurist Boccioni.[36] In the aerial photographs

[31] Cited by Rodionov, "Tvorchestvo arkhitektora K. S. Melnikova," p. 28.
[32] Lev Luntz, quoted by William Edgerton, "The Serapion Brothers: An Early Soviet Controversy," *The American Slavic and East European Review,* VIII, No. 1, 1949, p. 54.
[33] Brief reference to this protest is in Khazanova, *Sovetskaia arkhitektura pervykh let Oktiabria . . . ,* p. 201.
[34] K. Melnikov, "Arkhitektura moei zhizni," p. 27.
[35] Quoted by Charles Jencks, *Le Corbusier and the Tragic View of Architecture,* Cambridge, 1973, p. 66.
[36] See "Plan novogo rynka," *Vechernaia Moskva,* 1924, No. 227, p. 2.

that Walter Gropius published in an early *Bauhaus Buch* (Fig. 51), the market appears like a planned whirlpool with no vortex, a beehive in which consumers could swarm about according to the overall program imposed by the designer (Fig. 52). The same movement was recalled in the graphics for the market (Fig. 53).

The Sukharevka plan embodies Melnikov's belief that architecture should be expressive, and, through the use of inexpensive wooden stalls (Figs. 54-55), he showed that this could be attained without resorting to

51. Sukharevka Market, Moscow, 1924. Photograph by Alexander Rodchenko

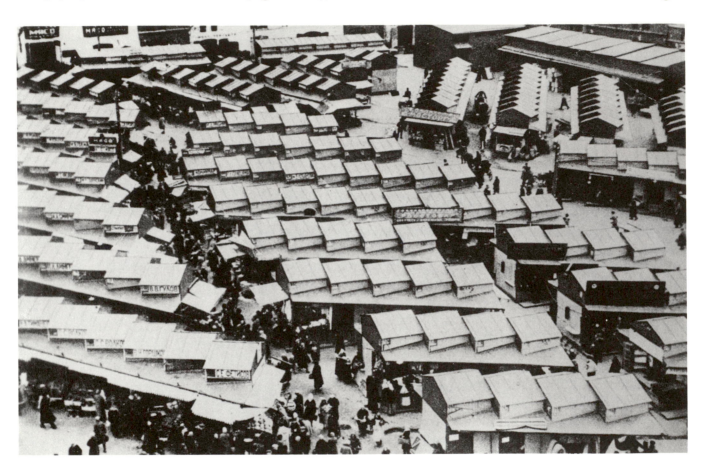

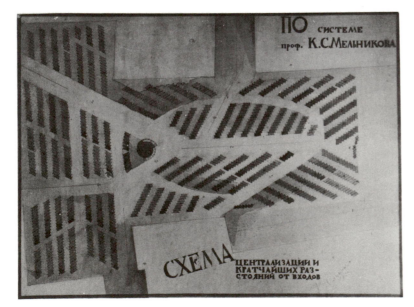

52. Site plan for Sukharevka Market, Moscow, 1924

53. Preliminary drawings of sign advertising the Sukharevka Market, 1924

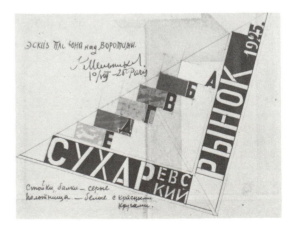

56. Vendors' stalls, Sukharevka Market, 1924

any of the most recent achievements of technology. Even the aesthetic form of these structures owed more to the past than may at first be obvious. The sloping roofs were deliberately designed so as to evoke the image of the rectilinear ranges of hills that are a constant fixture of Russia's medieval icon paintings (Fig. 56). Drawings that Melnikov submitted to a competition for the small Moscow branch of the newspaper *Leningradskaia Pravda*, however, took a different tack, in that they accepted the new technology but put it to flamboyant propagandistic purposes of which the engineers themselves might never have dreamed.

The purpose of this structure was to provide a modest base in the new capital for the leading newspaper of the old capital. The overtly propagandistic nature of the assignment stemmed from the fact that the newspaper was the official organ of the Communist Party's Leningrad branch, the local organization that had played the major role in bringing about the October Revolution in 1917. The space assigned to the building was a mere twenty-five meters square, though the height of the building was not limited. These conditions automatically ruled out any ordinary structure and opened the way to the submission of very tall, narrow, and highly sculptural solutions to the problem.

Those who conceive the history of Soviet architecture in the 1920s as the successive triumphs of rationalism and utilitarianism would do well to take note of the heavy symbolic cargo that entries in the *Leningradskaia Pravda* were expected to bear. After all, the building was intended to communicate the spirit of the Revolution, a task the competing architects accepted without quarrel. Even those who, like the Vesnin brothers, were later to be identified with a functional Constructivism, vied with one another to produce a lively and extroverted *architecture parlante*.

Several entrants utilized the image of the machine to convey the propagandistic message that technical advancement, motion, and power all emanated from the Party's official mouthpiece. Thus, Alexander Vesnin, in his widely reproduced entry, borrowed wholesale the steel frame, gears, and cranks of the machinery buildings constructed over coal-mine heads in Central Europe and adapted them to the practical work of raising and lowering the elevator within. In this way, he attained a high point in *architecture parlante* in Russia that was not to be surpassed until Melnikov did so later in the decade.

Melnikov's entry exploited more abstract forms and techniques to communicate essentially the same message. The design—for which unfortunately only one preliminary sketch and one drawing survive—was based on a series of identical glassed-in units that were to be stacked one on top of the other to form the sculptural whole. In the earliest sketch, these units were to be trapezoidal in plan (Fig. 57), while in the more definitive drawing (Fig. 58) they are lozenge-shaped. Each of these components was to be threaded onto a round, static core in which were to be housed the elevator, stairwell, and all services. Each floor was then to be motorized in such a

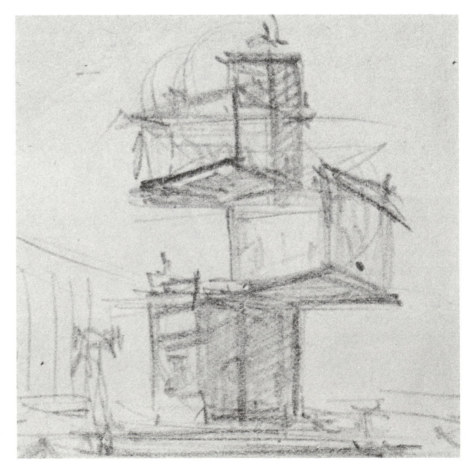

57. Preliminary sketch for *Leningrad Pravda* building in Moscow, 1924

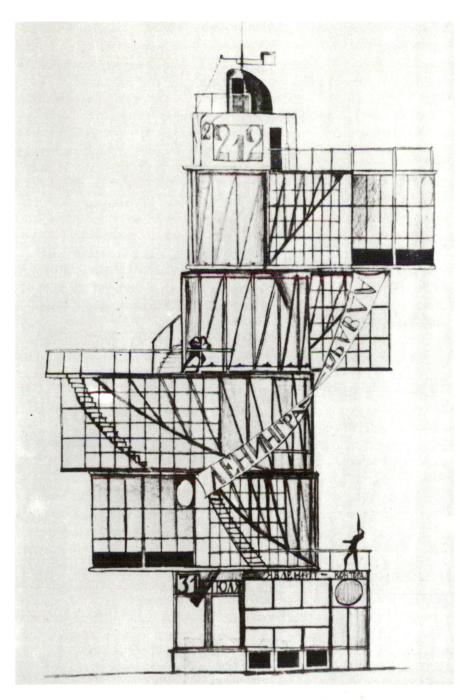

58. *Leningrad Pravda* building, 1924; each floor was intended to turn independently around the common core

way as to permit it to revolve freely and independently, thereby causing the structure as a whole to attract constant notice with a continuous parade of diverse architectural silhouettes.[37]

The Vesnin and Melnikov entries diverged on several points, particularly in the degree of abstraction of their symbolism but also in the way they related those within the building to those on the street outside and in the manner in which they treated individual human beings. Vesnin placed the office workers in the role of spectators to the show of mechnical power that the building itself provided. Because it was not they but the building that choreographed the spectacle, the office workers were no more significant to the building than was the public on the street.

[37] K. S. Melnikov, "Proekt pavilona gazety *Leningradskaia pravda* v Moskve," MS, Melnikov archive, p. 1.

Melnikov, by contrast, drew a sharp distinction between the performers and the public, as befits the relationship of the Communist Party members to society at large. The newspaper workers themselves were to be put on view so that their movements within the glass-walled structure would merge with the mechanical exhibition provided by the building. Nor were Melnikov's workers to be the mere spectators to the machine but its activators, since workers on each floor would be able to turn their lozenge in whatever way pleased them. In this way a sense of pluralistic vitality would be infused into the whole building and communicated to the public outside. Each Party worker would become, in fact, the choreographer for one autonomous part of the integrated mechanical extravaganza.

As Melnikov's *Leningradskaia Pravda* building clearly shows, the Russian Revolution gave a mighty impetus to the development of kinetic sculpture and to its exploitation for architectural and agitational purposes. To be sure, Marcel Duchamp had concocted his kinetic "Bicycle Wheel" as early as 1914, but more in anticipation of a dada-ist sense of meaninglessness than as a dynamic symbol of the machine age.[38] In contrast, Vladimir Tatlin's model for a four-hundred-meter-high spiral tower harnessed an as yet nonexistent technology to a very real political entity, the Third International Workingmen's Association (Comintern) formed only months before in March, 1919. In debates sponsored by the Free Workshops, Maiakovskii declared that the new kinetic architecture made the Eiffel Tower appear a mere bottle.[39] As if convinced by such hyperbole, a number of experimenters, including Liubov Popova and Alexander Vesnin, set out at once to build their own stage sets and buildings around whirling gears and throbbing pistons. As the direct heir to these efforts, Melnikov's *Leningradskaia Pravda* building attests that the impulse to create an architecture that somehow expressed the dynamism of the political and social revolution had not perished with the return to normalcy under NEP.

Thanks to his teaching position at the *Vkhutemas*, an innovating architect like Melnikov could enjoy a secure base in the capital from which to sally forth with projects whenever the opportunity presented itself. Until the years 1922-1923, however, the government had neither the time nor the resources for constructing any edifices on a scale commensurate with the architect's expectations. Because of this, the architectural forces released by the Revolution had yet fully to be tested. Until they were, it could not be known whether the various promising signs that had appeared during the years since 1917 would add up to a new architecture stripped of overt historic referents but itself constituting a historic epoch in the field, or whether it would turn out to have consisted of ephemeral improvisations to accommodate shortages of materials and destined to pass away once these constraints were removed. When concern over shortages were momentarily suspended during the Palace of Labor competition in 1923, the results were thoroughly unsettling. Here for the first time was revealed a very different side of many erstwhile partisans of asceticism and purism in architecture: an inclination towards megalomanic scale and overstatement that, submerged again during the rest of the decade, was to emerge full-blown under Stalin. For this competition Melnikov produced a design that embodied many of the more conservative strivings of the NEP period, with

[38] The American, Man Ray, a friend of Duchamp's, designed two mobiles in 1920 but without any clearly defined symbolic intent.

[39] As recalled by Naum Gabo, conversation with Kenneth J. Frampton and the author, November, 1968.

few of the bolder conceptions that characterized the rest of his work during the 1920s.

The occasion for this revelation was the competition for a "Palace of Labor" announced late in 1922. Whereas many calls to architecture since the Revolution had been issued by urban and regional administrators to meet the practical demands of their locality, this one came from the entire nation and carried the imprimatur of the First Congress of Soviets of the U.S.S.R. The moment was portentous. To the surprise of its critics, the new regime was showing every sign of being able to restore the domestic economy to reasonable order, but at the same time its earlier prognostication of a proletarian holocaust that would sweep all of Europe was proving embarrassingly naïve. The failure of western Europe's proletariat to rise in arms posed the most delicate challenge to the self-esteem and world image of the government. Some sort of official statement was called for, and the gathering in Moscow of delegates from all over the country to declare the establishment of the U.S.S.R. in December, 1922, provided an appropriate occasion. As the convocation was concluding, Communist Party official Sergei Kirov took the podium to address the issue in a speech rich with implications for architecture:

"I believe that we must mark [the foundation of the USSR] so that a living monument to what has just occurred will remain. I think that before much time has passed we will feel crowded in this fine and glittering hall. I think that for our assemblies, for our parliaments, a more spacious and open location will soon be needed. . . . Therefore, in the name of the workers I would propose to our Central Executive Committee that it immediately set about erecting a monument in which the representatives of labor could foregather. In this building, in this palace, which in my view must be built in the capital of the Union on the best and most beautiful square, the worker and peasant must be able to find everything needed to broaden his horizons. I think, furthermore, that this building must serve as an emblem of the forthcoming triumph and might of Communism, not only here but in the West.

"Many say of us that we are erasing from the face of the earth all the palaces of bankers, landlords and tsars with the speed of lightning. This is true. Let us erect in their places a new palace of workers and laboring peasants, let us gather all that enriches the Soviet lands, let us put all our worker and peasant artistry into this monument and show friend and foe alike that we 'semi-Asiatics,' we, upon whom they persist in looking with condescension are capable of ornamenting the sinful earth with monuments that our enemies cannot even dream of.

"Comrades! Maybe this will give the needed nudge to the European proletariat, for the most part still slumbering, still unconvinced of the triumph of the Revolution, still doubting in the correctness of the tactic of the Communist Party, so that at the sight of that magic palace of workers and peasants they will realize that we have arrived seriously and forever. . . . Perhaps then they will understand that the moment has finally come to shake the damned capitalist earth so that everything that has suppressed us through the centuries will be hurled into the abyss of history. . . ."[40]

Here was a new task for architecture! Though part of the cultural superstructure, it would strike awe into Europe's sluggish proletariat, charge it with fighting zeal, and thus unleash the world revolution that neither his-

[40] S. M. Kirov, *Izbrannye stati i rechi 1912-1934*, Moscow, 1957, pp. 150 ff.

tory nor the Red Army had been able to bring to pass. No mean feat, this, but Soviet architects were more than prepared to lead the way, as many had entertained the desire to do so through the long and lean war years. Now, the chance having suddenly appeared, they had the difficult job of selecting an idiom suitable to so grandiose an assignment.

Several points made by Kirov in his speech and elaborated in the published program for the competition bear special emphasis. First, it was not enough for the building to be functional; it had to be expressive, and to excite foreign workers with enthusiam for the Soviet experience. Second, it had to be an actual and symbolic center for the city of Moscow, much the way the Kremlin had formerly been. Third, it should be built to a truly gargantuan scale, embracing an auditorium for 8,000; a chamber for the Moscow Soviet with seating for 2,500 (with a dais for 100); a "small hall" for a thousand and an auditorium for 500; a "Museum and Library of Social Learning"; a banquet hall to seat 1,500, with buffets and restaurants for several thousands more; and "about fifty" offices.[41] Fourth, it must be expressed "with simple forms without resort to the specific style of any past epoch."[42] And, finally, the invitation to exoticism: this was to be a "magic palace" in which all the artistry of a nation of "semi-Asiatics" would be pooled to produce effects of which West Europeans could not even dream.

The forty-seven projects exhibited in the halls of the Moscow Architectural Association attest to the range of interpretations to which Kirov's charge was susceptible. Here were temples and ziggurats, towers of Babel, and an entry by the Petrograd architect, N. Trotskii, looking for all the world like a Byzantine church rebuilt successively by Seljuk Turks and a committee of the Academie Royale. Such wildly different approaches were shared by the jury, which awarded first prize to Trotskii's design and third to the only proto-Constructivist entry, submitted by the Vesnin brothers.[43]

Yet beyond this obvious diversity lay certain constant elements that unite many otherwise contrasting projects and Melnikov's own entry with the group as a whole.[44] All piled diverse elements together on asymmetrical site plans to create a dramatic and variegated profile. All used the same elements: grandiose facades; giant entryways; heavy, rusticated office blocks; and, in, every case except Melnikov's, a coliseum-like central auditorium. Moreover, everyone included soaring towers or sculptural appendages to give even greater height to the structure. The Vesnin brothers, who submitted under the motto "Antenna," bragged that the radio towers and guy wires atop their otherwise functional hall looked like a harp or a bouquet;[45] Kuznetsov and Toropov's entry sported a runway balanced in the air for airplanes; Ilia Golosov used a radio tower and added gear-teeth to the dome of his coliseum; and the civil engineer Grigorii Ludwig surpassed

[41] Ibid.

[42] "Programma konkursa na sostavlenie proekta Dvortsa truda v Moskva . . . ," Iz istorii sovetskoi arkhitektury 1917-1925, p. 146.

[43] The Vesnins managed to interpret the specifications as a call for "constructiveness, utility and rationality." "Konkursnyi proekt 'Dvortsa truda,' " LEF, 1924, No. 4, p. 59. The jury consisted of I. E. Grabar, I. V. Zholtovskii, D. S. Markov, I. P. Mashkov, E. V. Shervinskii, and F. O. Schechtel, Iz istorii sovetskoi arkhitektury 1917-1925, p. 148.

[44] For the entries of I. Golosov, M. Ginsburg and A. Grinberg, G. Ludwig, and A. Kuznetsov and A. Toropov, see Khazanova, Sovetskaia arkhitektura pervykh let Oktiabria . . . , pp. 136-45; Iz istorii sovetskoi arkhitektury 1917-1925, pp. 150-62; Ulrich Conrads and Hans E. Sperlich, The Architecture of Fantasy, Christine C. Collins, transl., New York, 1962, p. 108.

[45] loc.cit., LEF, p. 62.

them all with a permanent crane, a flower-shaped antenna to gather solar energy, and a spiral tower of twenty storeys!

Melnikov's entry, so atypical of his work as a whole during these years, is quite at home among these other projects. Its aggressively asymmetrical site plan (Fig. 59) is dominated by the two cone-shaped auditoriums turned outward like the morning-glory horns of early record players (Figs. 60-62). The profiles of these halls describe a round Norman arch, a motif that appears again in the variegated but somber complex of offices and restaurants adjoining the small hall. Articulating the entire ensemble and marking a plaza at the entry is a gracefully soaring circular colonnade rising in two stages from only a few meters to a point high on the radio tower. An arresting piece of monumental Futurist sculpture at first glance, this non-functional element also bears a striking and surely not accidental resemblance to a peasant sickle.

For all the giddy caprice of this great parabolic arch, the overall effect of the project is overwhelmingly stern and pensive. This somber monumentality—so uncharacteristic of early Soviet architecture—is felt in most of the other leading entries as well, particularly those of Golosov, Ginsburg, and Ludwig. Was this the result of having to design in stone after using only wood, concrete, and glass? Possibly, but a different explanation appears equally relevant, one pertaining to the function of the Palace of Labor: this was to be a national civic temple in the fullest sense of the word, the actual seat of government, a physical expression of the society's

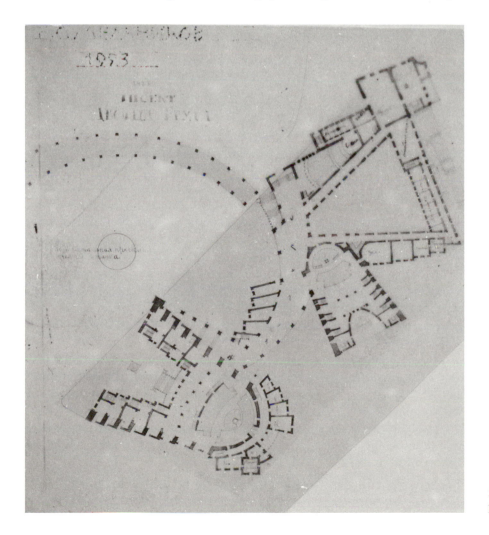

59. Palace of Labor, Moscow, 1923. Site plan

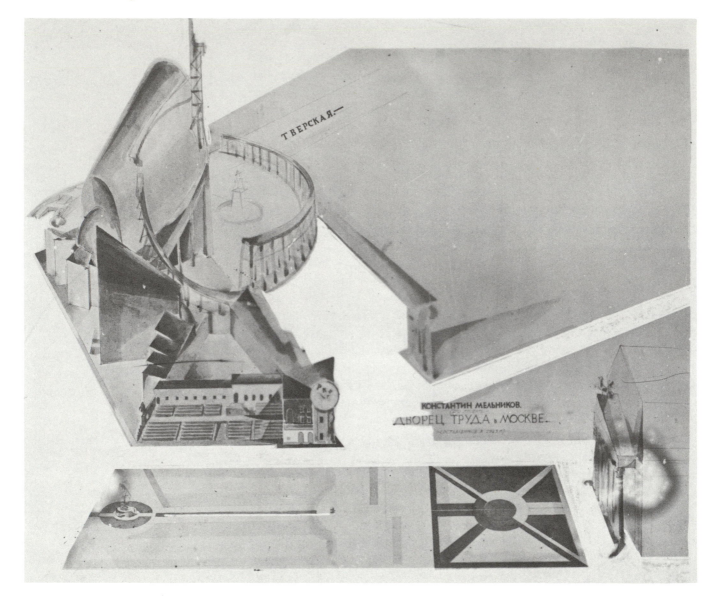

60. Palace of Labor, 1923

Opposite

61. Palace of Labor, 1923. View of the two main assembly halls

62. Palace of Labor, 1923. Elevation

first principles, and the visual center of the capital. A year before Stalin declared his theory of "Socialism in one country," Melnikov and the other leading entrants were already seeking the architectural language with which to express this ideal.

The mood in which Melnikov and his colleagues approached this assignment was uncompromisingly nationalistic. They cheered the recent publication of Oswald Spengler's *Decline of the West* and applauded when a Moscow art critic responded with a tract entitled *Against Civilization*, in which the primitive virtues of the new Soviet society were extolled.[46] Melnikov approved when his friend Ilia Golosov lectured Moscow architects that "The culture of the West has constantly impeded Russian culture" and, significantly, that "Russian temples of the past are absolutely individual in form."[47]

Given this cultural nationalism, it is the more surprising that Moscow architects should have turned for inspiration to the somber national ar-

[46] Nikolai Punin, *Protiv tsivilizatsii*, Moscow, 1919.
[47] Ilia Golosov, speech of December 13, 1922, published in full in *Iz istorii sovetskoi arkhitektury 1917-1925*, p. 27.

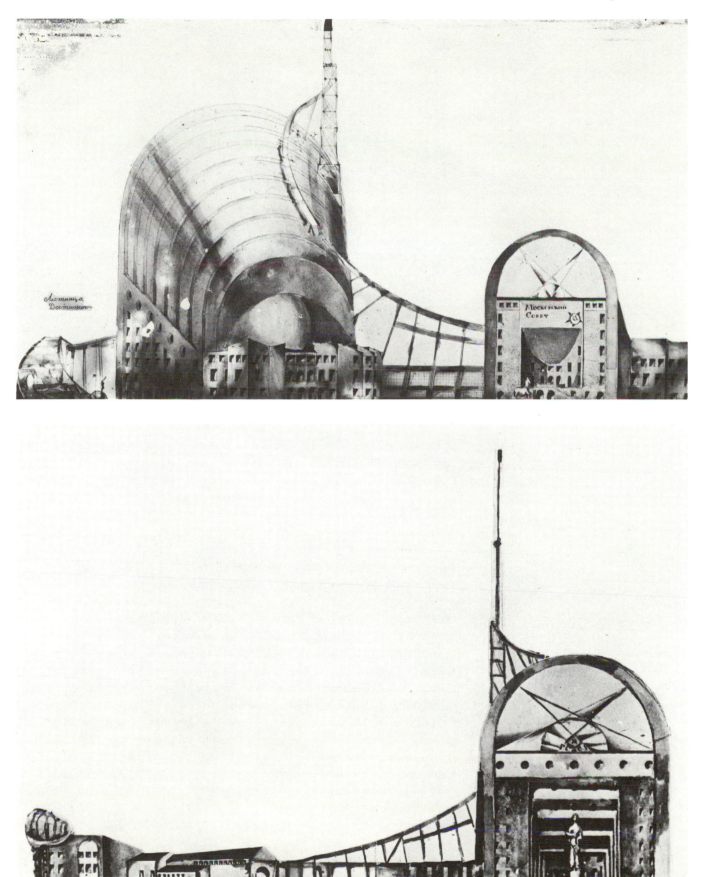

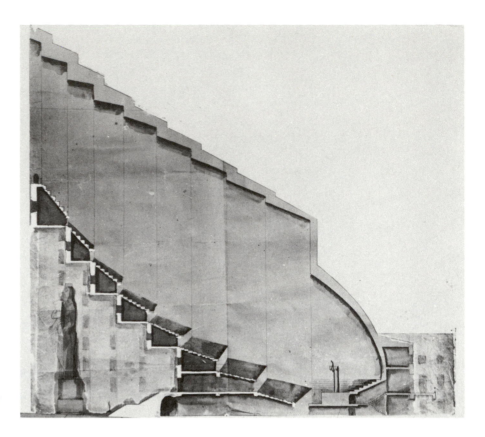

63. Palace of Labor, 1923. Section of main hall

chitecture of late imperial Germany. Yet this is precisely what they did. Just as the round arches and half-moon windows of Melnikov's project come straight from the prewar architecture of Hans Poelzig, so Golosov's complex included a portice lifted from Heinrich Tessenow's Dalcroze School at Hellerau, and Trotskii's winning design borrowed wholesale from Max Berg's pre-World War I Jahrhunderthalle in Breslau. Indeed, the cold rustication of the exterior of Melnikov's project, its cavernous interiors, and the forbidding immensity of its contrasting masses (Fig. 63) fairly exude the flavor of early German Expressionism.[48]

The Russians' indebtedness to German architects extends to the very conception of the project. For a decade, German and Dutch architect-planners had been producing tract after tract on the need to crown capital cities with monumental assembly halls where enormous throngs could celebrate the verities of a new civic religion. By the time Kirov announced the Palace of Labor, there had been a German competition for a great "House of Friendship," Hendrik Berlage had published in Holland his scheme for a "Pantheon of Mankind,"[49] and Hans Poelzig was actually building his cavernous Grosse Schauspielhaus in Berlin. Against this background, it is no more surprising that Melnikov and his colleagues should have utilized Germanic models for their national architecture than it was for nineteenth-century Russian composers and painters to have based their nationalistic art on German examples.

Thanks to such original ideas as the conical auditorium and the great

[48] For this characterization of Expressionism, I have relied on Wolfgang Pehnt's *Expressionist Architecture*, J. A. Underwood, Edith Kustner, translators, New York, 1973, pp. 52 ff.

[49] H. P. Berlage, *Het Pantheon der Menschheid,* Afbeeldingen der Ontwerpen, Rotterdam, 1915.

sickle fulfilling the functions of both tower and colonnade, the echo of the work of Poelzig and his German contemporaries seems muted in Melnikov's entry by comparison with other leading entries in the competition. But the Germanic element is nonetheless present, not just in the features noted above, but in the fact that he worked under the direct inspiration of an obscure but significant tract, *Die Stadtkrone*, by the North German architect, planner, mystic, and friend of Soviet Russia, Bruno Taut.[50] Melnikov recalled that as he and his colleagues discussed their projects they considered in detail Taut's notion of a complex of halls and facilities crowning the ideal metropolis.[51] What appealed particularly about Taut's idea was that it had been sketched as the center of a New Jerusalem. Russian architects who had survived the apocalypse of Civil War needed little persuasion to see Moscow as that New Jerusalem. Taut encouraged them in this view by including in his volume a picture of the Moscow Kremlin along with other world capitals. Thus, Soviet architects could readily interpret Taut's book as a call for them to show Europe their new civilization by expressing it in stone—"Ex Oriente Lux," as Taut put it in another essay of the same period, using a phrase soon to be popularized by Stalin.[52]

In the Palace of Labor competition of 1923 it appeared that Melnikov and other leading Soviet architects would again seek to build a distinctive national idiom on German precedents. But the results of this effort were disappointing. Melnikov's entry stands with the Vesnin's as one of the least derivative, but even it presents borrowed elements that are quite in contrast with the work he produced at the same time for the more modest but still agitational and symbolic *Leningradskaia Pravda* and Makhorka buildings.

On the whole, the Palace of Labor competition suggests one of two conclusions: either that the vast scale of the undertaking exceeded the capability of the emerging movement in architecture, or that the requirement that the building be heavily loaded with symbolism tended in a direction opposite from that in which the modernists were moving. The former was certainly true of many entrants, for the Palace of Labor was far more extensive a project than Melnikov or most of his contemporaries had ever attempted. But the latter was also true, for by 1923 even within the *Vkhutemas* the earlier preoccupation with the "expressiveness of forms" had begun to wane, and a new respect for sober practicality à la NEP was gradually taking its place.

The death of Lenin on January 21, 1924, vastly sped this process. Even more than the introduction of NEP, this sad national event cut off Soviet Russia from the first phase of its Revolution. During the ensuing uncertainties over succession, educated people found less and less sustenance in rehashing the glories of the earlier, more naïve stages of the upheaval and felt compelled instead to look soberly at the practical issues of the present. The Palace of Labor was an early fatality of this détente. No contenders for power felt sufficiently secure to convene the gargantuan congresses envisioned by Kirov only two years before, and Kirov himself dropped the proposal and quickly accepted an assignment in Central Asia. In the wake

[50] Bruno Taut, *Die Stadtkrone*, Jena, 1919.

[51] Konstantin Melnikov, conversation with the author, May 1, 1967.

[52] Taut's 1919 essay, "Ex Oriente Lux," is discussed by Wolfgang Pehnt, *Expressionist Architecture*, pp. 9 ff. For the same idea in *Die Stadtkrone*, see the essay by Adolf Behne, pp. 130-31.

of these events, Melnikov put his project for the Palace of Labor into the drawer and Moisei Ginsburg, as if in embarrassment over his own excesses, penned a tract on *Style and the Epoch*, in which he turned decisively from German Romanticism and Expressionism to French Rationalism and to Le Corbusier, author of the order-seeking doctrine of "Architecture or Revolution."[53] Another author lamely tried to justify the rejection of *engagé* architecture by claiming that "style" as such derives not from ideas—even revolutionary ones—but from the technological capabilities of the given era, an assertion he backed up with the bald statement that the Gothic cathedral sprang not from Christianity but from the engineering principles mastered by medieval man.[54] Clearly the old zeal for ideological expressiveness was on the wane.

The fate of the triangle and pyramid under NEP illustrates this process. Prior to 1917, both had carried primarily funereal connotations in Russia. Boullée had employed them in this way in the eighteenth century and his Russian follower Alferov merely followed this tradition in his 1817 monument to the Russian casualties at the Battle of Kazan; a number of monuments built later in the century continue this convention. Revolutionary architects upset this well-established classical iconography by stressing the potential dynamism of both the pyramid and the triangle. In addition to El Lissitzky's and Kolli's use of the symbol of the "Red Wedge," noted above, mention might be made of the skewed pyramids proposed by Alexander Vesnin for his version of the monument to the Third International in 1919, [55] and the truncated pyramid set up as a reviewing stand for May Day celebrations in Nizhnii Novgorod in 1921.[56] But when Melnikov's mentor, Aleksei Shchusev, was commissioned to draft a proposal for a permanent structure over Lenin's tomb to replace the temporary wooden sheds thrown up in the first days after the body was removed to Red Square, he reverted to the earlier iconography.[57] Indeed the most direct antecedent to Shchusev's pyramidal plan for the mausoleum appears to have been a 1919 project by his "disciple" Kolli intended for Moscow's first crematorium,[58] while its more remote forebearer was an ancient Persian stepped pyramid, or so the *Vkhutemas* pedagogue and Futurist publicist, K. Zelinskii claimed with vengeful glee: "I don't know how it happened, but the current temporary mausoleum over the grave of Lenin . . . is, in its architectural form, the very image of a similar mausoleum (though in stone) over the grave of King Cyrus near the city of Murgaba in Persia. . . . This literal translation from the ancient Persian speaks in the most convincing manner that the ideological baggage of contemporary Russian architecture is in need of a most careful customs inspection."[59]

Nor was Zelinskii's point as farfetched as it may at first appear, in light

[53] M. Ginsburg, *Stil i epokha*, Moscow, 1924; Le Corbusier, *Towards a New Architecture*, pp. 251 ff.

[54] Z. Tsimmer, "Mirovozrenie i formy stilia, " *Vestnik sotsialisticheskoi akademii*, 1923, No. 4, p. 362.

[55] Khazanova, *Sovetskaia arkhitektura pervykh let Oktiabria* . . . , p. 185.

[56] Speranskaia, *Agitatsionno-massovoe iskusstvo* . . ., Plate 104.

[57] For complete details on the construction of the Lenin mausoleum A. N. Kostyrev's monograph, *Mavzolei V. I. Lenina: Proektirovanie i stroitelstvo*, Moscow, 1971, should be consulted.

[58] *Iz istorii sovetskoi arkhitektury, 1917-1925*, p. 214.

[59] K. Zelinskii, *LEF*, 1925, No. 3, pp. 95-96. The possible influence of V. Frenkel's 1899 proposal for a monument to Bismarck might also be noted. Cf. *Stroitel*, 1899, 11-12, pp. 543-44.

of the fact that Shchusev had spent several years in the early part of the century excavating in Central Asia, where he encountered several structures that could have served as prototypes for the mausoleum. Unconcerned with the possible geneology of Shchusev's proposal, the Central Committee of the Communist Party approved it and eventually provided that the initial wooden stepped pyramid be rebuilt in granite. By these steps the earlier urge towards Revolutionary expressiveness gradually weakened.

As the planning of the mausoleum as a whole was taking this turn, a design for the sarcophagus within was selected by means of a hastily organized competition from which Melnikov emerged victorious. On the face of it, this would seem to have been an ideal opportunity for the young professor to give free reign to his passion for using abstract and modern forms to convey the sense of raw vitality he found in contemporary Russian life. But as he began his work, the function that the sarcophagus was to fulfill was rapidly being defined in such a way as to make it imperative that his design accord with the more conservative sensibility of the broader public. While the leader's body was on view in the building of the former Gentry Assembly, Stalin had called upon the Party to gather all relics of Lenin for the newly founded Lenin Institute; soon afterwards several *Vkhutemas* architects proposed that ground occupied by the Cathedral of Christ the Savior be commandeered for a great monument to Lenin.[60] The mass of people from all ranks of society who spontaneously converged on Moscow to bid farewell to "Ilich" removed all doubt that whatever would be constructed would be no museum of avant-gardism but a point of pilgrimage, the modern equivalent of the sarcophagus of Muscovy's patron, Saint Sergei, at the Trinity-St. Sergei Monastery near Moscow.

Melnikov entered into the task before him with fervor, and, conscious of the distance between what he himself preferred and what most likely would be possible, he submitted not one but five variants of ascending degrees of boldness. His strong preference was for a design consisting of a four-sided elongated pyramid cut by two internally opposed inclined planes of glass that by their intersection formed a strict horizontal diagonal, thus breaking up the static rectangle of the casket into two lively acute triangles (Fig. 64). Before the selection commission he defended this plan as a means of giving the upper cover of the sarcophagus extra strength against caving in. Privately, however, he viewed it as a "crystal with a radiant play of interior light, alluding to the tale of the sleeping Tsarevna."[61]

It need scarcely be said that this statement suggests a number of further avenues for enquiry concerning Melnikov's intentions in the Lenin sarcophagus in general and in this "crystalline" variant in particular. These will be explored in their relation to his architecture as a whole in the concluding chapter on the theme of death. For now, let us note that the Commission, too, preferred this crystalline variant, but in the end rejected it on the grounds that it would have been too difficult to construct and that it was an excessively bold solution for the problem at hand. Instead, it fell back on a "safer" alternative based on rectilinear forms that, in the emerging NEP-era iconography, were held to be more conservative (Fig. 65). In the same way that the final, granite version of the mausoleum stressed the

[60] Khazanova, *Sovetskaia arkhitektura pervykh let Oktiabria . . .*, p. 163.

[61] K. S. Melnikov, "Postroika sarkofaga dlia sokhraneniia na vechnye vremena tela V. I. Lenina," Melnikov archive, MS, n.d., p. 1.

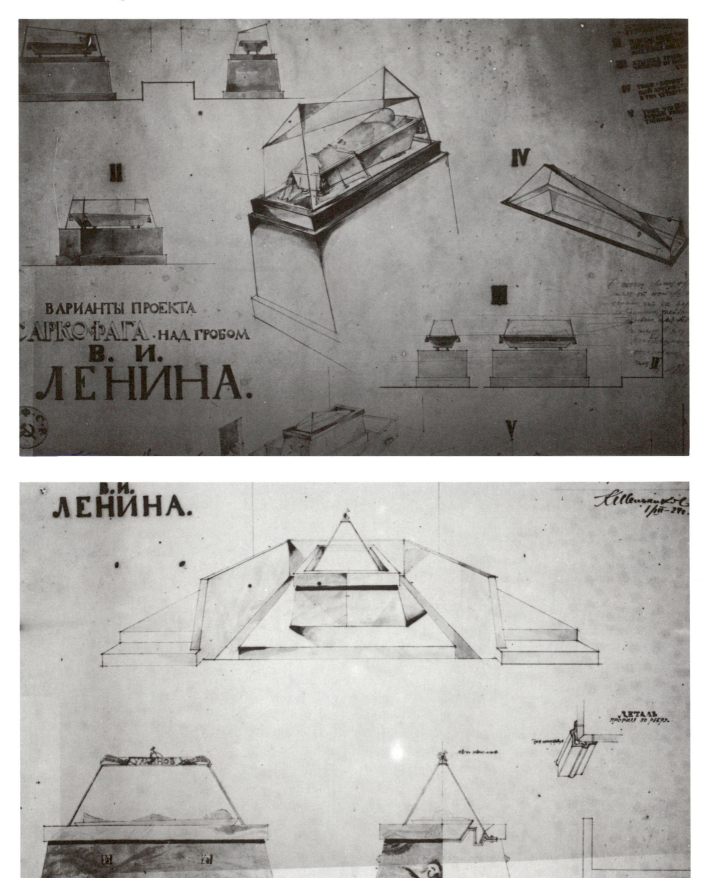

rectilinear blocks even at the expense of the already de-Revolutionized pyramid, so now the official patrons opted for the least restless design for the sarcophagus, much to the dismay of the Expressionist Bruno Taut, who harshly criticized the entire scheme for the mausoleum.[62] Prevailing aesthetic notions made these decisions all but inevitable, but a prime reason for shelving the more crystalline version of the sarcophagus may well have been that its construction would have required both skills and material that could scarcely have been found on such short notice. As it was, the Forestry Institute had to be raided for oak from which the piers could be hewn; the Bromley Metalworking Shop, closed since the Civil War, had to be reopened to cast the frame; and when the first glass panels failed to fit, new ones had to be unceremoniously cut from the plate windows of the restaurant "The Ravine" (Fig. 66).

Melnikov worked under tremendous pressure—forty years later he was to recall in a letter to Nikita Khrushchev that a G.P.U. official, Comrade Belenko, threatened his life if he failed to complete the sarcophagus on time.[63] But he succeeded. The final session with the government commission in charge of the work marked a personal triumph for Melnikov, though, due to his utter exhaustion, he received the praise of Leonid Krasin, its chairman, while asleep in his chair.[64] At last he had actually built a structure with materials other than wood. Never mind that it was not con-

[62] Bruno Taut, "Novaia arkhitektura v SSSR," *Stroitelnaia promyshlennost*, 1925, No. 8, p. 562.

[63] K. S. Melnikov, "Tovarishchu Nikite Sergeevichu Khrushchevu," June 1963, MS copy, Melnikov archive.

[64] Details of the process of planning and construction are drawn from Melnikov, "Postroika sarkofaga . . . ," and from conversations with the architect.

Opposite

64. Preliminary variants of sarcophagus for V. I. Lenin, 1923. Melnikov's preferred variant is in the center

65. Sarcophagus for V. I. Lenin, 1924. Final variant

66. Sarcophagus for V. I. Lenin, 1924. Final variant

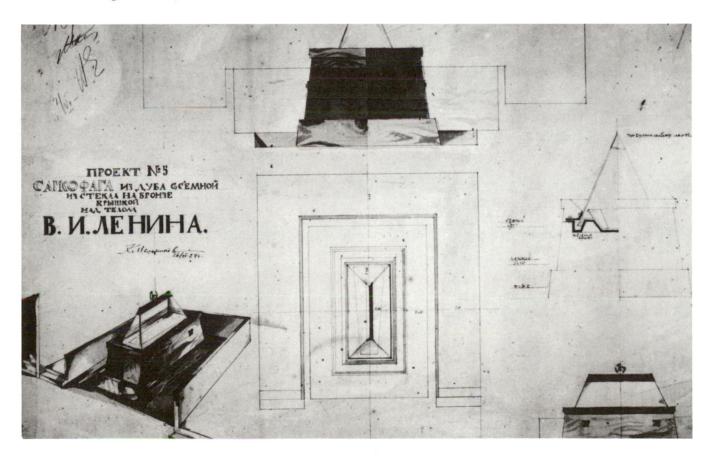

ПРОЕКТ №5
САРКОФАГА из ДУБА съёмной
из СТЕКЛА НА БРОНЗЕ
КРЫШКОЙ
НАД ТЕЛОМ
В. И. ЛЕНИНА.

structed according to his preferred plan, or that its small scale scarcely qualified it as architecture. For Melnikov had shown himself to have fully mastered both the practical and symbolic needs of his era and, equally important, had proved himself to be a man who could be entrusted with commissions of major national significance. Both of these qualities were soon to be tested in a way that would bring the thirty-four-year old Melnikov to international attention.

V. International Debut: Paris, 1925

P RIOR to 1925, Melnikov and the animated architectural world of which he was so prominent a part were almost wholly unknown beyond the Soviet frontier. The professional press of France had yet to treat seriously the Soviet scene; the British and American had ignored it entirely; and even the Dutch and Germans little appreciated the full extent of developments taking place in Moscow, though they were slightly better informed on Russia, thanks to exhibitions and a few scattered bulletins from compatriots returning from the East. If the still-fluid movement of intellectuals between Russia and the West brought pro-Bolshevik artists and writers from Moscow to the Café Rotonde on Montparnasse or the Romanisches Café in Berlin's Schieber district, their reports were as often as not offset by tales of other less sympathetic but nonetheless authoritative recent emigrés like Naum Gabo and his brother Antoine Pevsner. The 1922 exhibition of Russian art at the van Dieman Gallery in Berlin might have altered the situation had a larger and more fully representative architectural section been included, but it was not, while the architectonic paintings were insufficient in number and range to reflect the full vitality of activity in Moscow.[2]

For it to have been otherwise would have been quite remarkable, given the modest amount of printed information available even within Russia on the dramatic developments in its own architecture. The Moscow Architectural Association had revived its journal briefly in 1923, but after only two issues, neither of which contained any mention of Melnikov, that venture had collapsed. No regular architectural journal was as yet being issued in Leningrad and, even had one existed, Melnikov's work would probably not have been treated in it on account of the keen rivalry between the two great cities that persisted into the post-Revolutionary era. Indeed, the only specialized periodicals regularly to report on the burgeoning architectural front with any sympathy for the younger generation and the only two in which Melnikov's work had been touched on at all were the more narrowly technical journals *The Building Industry* (*Stroitelnaia promyshlennost*) and *The Construction of Moscow* (*Stroitelstvo Moskvy*), founded in 1923 and 1924, respectively. Several thousand Russians subscribed to each of these publications, but neither was at all known abroad. Given the amount of

"I am in Paris! The very thought causes a special, inexplicable, and pleasant quickening of the spirit . . . *I am in Paris!*"—NIKOLAI KARAMZIN, 1790

"[The West] is agitated, tormented by political and social problems. . . ; Russia has everything that is for them only a dream, something sought for, a subject of abstract thought."
—IVAN AKSAKOV, 1884[1]

[1] I. S. Aksakov, *Slavianofilstvo i zapadnichestvo, 1860-1886*, Moscow, 1886, II, p. 687. N. M. Karamzin, *Pisma russkogo puteshestvennika*, 2 vols., St. Petersburg, 1884, II, p. 83.

[2] Some two dozen architectural projects had been shown in the 1922 van Dieman Gallery exhibition in Berlin, as were several "architectonic" paintings. The latter attracted considerable attention but the former were all quite conservative in character.

space in both journals devoted to problems of sewage and heating, even those few foreigners who did see them would have to peruse every number with great diligence if they wanted to gain a sense of Melnikov's work.

The event that finally altered this situation, both abroad and at home, and that caused nearly every step of Melnikov's career henceforth to be taken under the full glare of public notice was his designing of the brilliantly successful Soviet pavilion for "L'Exposition internationale des arts décoratifs," held at Paris in the summer of 1925. Here, at a gleaming fair staged by the Dumargier government to prove to all Europe that France had recovered from the war, it was Melnikov's small but imposing Soviet pavilion that stole the show.

This did not happen by chance. Soviet cultural and trade authorities had from the outset identified the Paris exposition as a unique opportunity to show the world just what the emerging culture of a socialist state was and was not. Other such opportunities had already appeared, and by 1925 the Soviets had presented themselves creditably in Venice (where they devoted most of the exhibit to papier-mache utensils painted by the peasants of the village of Palech) and at lesser fairs in Riga, Grenoble, and Vienna. But, unlike the others, this one was to be held in Paris, for a century and a half the Mecca for cultivated Russians, whether princely balletomaines or pamphleteering Bolsheviks.

By 1925 Paris was very much in need of a refresher course on the nature of official Russian culture. The last major official Russian exposition there, if one excludes Sergei Diaghilev's 1906 show of Russian painting, had been at the Eleventh World Exposition in 1900, at which time the tsarist government had constructed a sprawling Muscovite fortress to which French wags immediately applied the sobriquet "The Trocadero Kremlin." Here medieval, rural, and Central Asian motifs were combined to render everything folksy, and, to West European eyes, "eastern"—the only exception being a specially housed "Galoshes Pavilion" that featured a resinous mountain of 35,000 pairs of boots, the product of one day's work at the Russian-American Rubber Company.[3] This image of Russia as semi-Asiatic had subsequently been capitalized upon by the smashingly popular but unofficial *Ballet Russe* and seemingly proven beyond doubt by the Revolution itself. Now, in 1924, when France had grudgingly granted diplomatic recognition to the U.S.S.R., the time had come to make France recognize the culture of the new Russia as well. Hence, the Soviet exhibition at Paris was intended to set right "all those who continue to believe that Russia presents nothing more than a desert haunted by wild men," as the Politburo triumvir, Lev Kamenev, explained in the French-language guidebook.[4] It was to hold up before the French public the ideological theater, the rapidly transformed folk culture, and especially the "vibrant architecture" that, together, according to Commissar of Enlightenment Lunacharskii, gave proof of the existence in Russia of a "new civilization unlike any that preceded it. . . ."[5] Through every means at hand, the exhibit was to propagandize the beneficial impact on cultural life of the new policy of "Socialism in One Country," and, in the process, communicate the notion that Soviet Russia warranted the attention both of western intellectuals in search of ideals and of western traders in search of products and markets.

[3] Information on this exposition is drawn from Albert P. Nenarokov, *Russia in the Twentieth Century*, David Windheim, transl., New York, 1968, Chapter I.

[4] *L'Art décoratif URSS*, Moscow-Paris, 1925, p. 5.

[5] *Ibid.*, pp. 15-21.

In November 1924, the Collegium of the Commissariat of Enlightenment named a special commission to select a design for the pavilion.[6] Thanks to the membership on that five-man body of the avant-garde painter and former Bundist, David Shterenberg, and the active but unofficial participation of Lunacharskii and Maiakovskii (who had been asked to do posters for the exhibit), radical architects for the first time could expect to figure prominently in the closed competition. And of the eleven architects invited to submit proposals, fully nine had cast their lot decisively with the avant-garde.[7]

This was all to the good, for just as the initial designs were being prepared, it became known in Moscow that the exposition promised to be a showcase of contemporary European architecture.[8] The Austrian pavilion, for example, would contain a model of an elementarist "Cite dans l'Espace" by the theater designer, Friedrich Kiesler; J. F. Stahl was known to be planning the Dutch pavilion in that country's distinctive postwar style; Tony Garnier, who had already inspired a generation of modernists, had been employed to do a pavilion for the Lyon-Saint Etienne region; the arch-purist Robert Mallet-Stevens was understood to be projecting some startling form of cubist trees to be "planted" near the entrance; and, to top it all, Le Corbusier was at work on a pavilion for his journal, *L'Esprit Nouveau*. News of such efforts by high priests of west European modernism so spurred on the Russian competitors that even Vladimir Shchuko, an unredeemed partisan of the Renaissance, abandoned his accustomed *genre* for something he considered to be daringly avant-garde.

Moscow architects had also heard vague rumors that, in its decor, the fair was likely to break all records for glossy chic and opulence. The full truth behind these rumors was not to be known until after President Dumargier opened the festivities in a ceremony held at the "Porte d'honneur" of chrome pylons surmounted by polished pewter sculpture.[9] But even before seeing such exhibits as Charles Moreau's model French embassy, with its jet-black smoking room and fur-covered bed in the "gentleman's chamber,"[10] the Russian committee had wisely prescribed that the Soviet pavilion be "original, and distinguished in character from the usual European architecture."[11] It might have added "simple," which was all but guaranteed by the scant 15,000 rubles designated for the cost of construction.

What did this actually mean? To the great champion of classicism, Ilia Fomin, the charge brought only bewilderment, disorientation, and confusion. While, on the one hand, he favored "a new style . . . reflecting the character of the country's government of workers and peasants,"[12] on the other, he sought to avoid "distorted and ultra-futuristic approaches."[13]

[6] Documents pertaining to this commission are presented in abbreviated form in *Iz istorii sovetskoi arkhitektury 1917-1925*, p. 190.

[7] These included the Vesnins; N. A. Ladovskii; N. A. Dokuchaev; V. F. Krinskii; M. Ia. Ginsburg; I. A. Golosov; and Melnikov. Of the conservatives, only V. A. Shchuko and I. A. Fomin were included. *Ibid*.

[8] For a general review of the art and architecture of the exposition, see Giulia Veronesi, *Style 1925: Triomphe et chute des "Arts-Deco,"* Lausanne, 1968.

[9] Information on the official structures and various exhibits is drawn from *L'Architecture officiele et les pavillons*, Paris, 1925, and *Devantures vitrines installations de Magasins à l'Exposition internationale des arts décoratifs*, Paris, 1925.

[10] Charles Moreau, ed., *Un Ambassade Française*, Paris, 1925.

[11] *Iz istorii sovetskoi arkhitektury 1917-1925*, p. 190.

[12] Iz poiasnitelnoi zapiski arkhitektora I. A. Fomina . . . , *Iz istorii sovetskoi arkhitektury 1917-1925*, p. 187.

[13] *Sovetskaia arkhitektura*, M. G. Barkhin, I. Ia. Tsigarelli, eds., *Mastera sovetskoi arkhitektury*, Moscow, 1975, I, p. 124.

The result, predictably, was a failure. For Melnikov, the specifications set down by the committee marked only the first step in a long, intricate, and, to the historian, extremely revealing process of defining the aesthetic forms appropriate to the peculiar demands placed upon him and his colleagues by the Exhibition Committee, a process that passed through innumerable stages before the final design for the Paris pavilion was achieved. He had no opportunity to linger over each of these, reflecting carefully over its relative merits and weaknesses before moving deliberately towards the next, for the entire process had to be crammed into a month between the issuance of the invitations by the committee a few days after its formation on November 13, 1924, and the final judging of projects on December 18, by which time finished plans and elevations had to be in hand. Yet for all the pressure of time, Melnikov succeeded in following an intricate line of reasoning to its conclusion.

Over the years, the Melnikov pavilion has become established in the minds of many as a symbol of the Constructivist movement in Russian architecture, the epitome of the "heroic" functionalism that later aroused such interest and admiration among visiting west European architects. This view was propounded by more than one writer in the 1920s and has been given currency more recently by the Belgian critic Victor Bourgeois,[14] and by others as diverse as the Soviet journalist and memoirist Ilia Ehrenburg, and the late British critic Camilla Gray,[15] who saw it as an emanation of militantly functionalist Constructivism. The Soviet official and member of the exposition committee that chose Melnikov's design, P. Kogan, encouraged this view in the official guide to the exhibit, in which he stated categorically that "true beauty consists in the adaptation of an object to its intended function."[16]

It is surprising that such a notion could have gained any currency about a building that was intended by its patrons more to define and promote a political image than to serve a technical function. At the least, it shows how the term "Constructivism" has been permitted to be associated with numerous phenomena that members of the Constructivist circle themselves would have flatly rejected. An examination of the actual structure, and particularly of the preliminary variants, shows just how seriously Melnikov was preoccupied with the task of identifying in the hermetic vocabulary of abstract form a symbolic system from which could be fashioned a modern *architecture parlante* capable of communicating to the Parisian public that buoyancy and optimism which he found in contemporary Soviet culture.[17]

The point of departure for Melnikov's investigation was the sphere, which served as the basis for his first variant. The sphere, like the triangle, had been radicalized by artists in the early days of the Revolution. Initially the obvious symbol of the world, it had made its debut in the graphic works of El Lissitzky, Alexander Rodchenko, and others as the passive object upon which the "Red Wedge of Revolution" acted. After October, 1917, as the expectation spread that the whole globe would soon be swept into the Revolutionary whirlwind, the image of the sphere as passive object gave

[14] Victor Bourgeois, *Zodiac*, 1957, No. 1, p. 47.

[15] Ehrenburg, *Memoirs, 1921-1941*, p. 91; Camilla Gray, *The Great Experiment*, New York, 1962, p. 251.

[16] *L'Art Industriel et Décoratif en U.R.S.S.*, p. 190.

[17] For a competent discussion of this building, see Philip I. Eliasoph, *"Melnikov's Paris Pavilion,"* unpub. M.A. thesis, State University of New York at Binghamton, 1975.

67. Soviet pavilion for the International Exposition of Decorative Arts, Paris, 1925. Preliminary sketch, 1924

68. Soviet Pavilion, Paris. Preliminary sketch, 1924

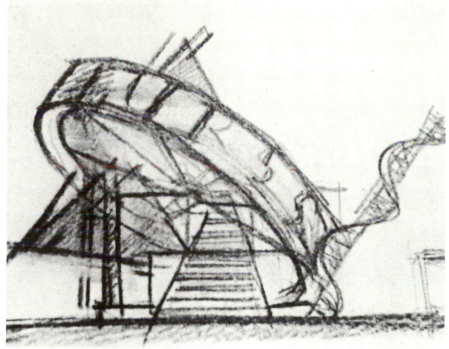

69. Soviet Pavilion, Paris. Preliminary sketch, 1924

way to an image of it as the revolutionalized world, so much so, in fact, that when in 1918 I. Zakharov and I. Agapeva drafted a scenario and props for the mass celebration in Moscow of the first anniversary of the Revolution, they included a great sphere, to be borne through the streets like a hunter's trophy.[18] Melnikov began with the same impulse, poising the globe (appropriately identified as the U.S.S.R.) above a wholly separate exhibition hall (Fig. 67).

Of course, this involved more than a slight exaggeration, for, although the Soviet Union spanned a sixth of the globe and eleven time zones, there remained five-sixths of the globe beyond Bolshevik control. The second variant acknowledged this, by girdling the not yet fully revolutionized globe with a waving band labeled in French "U.S.S.R." The poor integration of exhibit space with the symbolic elements was markedly improved in this second sketch by hollowing the globe and opening one end like a cornucopia, through which visitors would enter the hall (Fig. 68). Perceiving by now that the band and not the sphere represented the key symbolic element in the composition, Melnikov, in the next version, tried abandoning the sphere altogether, replacing it with a rotating element and raised pyramidal mass and emphasizing still further the triangular form of the entrance stairs, adding as if as an afterthought a spiral tower set at an angle at the rear of the structure (Fig. 69).

With this, the architect seemed about to incorporate into the pavilion several components from Tatlin's Monument to the Third International: the

[18] Speranskaia, *Massovoe-agitatsionnoe iskusstvo*, pl. 69.

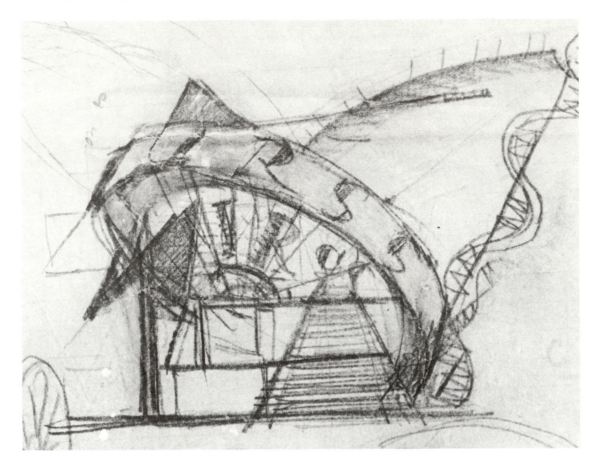

70. Soviet Pavilion, Paris. Preliminary
sketch, 1924

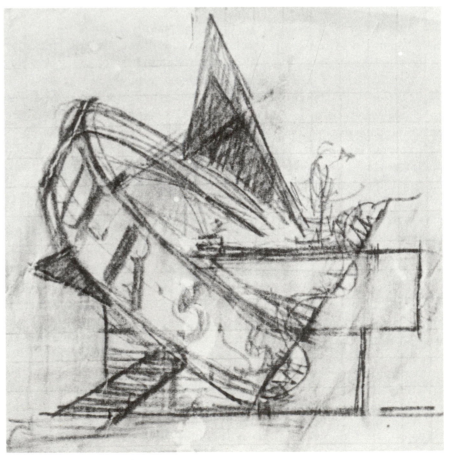

71. Soviet Pavilion, Paris. Preliminary
sketch, 1924

pyramid, the positioned orbital ring, the rotating spiral. This variant was elaborated in a series of sketches, all of which have been preserved (Figs. 70-71). Unfortunately, Melnikov in his old age was unable to reconstruct precisely the order in which these were drafted, although he reminisced vividly on the frustration he had felt over his failure to resolve the problem of exhibition space in an otherwise promising scheme. The one element from these variants that was to be carried over into the final structure was the stairway; but before this could enter the later drafts, the entire structure had to be reconceptualized.

72. Soviet Pavilion, Paris. Preliminary sketch, 1924

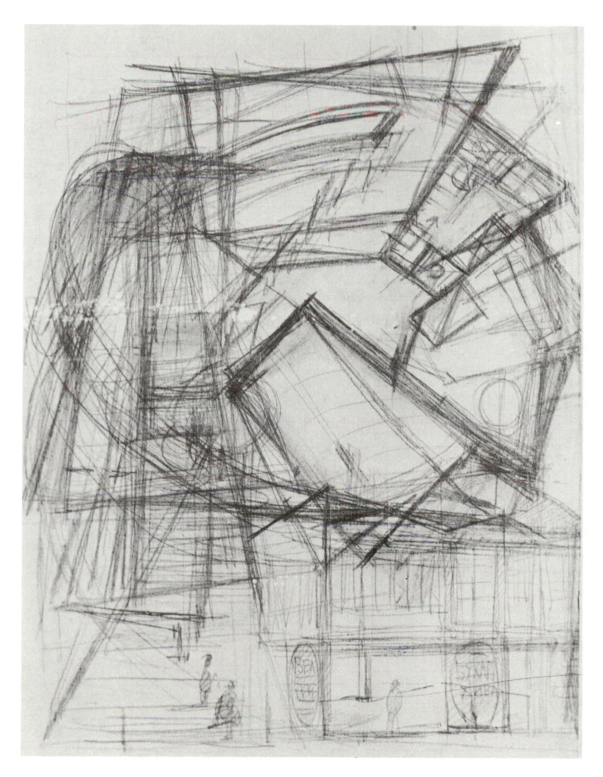

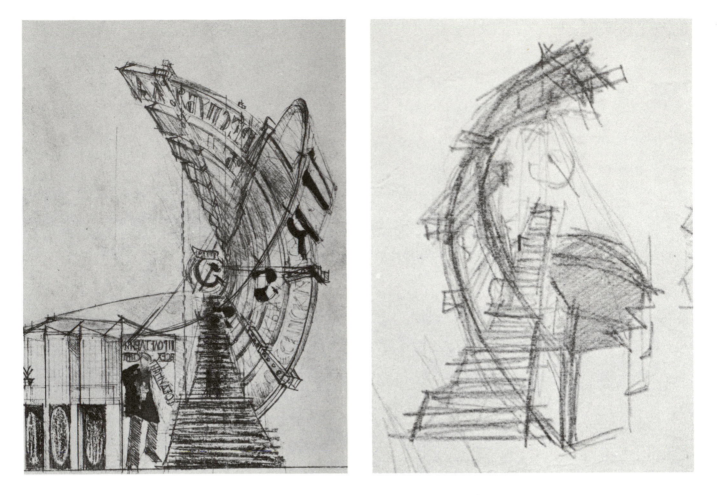

73. Soviet Pavilion, Paris. Preliminary sketch, 1924

74. Soviet Pavilion, Paris. Preliminary sketch, 1924

Having gone this far along the trail blazed by Tatlin, Melnikov abruptly reversed direction. In the next variant he dropped the pyramid, eliminated the spiral tower, and flattened out the globe, turning it into a hammer and curving sickle suspended over the main entrance. In a decisive step towards the final design, he then sliced open the perimeter of the orbital band, transforming it into a curvilinear tower soaring into space from a point over the other entrance. By these steps one of the central components of the earlier variants—the sphere—was all but eliminated in favor of another—the band. The rupturing of the encircling band opened before Melnikov another broad panorama of new sculptural possibilities. In a series of sketches he strove to place new soaring, sickle-shaped elements at the very center of the composition (Figs. 72-73). He undoubtedly succeeded in this, for the final version of this variant stands as one of the boldest sculptural monuments of Melnikov's career. But the closer he came to realizing the full potential of the soaring band, the more directly he came face to face with the original and as yet unresolved problem of the relation of the building's symbolic function to the practical needs of an exhibition structure. The first sketches carried out after the decision to turn the band into a tower show clearly the nature of this problem (Figs. 74-75). Here the pavilion is virtually an appendage to the sculptural element, its stark form appearing bland and devoid of expressiveness by comparison with the politico-astronomical extravaganza overhead. If the exhibition hall figures more prominently in the later sketches in the series, it does so at the expense of the sculptural element; the fact that it helps to balance the band overhead does not offset its continuing status as an appendage.

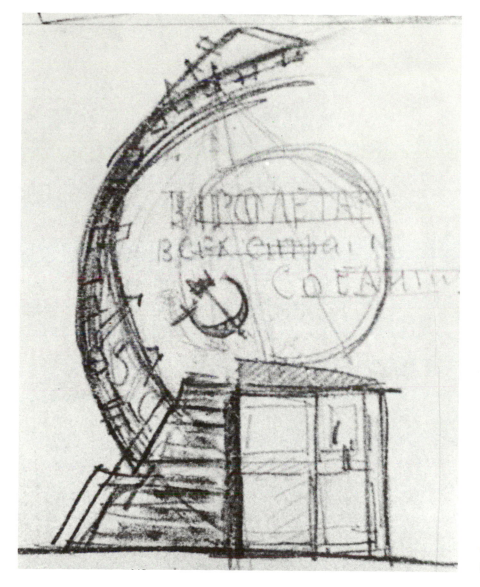

75. Soviet Pavilion, Paris. Preliminary sketch, 1924

Neither symbolic nor practical demands are fully satisfied in any version of this fourth variant, and, to make matters worse, the two demands are poorly integrated with one another. Melnikov appreciated this and was disturbed by it. Accordingly, he devoted the last phases of the process of design to elevating the exhibition hall itself to the central element, and then to endowing it with the symbolic significance that had originally been born by the globe and band of revolution. He did not accomplish this task at once, however. A fifth set of variants continues his earlier attempts to utilize the arc of revolution, now by turning it into a nearly vertical tower soaring over the structure (Figs. 76-77). In the end, all of these fluidly Expressionistic variants were rejected in favor of a harder, more linear solution, but one that still involved an Expressionist aesthetic in its use of crystalline forms.

In its final form, the Paris pavilion adhered to a rhomboidal plan, with two stairways slicing dramatically in opposite corners, dividing the structure into two acute triangles (Figs. 78-79). By this simple device, the rhombus is denied the slightest chance of settling into a stable—and hence non-Revolutionary—form, and the exhibition hall is given the dynamism that it had heretofore lacked. This scheme was developed first in presenta-

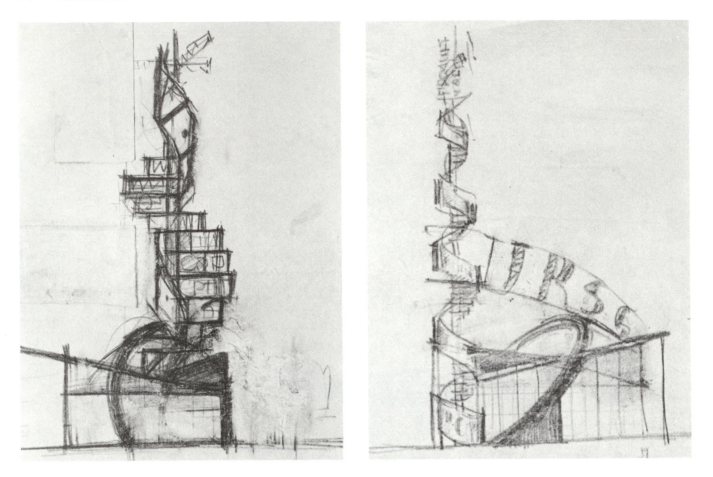

76. Soviet Pavilion, Paris. Preliminary sketch, 1924

77. Soviet Pavilion, Paris. Preliminary sketch, 1924

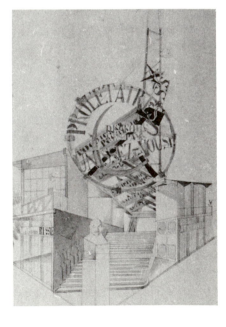

78. Soviet Pavilion, Paris. First presentation drawing, 1924

tion drawings and then in a final reworked variant (Figs. 80-81). There were ample precedents in Melnikov's *oeuvre* for this solution. In the same way that as a student he had drawn heavy diagonal patches of shade across the rectangular façades of neoclassical buildings and more recently had sliced the square floor plan of his 1919 house into two right triangles, so he now stressed the triangle or wedge at the expense of the more passive rhombus, even to the point of requiring visitors to enter the exhibit hall along the diagonal axes of the hypotenuses.

The most immediate antecedent for the floor plan of the final pavilion is to be found in Melnikov's preferred variant of the sarcophagus for V. I. Lenin. Indeed, so close is the relationship that it immediately raises certain rather startling possibilities concerning his broader intentions, namely, that he conceived the pavilion as nothing less than Lenin's sarcophagus and that he was somehow inviting the Parisian public to enter the body of "the leader of Humanity." Since this hypothesis poses questions that bear on the "system" of Melnikov's architecture as a whole, and not just on this one building, it will be taken up separately in the concluding essay on the theme of death in his architecture.

That such concerns as these could have had any role in the design of the structure indicates just how wide a gulf separates the Paris pavilion from the cool technological ideal that informed the so-called Constructivism of the years 1925-1928. The comparison of Melnikov's design to the project by Moisei Ginsburg is instructive in this respect, for, while the former is rich with symbols and allusions, all highly political in character, the latter spurns all such romanticism, its ideological baggage being limited to rather

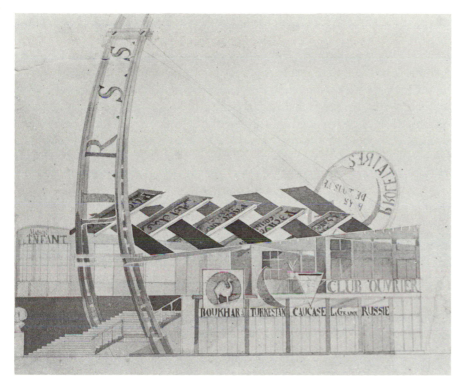

79. Soviet Pavilion, Paris. Elevation of first variant submitted to the committee

Below

80. Soviet Pavilion, Paris. Final presentation drawing

81. Soviet Pavilion, Paris. Elevations and plan

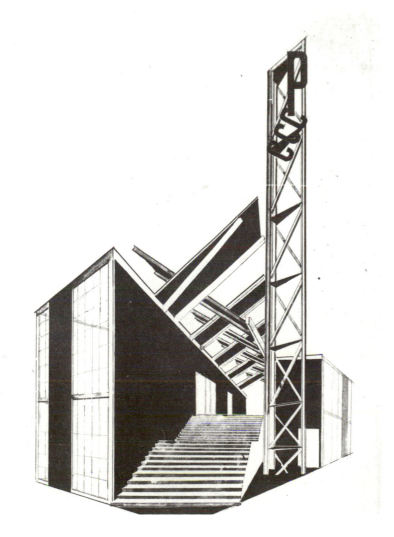

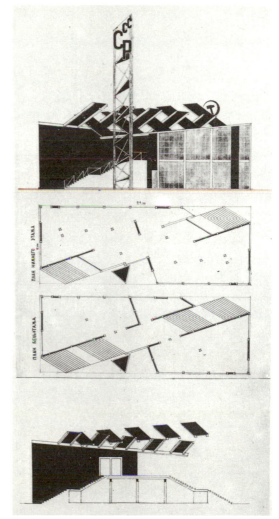

literal references to the factory and to the same mine-head structure that Vesnin had exploited two years earlier in his *Leningradskaia Pravda* tower. The Melnikov pavilion also exudes an enthusiasm for modern technology, but through the successful mobilization of abstract forms rather than by means of blatant allusions or machine-age materials. How unsettling it must have been for Ginsburg to learn that Melnikov intended his structure to be framed not with steel but with wood, fitted in Moscow by peasants wielding the traditional Russian axe and shipped to Paris for assembly (Figs. 82-83)!

But if Melnikov's pavilion is not the epitome of Constructivism that some observers have claimed it to be, neither is it an experiment in pure form, such as Nikolai Ladovskii's graphically impressive but ideologically neutral project based on four elegantly interpenetrating blocks of progressively greater size. To be sure, Melnikov had participated in the foundation in 1923 of Ladovskii's "formalist" group, "The Association of New Architects" (ASNOVA) and was to be associated with many of its members as colleague and in some cases friend down to its disbandment in 1930.[19] But in his highly selective passion for the most dynamic and hence symbolically rich forms of the triangle and the diagonal (and later the cylinder) Melnikov already placed himself at a certain distance from Ladovskii and his circle. To ASNOVA's all-embracing interest in abstract form per se, Melnikov juxtaposed an interest in abstract forms as the basis for his *architecture parlante*.

82. Soviet Pavilion at Paris under construction, spring, 1925

83. Soviet Pavilion at Paris under construction, spring, 1925

[19] On Melnikov's initial membership in *ASNOVA*, see K. N. Afanasiev, ed., *Iz istorii svetskoi arkhitektury 1926-1932, dokumenty i materialy*, Moscow, 1970, p. 40. On Melnikov's further relations with *ASNOVA*, see below, pp. 114 ff.

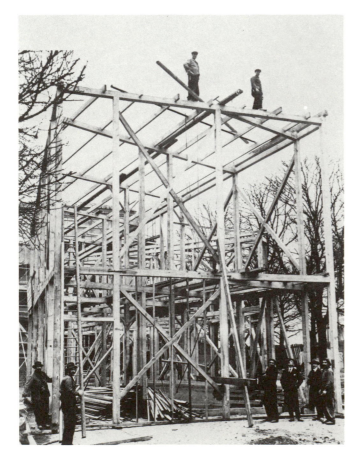

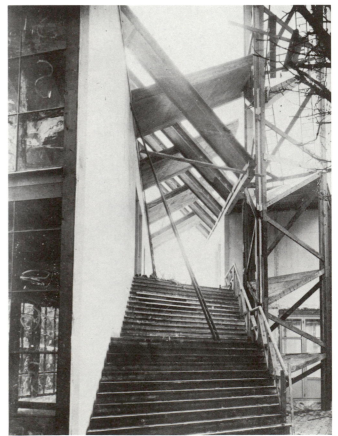

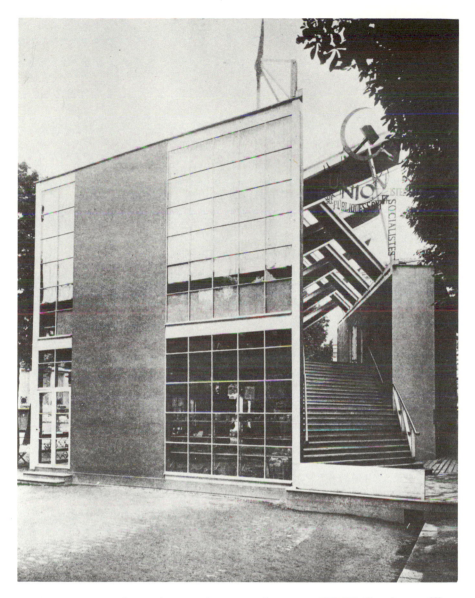

84. Soviet Pavilion at Paris. Contemporary photograph

Much as the dynamism and expressiveness of Melnikov's pavilion (Figs. 84-85) is to be contrasted to the rejected entries by Ginsburg and Ladovskii, so the various exhibits within the hall stand out from the less restlessly innovative styles that constituted the backbone of Russian design in the NEP era. Leafing through the catalogue today, one gains the impression that a diverse group of the most adventurous artists had succeeded in laying hold of the entire show. Thanks very likely to the influence of Maiakovskii and Lunacharskii on the selection process, numerous of the exhibits within the pavilion were executed in the same abstract but politically engagé idiom that the architect had employed for the structure itself. Just as Melnikov used modern design to reinvigorate the traditional peasant building techniques, so many of the boldly figured textiles by Liubov Popova gave new meaning to the art of the peasant home weavers. Side by side with porcelain decorated in a primitive folkish style was flatware ornamented with motifs drawn directly from Suprematism. Most radical artistic currents were represented, but the one that was soon to expropriate the banner of Constructivism in order to advance a kind of fetishism of materials by no means dominated the occasion.[20] True, Alexander Rod-

[20] Thus N. Dokuchaev acknowledged the existence of this current in his essay on architecture for the French language guidebook, but rejected it as not constituting a promising basis for future development. *L'Art décoratif et industrielle de l'U.R.S.S.*, pp. 80-85.

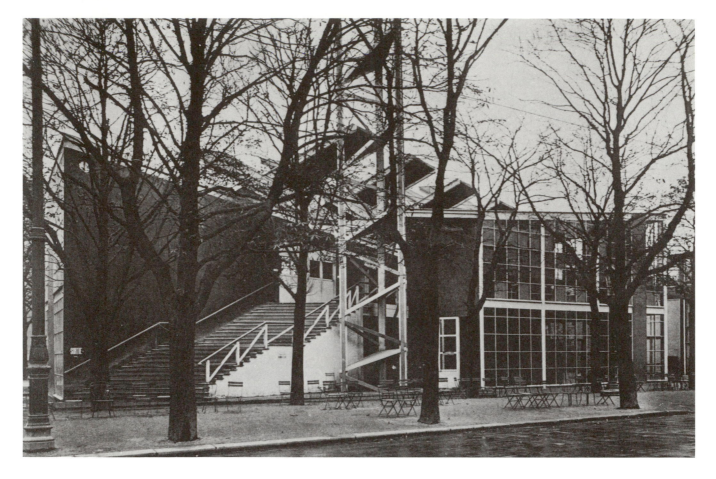

85. Soviet Pavilion at Paris. Contemporary photograph

chenko carried out the design for a model room from a worker's club in a reserved and purist idiom that anticipated Constructivist work of the later 1920s.[21] But the architectural section gave prominence not to work by Ginsburg or other functionalists, but to projects by Maiakovskii's utopian friend and contributor to the journal *LEF*, Anton Lavinskii, to El Lissitzky, and to a model of Tatlin's Monument to the Third International.

The presence in Paris of Tatlin's tower several years after that same structure had been criticized in Moscow for being the work of a naïve romantic strikingly reveals the dual tensions prevailing in NEP Russia between reality and the nation's Revolutionary self-image, on the one hand, and between rival Revolutionary images on the other. At the Art Deco exposition, the more innovative Soviet artists tried to resolve both tensions in favor of their own radical positions. Let the cool functionalists and classicists rail against Revolutionary emotionalism and utopianism in architecture; let the newly founded Association of Artists of the Russian Revolution (AKhRR) clamor for their realistic "new heroism" in painting.[22] For the moment, the original declamatory impulse of 1917 again held sway in the arts as if nothing had happened in the intervening years, and its chief spokesman in architecture was Konstantin Melnikov.

Even though structural designs for the pavilion were not carried out by

[21] O. Aizenshtat, "Khudozhnik A. M. Rodchenko," *Dekorativnoe iskusstvo*, 1962, No. 7, p. 27; German Karginor, *Rodcsenko*, Budapest, 1975, pp. 174-75.

[22] The militantly conservatising thrust of the politically radical AKhRR is documented by I. M. Gronskii, V. N. Perelman, ed., *Assotsiatsiia khudozhnikov russkoi revoliutsii: sbornik vospominanii, statei, dokumentov,* Moscow, 1973, pp. 208 ff.

Melnikov but by the engineer, B. V. Gladkov, it went without saying that the architect would be on hand in Paris for the actual work of assembly. So at thirty-five years of age, Melnikov set out by rail for the city of which he had been hearing since his student days in Korovin's studio, arriving on January 26, 1925. "Forty-nine years have passed since that day," he was later to recall, "but for me it is still as fresh as the present moment."[23] His excitement grew over the following months as box-cars filled with the pre-fabricated parts of the pavilion were unloaded and the local carpenters' union began to assemble the structure on the small plot assigned it on the Avenue Le Rien.[24] Meanwhile, thanks to the intervention of the triumvir Kamenev, Melnikov's wife and two children were permitted to join him in France.

The arrival in Paris of Leonid Krasin, Commissar of Foreign Trade and an old acquaintance of Melnikov, both through his role in the Arcos competition and through his chairmanship of the commission to plan Lenin's mausoleum, brought the architect an unexpected new commission to design inexpensive wooden booths at which wares shown at the larger exhibits would be available for purchase. The purpose of these *Torgsektor* kiosks was unblushingly commercial, and their counters, laden with Caucasian carpets, porcelain, and other products, give the lie to those who claim that the propagandistic character of the main pavilion was due to the fact that the Communist republican had nothing to offer the public but ideology.[25] The simple booths that Melnikov finally settled on (Fig. 86)—after rejecting a more elaborately sculptural alternative (Fig. 87)—admirably served their purpose, while at the same time providing a link in design with the main pavilion through their stress on diagonals rather than horizontal planes.

[23] Melnikov, "Arkhitektura moei zhizni," p. 6.
[24] Kopp, *Town and Revolution*, p. 60, fn. 24, reports a conversation with the man who in 1925 directed operations for "Les Charpentiers de Paris" and who experienced "Tremendous difficulties" during construction, arising from "the novel use of lumber and plywood in thin sections, unusual then, though commonplace today."
[25] Kopp makes this claim, though he printed an excellent photograph of the kiosks in question, *Town and Revolution*, p. 60.

86. *Torgsektor* sales kiosks, Paris, 1925

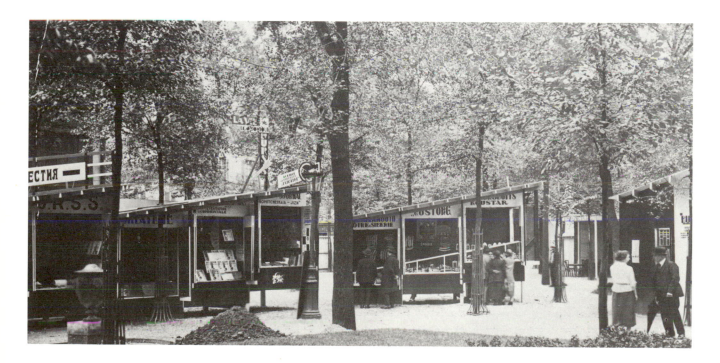

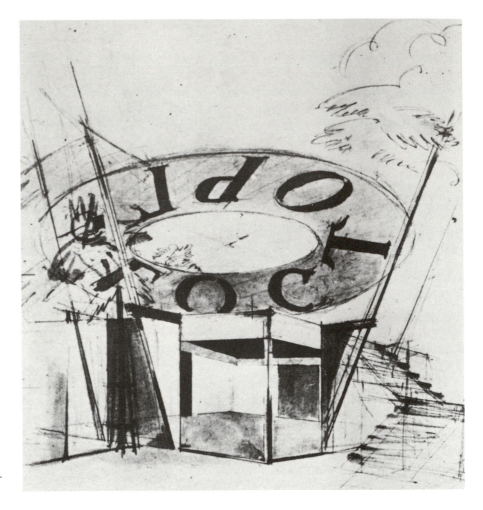

87. *Torgsektor* sales kiosks, Paris, 1925.
Presentation drawing of first variant

His various buildings completed, Melnikov, freshly outfitted in the latest Parisian fashions, and having mastered at least the rudiments of French, was in a high state of euphoria, eager to know France but at the same time immensely proud of his own and Russia's contribution to the fair. The Danish art historian, R. Broby-Johansen encountered him in just this mood, and, after a breathless tour of the pavilion, which featured a rhapsodic introduction to the model of Tatlin's tower, confessed himself to have been "... slightly astonished at [Melnikov's] obvious, childish eagerness to show something to a complete stranger, who intruded on him only five minutes ago."[26] By no means all the Russians associated with the exposition shared this wild enthusiasm. Vladimir Maiakovskii, for one, had been through Paris several times prior to 1925, had already published his negative assessment of the city in his collection *Parizh* of 1923, and now groaned under a colossal boredom relieved only by the hope of fleeing to America or back to his mistress in Moscow.[27] Worse, the sculptor Alexander Rodchenko eyed the whole city with Dostoevskian suspicion, if not paranoia. Skulking through the streets in search of the Parisian proletariat and finding only debauched prostitutes to ogle, he finally holed himself up in a hotel room to pen pathetic letters home with the monotonous refrain "I want my Mama."[28]

[26] Quod Felix. *Akademisk Tidshrift*, No. 10, February 15, 1926, pp. 134-35, reproduced and translated by Troels Andersen, *Vladimir Tatlin*, Moderna Museet, Stockholm, 1968, p. 63.
[27] Maiakovskii's revealing letters of 1924-1925 can be consulted in V. V. Vinogradov, ed., "Novoe o Maiakovskom," *Literaturnoe nasledstvo*, 1958, pp. 137 ff.
[28] Aleksandr Rodchenko, "Pisma iz Parizha," *Novyi LEF*, 1927, No. 2, pp. 12 ff.

This was not for Melnikov. Whereas the more restrained Rodchenko had averted his eyes as he passed by the Rotonde and the other boisterous cafés where Russian émigré artists gathered, Melnikov and his wife walked right in the door. Within weeks he had made the acquaintance of the one-time *enfant terrible* of the painting department of the Moscow School and commander-in-chief of the prewar avant-garde, Mikhail Larionov, now the central figure in the large and intricate circuit of artists, musicians, and writers that was émigré Paris. This gangling, open-faced former sailor had recently elevated the planning of elaborate but outrageously bohemian dances into a minor art. Each spring since 1923 he had rented the commodius but pungent Salle Bullier on the Avenue de l'Observatoire for these festivals of the Russian art world, beginning with a "Grand Bal Transvestimental," followed in the next year by a "Bal Banal" and now, for 1925, having already planned a "Bal de la Grande Ourse." Here the more confirmed exiles like Chagall, Goncharova, Lipschitz, Diaghilev, and Stravinsky exchanged gossip with temporary émigrés or visiting ambassadors such as Maiakovskii, Iakulov, Shterenberg, and Ehrenburg, the whole group of Russians rubbing shoulders with foreign artists as diverse as Braque, Leger, Brancusi, Man Ray, Utrillo, van Doesberg, Picasso, and Matisse.[29] As it happened, programs for the Bal de la Grande Ourse had not yet been printed and so Larionov, upon meeting Melnikov and visiting the Soviet pavilion, decided to turn the occasion into a costume ball in honor of Melnikov's "Constructivist" architecture. With a drawing of the Paris pavilion featured in the program along with lithographs by Picasso, Larionov, Leger, and others, and with hundreds of guests costumed to look like the new Soviet architecture that the pavilion represented, the entire throng danced until dawn to a gypsy band and an "invisible orchestra." The reality of the evening surpassed the wildest fantasies of Parisian life that the peasant-turned-architect had ever dreamed as a student in Moscow. When his old patron, Chaplin, telegrammed his warm congratulations from Moscow, the circle was complete.[30]

The reception Melnikov received from Russians in Paris was matched only by the superlatives that the press showered on the pavilion. *Le Quotidien* forecast that it would "undoubtedly be the hit of the exhibition";[31] *Les Annales* noted that "French workers, without knowing the Russian language, are head over heels at the sight of the pavilion";[32] *La Revue de L'Art* found it extremely effective as publicity,[33] while *Art et Décoration* termed it "one of the most celebrated [pavilions] of the Exposition."[34] Similar judgments were passed by the architectural press of England and Switzerland.[35]

Not all the superlatives were positive, however. As the New York *Architectural Record* put it: "The most eccentric [of the pavilions] is divid-

[29] Information on these gatherings sponsored by the Union des Artistes Russes in Paris is provided by Anna Gavrilovna Melnikova, and by the published programs, collection of Madame Larionova, Paris. See also N. Berberova, *Kursif moi*, Munich, 1972, pp. 339 ff.

[30] Melnikov, "Arkhitektura moei zhizni," p. 31.

[31] *Le Quotidien*, April 17, 1925.

[32] *Les Annales*, April 19, 1925.

[33] Yvanhoe Rambosson, "La participation Étrangere," *La Revue de L'Art*, Tome XLVIII, 1925 (July), p. 172.

[34] *Art et Décoration*, Tome XLVIII, 1925 (September), p. 114. Other French evaluations are to be found in *Mercure de France*, July 1, 1925; *Concordia*, July 19, 1925; and *La Construction Moderne*, 1925 (May), pp. 361-62.

[35] *Architectural Review*, Vol. XVIII, No. 344, 1925 (July), p. 6; *Wasmuths Monatshefte für Baukunst*, 1925, Heft I, p. 394.

ing the opinion of the many who have stood aghast before it, some declaring it a practical joke on the Exposition and the others warmly asserting this monstrosity to be rich in symbolism and an advance in the direction of a new art millennium. This building is the contribution of the Soviet Russians to the new modern school and it follows closely the formula which banishes completely all curves and ornament. A facetious writer in the Paris press hazards the guess that the edifice must have been completely constructed in Russia and then taken down, piece by piece, for shipment to Paris. It is quite clear, says this humorist, that some of the packing boxes were mistakenly labelled and that in reconstructing the Soviet monument the workmen have mixed up the various units."[36]

Other journalists found even less to admire in Melnikov's building. An Italian critic insisted that it was modelled after an amusement park sledding hill;[37] *La Revue de L'Art* compared it to a guillotine;[38] and *L'Intransigent* declared flatly that it should be burned.[39] When *Art et Décoration* observed that the pavilion ". . . á frappé par son étrangête et son imprevu,"[40] it reflected a not uncommon view.

Far more gratifying to Melnikov than any press reviews was the news, first, that the pavilion had been awarded the highest award by the French commission established to judge the various entries, and, second, that it had earned the plaudits of several of western Europe's leading architects. Josef Hoffman, director of the Vienna School of Art and architect of the Austrian pavilion, termed it "the best pavilion in the entire exhibition,"[41] an assessment that was echoed by many of the architects who sought out Melnikov during the spring and summer months. Among the local architects to do so were August Perret, Le Corbusier, and Robert Mallet-Stevens. Le Corbusier, Melnikov recalls, spent several days escorting the young Russian on a tour of all the most advanced architecture of Paris and its environs. Though he retained an impression of Le Corbusier's and Pierre Jeanneret's *Ozenfant* house, Melnikov seems not to have been awestruck by anything he saw, with the possible exception of Le Corbusier's private automobile, which nearly half a century later he still remembered as a symbol of the great Swiss architect's worldly success.

The recognition by professional peers promptly assumed more tangible form when Melnikov was invited to participate in the 1926 "Exhibit of the Latest Architecture," held in Warsaw under the sponsorship of the Polish Artists' Club (*Polski Klub Artystyczny*), and then by an invitation from *The Little Review* of New York to show his work at a proposed exhibition on "The Machine Age," to be held in 1927. The latter show, organized by an artistic committee that included three of Melnikov's new Paris friends, Man Ray, Archipenko, and Andre Lurçat, was being staged in protest against an article in the *Bulletin* of the Metropolitan Museum that had denounced "the Bolshevik philosophy applied to art" and the "ego maniacs and satanists" of abstract art whose work causes "insanity and deterioration of the optic nerve."[42] To set right such pernicious views, *The Little*

[36] W. Franklyn Paris, "The International Exposition of Modern Industrial and Decorative Art in Paris," *Architectural Record*, 1925, Vol. 58, No. 4, pp. 376-79.

[37] "Le Arti a Parigi nel 1925," *Archittura e Arti Decorative*, 1925, Vol. I, p. 224.

[38] Rambosson, *La Revue de L'Art*, p. 177.

[39] Andre Laphin, "Une maison pour un escalier," *L'Intransigent*, May 9, 1925.

[40] *Loc.cit., Art et Décoration*.

[41] Quoted by G. Lukomskii, *Poslednye novosti*, 1925, February 1.

[42] "A Protest Against the Present Exhibition of Degenerate 'Modernistc' Works in the Metropolitan Museum of Art," *Metropolitan Museum of Art Bulletin*, 1921, p. 179.

Review invited the New York architect Hugh Ferris to assemble a representative collection of works by the most innovative designers from around the world. While Melnikov was among the few from any country to have an entire section devoted to his work, most of the other leading Soviet architects were also represented, the group of them together constituting the largest division of the exhibit.[43] For the first time Melnikov and the movement of which he was so prominent a part were introduced directly to the American public, or at least to that small part of it which could crowd into the Fifty-Seventh Street offices of *The Little Review*, where the show was held.[44]

Of more practical moment than these evidences of approval from the architectural community was an entirely unexpected request from the city government of Paris for Melnikov to design a parking garage for 1,000 automobiles. Seeking Krasin's permission to undertake the commission, Melnikov was told that "of course he should do so. If we export wood, why shouldn't the U.S.S.R. export brains also?"[45] Forthwith, Melnikov advanced the unprecedented idea that the garage should be constructed atop a bridge over the Seine. When the city fathers responded favorably to this unexpected notion, Melnikov turned his full attention to the project, devoting a vacation of several weeks at St. Jean de Luy to working out the details of two radically different variants. As usual, one was a minimal and the other a maximal program, with the choice between them being left to the patrons. In this instance the more cautious variant was based upon the

[43] On the Constructivists' participation, see *Sovremennaia arkhitektura*, 1927, No. 3, p. 158. The Polish movement was also introduced to the U.S. at this show, thanks to Szymon Syrkus and the "Praesens" group from Warsaw. Izabella Wislocka, *Avangardowa Architektura Polska, 1918-1939*, Warsaw, 1968, p. 151.

[44] A copy of the rare catalogue, with cover by Leger, is in the New York Public Library: *The Machine Age Exposition*, New York, 1927.

[45] As recalled by Anna Gavrilovna Melnikova, April, 1976.

88. Parking garage to be constructed over the Seine, 1925. Elevation of first variant

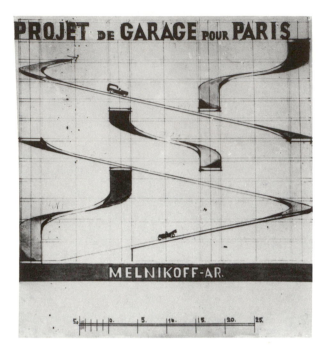

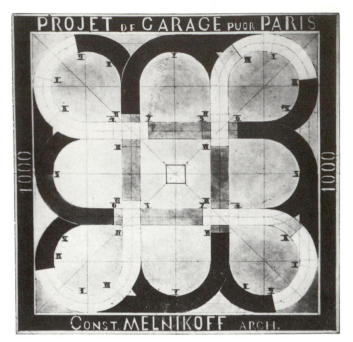

89. First variant of parking garage to be constructed over the Seine. Section showing internal ramps

90. First variant of parking garage to be constructed over the Seine. Plan showing pattern of vehicular movement

Opposite

91. Parking garage to be constructed over the Seine in Paris, 1925; second variant. The atlantids were added after the drawing was submitted, as a humorous response to criticism

92. Section of second variant of parking garage, to be constructed over the Seine in Paris

hard rectangles favored by Melnikov's new acquaintance, Perret, the smooth façades on the river side being divided into neat squares like an Art Deco perfume bottle (Fig. 88). Interrupting these surfaces—and thereby relieving their monotony—were exposed ramps, along which ascending and descending automobiles would pass, advertising the mechanical function of the building to passers-by much the way the spiral stairway of the Makhorka pavilion proclaimed the human activity taking place within that structure (Figs. 89-90).

The maximal program retained these exposed ramps but multiplied and expanded them to form a graceful concrete skeleton that anticipates in its fluidity the laminated ribs of Tatlin's experimental glider, the *Letatlin* (Fig. 91). The parking area itself consists merely of two large consoles cantilevered into space from the four piers rising at midstream in the river. Frightened at the prospect of these staggeringly unorthodox forms collapsing onto a rush-hour crowd of Parisians, French acquaintances prevailed on Melnikov to prop them up. Amused by their concern but confident that such external support was quite unnecessary, he humorously added to the drawings two enormous and ludicrous Atlantids, which unfortunately remain in every surviving elevation and sketch of the garage (Fig. 92). If they are ignored, as they should be, it can readily be seen that in this structure Melnikov was creating not merely a functional garage but a great sculptural monument to industrial France, just as Tatlin's tower spanning the river Neva at Petrograd was intended as a monument to revolutionary Russia.[46]

The entire conception proved too extreme for the Parisian city fathers, from whom nothing further was heard. That Melnikov could treat his own work with humor, however, shows how confident he had grown in his own ability and how much at ease he felt in the French capital. But by now it was late summer and, with the exposition about to close, it was time to

[46] In Maiakovskii's 1923 poem "Paris (Chats with the Eiffel Tower)," reference is made to how "the autos fantasizing dance about me," as though they epitomized the city as much as did the Eiffel Tower or the Bourse.

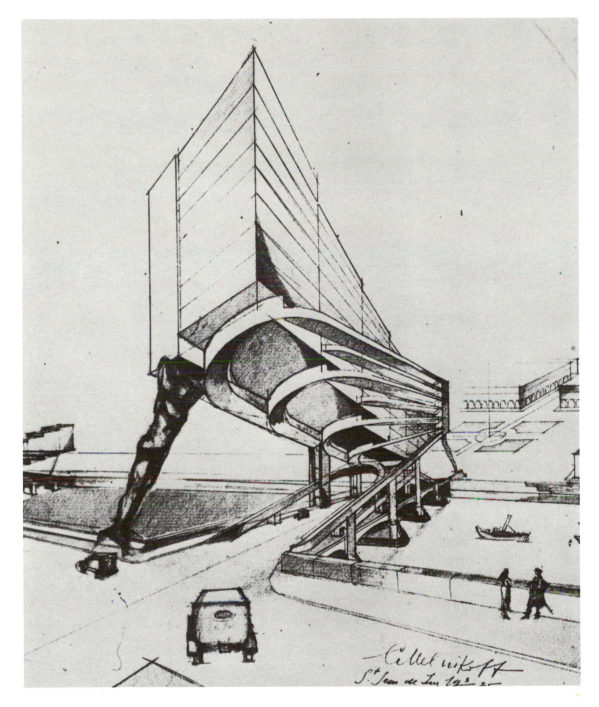

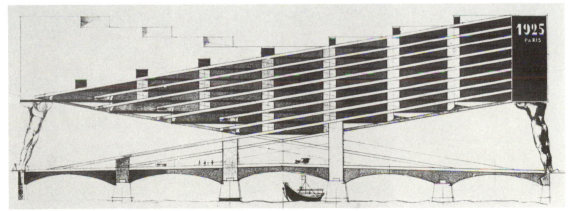

return to Moscow. It would have been difficult for anyone blithely to depart the scene of such great triumphs as Melnikov had achieved in Paris. With an enthusiastic West European public offering him assurances of further commissions on every side and the prospect in Moscow of nothing more positive than a continuation of the string of unrealized projects that stretched back to 1919, the decision to return was especially difficult. Much later, in 1967, Melnikov reported on his mood at the time in the following words: "I will speak openly with you. While I was in Paris, being introduced to everyone and enjoying that marvelous city, I considered for a long time not returning. For many months I was certain that I would not return."[47] To the comment that, after all, he did return and eventually found that some of his greatest buildings would be designed for Moscow, he replied dryly, "Yes, they were, but there were buildings being designed everywhere at the time, of every sort." Burdened with such ambiguous feelings and unresolved doubts, but with his confidence in his own abilities at a high point, Melnikov nonetheless boarded the train, reaching Moscow late in Russia's gloomiest month, November.

[47] Conversation with the author, May, 1967.

VI. Architecture and Daily Life, 1926-1928

A photograph of Melnikov upon his return to Moscow shows him puttering around a construction site—his own house—sporting a trimly cut overcoat, modish hat, and spats, and, by his side, his wife bundled up in an elegant-patterned coat, doubtless covering one of the forty dresses she had purchased in Paris (Fig. 93). To the casual observer, such finery, coupled with the backdrop of a new private home, could easily have appeared as the ostentatious manifestations of success, which to some extent they were. As such, both the success and its manifestations gave rise to bitter outbursts of jealousy from numerous professional colleagues who had bided their time in Moscow while Melnikov was being feted in Paris. A system of vehicular movement that Melnikov had devised for parking garages was claimed by an engineer, Tsvetaev, as his own invention,[2] while several former students at the *Vkhutemas* began quietly maligning Melnikov on the basis of gossip reaching them from Paris. When Melnikov was named to design the Soviet pavilion for another international exposition, this one to be held in 1927 at Salonika in Greece, such feelings intensified (Fig. 94). Little did it matter that the building in question was only a temporary structure of extremely modest scale, or that it was given little publicity beyond the Macedonian city.[3] Melnikov, who had yet to build a major building in anything but wood and who only a year before had been quite as unknown to the international public as any of his colleagues, had now become fair game for all criticism.

However understandable, the envy that hovered around the architect after his return from abroad was based in part, at least, upon a misunderstanding of his actual position. On the one hand, it was clear to at least one observer that the wild outburst of revolutionary images at Paris had been "in the nature of an epilogue,"[4] more directed towards achievements in the immediate past than any hopes for the future. On the other hand, what architectural currency Melnikov had acquired in Paris was not immediately convertible in the very different world of Moscow. As he put it: "The triumph abroad was not an edict for Moscow, and when my family and I returned from Paris, Moscow pitilessly threw us into the painful battle for life, clad in Parisian attire but without employment, commissions, or laurels."[5]

"People are trying to organize a cozy tea-party on a tightrope."
—ILIA EHRENBURG[1]

[1] Ehrenburg, *Memoirs, 1921-1941*, p. 92.

[2] V. Tsvetaev, "Garazhnoe stroitelstvo," *Stroitelnaia promyshlennost*, 1928, No. 5, p. 362.

[3] The only article in Russian was "Pavilon SSSR na Salonikskoi vystavke," *Vechernaia Moskva*, 1926, November 15, p. 7.

[4] Ehrenburg, *Memoirs: 1921-1941*, p. 91.

[5] Melnikov, "Arkhitektorskoe slovo . . . ," p. 42.

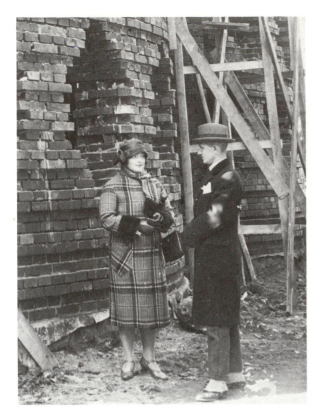

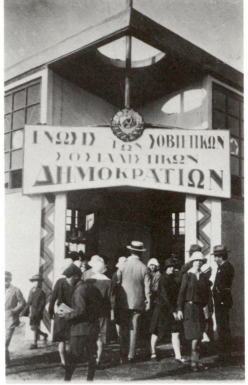

93. Konstantin Melnikov and his wife during the construction of their home in Moscow, 1927

94. Soviet Pavilion, Salonika, Greece, 1926

Opposite

95. Site plan for the Leyland bus garage, Bakhmetevskaia Ulitsa, Moscow, 1926

96. Parking plan for Leyland buses, Bakhmetevskaia Ulitsa, Moscow

97. Interior of Leyland bus garage, Bakhmetevskaia Ulitsa, Moscow. Photograph by Alexander Rodchenko

Once the Salonika pavilion was completed, no further national commissions were forthcoming, and Melnikov had to search for work. Fortunately, the Economic Administration of the Moscow Soviet was at that moment, in May, 1926, undertaking to build a large depot to house the fleet of Leyland buses it had recently purchased from England.[6] With no formal relation to the project, Melnikov had no formal right to enter a proposal. His experience in Paris with such structures, however, emboldened him to forge ahead uninvited. His project (Figs. 95-96) was accepted at once and was actually constructed on Bakhmetevskaia (now Obraztsov) Ulitsa, where it can still be seen today. It consists of a large brick shed roofed over with a system of girders, all extremely simple but so visually effective that Melnikov's friend, Alexander Rodchenko, took an entire series of photographs of it, one of which was published by El Lissitzky in his polemical *Russland, Die Rekonstruktion der Architektur in der Sowjetunion*[7] (Fig. 97). The main portals (Figs. 98-99), heavily ornamented with Art Deco fluting, marked the first appearance of the exposition style on a building actually constructed in the Soviet Union. It is the rear portals, however, where Melnikov's distinctive hand is most evident. Here the unity of the unpainted brick façade is destroyed in favor of individual segments for each door, every one of them set off from the mass by means of a "saw-tooth" treatment of the outer wall and bands of ground-to-roof fenestration. Each portal is further individuated by a circular window of exaggerated size, as if to provide an eye through which the animated machines stabled within could peer out at the world (Fig. 100).

[6] *Stroitelstvo Moskvy*, 1926, No. 10, p. 5-7, contains information on the garages built by the *Moskvoskoe kommunalnoe khoziaistvo.*

[7] El Lissitzky, *Russland: Die rekonstruktion der Architektur in der Sowjetunion*, Vienna, 1930, p. 90; American ed., *Russia, An Architecture for World Revolution*, Eric Dluhosch, transl., Cambridge, 1970.

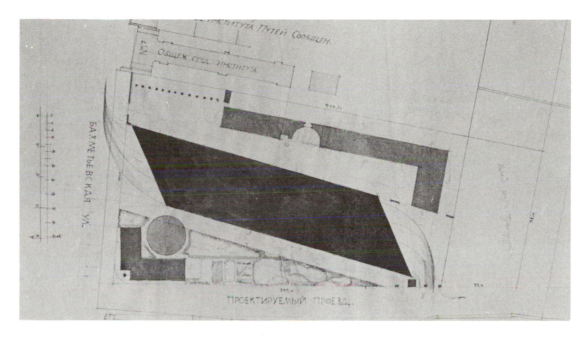

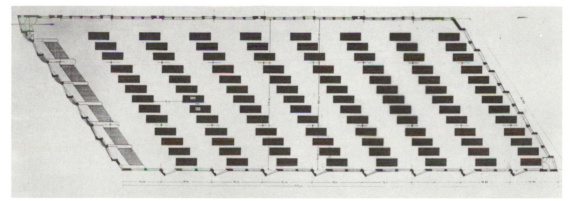

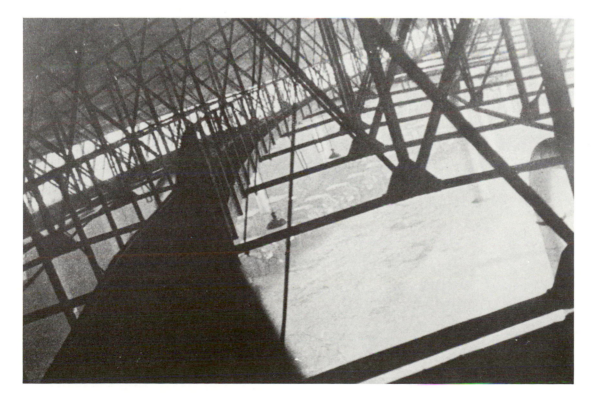

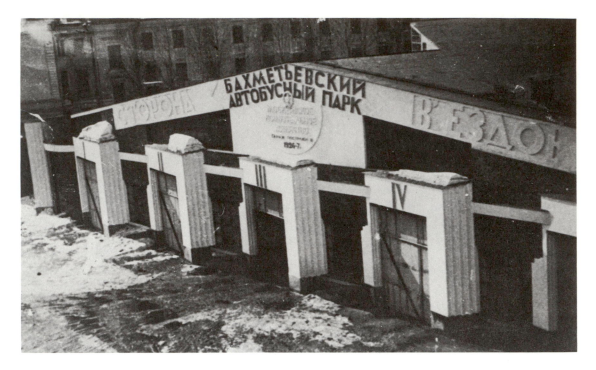

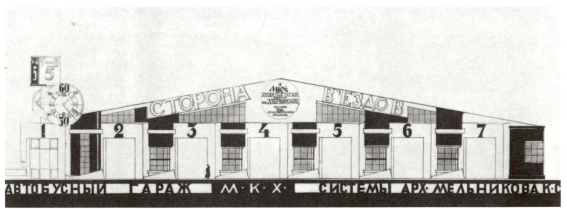

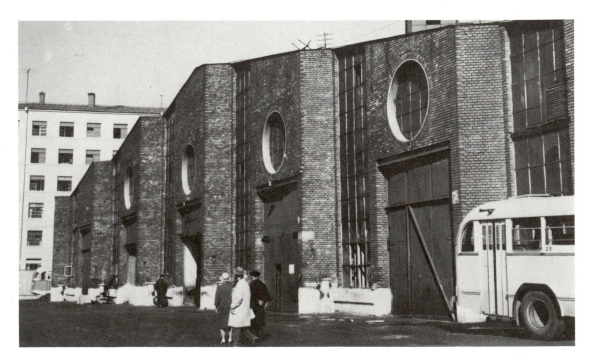

Immediately after this project for the Leyland garage was accepted, the Moscow Soviet's Economic Administration announced its intention to build a second and much larger truck garage and terminal, this one on Novo-Riazanskaia Ulitsa. Having established his expertise with the successful design for the Leyland garage on Bakhmetevskaia Ulitsa, Melnikov was the natural choice as architect for the new undertaking. During the late summer of 1926, he prepared a first variant of this project, embodying his maximal program (Fig. 101). Infinitely more elaborate than the garage he had just constructed, this was to be nothing less than a palace of cyclopaean proportions, a five-storied Temple of the Truck in the spirit of Ledoux or Boullée. But however great the monumentality of the exterior, its form grew directly from a vision of the ideal channels of flow for the vehicular traffic within. Drawings for the project are replete with abstract representations of the "Circulation of Forces and the Statics of Form" and slogans heralding the triumph of diagonal flow as opposed to rectilinear motion. In short, Melnikov turned this pedestrian task into a technical-philosophical-aesthetic discourse, much to the consternation of officials of the Moscow Soviet, who rejected it in favor of a second variant, which was actually constructed and still stands today.

This variant, too, rejects rectilinear movement, but in favor of circular rather than diagonal flow. The large semi-circular barn (Fig. 102) standing with its two ends to the street superficially resembles a railroad roundhouse, but the structure functions quite differently, with vehicles moving around the perimeter rather than to the perimeter from the center (Fig.

Opposite

98. Main portal, Leyland bus garage, Bakhmetevskaia Ulitsa. Photograph by Alexander Rodchenko

99. Elevation of main portal, Leyland bus garage

100. Rear portal of Leyland bus garage, Bakhmetevskaia Ulitsa

101. Truck garage for Novo-Riazanskaia Ulitsa, Moscow, 1927. First variant

102. Truck garage, Novo-Riazanskaia Ulitsa, Moscow. Second variant

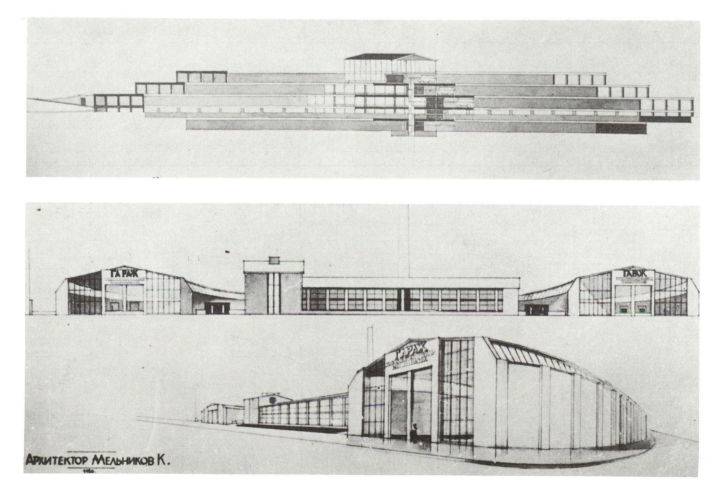

103). The general layout of the structure builds on Melnikov's first experiment with circular plans at his communal dwelling of seven years earlier. Nearer at hand, the brick gable-ends on the garage on Novo-Riazanskaia Ulitsa directly recall the Bakhmetevskaia Ulitsa garage, but here the same devices are used, not to individuate each portal, but to render imposing what would otherwise be a perfectly plain shed (Fig. 104). It is easy to find in this latter point an echo of the decadent St. Petersburg classicism, in which all aesthetic impulses were focused on the stage-set façades at the expense of the structure as a whole. To be sure, there is something of the Potemkin village in Melnikov's Novo-Riazanskaia Ulitsa garage, especially in the artificial beam-ends in brick, which go so far beyond the need to protect the roof trusses running flush to the outer wall (Fig. 105). But the glass façades of the two gable-ends frame perfectly the maintenance buildings between them and impart to the entire ensemble a lively presence that contributes immeasurably to the otherwise faceless city-scape.

103. Parking plan for truck garage, Novo-Riazanskaia Ulitsa, Moscow

104. View of the truck garage from Novo-Riazanskaia Ulitsa in the 1970s

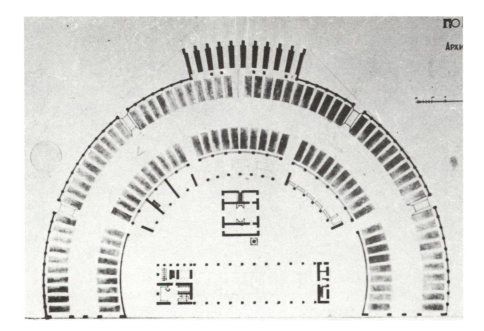

105. Truck garage on Novo-Riazanskaia Ulitsa. Detail

Over the years, Melnikov devoted considerable time and intellectual energy to the seemingly humdrum problems of parking motor vehicles. One might well ask, therefore, the reasons for his peculiar fascination with the automobile at a time when other Soviet architects were ignoring the problem almost entirely? A possible explanation for this may be found in his broader philosophical perspectives, which are the subject of the concluding chapter of this book. Lest the more obvious explanation be lost sight of, however, it might be noted that in designing so many garages, Melnikov merely responded positively to the wishes of his institutional patrons. Indeed, he consistently accepted whatever architectural challenges contemporary life put before him, without imposing some a priori hierarchy of tasks that he deemed appropriate for a Revolutionary architect. Because of this, he surpassed most of his contemporaries in the actual impact of his architecture upon society, even while yielding to them in the impact of his theoretical formulations.

While Melnikov was engaged in these projects, a debate was brewing elsewhere in the capital that was to have the most direct impact on his work and career. During his Parisian sojourn, the Central Committee of the Communist Party, responding to mounting dissension within the fields of *belles lettres*, had promulgated a resolution "On Party Policy in the Field of Imaginative Literature."[8] This document of June 18, 1925, while ostensibly directed towards a feud between "fellow travelers" and advocates of a narrowly proletarian approach to literature, was at once acknowledged as having application for all fields of the arts, including architecture.

Specifically, it posited, on the one hand, that the Communist Party possessed an absolute standard for ascertaining the social and political *content* of any work of art that it was duty-bound to impose, and, on the other, that the question of *form* remained open and should rightly be thrown open to free debate among advocates of competing tendencies. Because of its combination of injunctions and sanctions, the document has been seen variously as a broadening of Party authority in the arts, as a description of the *status quo*, and, in its invitation to open debate on form, as a "Bill of Rights for Artists."[9] For architecture it was none of these. True, no organs were created for judging the ideological content of buildings, but at the same time absolutely no legal rights were granted to any contending group or groups, and no privileges were specifically confirmed. But if the specific provisions of the resolution were all but meaningless from a juridical standpoint, its rhetorical separation of "form" and "content" was to prove profoundly important. The author of the text had been the Communist Party official Nikolai Bukharin, a man who had little direct contact with any of the arts beyond an amateur interest in painting, but whose pretenses in the area were considerable. To Bukharin, it was utterly obvious that

[8] The text is translated in Robert Maguire's *Red Virgin Soil: Soviet Literature in the 1920's*, Princeton, 1968, pp. 235-40.

[9] The literature on this document is rich and contradictory. Among the best expositions are those by Maguire, *Red Virgin Soil*, pp. 163 ff., who sees it as a compromise and an evasion of decision; Edward J. Brown, who finds the text "rambling, repetitious, verbose, and pompous" (*The Proletarian Episode in Russian Literature*, New York, 1953, p. 45); E. H. Carr, who argues that its uncertainty was based on the need to avoid a head-on controversy in higher echelons of the party (*Socialism in One Country, 1924-1926*, 2 vols., New York, 1960, II, 76 ff.); Gleb Struve, who stresses its sanctions rather than its injunctions (*Soviet Russian Literature, 1917-1950*, Norman, 1951, pp. 84-85); Herman Ermolaev, who, correctly in this writer's view, emphasizes its contribution to the hegemony of one faction (*Soviet Literary Theories, 1917-1934*, University of California Publications in Modern Philology, vol. LXIX, 1963, p. 50).

"form" and "content" were distinguishable categories, both of which could be regulated but regulated separately, like two thermostats in a house. To be sure, he was not the first to expound this view, and those of every faction who found in it a convenient tool for attacking their opponents had long since incorporated it into their rhetoric without official encouragement to do so. But the 1925 resolution gave it a new authority among many architects who otherwise disagreed sharply with one another. For the next decade, this overly tidy distinction between form and content was to be bandied about endlessly, sometimes by persons motivated by the most sinister intentions.

Of all avant-garde architects, Melnikov was the least inclined to accept this juxtaposition and hence the most prone to attacks couched in its terms. By the time he arrived back from Paris, discussion among his colleagues at the *Vkhutemas* had come to be dominated by concerns over "form" and "content." His having missed eleven crucial months of these exchanges did not make it any easier for Melnikov to connect the neatly drawn verbal distinctions with anything concrete in his own practice of architecture. Trying to follow the discussions, he became the more confirmed in his conviction that the very terms of reference were confusing and irrelevant to the work at hand—"ideas about ideas" rather than "ideas about architecture." Accordingly, he adopted a position of complete disengagement from the entire polemic, neither approving nor censoring any party.

There was far more at stake in these discussions than Melnikov at first may have realized. Two years before, as we have noted, he had attended the first meetings of the Association of New Architects (ASNOVA), directed by his colleague, Nikolai Ladovskii. Returning from Paris, he discovered that ASNOVA was no mere academic seminar but a chartered professional group whose members hoped to make it the focal point for the reorganization of all architectural cadres in Moscow.[10] Thanks to the perennial activist, El Lissitzky, it was soon to publish the first (and as it turned out, the only) number of its *News of ASNOVA*, and its members were already submitting projects jointly as brigades of the organization.

There was no denying that Melnikov shared much in common with Ladovskii and the three and a half dozen members of ASNOVA. He could only approve of their diatribes against those who persisted in dragging out and assembling "atrophied forms"; of their attacks on the "deadly monotony" of much contemporary west European architecture, rooted as it was in a pedantic application of cubistic ideas; and especially of their denunciations of the "technological fetishists" who claimed that buildings were mere machines, to be designed in a heavy-gaited and jejune idiom of the engineer. On the positive side, he, too, was moved by the vision of architecture as the synthesizer of all the arts, and he could join them in appreciating its potential for manipulating abstract forms to create conscious and unconscious symbols that could minister to man's psyche as well as to his lust for efficiency.

At the same time, Melnikov's hostility to their chronic verbalizing ran deep. He wearied of ASNOVA's narrow and dogmatic system of pedagogy, which neglected the worthy discipline of the past in its haste to convert architecture into a vaguely occult pseudo-science. While ASNOVA adopted

[10] Basic documents on ASNOVA are reproduced in *Iz istorii sovetskoi arkhitektury 1926-1932 gg.*, pp. 41-64.

as its motto the smug slogan that "TAILORS MEASURE MEN BUT ONLY ARCHITECTURE CAN TAKE THE MEASURE OF ARCHITECTURE,"[11] Melnikov had long since discovered that some of the most discerning followers of contemporary architecture were in fact laymen who knew nothing at all of Ladovskii's "psychoanalytic method" and would not have cared for it if they had. Finally, he bridled at the oppressive groupiness of ASNOVA members and felt little need to align himself with cadre-type organizations in order to foster his own art.

The underlying basis of respect between Melnikov and the ASNOVA leaders prevented these points of disagreement from festering into open hostility. But the disagreement remained, chilling relations between them and preventing Melnikov from considering himself as one of their group. Not once did he collaborate with an ASNOVA member on any project, nor did he ever publicly indicate his affiliation with the group. For its part, ASNOVA was not above including Melnikov's name on its roster when it was felt that such publicity might prove beneficial (as it did during the Cultural Revolution of 1928-1931),[12] but otherwise it made no special effort to engage his support.

Amid the growing polarization of Moscow's architectural elite, it would have been natural for Melnikov, having refused to cast his lot with the Association of New Architects, to forge ties instead with the rival Organization of Contemporary Architects (OSA). Several of Melnikov's colleagues did go over from ASNOVA to the new group after its foundation in 1925, and there is little doubt that he, too, would at one time have been welcomed. But if Melnikov's association with ASNOVA could settle by tacit consent of both sides into a kind of sympathetic aloofness, his relations with OSA were married from the outside by ill will.

In its early phases, the Association of Contemporary Architects seemed to be the very antithesis of ASNOVA.[13] ASNOVA members searched for unique and expressive forms, OSA for archetypes suitable for mass production; ASNOVA blithely passed over technical problems of construction, OSA was infatuated with them; ASNOVA dreamt of a science of art, OSA of a science of craft; ASNOVA prided itself on its aesthetic insights, OSA's journal SA all but apologized when it used the language of aesthetics. And, finally, where ASNOVA's enthusiasm for expressive forms at the expense of practicality linked it politically with the extreme left, the OSA passion for bald and mechanistic functionalism lay that group open to criticism as being rightist, notwithstanding its own frequently repeated claims to being the only truly Marxist architectural association in Russia.[14] On the background of these sharp polarities, on each of which Melnikov inclined towards the ASNOVA position, there is little cause for wonder in the fact that he was

[11] *Izvestiia ASNOVA*, 1926, No. 1, p. 4.

[12] See, for example, V. Petrov, "ASNOVA za 8 let," *Sovetskaia arkhitektura*, 1931, No. 1, p. 49; No. 3, p. 46.

[13] *OSA*'s constantly evolving program is reviewed in S. Frederick Starr, "The Union of Contemporary Architects," *Russian Modernism: Culture and the Avant-Garde, 1900-1930*, George Gibian, H. W. Tjalsma, eds., Ithaca, 1976, pp. 188-208. Basic documents on the group are reprinted in *Iz istorii sovetskoi arkhitektury, 1926-1932*, pp. 65-105; the most comprehensive source for its views, of course, is its remarkable journal, *Sovremennaia Arkhitektura (SA)*.

[14] A brilliant and concise exposition of this point is to be found in the late Donald Drew Egbert's regrettably unpublished *Communism and the Arts in Russia*, V. 164 ff. For the use of this valuable study I am indebted to Mrs. William Kilborne, Princeton, New Jersey.

excluded from OSA's 1927 Exhibit of Contemporary Architecture, and that the OSA journal SA managed to appear for five years without so much as mentioning Melnikov's name, not even to criticize him.[15]

Yet the enmity between Melnikov and Moisei Ginsburg, the founder of OSA, was so intense as to require further explanation. After all, Melnikov could have subscribed to many points raised by Ginsburg in his 1924 tract on *Style and the Epoch*, particularly his attack on eclecticism;[16] and by training, age, and outlook Melnikov certainly had more in common with most OSA members than with either the older generation of academics or his contemporaries in the provinces. He taught at the same institution with Ginsburg, moved in the same circles, and even attended the meeting on December 10, 1925, at which OSA was organized.[17]

But such common elements shrank to utter insignificance before the fact that these two towering figures of Russian architecture were moving rapidly in precisely opposite directions at the time. Ginsburg, a Jew from western Russia who several years earlier had been citing Spengler and even the violently nationalistic nineteenth-century Pan-Slav, Danilevskii,[18] to prove the emptiness of western European culture, was now working diligently to gain the international recognition and acceptance that he felt was his due. As if filling an inner need for the worth of his work to be confirmed abroad, Ginsburg was sending copies of his tracts to Le Corbusier,[19] writing in the Berlin architectural press on his school of functionalism,[20] and generally striving to establish relations with kindred spirits from Amsterdam to Vienna. Melnikov, in contrast, by origins a peasant from Moscow, had already satisfied his long-felt yearning for contact with the West and, having done so, had returned to Moscow firmly confident in his own worth and feeling no further need for international certification. Ginsburg, who was rapidly purging himself of all traces of Expressionism and revolutionary romanticism, confronted Melnikov precisely at the point in his career when the latter had finally achieved recognition for work in his dramatically expressionistic style. Given the opposing tendencies of their respective paths of development, then, and particularly Melnikov's enormous stature among precisely those West European purists whose respect Ginsburg was courting at the time, the rupture between them was all but inevitable.

By early 1926, Melnikov's alienation from both of the avant-garde groups in Moscow was complete. As he recalls, ". . . the devotees of architectural discussion in Ladovskii's ASNOVA and Ginsburg's OSA stood about posing, without building anything. The former called themselves "new" architects, the latter, called themselves "contemporary." I understood their torrent of words less than anyone else among us. . . ."[21] Cut off from these two important foci of organizational life, Melnikov rapidly became isolated within the *Vkhutemas*, so completely, in fact, that when in

[15] "The crooked line of information began in 1926 with the publication here of the journal *SA*. It was exported abroad and, as the only source of information, served as a standard for world opinion, hiding from it [my work]." Melnikov, "Arkhitektura moei zhizni," p. 65.

[16] *Stil i epokha*, Moscow, 1924, pp. 15-18.

[17] *Iz istorii sovetskoi arkhitektura, 1926-1932*, p. 67. B. Lubetkin ("Soviet Architeture, Notes on Developments from 1917 to 1932," *Architectural Association Journal*, 1956, May, p. 262) errs in claiming that Melnikov was a member of OSA.

[18] *Stil i epokha*, p. 20.

[19] Dencks, p. 58.

[20] *Wasmuths Monatshefte für Baukunst*, vol. 11, 1927, October, pp. 9-12.

[21] Melnikov, "Arkhitektura moei zhizni," p. 26.

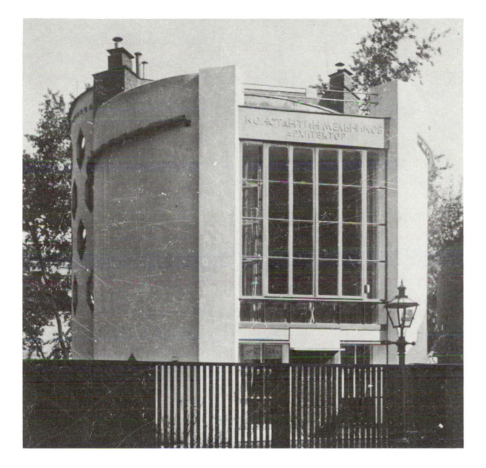

106. Home of Konstantin Melnikov,
Krivoarbatskii Pereulok, Moscow, in 1929

1927 the Armenian Karo Alabian and several other students from the architectural section produced a retrospective volume on *Architecture at the Vkhutemas*, his name was not mentioned, nor was it mentioned on the pages of a periodical published by the school in 1929.[22] Such were the professional tensions and rivalries of the golden age of the Russian avant-garde!

Several paths out of this unenviable position lay open to Melnikov. On the one hand, he could strengthen more firmly his association with the old and respectable Moscow Architectural Society and with the new Moscow City Council, or *Soviet*. This he did and down to the end of the 1920s these two bodies provided most of his more important commissions, as well as publicity for his works on the pages of their nonpartisan journals. On the other hand, he could follow his strong inclination to declare his independence from all such polemical concerns and set up himself, Konstantin Melnikov, as patron, architect, and builder. This he did. "Having made myself the boss, I entreated Her [Architecture] to throw off from herself the shawl of marble, wash off the powder and rouge and reveal herself, unclothed, as good, graceful and young. And as befits a true beauty, she turned out to be very agreeable and compliant."[23]

The cylindrical house that Melnikov built for himself in 1927 at Number 10 Krivoarbatskii Pereulok in Moscow stands as one of the most daring, problematic, idiosyncratic, yet, in its way, emblematic structures of the NEP era in Russia (Figs. 106-107). It dazzles its critics, yet for half a cen-

[22] *Arkhitektura VKhUTEMASa*, Moscow, 1927; *Arkhitektura v VKHUTEIN*, vol. 1, No. 1, Moscow, 1929.
[23] K. S. Melnikov, "Na shchet doma," M.S., 1953, Melnikov archive, p. 1.

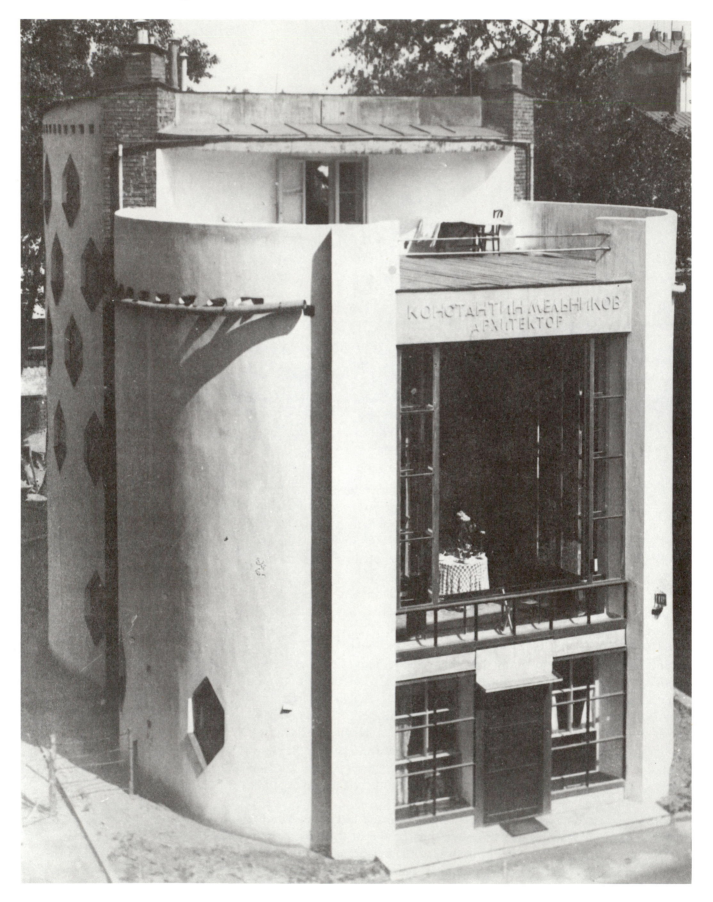

107. The architect's house

tury it has confounded them as well, so imperfectly does it conform to any of the frames of reference through which it is normally approached. Is it, as its author claimed and as Nikolai Bulganin—the Communist Party official who helped put the land at Melnikov's disposal—expected, a design applicable to the then pressing problem of public housing, or is it rather some perverse outcropping of that stratum of individualism and privatism which the Revolution had supposedly submerged? Should it be seen as an indulgence in modernism for its own sake, a formalist's "unprincipled experiment" in abstract design, as one hostile Soviet critic of the 1920s claimed, or instead as the homage of an avant-gardist to Russia's architectural heritage? Finally, was it intended at all as a political or social statement, or was it merely the result of one man's very personal desire to house himself and his family?

At least some of this confusion may have arisen from a misunderstanding by Western writers of the status of private housing after the October Revolution. Notwithstanding the 1918 law nationalizing land and immovable property, privately owned buildings housing fewer than five families were permitted to remain in the possession of their former owners, the state claiming only the right to establish upper and lower limits on dwelling space per inhabitant and to allocate rental properties according to social need.[24] With the introduction of NEP in 1921, even these provisions were softened. Many dwellings were denationalized, and both private entrepreneurs and cooperative societies were encouraged to expand the drastically depleted housing stock. As a result, during the years when Melnikov was planning and building his house, single-family dwellings were the rule rather than the exception in most Soviet towns and cities, and private ownership no particular cause for surprise.

All this provides ample grounds for classifying the Melnikov house with those other pioneering one-family dwellings being designed by Europe's avant-garde architects in the years before the Great Depression: Rietveld's Schroeder house in Utrecht; Mies van der Rohe's Wolf house at Guben; Adolf Loos' Tzara house in Paris; and Le Corbusier's Ozenfant house or his Villa Savoie at Poissy-sur-Seine. Yet the fact that several of these buildings postdate Melnikov's house while those known to him directly or through publications differ widely from his own, serves caution against ascribing too much importance to foreign examples, the more so since the idea of building himself a cylindrical studio-house dates to as far back as 1922 (Fig. 108). The only foreign model that seems to have played a significant role in directing Melnikov towards cylindrical forms was the American grain elevator with which he was acquainted either through the Russian sources noted earlier in the discussion of the Makhorka pavilion, or through Le Corbusier's publication *L'Esprit Nouveau*.[25] But more than from any international currents of the day, the basic definition of the Melnikov house flowed from the architect's own and long-standing commitment to classical purism, his fascination with the primitive handicrafts of the Russian past, and his social utopianism.

The aesthetic purism of Melnikov's use of interlocking cylinders (Figs. 109-110) makes so strong an initial impression upon one that it is easy to overlook the profoundly classical aspects of the house. The site plan indi-

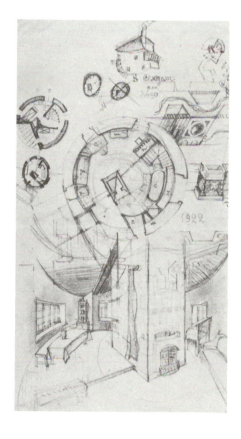

108. Sketches for a cylindrical house, 1922

[24] John N. Hazard, *Soviet Housing Law*, New Haven, 1939, pp. 2-7.

[25] Le Corbusier-Saugnier, "Trois rappels à Mm. les architectes," *L'Esprit Nouveau*, 1920, No. 1, pp. 90-95; in the same issue Le Corbusier and A. Ozenfant codified their interest in cylinders with the formula that "Tout est spheres et cylindres" (p. 43).

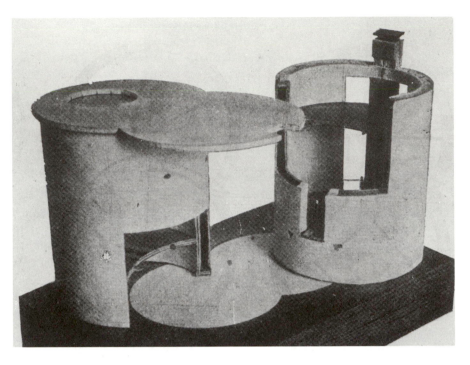

109. Model of the architect's house, showing method of interlocking cylinders

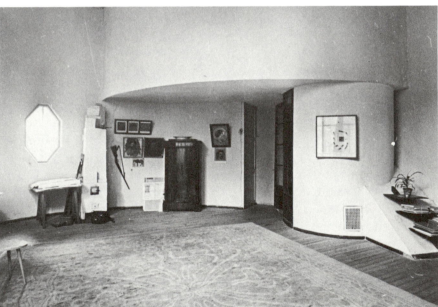

110. Main salon, the architect's house, showing interpenetration of cylinders

cates what care he took to achieve symmetry both along the longitudinal axis and across it, the one exception being the layout of the forward section of the ground floor (Fig. 111). Similarly, the building is dominated by a palatial façade framed with square pilasters, with the doorway placed directly in the middle (Fig. 112), in spite of the fact that this gave rise to problems in the layout of the interior space of the entrance that were never fully resolved (Fig. 113). In each of these respects the house is surprisingly close in spirit to the late-eighteenth-century residences of classical Moscow.

Under its skin, however, and on every exterior exposure except the front, the structure has close affinities with an older and simpler architectural world. By 1927-1930, the long-standing debate over the relevance to contemporary Russia of traditional materials and techniques of construc-

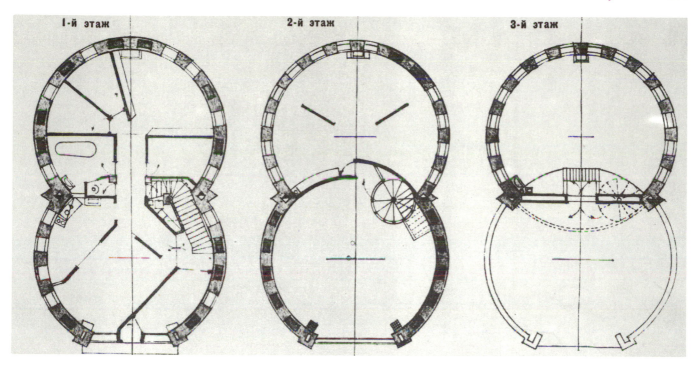

1-й этаж 2-й этаж 3-й этаж

111. Floor plans of the architect's house, 1927

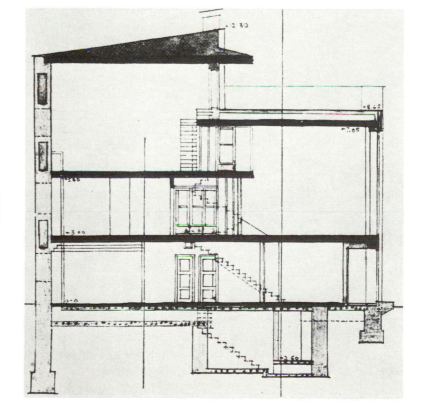

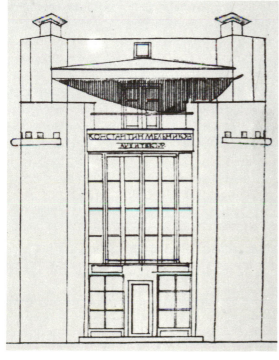

112. Facade of the architect's house, 1927

113. Section of the architect's house, 1927

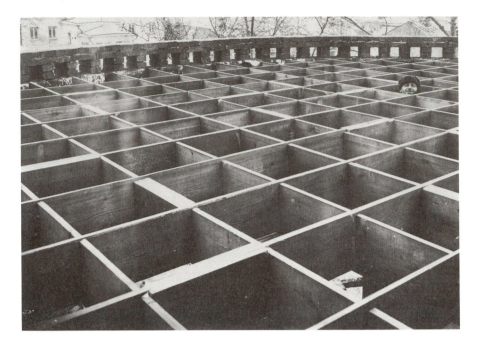

114. View of floor construction, the architect's house, 1927

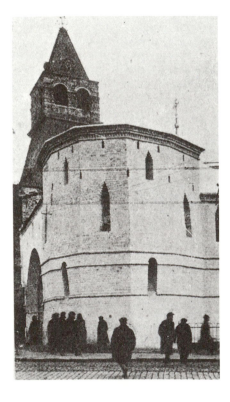

115. Tower in the medieval wall of the Belgorod district, Moscow, after restoration in 1926. Photograph from a contemporary journal

tion had sharpened. The fact that new construction in stone and brick held only a slight edge over wood, even in the capital cities, was evident to anyone who visited new building sites at the time,[26] and the causes of this were equally obvious: the shortage of the more durable materials and especially the domination of the construction industry by a peasant labor force practiced only in traditional techniques. Earlier, those expecting an instant transformation of life were able to close their eyes to these facts, but now some highly respected authorities were calling upon architects to accept reality and to work with it. Moscow's Grigorii Barkhin, whose credentials as an innovator were impeccable, sang the praises of peasant construction,[27] while, in Leningrad, V. S. Karpovich, an old urban reformer, made the same case.[28] Another convert to peasant construction, V. D. Machinskii, went even further, claiming that ". . . peasant construction, devised over the ages and the result of the experience of many generations, constitutes the type best suited to the conditions of nature and the economy, and is most deeply rooted in the way of life and instincts of the population. We repeat, it is *not* alien to our workers."[29]

Nearly all such statements, which closely parallel the general NEP outreach to the average Russian, concluded with a paean to wooden construction. Melnikov was fully in sympathy with such views, and he adapted the techniques of the peasant carpenter to his highly innovative system of flooring (Fig. 114). For the walls he turned to another peasant craft, the rough brickwork covered with plaster that had been used on Russian urban churches since before the Mongol conquest. Even the inspiration for the hexagonal corbelled windows that are so distinctive a part of the building came straight from the past, in this case from the tower of a seventeenth-century fortification surrounding Moscow's ancient Belgorod district, which was at that very time undergoing extensive restoration (Fig. 115).

[26] Iu. Larin, B. Belousov, eds., *Za novoe zhilishche*, Moscow, M. 1930, pp. 108 ff.
[27] G. B. Barkhin, *Sovremennye robochie zhilishcha*, Moscow, 1925, p. 13, went so far as to defend the traditional peasant stove.
[28] V. S. Karpovich, *Sovremennoe rabochee stroitelstvo,* Leningrad, 1926, pp. 88 ff.
[29] V. D. Machinskii, *Rabochii poselok*, Moscow, 1925, p. 3.

But this was no mere imitation, for, unlike the prototype, the house's walls were riddled with scores of such openings so that they could be blocked up or glassed in at will, according to the caprice of the residents. (Fig. 116). [30]

That so small a building should glitter with over sixty windows and be fitted for up to one hundred and fifty more, and on top of that be entirely fronted with glass, is evidence of Melnikov's almost fanatical worship of sunlight. Though he apparently did not know of the Fourierist entrepreneur of the 1850s, Jean-Baptiste Godin, he would have enthusiastically endorsed the Frenchman's maxim that: ". . . The way man uses light in the material order is an index of his progress in the moral order."[31] Where the peasant *izba* had been filled with smokey gloom and the nobleman's villa had relied on gleaming interiors to relieve the darkness, Melnikov's house is literally bathed in light (Fig. 117). Like the French utopians too, he made a cult of cleanliness and the circulation of fresh air, going so far as to open all of the sleeping areas to one another and to cover their walls with polished stone so as to remove the slightest possibility of dust lodging

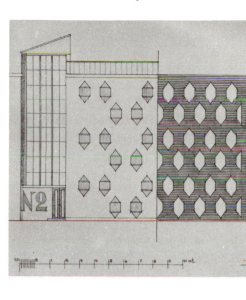

[30] Details on the innovative use to which Melnikov put wood and brick construction are to be found in "Opisanie konstruktsii sobstvennogo doma," MS., 1927, 3 pp. (Melnikov archive). These techniques are reviewed favorably in "Voprosy zhilishnogo stroitelstva," *Stroitelstvo Moskvy*, 1925, No. 12, pp. 863 ff.

[31] Jean-Baptiste André Godin, *La Richesse au Service du Peuple*, Paris, 1871, p. 56.

116. Side elevation of the architect's house, 1926

117. Interior of the studio, the architect's house

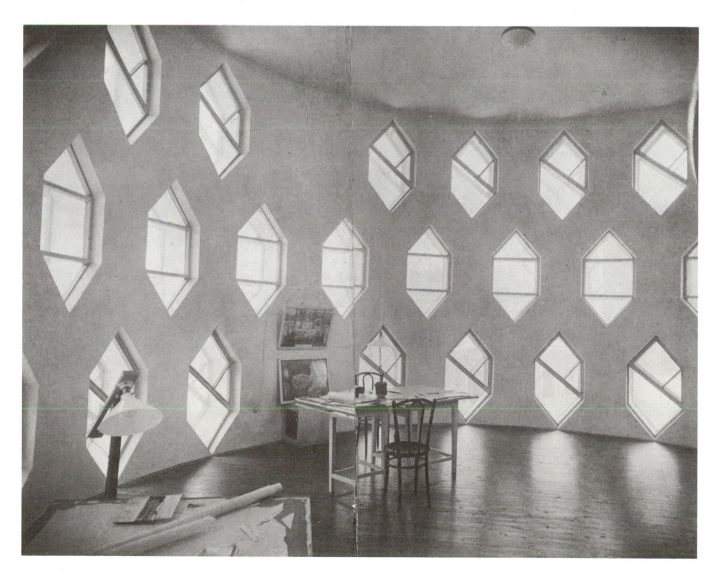

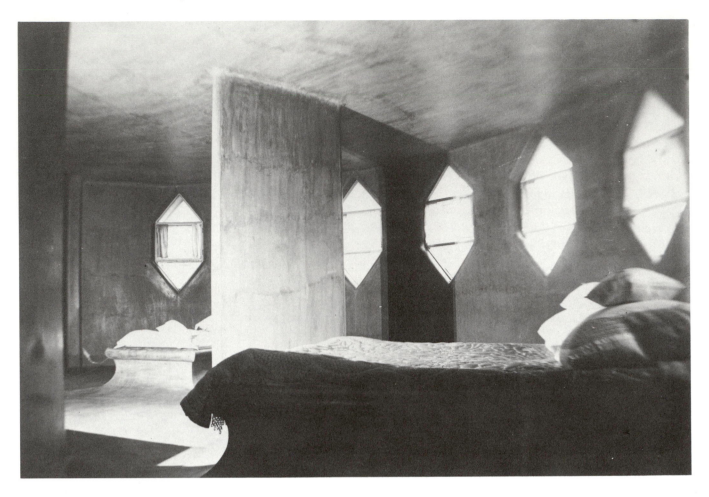

118. Bed chamber of the architect's house, showing bed-pedestals as originally constructed

anywhere. Beds were summarily abolished, and in their place were erected stone pedestals on which the human body would rest in dust-free purity and be restored by the effects of fresh air (Fig. 118).

Such issues claimed Melnikov's attention, but they eluded contemporary critics, all of whom chose to dwell primarily on the house's blatant individualism. At a time when the Leningrad theorist G. K. Kosmachevskii, writing on "The Ideology of Architecture," could claim baldly that the individual architect had become an anachronism, Melnikov's proud signature across the façade of his house could be read only as an act of defiance, a deliberate affront to all the collective groupings that were coming to dominate the field.[32] Far worse in the eyes of many was the fact that the house perpetuated the individuated family as the basic social unit. True, in 1926-1928 few leading architects as yet opposed this notion and it was embodied in nearly all the garden cities then under construction, including the large Sokol settlement outside Moscow.[33] But the Commissar of Enlightenment, Lunacharskii, had already raised his voice on the question of the family in both lectures and polemical tracts;[34] the OSA group was com-

[32] G. K. Kosmachevskii, "Ideologiia zodchestva," *Zodchii*, 1924, No. 1, p. 20. Compare to the unsigned article in Russia's first architectural journal in 1859 on "The Meaning of the Word 'Signature' in Antique Architecture," *Arkhitekturnyi vestnik*, 1959, No. 1, p. 74.

[33] The project is reviewed by D. Protopopov in "Novyi poselok pod Moskvoi," *Zodchii*, 1924, No. 1, pp. 51-53.

[34] A. V. Lunacharskii, *Meshchanstvo i individualizm*, Moscow-Petrograd, 1923; also his *O byte*, read in Leningrad on October 18, 1926, and published separately in Moscow in 1927.

ing to champion collective housing (though its journal continued to publish one-family homes by Rietveld and Le Corbusier);[35] and ASNOVA's theoretician, Nikolai Dokuchaev, was complaining that the importation of advanced building techniques from the West was bringing in its wake housing types suited only for the most "bourgeoisified and tractable workers."[36] The first to apply these critiques to Melnikov's house was Nikolai Lukhmanov of Moscow, who twice used the pages of *The Construction of Moscow* (*Stroitelstvo Moskvy*) to assail the architect's adherence to outmoded social ideals as well as his resort to old-fashioned building materials.

Lukhmanov at least conceded that Melnikov's "housing laboratory" contained many features of exceptional interest, including the absence of internal bearing walls, the self-reinforcing floor construction, and the built-in furniture.[37] Far more uniformly vitriolic was the attack of A. Karra and V. Smirnov, who, writing in 1929 as champions of Stalin's "Cultural Revolution," found the house to be an "unprincipled experiment" consisting of little more than "an original variant of the bourgeois type of particularized housing cell."[38]

Melnikov was stung by these criticisms, since from the outset he had believed that his experiment with cylinders could have some relevance for public and communal housing. Even before these attacks appeared in print, he had proposed two alternative means of expanding his cylindrical house to accommodate larger numbers of persons and families (Figs. 119-120) and, later, even a third scheme for public housing based on a more nearly rectilinear plan (Figs. 121-122). Meanwhile, several other architects paid him the ultimate compliment of pirating his conception.[39] These more or less direct imitations established the extent of Melnikov's impact, but they do more. For, whether applied to the problem of housing Central Asian nomads or Great Russian peasants, Melnikov's cylinders were taken to have their greatest relevance to rural life, or at least to anti-urban and utopian housing projects for the future. Of course, there were those who praised the low construction costs of the house (32,000 rubles).[40] and there were others, like the Leningrad visionary Iakov Chernikhov, who took inspiration from the purely aesthetic aspects of the form.[41] But Melnikov's resort to the cylinder as a practical and symbolic alternative to the superorganizing and hence urban form of the cube was not lost on his contemporaries. It is the prominence of this slightly anarchistic social concern, as opposed to purely formal or practical interests, that distinguishes the cylin-

[35] *SA*, 1927, No. 3, pp. 91 ff.

[36] N. Dokuchaev, "Arkhitektura rabochego zhilischa i byt," *Sovetskoe iskusstvo*, 1926, No. 3, pp. 20-21.

[37] N. Lukhmanov, "Tsilindricheskii dom," *Stroitelstvo Moskvy*, 1929, No. 4, pp. 16-22; L-nov (sic.) "Neudachnye konstruktsii," *Stroitelstvo Moskvy*, 1929, No. 10, pp. 19-20.

[38] A. Karra, V. Smirnov, "Besprintsipnyi eksperiment," *Stroitelstvo Moskvy*, 1929, No. 10, p. 20. A. Mikhailov repeated these criticisms in 1932, stressing also the "formalism" of the design. *Grupirovka sovetskoi arkhitektury*, Moscow, 1932, p. 58.

[39] On the architect Kalmykov's use of cylinders in Central Asia, see his "Nash proekt," *Arkhitektura SSSR*, 1933, No. 5, pp. 24-27; peasant housing is covered in P. Osipov's "Standartnye kruglye zdaniia dlia poselkov," *Stroitelstvo Moskvy*, 1930, No. 5, p. 14; and the architect Grinshpun's village of cylindrical *dachas* presented in *Arkhitektura i Vkhutein*, 1929, No. 1, p. 7. A defense by G. B. Krasin of cylindrical forms for housing is in *Stroitelstvo Moskvy*, 1929, No. 5, p. 8.

[40] V. Zheits, "O tsilindricheskom dome arkhitektora K. S. Melnikova," *Stroitelstvo Moskvy*, 1929, No. 10, pp. 18-19.

[41] *Cf.* Iakov Chernykhov, *Konstruktsiia arkhitekturnykh i mashinnykh form*, Leningrad, 1931, p. 142.

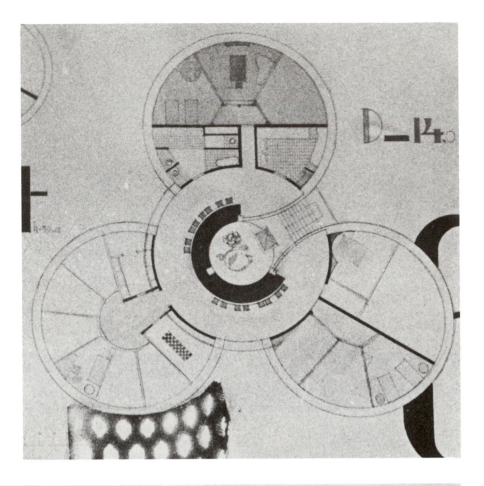

119. Cylindrical public housing, 1929.
Plan of clustered variant

120. Cylindrical public house, 1929.
Linear variant

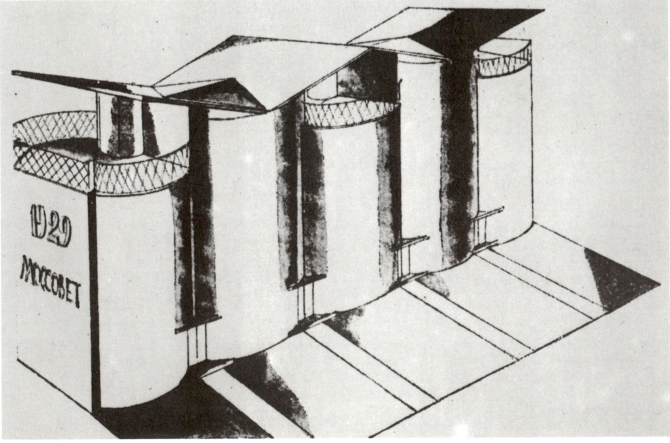

 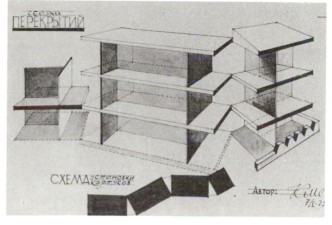

121. Plan of rectilinear housing units, 1929

122. Method of integrating rectilinear housing units, 1929

drical projects by Melnikov and his Russian followers from analogous works by Le Corbusier, and especially from the creations of America's engineers.

The polemic over Melnikov's experiment drew a parade of visitors to his door. German and American engineers, delegations of Old Bolsheviks, Donbass miners, and students from Tobolsk in Siberia all recorded their enthusiasm over the project in his visitors' book. In the face of all the attacks in the press, an entry by Igor Grabar, the historian of art through whose writings Melnikov had long before made contact with the Romantic Classical tradition of European architecture, must have been especially heartening: "I am not one to be jealous, but as I leave here I am seized by envy. How I would like to live like this!"[42]

A note that sounded in Melnikov's visitors' book and in the reviews as well was the need to apply his experimental forms and techniques to other types of structures. In the words of Nikolai Miliutin, Party official, editor, and theoretician of Socialist cities, "The planning [of the house] is not only economical but beautiful and functional. This system must now be tested in a series of public buildings. . . ."[43] Melnikov did precisely this, first in the cylindrical housing projects of which note has been taken, then through two cylindrical workers' clubs, and finally in a proposal for a cylindrical military academy. Of these, his proposal for a workers' club (Fig. 123) for the Zuev factory on Lesnaia Ulitsa in Moscow is particularly noteworthy, in that the spaces formed by the overlapped cylinders were designed to be used interchangeably for the most diverse functions, ranging from kindergartens, vestibules, a theater and stage, and a meeting hall (Fig. 124).[44] Melnikov's friend Ilia Golosov stopped short of this in his project for the same competition, using only one cylinder at the corner of the structure to house a stairway and thereby to relieve the hard rectilinear form of the whole. This more narrowly ornamental application did little to advance the testing that Miliutin had proposed. But it won the competition, and even in its present dilapidated condition Golosov's building impresses with its cleanly articulated masses.

Melnikov did not fail to draw the lesson from Golosov's success in the Zuev competition, and in his next experiment—another factory club on the industrial perimeter of Moscow—he confined his use of cylinders to a

[42] K. S. Melnikov, "Avtografy lits, posetivshikh sobstvennyi dom K. S. M.," M.S., Melnikov archive, p. 4.

[43] *Ibid.*

[44] "Proekt kluba kommunalnikov," *Vechernaia Moskva*, 1927, April 4, p. 4.

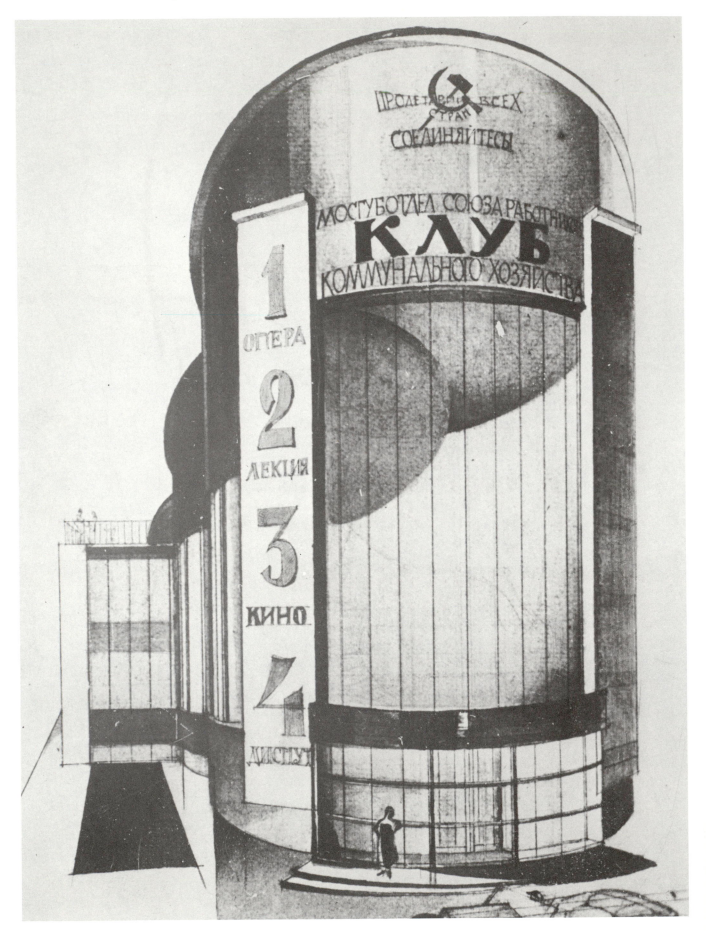

tower at one end of the more standard rectilinear structure in which most of the principal facilities were placed (Fig. 125). Yet because of the club's short street frontage and the placement of the tower of six conjoined cylinders at a point commanding both the entrance and the street corner, the cylindrical element dominates the Burevestnik Factory Club far more than Golosov's cylinder dominated the Zuev Club (Figs. 126-127).

Moreover, the function of the Burevestnik tower is not limited to creating sculptural effects, for it also inculcates its designer's outlook on architecture and society. As has been seen, Melnikov was unwavering in his

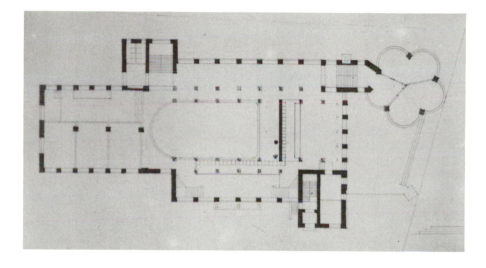

124. Plan of Zuev factory club, 1927

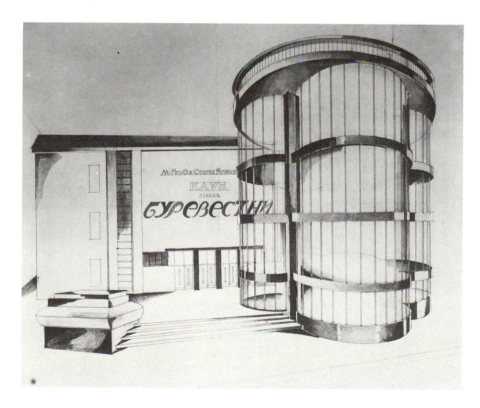

Opposite

123. Project for workers' club at Zuev factory, Lesnaia Ulitsa, Moscow, 1927

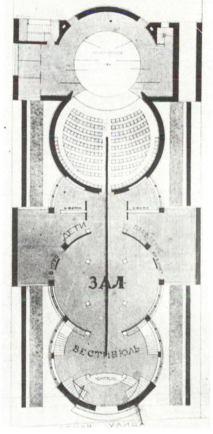

125. Workers' club for the Burevestnik factory, Moscow, 1929

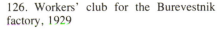

126. Workers' club for the Burevestnik factory, 1929

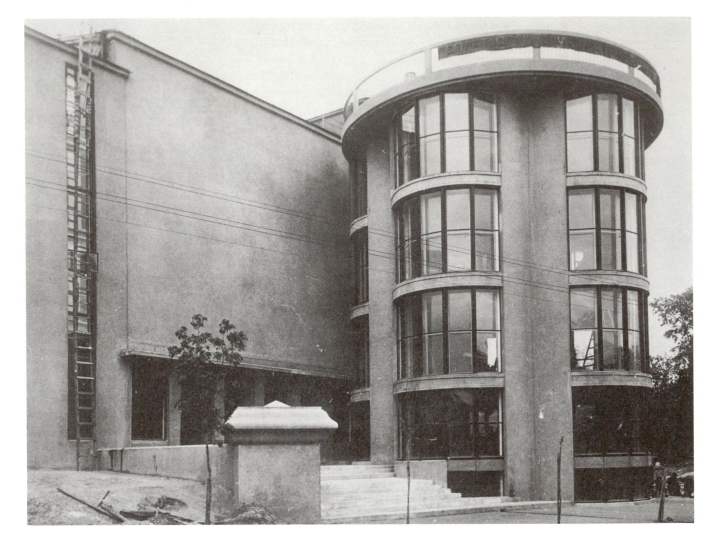

127. The Burevestnik factory club at the time of its completion in 1929

hostility to the rectangle and cube as devices for achieving social discipline, regimentation, and control. When confronted with the need to house his own family, he had created instead a series of curving and unspecific spaces, readily adaptable to diverse functions at the inhabitants' whim. Likewise, Melnikov's design for the Zuev Club stressed spontaneity far more than did Golosov's, and would have lent itself well to a loosely structured organization that would constantly be converting spaces from one function to another as needs changed. In both of these projects, and in the Burevestnik Club as well, the interiors of Melnikov's cylinders face outward rather than inward, and stress the glass perimeter rather than the closed center. In these respects the contrast to the eighteenth-century's arch-rationalist, Jeremy Bentham, is instructive. Bentham, too, had found in cylindrical forms the answer to his social ideal, but for him the ideal was a centrally regulated uniformity. Hence his cylindrical jail, the Panopticon, consisted of a ring of apple-pie wedges with windows on the center, where Authority sat enthroned in the person of the benevolent warden.[45] Melnikov's Burevestnik Club is precisely the opposite, as any passerby can see today. Different and changing functions might be taking place on all four floors, and within the different rooms on any one floor. The outer walls

[45] Jeremy Bentham, "Panopticon Papers," in *A Bentham Reader*, Mary Peter Mack, ed., N.Y., 1969, pp. 189-208.

were all but non-existent; no barrier separated those inside from the out-doors. Far from confining, structuring, and regulating human existence, the Burevestnik Club contented itself with proclaiming the compatibility of all spontaneous activity. Compared with Bentham's authoritarianism, Melnikov cylinders are the apotheosis of self-regulating anarchy.

It is this implied social and political stance that makes it so puzzling that Melnikov, in 1930-1931, should have chosen to employ cylinders for his entry in the closed competition to design the Moscow campus of the Red Army's Frunze Military Academy [46] (Fig. 128). Conceived by its patrons, the Revolutionary Military Council, as a "palace of military culture," the complex was to house all the classrooms, offices, laboratories, gyms, etc., needed to train the Soviet Union's top army commanders. To this end Mel-nikov drew up one dozen cylinders in tight rank, and parcelled out fixed tasks to each tower (Fig. 129). In one variant he even reduced the window area of the towers, as if to prevent outsiders from inadvertently glimpsing the informal activity within and thereby diminishing the overwhelming im-pression of order and uniformity he wished the complex to make (Fig. 130). Yet for all this, the fact that the "army" consisted of individuated cylinders of equal size rather than a single, undifferentiated mass directed by towering leaders made the conception somewhat inappropriate to the aspirations of the Red Army. In the end, Melnikov's entry lost out to a massive rectangular Renaissance palace featuring a tank mounted—appro-priately—atop a cube.

[46] M. M. Minkus, Iu. E. Shass, "Proektirrovanie krasnoznamennoi voennoi akademii im. M. V. Frunze," *Sovetskaia arkhitektura*, 1933, No. 5, pp. 60-62.

128. Project for Frunze Military Acad-emy, Moscow, 1930

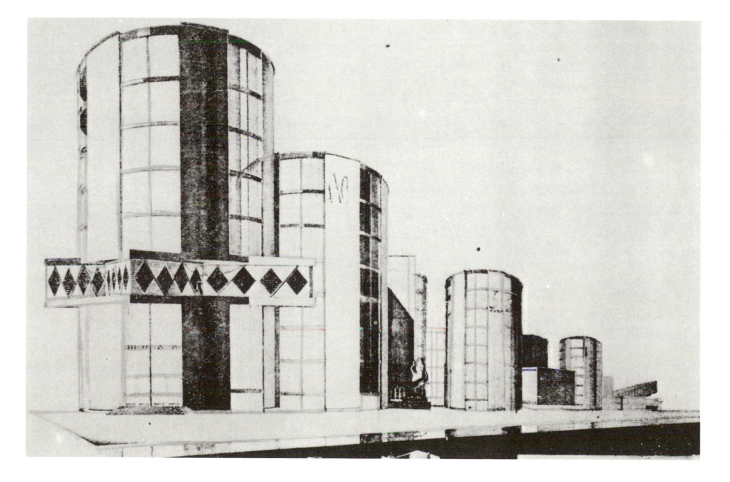

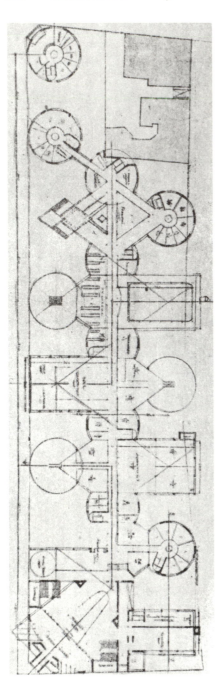

For all the persistence with which he pursued these experiments, Melnikov's infatuation with the cylinder constituted but one brief phase in his career, corresponding to the last years of the free-wheeling New Economic Policy. Like NEP, Melnikov's cylinders adjured the role of social engineer. They optimistically accepted people as they were, and merely provided them with free spaces in which they could live and work without tangling with the hard laws of the T-square. There is an obvious parallel between his research on cyclinders and the efforts by the Constructivists Ginsburg and Alexander Vesnin in the same years to apply cubic forms to every purpose. But compared with them, and with himself both before 1925 and after 1928, Melnikov in his cylindrical projects emerges far less as the technocratic ideologue than the person-oriented architect.

He was also less consistent than the Constructivists, who, except for their heretical and enigmatic protégé Ivan Leonidov, were for the while content to elaborate with ever greater refinement their blend of cubistic purism and functionalism. Not so Melnikov. In the very years when he seemed to be working so deliberately to develop an architectural language based upon only one form, the cylinder, he also created a brilliant series of workers' clubs that exhibit the most extravagant diversity of form. These structures, which together stand as one of the finest achievements of the NEP era in architecture, left many members of Russia's architectural world earnestly questioning whether any single aesthetic system or canon could ever satisfy Melnikov's restless genius. In this very quality they provide a link between the diversity and dynamism of artistic life during the era of the Civil War and the explosive and ultimately tragic fragmentation of aesthetic perception that occurred during the Cultural Revolution of 1929-1931.

129. Plan of Frunze Military Academy, 1930

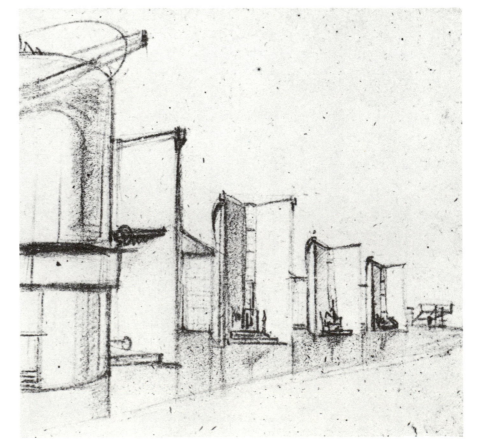

130. Variant proposal for Frunze Military Academy, 1930

Given their importance in Melnikov's complete *oeuvre* and their centrality in the architecture of the New Economic Policy, the workers' clubs must be fixed correctly on their political and social coordinates. In recent literature these institutions have more than once been presented as some wildly utopian conception of the Revolutionary era. Contemporary polemicists provided ample support for such a view, hailing them as "hotbeds of the class war," "sources of light and knowledge,"[47] or, in a phrase from a 1923 pamphlet on workers' clubs, "a smithy in which proletarian class culture is forged."[48] Some partisans of the workers' club would have accepted these characterizations as accurate and sufficient, but most advocates of clubs viewed them in a far more practical light. They realized that the institutions bore the stamp not just of Revolutionary ideology but of the efforts of the municipal government of tsarist Moscow to deal with the age-old problem of alcoholism. It was this concern that in 1915 had prompted the City Council *(Duma)* to set up People's Houses in various districts on the model of the French *Maisons du Peuple* and to equip them with reading rooms, moving-picture theaters, concert stages and lecture halls, so that they "would serve in the capacity of cultural centers and educational institutions with the objective of satisfying the special needs of the laboring class of the population and of providing them with the possibility of profitably utilizing their free time."[49]

For several years after 1917, partisans of the "Proletarian Culture" movement and Lenin himself had promoted these institutions as tools for instilling Revolutionary values in the laboring populace. But by 1924, most workers had shown themselves to be less than zealous for such uplift. In that year Trotsky spoke cynically of the boycott of workers' clubs by the workers themselves, and soon afterwards Tomskii, head of the trade unions, called for the clubs to spend less time preaching about "the proletarian Revolution and its problems" and do more to generate "healthy recreation and healthy laughter."[50] The construction of a large number of workers' clubs on the industrial perimeter of Moscow and other cities during the late 1920s was undertaken in response to this simple demand.

The Soviet trade unions that sponsored this construction proved to be ideal patrons. Though it has been argued that the twenties framed *The Life and Death of Soviet Trade Unionism*, to quote the title of one Western study,[51] the efforts of numerous unions to expand the network of workers' clubs were eminently successful. They succeeded because union leaders had the good sense to give the commissions to some of Russia's most talented architects and then to clear the way at the Moscow Soviet for those architects to realize their plans without official impediments. The Union of Chemical Workers, for example, commissioned Melnikov to do four clubs at a cost of over a million rubles; the Union of Municipal Workers had him do plans for two more, of which one was built; and the Union of Tanners undertook one; in every case the plans were submitted and approved and construction begun, all within days, leaving the architect dazed and as-

[47] *Griadushchee*, 1918, No. 5, p. 9.

[48] V. Pletnev, cited by L. Trotsky in "Leninism and Workers' Clubs," in *Problems of Everyday Life and Other Writings on Culture and Science*, p. 313.

[49] Resolution of the Moscow City Duma, 16 June 1915, *Izvestiia Moskovskoi gorodskoi dumy*, vol. XLI, No. 2, February, 1917, p. 59. See also P. Kritskii, *Kak ustroit i vesti narodnyi dom*, Iaroslavl, 1915, for their link to the temperance movement.

[50] Trotsky, "Leninism and Workers' Clubs," pp. 297-303; *XIV Sezd vsesoiuznoi kommunisticheskoi partii (b)*, Moscow, 1926, pp. 737-38.

[51] Jay B. Sorenson, *The Life and Death of the Soviet Trade Unionism 1917-1928*, New York, 1969.

tonished. "Business was conducted informally and without bureaucracy back then," Melnikov later recalled,[52] which is surely to the credit of the trade union officials.

The only limit to the unions' patronage was the paucity of funds, which necessitated the drastic simplification of several of Melnikov's proposals and caused all of them to be rather crudely finished, with none of the furnishings he would have liked to have included. Nonetheless, he was convinced that these institutions represented "all the highest aspirations of the intellectual life of man, of the human personality."[53] At a time when living space in Moscow averaged only about five square meters per capita and was shrinking,[54] he saw them as a welcoming home away from home. And for the millions of peasant immigrants fresh from rural Russia who comprised the post-Civil War labor force, Melnikov wanted the clubs to represent one's community, one's point of contact with higher cultural values, and the avenue to one's further advancement in society.[55]

Inclined as Melnikov was to identify personally with the new urbanites for whom the workers' clubs were built, he naturally considered his own values relevant to the situation and sought to apply them in the clubs. Hence, as in his own house, he set the clubhouses *against* the hostile city rather than *in* it, employing sharply distinctive forms to make them appear "as individualist against the general backdrop of urban building."[56] Inside, far from providing space for mobilizing people into a faceless mass, he envisioned settings that would enhance "close intercourse among people, but in the context of their diverse strivings with respect to one another."[57]

All these intentions were realized in the audacious Rusakov Club, built for the Union of Municipal Workers in 1927-1928 (Figs. 131-132). So clearly were they manifest, in fact, that from the moment the Moscow

[52] Conversation with the author, April, 1967.
[53] K. S. Melnikov, "Zdaniia klubov," MS, n.d., Melnikov archive, p. 1.
[54] Hazard, *Soviet Housing Law*, p. 16.
[55] S. O. Khan-Magomedov has discussed Melnikov's views on the workers' club as an institution in "Kluby segodnia i vchera," *Dekorativnoe, iskusstvo*, 1966, No. 9, pp. 2-6.
[56] Melnikov, "Zdaniia klubov," p. 1.
[57] K. S. Melnikov, untitled MS, 1927, Melnikov archive, p. 1.

131. Facade of workers' club for the Rusakov factory, Moscow, 1927

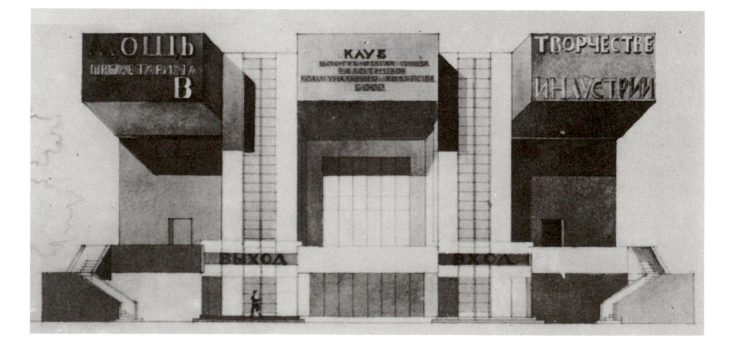

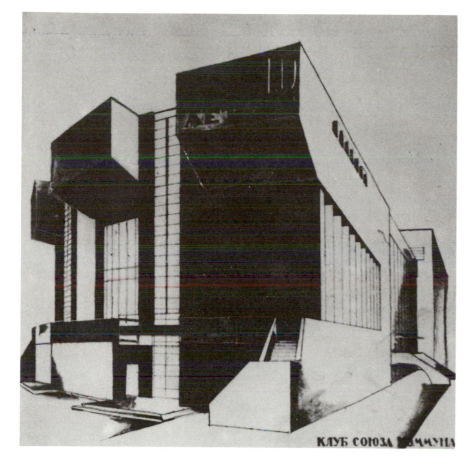

КЛУБ СОЮЗА КОММУНЫ

132. Rusakov factory club, 1927

Soviet's building engineer yielded to a threat from the union and approved the plans virtually unseen[58] down to the time of Khrushchev's denunciation of it in 1966, this structure has been surrounded with notoriety. Stalinists were to find its soaring lines evidence of "left-wing deviation,"[59] while Constructivists took it as yet further proof of Melnikov's right-wing "formalism." Praised or damned, the club on the Stromynka yields to no building in Moscow as a symbol of the most radical architecture of the twenties. For better or worse, this was acknowledged at the time of its construction, when thousands of visitors to the capital chose postcard photos of it by Alexander Rodchenko to carry their greetings back to Minsk, Baku, or Tomsk (Fig. 133).

In 1930, the Berlin journal of design *Die Form* ran an article on the latest Soviet architecture, in which the author drew a comparison between the Rusakov Club and Eric Mendelsohn's 1914 sketch for a factory (Fig. 134), claiming the latter had inspired the former.[60] Some months later, the French magazine *L'Architecture d'Aujourd'hui* also printed an article on the Rusakov Club, this time by the Leningrad architect M. Ilin, entitled "Expressionism in Architecture" and featuring Mendelsohn's drawing, which was printed next to the title.[61] Indirect evidence in support of this hypothesis is the fact that Melnikov met with Mendelsohn during the lat-

[58] Melnikov, "Arkhitektura moei zhizni," p. 45.

[59] A. Nemov, "Protiv 'levykh' zagibov v klubnom stroitelstve," *Iskussto v massy*, 1930, No. 2 (10), pp. 12-16.

[60] Leonie Pilewski, "Neue Bauaufgaben in der Sowjet-Union," *Die Form*, 1930, Heft 9, p. 237.

[61] M. Ilyine, "L'Expressionisme en architecture," *L'Architecture d'Aujourd'hui*, 1930, December, vol. l, No. 2, pp. 29-31. On the impact of Expressionism in Russia, see L. Ia. Zivelchinskaia, *Ekspressionizm*, Moscow-Leningrad, 1931, ch. 5.

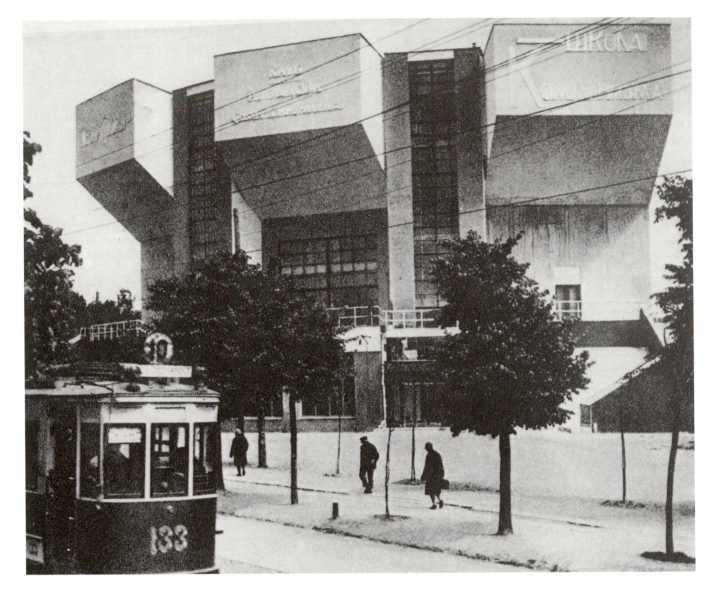

133. Rusakov club at the time of its completion. Photograph by Alexander Rodchenko

134. Erie Mendelsohn, sketch for an industrial complex, 1914

ter's visit to Moscow in the spring of 1926, and admitted to having been favorably impressed by the German. But beyond this there exists no hard proof that Mendelsohn's sketch helped to inspire the plan for the Rusakov Club. Whatever the specific links to Mendelsohn, the general orientation of the building towards an Expressionist aesthetic is evident, not only in the searing angles of the cantilevered forms on the street façade or the colliding planes and surfaces at the rear (Fig. 135),[62] but also in the attempt to convert a utilitarian structure into a kind of temple that would celebrate a generalized "humanity" or "labor" through the use of distinctive forms. At the same time the aggressive diagonals, set off by the contrasting shades of grey with which the building was originally painted, call to mind Sant'Elia and Marinetti's caution in *Futurist Architecture* (1914) against forms that are "static, grave and oppressive. . . ."[63] If Melnikov's later statement

[62] The comparison to Bruno Taut's house at Dahlewitz would be appropriate, except that the colliding angles of Melnikov's club are more extreme. *Cf.* Bruno Taut, *Modern Architecture*, London, 1932, p. 147.

[63] Antonio Sant'Elia, Filippo Tomonaso Marinetti, "Futurist Architecture," in Ulrich Conrads, ed., *Programmes and Manifestoes on 20th Century Architecture*, London, 1970, p. 36.

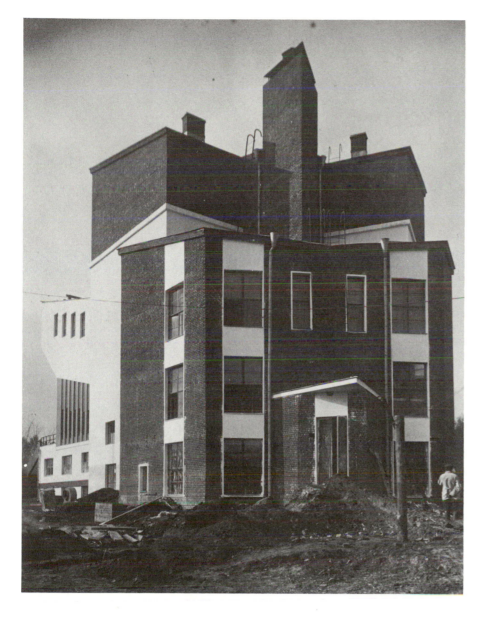

135. Rear view of Rusakov club at the time of its construction. Photograph by Alexander Rodchenko

about his use of form "to create the impression of a tensed muscle"[64] recalls again the Futurists' bravado, then so much the better. Melnikov, like Russia's avant-garde artists Malevich, Larionov, or Tatlin, readily absorbed all tendencies of the day but had the capacity, in the Rusakov Club especially, to combine these various impulses in a strikingly innovative and distinctive manner.

From the expressiveness of its exterior, one might expect that the interior would show the usual signs of a building having been designed "from the outside in." But formal and functional elements in the Rusakov Club are virtually indistinguishable, so that the whole is integrated to a degree rarely attained either by Melnikov or by his contemporaries, who persisted in juxtaposing social and aesthetic considerations. Memoranda by the architect on the acoustics of the six meeting halls, on the economies to be effected by making all of these halls part of one single but divisible space, and on the best means for groups and organizations to utilize the building,

[64] Quoted by S. Khan-Magomedov, "Konstantin Melnikov: Arkhitektor," *Nedelia*, 1966, No. 7, February, pp. 6-12.

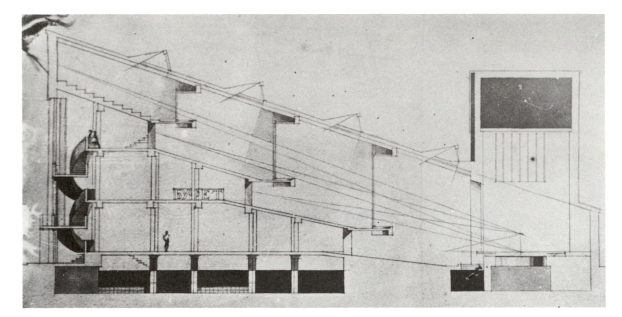

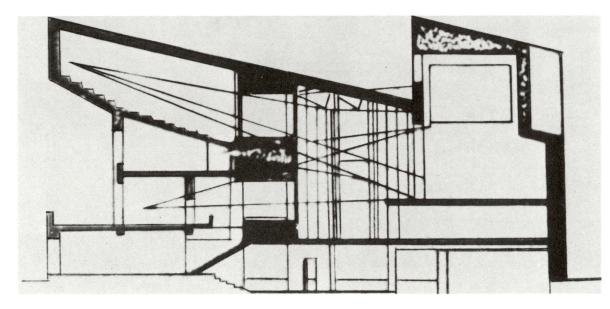

136. Section of early variant of Rusakov club

137. Section of Rusakov club as constructed

all indicate his simultaneous concern for utility and beauty.[65] The acoustical study compares the triangular shape of the hall to a megaphone (Figs. 136-137), and argues that the walls separating the three balconies would increase resonance but not echo. The paper on the building's economics establishes that the low caloric loss per hour for the structure would save some 35,280 kilos of fuel per year. Finally, he showed how the configuration of the building rendered it possible for the single hall for 1,200 persons to be divided into three upper halls seating 190 each, two side halls accommodating 120 each, and the pit for 360 persons—all through the manipulation of mechanized soundproofed panels (Figs. 138-139).[66] It would

[65] K. S. Melnikov, "Akusticheskie svedeniia dlia zdaniia kluba imeni Rusakova," MS 1927; "Opredelenie ekonomicheskikh soobrazhenii k proektu zdaniia kluba imeni Rusakova," MS, 1927; untitled MS on "Sistema zalov," 1927 (all Melnikov archive).

[66] Notwithstanding these provisions, the architect Ia. Kornfeld criticized the Rusakov Club for having too little meeting space ("Povisit kulturu klubnogo stroitelstva," *Revoliutsiia i kultura*, 1930, No. 11, pp. 42-46). *Cf.* "Klub kommunalnikov na Stromynke," *Stroitelstvo Moskvy*, 1927, No. 11, pp. 3-5.

be hard to deny that such features do as much as the explosive boldness of the outer form to warrant consideration of the Rusakov Club as one of the monuments of modern architecture.

As the Rusakov Club was being completed, a many-sided polemic broke out in the Russian press over what constituted the ideal workers' club.[67] However remote much of this debate seems from the actual problems of design, the discussion was nonetheless pertinent to Melnikov's efforts, if only because all of those taking part (of which he was not one) assumed from the outset that ultimately they would succeed in defining a *single*

[67] See V. Shcherbakov, "Konkurs na zdaniia tipovykh klubov," *Stroitelstvo Moskvy*, 1927, No. 5, pp. 8 ff.; Babitskii, "Klubnoe stroitelstvo tekstilshchikov," *Stoitelstvo Moskvy*, 1928, No. 7, pp. 5-10. This polemic is reviewed in N. Lukhmanov's *Arkhitektura kluba*, Moscow, 1930.

138-9. Floor plans of Rusakov club, showing units that can be assembled into one or various numbers of halls

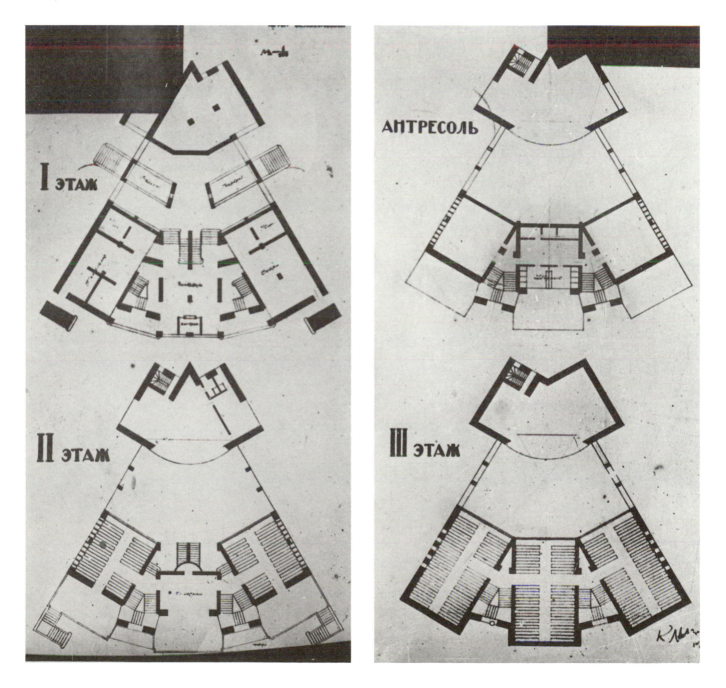

model or set of models applicable to all times and circumstances. Melnikov rejected this notion out of hand and devoted the years 1927-1929 to planning a half-dozen clubs, each of them differing radically from every other. Without pausing to examine each of these in detail, we can say that they all embodied elements of improvisation and fantasy but that each at the same time was conceived with due regard for certain formal limits.

The "language" of Melnikov's workers' clubs consists of primary geometric forms assembled according to the principles of Romantic Classicism. Thus, the Zuev Club and the Burevestnik Club were designed around cylinders and rectangles, while the Kauchuk Club, built near the Novodevichei convent in Moscow in 1927-1928 (Fig. 140), has as its core the combination of a triangle and a semi-circle (Figs. 141-142), set off by a

140. Workers' club for the Kauchuk factory, Moscow, 1927

141. Site and floor plans of Kauchuk club, 1927

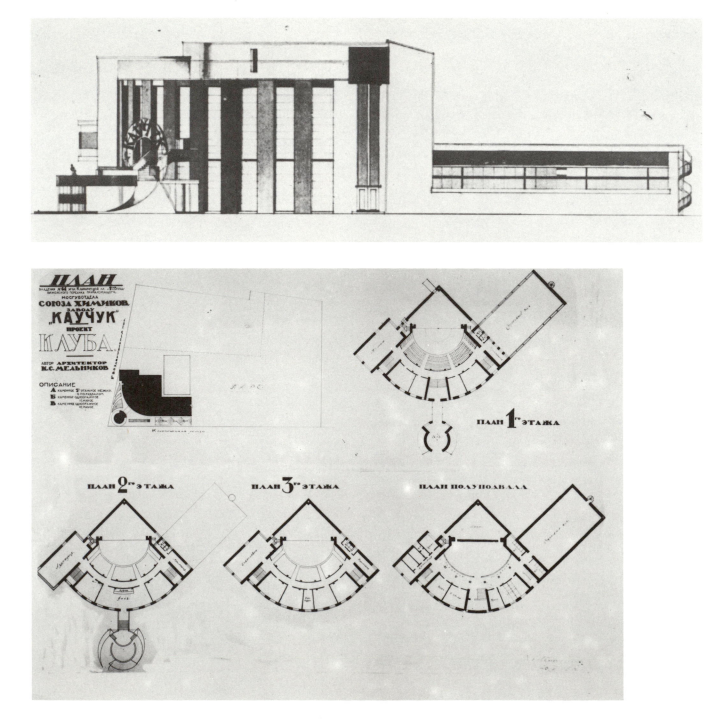

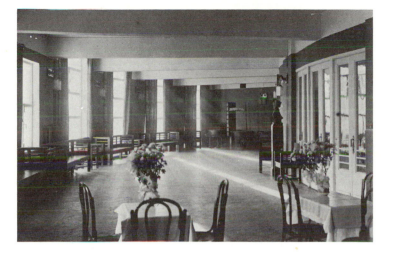

142. Semi-circular reception area, Kauchuk club. Photograph by Alexander Rodchenko

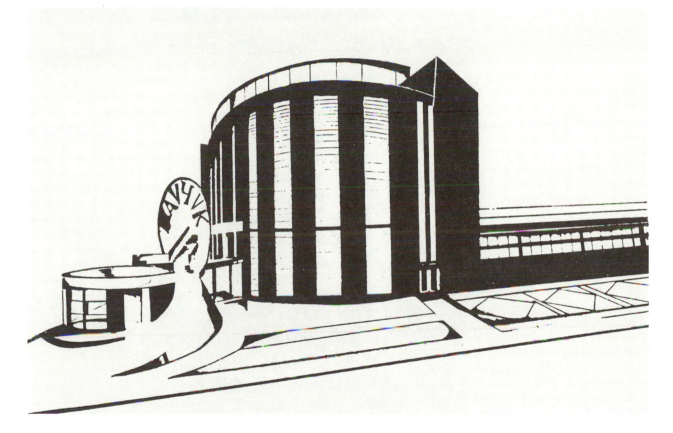

circular stairway that derives directly from classical models.[68] But as in Romantic Classicism, the classical order is never really stable in these buildings of the high NEP era, as Melnikov strained to achieve ever greater dynamism of form. When he sketched the Kauchuk Club for the benefit of its patrons, the Union of Chemical Workers, he adjured the cool symmetry that in fact underlies the plan, and presented a stark black-on-white drawing stressing the Expressionistic element in the project (Fig. 143).

143. Kauchuk club, 1927

[68] This and other Melnikov clubs are the subject of articles by "M," "Novye kluby u khimikov," *Stroitelstvo Moskvy*, 1928, No. 1, pp. 18-20; Michel Ilyine (sic.) "L'Architecture du club ouvrier en U.R.S.S.," *L'Architecture d'Aujourd'hui*, 1931, November, pp. 17-19; Michel Ilyine, "L'architecture Moderne en U.R.S.S.," *L'Architecture d'Aujourd'hui*, 1931, January-February, pp. 126-29; as well as the works by Lukhmanov and Khan-Magomedov cited above.

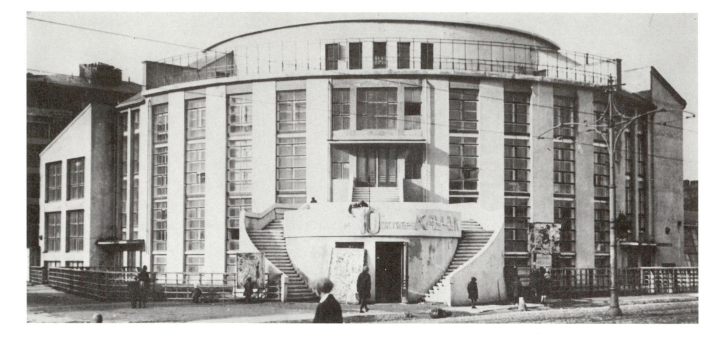

144. The Kauchuk club at the time of its completion. Photograph by Alexander Rodchenko

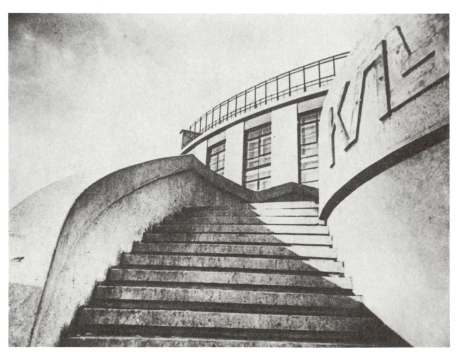

145. Entrance to the Kauchuk club. Photograph by Alexander Rodchenko

Likewise, when Alexander Rodchenko went out to photograph the recently completed building, he took one view that acknowledged the classical order of the façade (Fig. 144) and another of the circular entrance that captures all the drama of an Eisenstein film set (Fig. 145).

This tension between repose and dynamism is evident in two other clubs built for the Union of Chemical Workers, the Frunze Factory Club on the Moscow River embankment (Fig. 146) and the Svoboda (now Gorkii) Factory Club on Viatskaia Ulitsa (Fig. 147). Both are unusual among Melnikov buildings in that their ground plans are purely rectilinear. Indeed, the plan for the Svoboda Club could well have been drawn directly from an eighteenth-century workbook, so controlled is its regularity (Fig. 148). Yet in each case more restless elements are present as well. The triangular mass

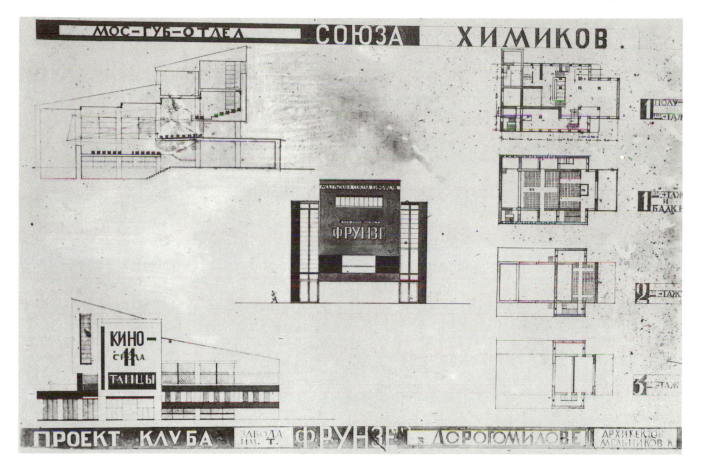

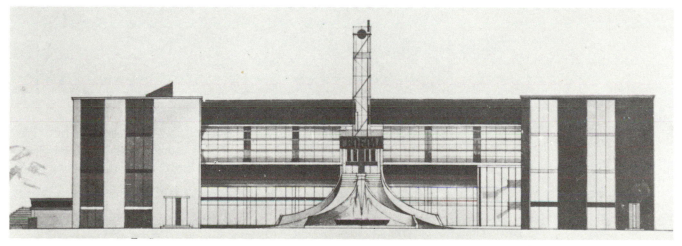

146. Plan and elevation of workers' club for the Frunze factory, Moscow, 1928

147. Workers' club for the Svoboda (now Gorkii) factory, Moscow, 1928

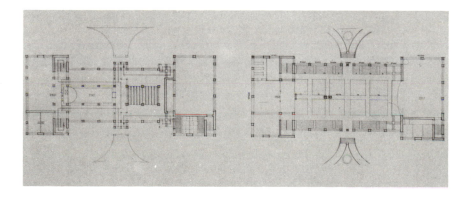

148. Plan of Svoboda factory club, 1928

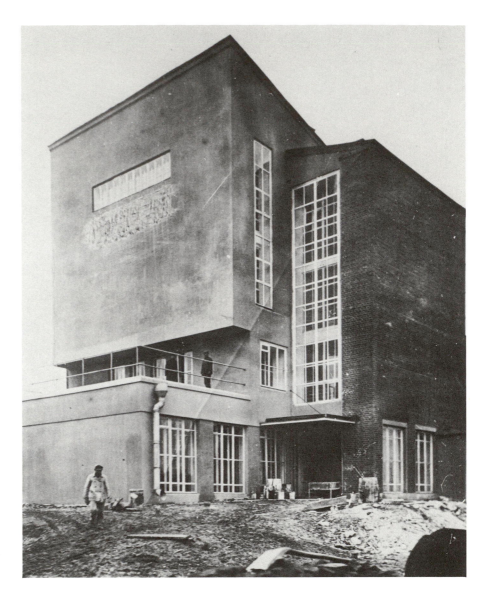

149. The Frunze factory club at the time of its completion

of the small Frunze Club gives a strong forward thrust to the structure (Fig. 149), forcing the building on the public's attention like an advertising billboard, which it in fact was, thanks to the brilliantly colored graphics on the exterior. Similarly, the calm symmetry of the longitudinal axis was destroyed on the exterior by lifting the front façade off the ground and suspending it between two pylons formed by the stairwell blocks. If the plan of the cafeteria that was added to this club in 1928 seems at first to be utterly lacking in such dynamic elements, it should be remembered that the use of shed roofs for the lower elements of the basilica-like structure would have relieved the sense of symmetry for the passer-by (Figs. 150-151).

The two ends of the Svoboda Club were also turned into pylons that framed an entranceway so dramatic as to overpower any sense of calm that the overall plan might give rise to (Figs. 152-153). Indeed, Melnikov took great pains to assure that the viewer would be struck most of all by the sculptural grouping of multi-colored masses at the ends and especially by the dramatic split stairway rather than by the traditional ground plan (Fig. 154).[69]

[69] An immediate and direct heir of the Svoboda Club is the project by M. P. Parusnikov, S. N. Kozhin, and I. N. Sobolev for the Ivanteevka Factory, 1927.

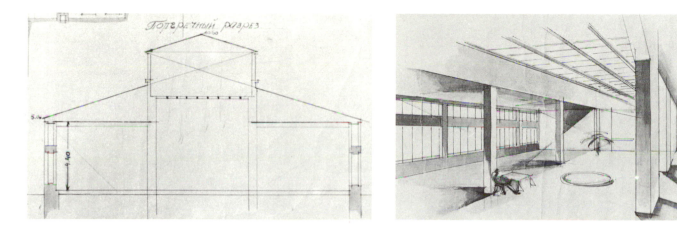

The Melnikov clubs all possess certain important common features. First, all are built around a single large auditorium, which can be subdivided—"transformed," as Melnikov put it—into a flexible *system* of smaller halls and assembly rooms. Second, all are designed to achieve the utmost economies in construction, employing inexpensive materials and simple techniques that semi-skilled and unskilled craftsmen could manage. Third, all are designed to minimize maintenance and heating costs—hence the resort to exterior stairways rather than large internal stairwells.[70]

The diversity among the various clubs is no less striking. The fact that none really builds systematically on those preceding it, though all were designed within the span of three years, underscores Melnikov's belief that

[70] See Khan-Magomedov, "Kluby segodnia i vchera," p. 4.

150. Cafeteria for the workers' club at the Frunze factory, 1928

151. Interior of projected cafeteria for the Frunze workers' club

152. The Svoboda factory club at the time of its completion. Photograph by Alexander Rodchenko

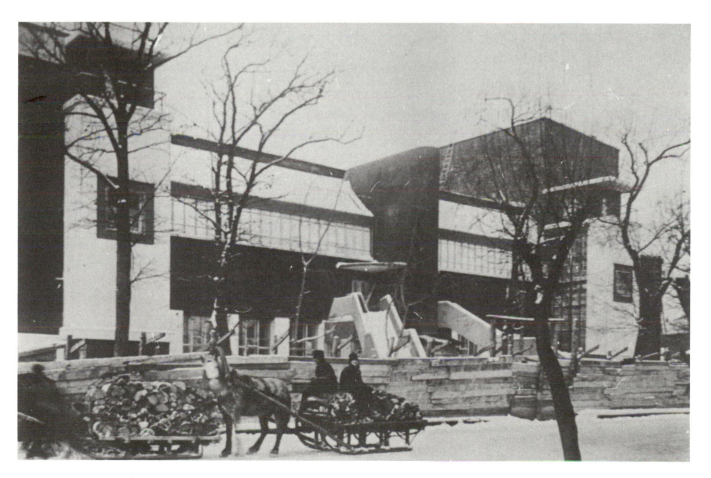

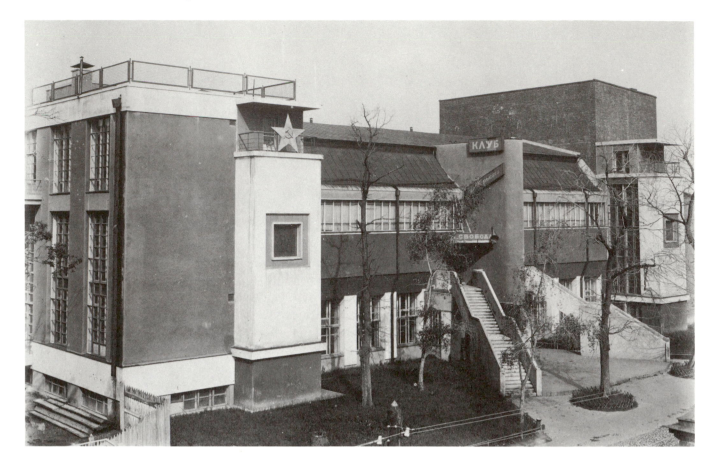

153. The Svoboda club at the time of its completion

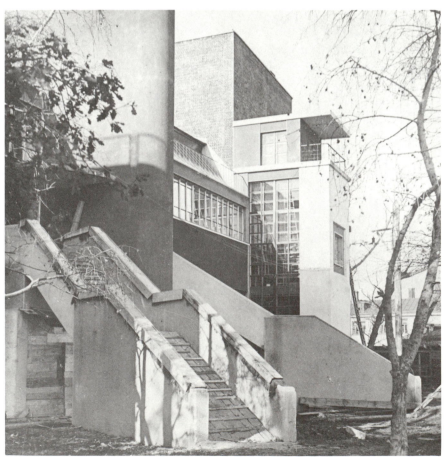

154. Entrance to the Svoboda club during construction

architecture must foster the utmost pluralism and sense of individual identity within the emerging urban labor force, even as it helps to expose the worker to the common aspirations of society. They suggest a greater regard for personality than for society, and a greater fear of impersonality than of atomization. The fact that all but one were actually constructed, while only two of the series of cylindrical projects undertaken in the same period were built, suggests that the trade unions that patronized avant-garde architecture during the last phase of NEP may have shared Melnikov's outlook.

Mighty new forces in Soviet life were soon to overwhelm those holding such views, and were to force both patron and architect to modify their independent attitudes or to abandon them entirely for the sake of a more collectivist orientation. The unions, from being a relatively autonomous series of diverse bodies possessing important decision-making powers, transformed themselves—not without compulsion—into executors of state policies in the labor area. Melnikov, too, redefined his posture in a number of respects during the following years, even to the extent that he could serve as head of a body set up explicitly to execute Party commands in the area of architecture. Yet, unlike the trade unions, his reorientation towards a relatively more collectivist stance did not prevent him from retaining a large measure of his accustomed autonomy and individualism, nor did he permit the public demands placed upon him to frustrate completely his longstanding desire to explore a diversity of architectural options. Indeed, his failure (or refusal) to redirect his energies unequivocally into any one channel and to defend that channel in terms of the emerging ideology of Stalinism was to be one of the leading causes of the sudden and premature termination of his professional career in 1937.

VII. Architecture for a Cultural Revolution

"We are 'evolving'—effortlessly evolving to a point where it will again be necessary to revolutionize to the roots. . . ."
—SERGEI EISENSTEIN, 1928[1]

"There is beginning a renovation of life through artistic forms."[2]
—KAZIMIR MALEVICH, 1928

RUSSIAN history of the years 1928-1931 seems not to have been cut to human scale. In order to deal with the merciless demands of forced-march industrialization, the brutality of the effort to drive peasants from private homesteads into collective farms, and the savage resistance of millions to such programs, the observer is all but compelled to conjure up vast and impersonal forces behind which to hide his own incomprehension. Thus, there exist learned hypotheses on "class war" and "generational conflict," not to mention yet broader notions of "the rise of totalitarianism" and the growth of the "cult of personality"—all of them somehow falling short of the scale of the events themselves. Where hypothesis ends, hyperbole begins. An American journalist called these years "Russia's Iron Age,"[3] while others have likened them to a cyclone, an earthquake, or a snowball careening out of control with mounting speed and destructive force. Soviet citizens themselves coined a more pointed phrase for them: the "Cultural Revolution."

Such metaphors are by no means inappropriate. Simultaneously with the consideration of the First Five-Year Plan at the Fifteenth Congress of the Communist Party in August, 1928, Russians began to advance, and in many cases act upon, the most radical proposals ever heard for the complete transformation of their society and culture. At the moment when private agriculture was being liquidated, Marxist millennialists called for the withering away of bureaucracy, ideologues in the research institutes demanded the withering away of the Academy of Sciences, educationists proposed the withering away of the schools, and a host of urban specialists foresaw the immediate withering away of that wicked legacy of capitalist Russia, the city.[4] Each would be replaced by wholly new, socialist forms appropriate to the industrial order, the foundations of which were even then rising from the rubble of revolution.

A wild orgy of negation and innovation engulfed broad segments of edu-

[1] Quoted by Yon Barma, *Eisenstein*, Lise Hunter, transl., Bloomington, 1973, p. 127.

[2] K. Malevich, *Essays on Art, 1928-1933*, Copenhagen, 1968, Troels Andersen, ed., vol. II, p. 16.

[3] W. H. Chamberlin, *Russia's Iron Age*, New York, 1933.

[4] On the anti-bureaucratic and anti-school currents, see Sheila Fitzpatrick, "Withering Away: State and Schools in the Period of the First Five-Year Plan," MS., Columbia University Seminar on Slavic History and Culture, April 26, 1974; and on the Academy of Sciences, L. Graham, *The Soviet Academy of Sciences and the Communist Party*, Princeton, 1967; on the anti-urban movement, see S. Frederick Starr, "Visionary Town Planning During the 'Cultural Revolution,'" *The Cultural Revolution, 1928-1931*, Sheila Fitzpatrick, ed., Bloomington, 1977.

cated society, affecting many who were later to suffer the consequences of their own enthusiasm. Modern architects, as the bearers of many of the most utopian hopes of the earlier phases of the Revolution, were particularly susceptible. To be sure, their professional societies and avant-gardist groups were in a shambles by 1928, the victims of their own inability to assimilate the large numbers of more conservative provincials recruited into the field through the open-admissions policies of the earlier twenties. Notwithstanding this, the modernists rose to the occasion with scores of the most far-ranging proposals of our century. In the process, however, they abandoned many of their own vaunted ideals.

Functionalism was an early casualty of this mood. Melnikov had never had much use for it, but now even its defenders abandoned the faith. In Leningrad, Iakov Chernikhov noted that few had ever been attracted to functionalism and concluded that this was because "Constructivism for the sake of Constructivism is an unnecessary and insignificant affair."[5] He turned instead to "architectural fantasies" that were reminiscent of Melnikov's sketches from 1925 and before. In Moscow, young architects grouped around Moisei Ginsburg exhorted their colleagues to "Think with the head and not the ruler";[6] following this advice, Ginsburg indulged in fantasies about portable towns grouping and regrouping at random across the landscape according to the whim of their "residents."

Melnikov and many other architects found nothing particularly startling about such flights of fancy, for during the Cultural Revolution the line between actual and ideal, present and future, became blurred. Only time and effort separated the two realms, and these were closely scrutinized in novels with titles such as *Forward, Oh Time* (Kataev) or *Energy* (Gladkov). The architect could leap into the future even more easily than the novelist. Sitting at his drafting table, he could simply obliterate present reality with a few strokes of the pen and create a new world with a few more strokes. In this Archimedean spirit, Melnikov for the first time began to produce bird's-eye drawings taken from some imaginary point in space. So as to underscore the newness of the world he was creating, he included immense dirigibles hanging in the air, and stretched the distance between viewer and building so as to reduce all people in the plan to the size of ants.

But there were limits to Melnikov's flight from reality. He could not favor the sleight-of-hand whereby Ivan Leonidov would destroy reality by drawing his buildings on black paper with white ink.[7] If for Leonidov this flight to Suprematism meant liberation from the NEP era's earnest functionalism, for Melnikov it meant insecurity. Under the pressure of the heightened tempo of life, he sought not some interplanetary void but a new connection with real objects. Spurred on by this desire, Melnikov expanded his earlier *architecture parlante* by blowing up ordinary objects into whole buildings that could serve as hyper-realistic talismans of the Cultural Revolution.

The first evidence of this new line of exploration came late in 1927, while the Five-Year Plan was still being debated behind closed doors in the

[5] Chernikhov, *Konstruktsiia arkhitekturnykh i mashinnykh form*, p. 13, 29.

[6] Comment by Ginsburg on project by N. Sokolov, reprinted from *Sovremennaia arkhitektura* in *Iz istorii sovetskoi arkhitektury 1926-1932*, p. 113.

[7] P. A. Aleksandrov and S. O. Khan-Magomedov, in their biography *Ivan Leonidov* (Moscow, 1971, p. 31), date this technique to Leonidov's unrealized government building for Alma-Ata, 1928.

Moscow offices of the State Planning Commission. This was the year in which buildings in the form of oil-fired burners and light bulbs were projected by entrants in the competition for the new Lenin Library.[8] Melnikov did not enter that competition, but for the first variant of the workers' club for the waterproof-rubber-shoe factory "Svoboda" he took the form of a water cart as his point of departure.[9] The flow of water from the nozzle was to be represented by a sweeping double entranceway without steps (Fig. 155), and the barrel itself would have formed an elliptical hall—convertible into a swimming pool—on the main floor and a large reception room without columns on the ground floor. Though the allusion to water was by no means blatant and the specific image of the water cart largely absorbed within the grandly classical conception of the building, the union's officials preferred a less venturesome structure. "Sick at heart," Melnikov compliantly redesigned the project, first in a form that retained the cylindrical "water cart" motif but with its end turned towards the street (Fig. 156), and finally in the form discussed in the preceding chapter.

155. Preliminary sketch of the entrance to the Svoboda factory club, 1927

[8] On these projects see Werner Hegemann, "Lenin Ehrung: Auditoriums, Glühbirne oder Luftballon," *Wasmuths Monatshefte für Baukunst*, XIII, 1929, pp. 129-32.

[9] K. S. Melnikov, "Zdaniia klubov," p. 3.

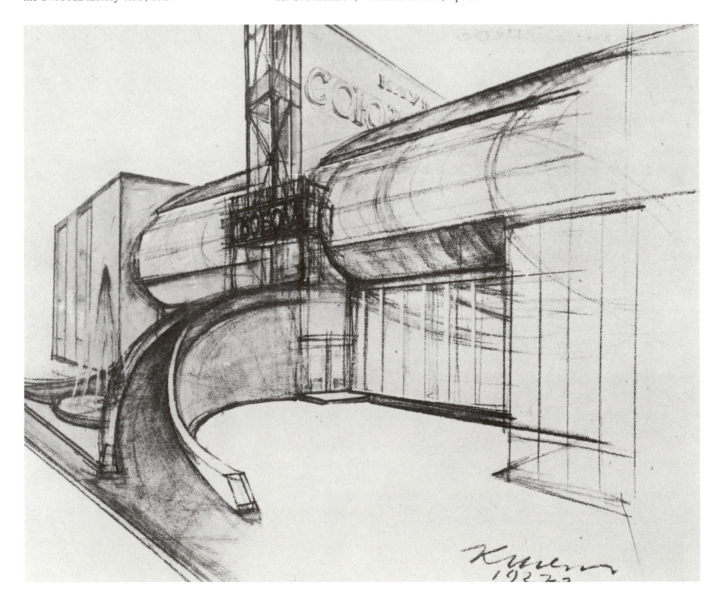

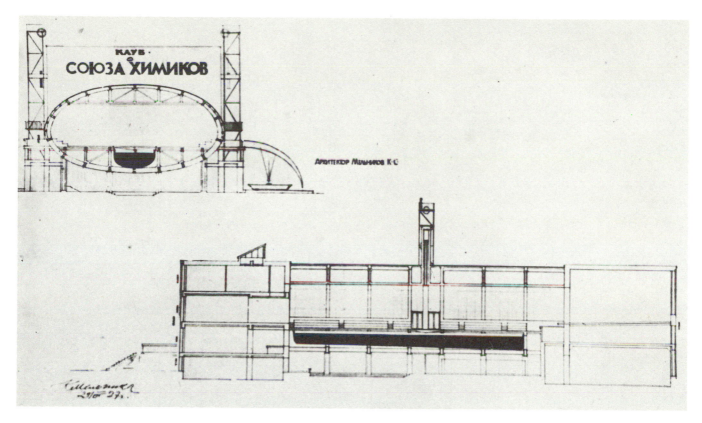

In the Svoboda Club the image of the water cart alluded to the factory's product but did not really "explain" the building to its users. In three further projects from the era of the Cultural Revolution, the literal borrowing of representational forms served to intensify the public's perception of the purpose and reality of the structure. One of these, the ranks of cylindrical "soldiers" designed as the headquarters of the Frunze Military Academy, has been touched upon already. Far more punctilious in its literalism was the large parking garage that Melnikov and his assistant, V. I. Kurochkin, designed for the State Planning Commission (*Gosplan*) in 1929. No longer content to allow the building to exhibit the actual work of moving and storing vehicles, Melnikov here demanded that the building actually *be* an automobile, with a block-long, one-storey "grill" framed at either end by two giant glassed "headlights" (Figs. 157-158). The weakness of such hyper-realism is that it blithely ignores the bounds of reality. Just as forty years later the giant football scoreboard projected for the Football Hall of Fame by the American architect Robert Venturi would shock, not with its factuality but with its glib translation of fact into illusion, so now Melnikov's *Gosplan* garage cavalierly took hold of a modest reality and blew it up to a scale that rendered it illusory, subjective, and surreal.

Due to financial constraints, only one of the building's "headlights" was actually constructed; hence, the second does not appear in the published elevation either. But the fact that even part of such a design would have been approved and actually built by the very agency upon which rested all hopes for transforming the economic and social life of the country, and hence one of the most powerful public organs on earth, is indicative of the extraordinary state of affairs induced by Stalin's "great leap forward." Melnikov's playing with reality did not stop with this, however. By early 1931, the feverish pace of change had further intensified and had given to

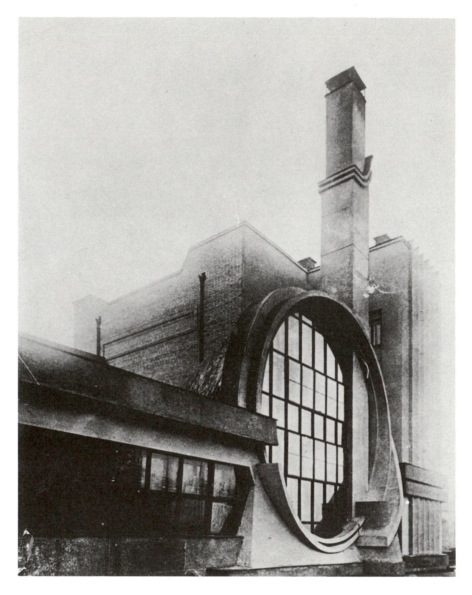

157-8. Parking garage for *Gosplan*, Moscow, 1929. The office block at the right in Ill. l58 was designed by Melnikov's assistant, V. I. Kurochkin

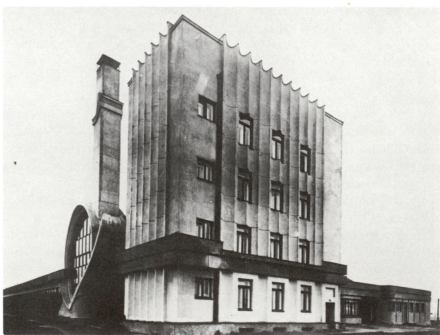

Moscow the aura of a great stage upon which everyone was participating in a titanic drama. At this moment, Melnikov was given the opportunity "of erasing all limits to the transformation of the real into the theatrical."[10]

The occasion was provided by the Moscow Regional Council of Professional Unions (MOSPS) when it decided to erect in the center of the city near the Dmitrovka (now Gorkii Street) a large theater complex.[11] Given the fact that several of Russia's most innovative theatrical directors and filmmakers were already experiencing grave difficulty by 1931, this may seem an inauspicious time to have been planning a great new theater. But the MOSPS theater was to be not a bastion of high culture but a proletarian temple in which the emerging society would be celebrated. This assignment captured Melnikov's imagination. In a statement that he submitted with his drawing, he indicated how he conceived the vast pedagogical function of the MOSPS theater:

"The aesthetic of theater is not beauty, but the force of maximal possibilities; that which people can only dream of in their everyday lives can be incarnated in the theater. To enable people to witness events that are changing with incredible speed and yet to remain alive and unharmed will be the goal of contemporary theatrical spectacles. . . .

"The theater is necessary so as to express with special force the moral substance (*ideinost*) of the moment, so the viewer, regardless of his individual desire, would be penetrated by one concentrated thought, along with everyone sitting with him. The theater must be convincing for everyone in it; if its persuasiveness is debatable and subject to differing interpretations, it would not be a theater.

". . . It is better not to build a theater at all if scenes [which call for it] do not have live water. *Sadko, Lohengrin, Rusalka* and *Tsar Saltan* will all make fresh appearances when [those figures] learn that there exists a theater for such fantastic realism."[12]

"Fantastic realism" indeed! Not only would the theater present visions of the future to refugees from the dispirited present, but it would project those visions outward onto the streets of Moscow. Designed in the form of a huge film projector, the theater would all but shout its function to passersby (Figs. 159-162). Those not actually drawn into its mechanized interior were not permitted to escape the theater's message, for dramatized representations of man's future would periodically sweep forth onto the street from one of several cavernous portals opening from the proscenium (Fig. 163). Using a device he had pioneered in the Makhorka pavilion and refined in the Paris garage, Melnikov brought the building's activity to the outside, so that even the casual stroller would be stunned by intimations of what history had in store for him.

The MOSPS competition was only one of several held during the First Five-Year Plan to elicit proposals for great auditoriums in which large theatrical spectacles and meetings could be held. A competition for the design of a "Theater of Mass Acts" in Kharkov attracted as much interest as the MOSPS project (including an entry from Walter Gropius), while another

[10] Quoted by Rodionov, "Konstantin Melnikov . . . ," p. 16.

[11] Sixteen projects were submitted to the competition by such diverse architects as Vladimir Shchuko, Vladimir Helfreikh, Nikolai Ladovskii, and Bruno Taut. A. Karra, "Arkhitektura teatra. Konkurs na proekt teatra MOSPS," *Stroitelstvo Moskvy*, 1932, No. 7, pp. 16-17. A. G. Mordvinov, "Dvorets truda MOSPS v Moskve," *Sovetskaia arkhitektura*, 1933, No. 1, pp. 56 ff.

[12] K. S. Melnikov, "Poiasnenie k proektu teatra im. MOSPS v Moskve," January 1931, MS, Melnikov archive, pp. 1-2.

159. Preliminary sketch for the MOSPS theater, Moscow, 1931

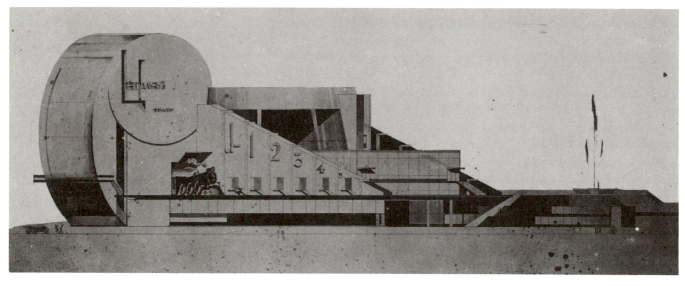

160. Project for the MOSPS theater, 1931

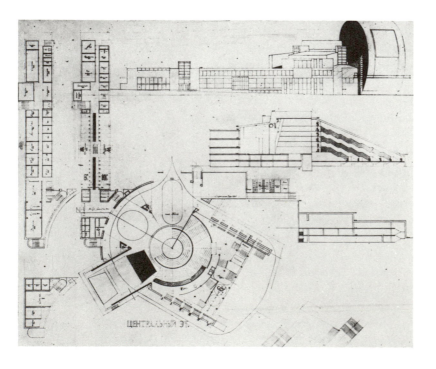

161. Plan, elevation, and section of the MOSPS theater complex, 1931

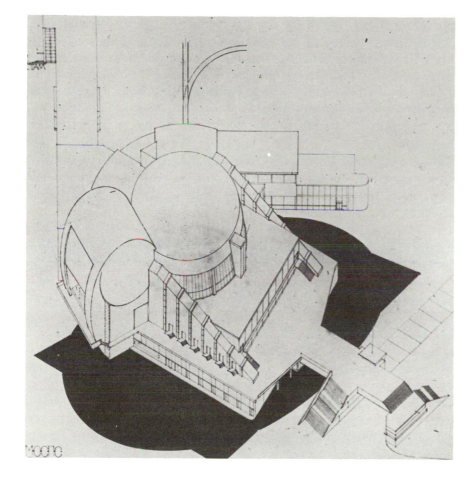

162. Axiometric drawing of the MOSPS theater

163. MOSPS theater, 1931, showing stage opening onto street

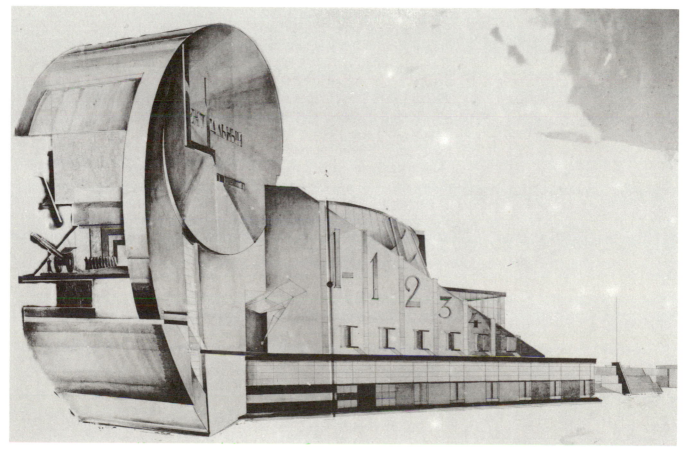

competition of 1931 involving a theater complex for the "proletariat" district in Moscow drew forth a host of interesting designs, among them an entry by the Vesnin brothers that was eventually built. Yet no one went to such extremes as Melnikov to get across to the public that the Cultural Revolution would enable everyone to participate in a national drama of deliberately conceived change. As he explained to the jury: "The essence of the architecture of my project is to consider the theater as a dynamic art. The actor is in motion, his voice is in motion, the scenes are changing, the light is in motion. In order to bring the viewer closer to all this, I put him, too, in motion."[13] But for all his talk of the "one concentrated thought" that would be communicated to each spectator, we are left ignorant of just what that great thought might be. In the MOSPS theater, Melnikov produced a teleological architecture, but he did not define the *telos*. In no way does the form of the building suggest that films shown within should conform to any one line, nor do any of the supporting documents submitted with the project specify that some productions might be more appropriately staged there than others.

The decision by the League of Nations in 1928 to build a headquarters in Geneva set in action a chain of events that resulted in Melnikov's elaborating in detail his version of the message the new art would convey, and in his devising an architecture to communicate it. Notwithstanding the participation of Commissar of Foreign Affairs, Litvinov, in certain conferences sponsored by the League in the late 1920s, that body remained in Soviet eyes a "Holy Alliance of the bourgeoisie for the suppression of proletarian revolution." When the most progressive architects of Europe flocked to submit projects for the capital of this bourgeois Holy Alliance, Moscow was outraged. To Russian leaders, the League of Nations competition proved only the "low creative and qualitative level of bourgeois architecture and underscored the absence [in the West] of profound architectural enquiry."[14] It was now the Soviet Union's turn to show how to design a world capital. Using the site of the Cathedral of the Resurrection built by Nicholas I as the architectural culmination of his policy of "Official Nationality," the Soviet State would erect its own national capital, a Palace of the Soviets.[15] In a two-phase competition stretching over three years, nearly every major Soviet and Western architect came forward with a proposal, among those submitting being Eric Mendelsohn, Auguste Perret, the American George Hamilton (who was one of the eventual winners), and Le Corbusier.[16]

Konstantin Melnikov participated in the first phase of the competition. Although his entry was rejected out of hand as the delirious fantasy of a fanatic and has been passed over in tangible embarrassment by recent au-

[13] Melnikov, "Poiasnenie k proektu teatra im MOSPS v Moskve," p. 2.

[14] N. Zapletin, "Dvorets sovetov SSSR," *Sovetskaia arkhitektura*, 1932, No. 2-3, p. 10.

[15] There exists a voluminous literature on this structure, upon which over 25 million rubles were spent with nothing more to show than the foundations, now used as an open-air swimming pool. The most comprehensive sources are *Dvorets sovetov: vsesoiuznyi konkurs 1932 g.*, Moscow, 1933; N. S. Atarov, *El palacio de los Soviets*, 2nd ed., Montevideo, 1945; and the study by N. Zapletin, cited above. Others, but by no means all, are conveniently listed in A. Senkevitch, *Soviet Architecture, 1917-1962*, pp. 166-73. The only study in English on the subject is Peter Lizon, *The Palace of the Soviets; Change in Direction of Soviet Architecture*, unpubd. Ph.D. diss., University of Pennsylvania, 1971.

[16] Le Corbusier's displeasure with the outcome led to a heated polemic with Commissar of Enlightenment Lunacharskii that is reprinted in A. V. *Lunacharskii ob izobrazitelnom iskusstve*, Moscow, 1967, pp. 488 ff.

thors seeking to revive interest in early Soviet building, it richly deserves study. In its concern to synthesize ancient and modern elements, in its restless groping for astonishing effects, in its gargantuan scale, and especially in its striving to make structures express political ideas, it anticipates all the major features of what is loosely termed Socialist Realism in architecture. Yet for all that, it offended no one more than the partisans of Socialist Realism, and not without cause. Just when the lofty idealism that had given rise to the search for a socialist culture showed signs of crystalizing into a canonical system of clichés, Melnikov made the outrageous claim that the same ideological ends that Socialist Realism was supposed to serve could be fostered better through different means.

The architect went to great lengths to insure that the form of his Palace of Soviets would be determined by its ideological purpose, which he believed was to apotheosize the Russian Revolution and its social consequences. Unlike nearly all the other entrants, including the ultimate winner, Boris Iofan, Melnikov did not consider it adequate merely to produce a structure of striking modernity or august and classical majesty, in hopes that the viewer would automatically equate modernity or majesty with the Soviet experience. Nor did he resort to the lazy device of simplifying that experience to such a degree that it could be encapsulated in one neat symbol, such as one entrant's ten-storey-tall head (male) gazing into the future, or the enormous statue of Lenin that was later added to Iofan's winning design at Stalin's behest. Rather, he employed the method of hyperrealism that he had developed in the Svoboda club, the *Gosplan* garage, and the MOSPS theater.

Given the intricate and abstract nature of his subject, however, he could not turn to anything as simple as a film projector or automobile grill. Even the hammer-and-sickle motif that he appears to have had in mind with the 1923 Palace of Labor project fell short of communicating the message of the Russian Revolution. Dissatisfied with more obvious solutions, Melnikov dipped into the language of politicized geometric forms that he had done so much to elaborate during the 1920s.

The most significant aspect of the Revolutionary experience Melnikov saw as the overturning of the Tsarist social order. Notwithstanding his own origins in that world, he represented it as having been utterly moribund. Beginning with the traditional symbol of death, the pyramid (Fig. 164), he proceeded to compare Tsarist society to that of Pharaonic Egypt by diagramming a social pyramid ranging downward from "Archon" through "Priests," "Aristocrats," "Gentry," and "Peasants" to "Slaves" (Fig. 165). Quite conveniently from the standpoint of architecture, Melnikov conceived the Russian Revolution as having split apart this pyramidal order and upended it. Here, finally, was a dynamic form with which one could work! It remained only to transform the pyramid into a cone and the basis for a "palace monument" was at hand (Figs. 166-168).

Various other entrants in the competition, including architects as different as Eric Mendelsohn and Boris Iofan, employed pyramids or cones, usually in their most static, stepped form, with all diagonals converted to verticals and horizontals. In contrast, Melnikov expended great effort to impart dynamism and thrust to the up-ended "revolutionary" side of the cone (Figs. 169-170) and also to stress the broad, "popular" base of the other half (Fig. 171). To do this, he borrowed liberally from his own Rusakov Club and also from the eighteenth-century master Etienne

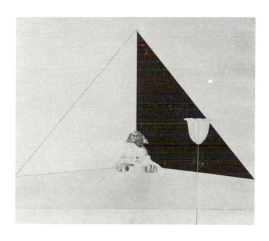

164. The pyramid as symbol of all old regimes

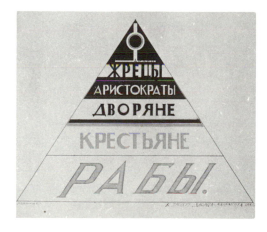

165. Social categories comprising prerevolutionary society. (From bottom to top) slaves, peasants, gentry, aristocrats, high priests, archon

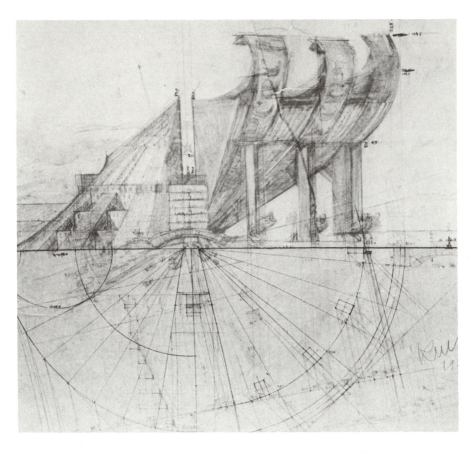

166. Sketch of the Palace of Soviets, showing how the pyramidal form of the moribund society was split asunder vertically by revolution and the parts reassembled upside down

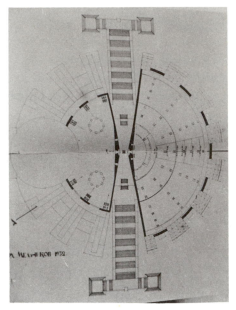

168. Plan for the Palace of Soviets, 1932

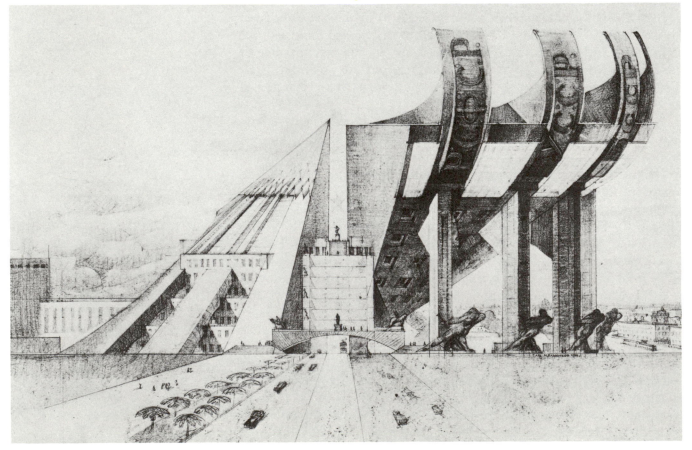

167. Project for a Palace of Soviets, 1932

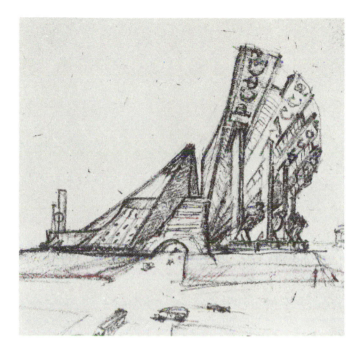

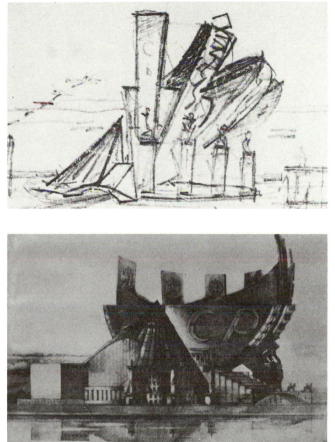

169-70. Sketches of variant forms for the Palace of Soviets, 1932

171. View of proposed Palace of Soviets from behind the proscenium, looking towards the seating area

Boullée, whose direct influence is felt not only in the gargantuan scale of the monument and in the technique employed for certain of the renderings (Fig. 172) but also in the very form of the standing half of the cone (Fig. 173).

Why was this project rejected by the jury and then systematically ignored in all of the major publications on the competition issued at the time? Upon examination, several of the most obvious explanations turn out to be unconvincing. Surely, it was not because Melnikov conceived his entry as a program piece, an "architectural poem," as he proudly dubbed it, for a substantial number of the entries, including the winning design and many of the naïve efforts submitted by amateurs, made good use of leaden symbols and heavy-gaited allusions. Nor could it have been due to the jury's fear that Melnikov's palace would be structurally unsound, for, on the one hand, the architect had submitted quantities of engineering data to prove the technical feasibility of his project, and, on the other, dozens of entries that did receive publicity presented structural challenges of equal magnitude. Nor could the cause have been Melnikov's heavy debt to Boullée, since his old mentor Shchusev received good marks for an entry that was unabashedly plagiarized from the same source. Nor could the screen of silence have been due to the "formalism" of Melnikov's approach, for other equally formalistic projects were published.

Lacking direct evidence from the jury, one may surmise that an important reason for the censorship of Melnikov's project stemmed from its objectionable politics. Taking his formulation literally, as he insisted we do, it can be seen that once the Revolution had turned the old society upside

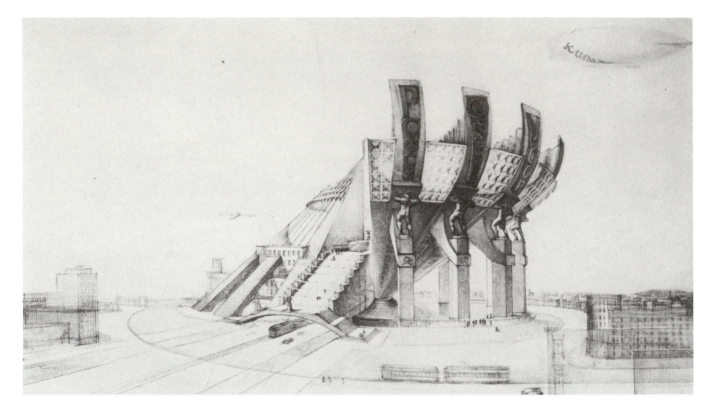

172. Palace of Soviets, 1932

down, the former slaves and peasants emerged on top, crushing the archons, priests, and bureaucrats beneath. A fine idea, but one that afforded no position to leadership, whether that of Lenin, the Party, Stalin, or even the State. In his haste to define that "one concentrated thought" towards which history was moving, Melnikov had presented himself as an anarchist!

If from the perspective of the jury it might have appeared that Melnikov committed one form of heresy, from the standpoint of Melnikov himself he had committed another, by losing sight of the individual human being whose welfare had been his steady concern throughout the many projects of the late twenties. No less than Iofan's winning design, Melnikov's Palace of Soviets deals with humanity as a mass. The scale is deliberately inhuman, and where mortal forms enter the composition at all it is in the role of caryatids five stories tall. The few people introduced in the drawings are either huddled together beneath the immensity of the inverted cone or crammed inside machines—cars, trains, and streetcars—rolling by the Palace. Those not utterly humbled by traversing the vast open space surrounding the edifice would be struck dumb as they ascended the eight-story entranceway.

Such extreme impersonality and mechanization, manifested also in the MOSPS theater project, was not without precedent in Melnikov's earlier work, as the parking garage over the Seine and the Palace of Labor attest. But neither of these buildings had made any claim against ordinary human experience, the former because it was designed to deal only with machines —albeit animate ones—and the latter because people had been conveniently excluded from every one of the drawings. The Palace of Soviets went beyond both; it moved the throngs around like machines and at the same time sought to awe them as people. Writers and literary critics of the day were struggling to express the vast and impersonal mobilization of so-

ciety that Stalin's Cultural Revolution was bringing about. At the same time that writers adopted the notion of "social command" (*sotsialnyi zakaz*) in their work, Melnikov had arrived at a powerful if unorthodox statement of a similarly collectivist principle in architecture.

There is evidence to suggest that Melnikov's belief in the faceless might of the Cultural Revolution was qualified, and that his long-term commitment to architecture as a means of celebrating and uplifting the individual personality remained at least partially intact. The simultaneous and powerful attraction of these polar opposites set up in him a profound tension that he endeavored both to express and to resolve in works undertaken between 1928 and 1932.

The growth of this tension between individual and social betterment can be traced by comparing a project completed before the beginning of the First Five-Year Plan and one designed at its height, in 1929. The first was one of Melnikov's last workers' clubs, commissioned in 1927-1928 by the Chemical Workers' Union for the "Pravda" china factory in the village of Dulevo, outside Moscow.[17] At first glance, this structure appears as just one more nondescript building in the functionalist style of the twenties

[17] "M," "Novye kluby u khimikov," *Stroitelstvo Moskvy*, 1928, No. 1, pp. 18-20; Melnikov, "Zdaniia klubov," p. 3.

173. Palace of Soviets. View of proscenium entrance

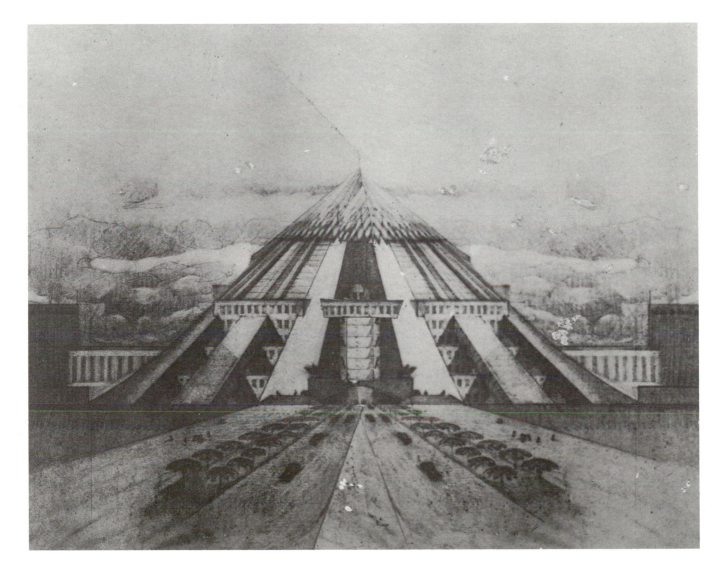

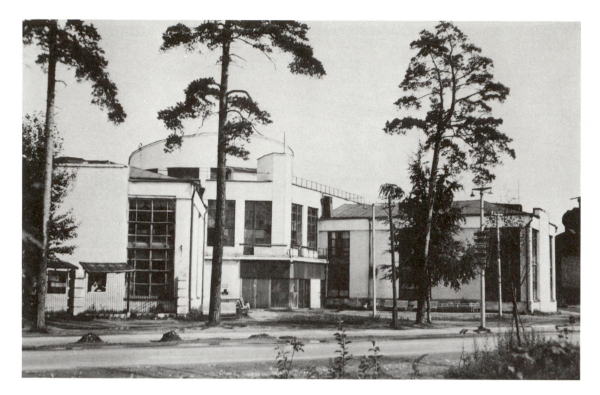

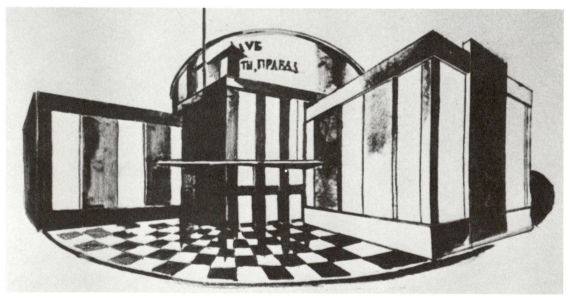

174. Workers' club for the Pravda china factory at Dulevo, near Moscow

175. Workers' club at Dulevo

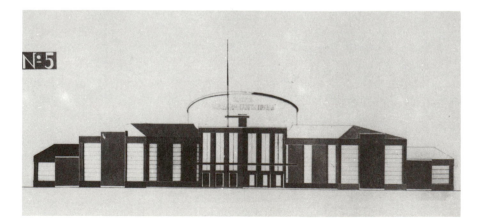

176. Elevation of workers' club at Dulevo

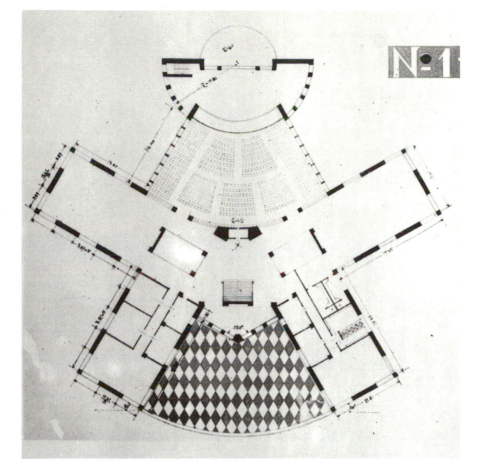

177. Plan of workers' club at Dulevo, showing anthropomorphic form of the structure

(Figs. 174-175), with Melnikov's signature evident only in the cylindrical meeting hall on the second floor and in the single axis of symmetry running longitudinally through the structure. A closer look reveals strong elements of Romantic Classicism (Fig. 176), especially in the two protruding wings linked by a cupola which recalls the Moscow estate of Liublino designed by the architect I. Egotov in 1801.

Upon still closer examination, it turns out that the building conforms precisely to the general form of a human being, with every element of the floor plan correlated with a feature of the body (Fig. 177). The relation of this motif to certain metaphysical issues with which Melnikov was apparently very much concerned will be considered in the concluding chapter devoted to the theme of death and rebirth in his architecture. For now, let us note only that the use of the human form as a basis of design is by no means new in the history of architecture, its antecedents stretching back to the Renaissance and beyond. What is striking is that Melnikov would resort to so ancient a device to stress the role of the individual amid Russia's dawning Cultural Revolution.

Melnikov wanted his architecture to underscore the human dimension of history. In the club at Dulevo he took this desire to its logical limit by transforming a building into a human being. So completely did he contain his Futuristic passion for dynamism, in fact, that the finished building is stolid to the point of blandness. In sharp contrast is his Monument to Christopher Columbus (Fig. 178) for the harbor of Santo Domingo (Figs. 179-180), designed in 1929 amid the most frenetic phase of the Cultural Revolution and entered in an international competition sponsored by the Pan

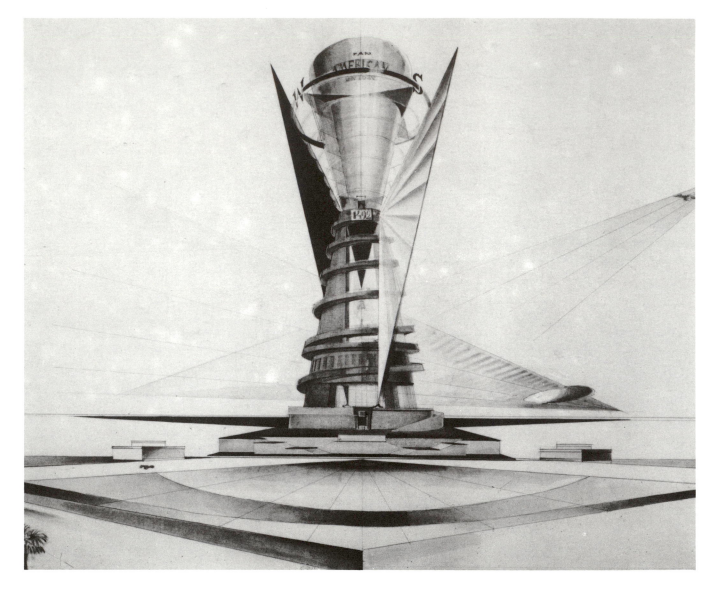

178. Project for a monument to Christopher Columbus, to be constructed at Santo Domingo, 1929

American Union. Here one feels all the dynamism that was absent in the more humane Pravda club of one year earlier. The dynamic elements are impersonal, however, and stand in open and unresolved conflict with the passive image of the single man, Columbus, to whose memory the monument was dedicated.

Given the rules governing the first stage of the competition, it is surprising that more architects did not sense an antagonism between the need to pay homage to the simple Genoese mariner and, as the competition rules stated, "to fire the beholder with an eager interest in things American"[18] The reason they did not is that most participating architects dispensed entirely with Columbus and turned headlong to the serious business of creating artificial mountains or spiral ziggurats, or of recreating Tibetan temples, Moorish castles, and Eiffel towers. Melnikov neither ignored the man Columbus nor neglected to celebrate the New World's vitality. Moreover, his fantastic kinetic sculpture (Figs. 181-182) succeeded in attracting the

[18] Albert Kelsey, ed., *Program and Rules of the Competition for the Selection of an Architect for the Monumental Lighthouse . . . to the Memory of Christopher Columbus, Together with the Report of the International Jury*, 2 vols., Washington, 1928-1930, I, pp. 17-20.

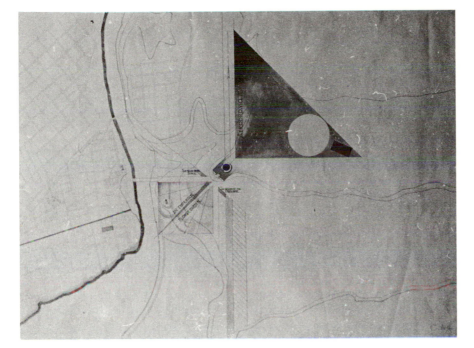

179. Site plan for monument to Christopher Columbus, 1929

180-1. Elevation and section of monument to Christopher Columbus, 1929

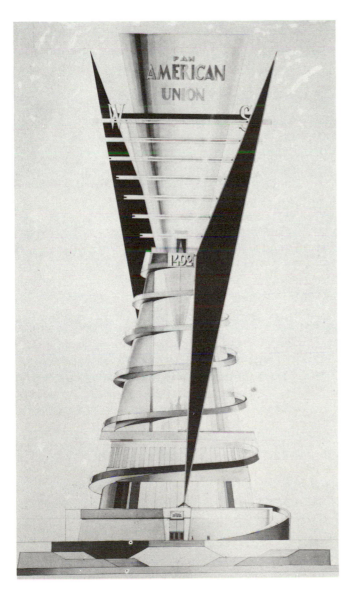

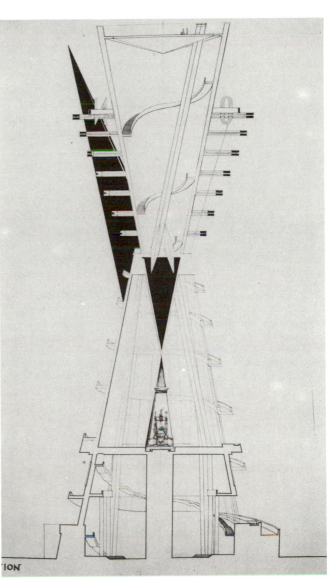

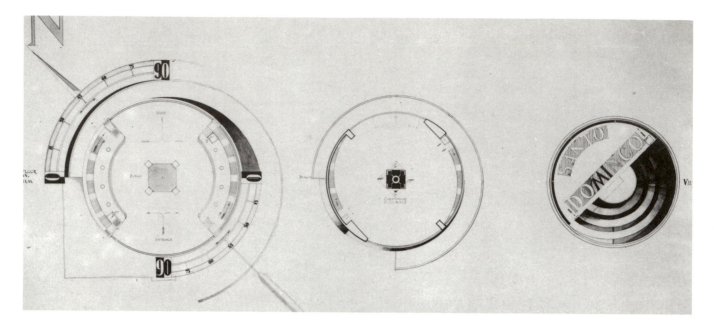

182. Plan of monument to Christopher Columbus

183. Description of Columbus monument, as published in Albert Kelsey, ed., *Program and Rules of the Competition for the Selection of an Architect for the Monumental Lighthouse . . . in the Memory of Christopher Columbus, Together with the Report of the International Jury*, 2 vols., Washington, 1928-1930, I, p. 19

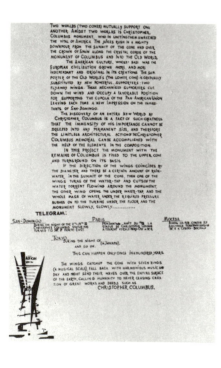

lion's share of attention at the exhibit of entries held in Madrid and in shocking the jury to such a degree that, as the coordinator of the competition declared in a private note to the architect, "it was considered too risky to honor [your project] with a prize."[19] The English text submitted with the drawings enables us to appreciate the juror's trepidations (Fig. 183):

TWO WORLDS (TWO CONES) MUTUALLY SUPPORT ONE ANOTHER. [BETWEEN] TWO WORLDS IS CHRISTOPHER COLUMBUS, WHO, IN UNITING THEM, AWAKENED THE VITAL[ITY] OF AMERICA. THE JUICES RUSH IN A MIGHTY DOWNPOUR FROM THE SUMMIT OF THE CONE AND OVER THE CROWN OF SPAIN ALONG THE CRYSTAL COROS OF THE MONUMENT OF COLUMBUS AND INTO THE OLD WORLD.

THE AMERICAN CULTURE, WHOSE BASIS WAS THE EUROPEAN CIVILIZATION, GROWS MORE AND MORE INDEPENDENT AND ORIGINAL IN ITS CREATIONS. THE SUPPORTER OF THE OLD WORLD (THE LOWER CONE) IS GRADUALLY SUBSTITUTED BY NEW POWERFUL SUPPORTERS: TWO FLYAWAY WINGS. THESE MECHANIZED SUPPORTERS CUT DOWN THE WIND AND OCCUPY A FAVORABLE POSITION FOR SUPPORTING THE CUPOLA OF THE PAN-AMERICAN UNION LEAVING EACH TIME A NEW IMPRESSION ON THE INHABITANTS OF SAN-DOMINGO.

THE DISCOVERY OF AN ENTIRE NEW WORLD BY CHRISTOPHER COLUMBUS IS A FACT OF SUCH GREATNESS THAT THE IMMENSITY OF HIS IMPORTANCE CANNOT BE SQUEEZED INTO ANY PERMANENT SIZE, AND THEREFORE THE LIMITLESS ARCHITECTURAL ACTION OF THE CHRISTOPHER COLUMBUS MEMORIAL [MUST] BE ACCOMPLISHED WITH THE HELP OF THE ELEMENTS IN THE COMPOSITION.

IN THIS PROJECT THE MONUMENT WITH THE REMAINS OF COLUMBUS IS FIXED TO THE UPPER CONE AND TURNS ROUND ON ITS BASIS.

IF THE DIRECTION OF THE WINGS COINCIDES BY THE DIAMETER AND THERE BE A CERTAIN AMOUNT OF RAINWATER IN THE SUMMIT OF THE CONE, THEN ONE OF THE WINGS TURNS OFF THE WATER-TAP AND CUTS OFF THE WATER TORRENT FLOWING AROUND THE MONUMENT. THE OTHER WING OPENS THE UNDER WATER-TAP AND THE WHOLE MASS OF WATER UNDER THE REQUIRED PRESSURE RUSHES ON TO THE TURBINE UNDER THE FLOOR AND THE MONUMENT SLOWLY, SLOWLY. . . .[20]

[19] A. Kelsey to K. S. Melnikov, undated Russian translation, Melnikov archive.
[20] Kelsey, *Program and Rules . . .* , I, pp. 97-99.

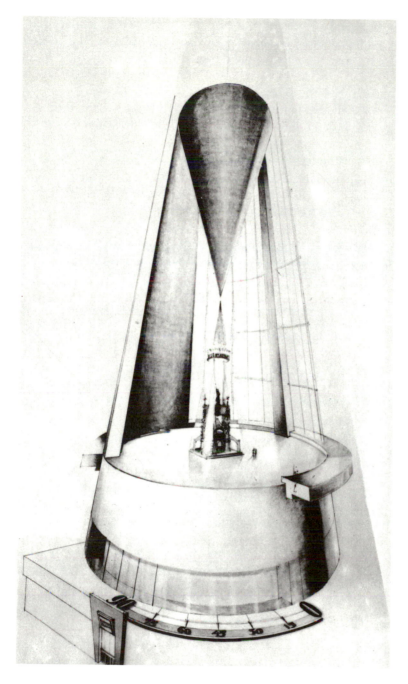

184. Monument to Christopher Columbus.
Detail of interior

At the very core of this outlandish winged machine stands Columbus.
Lost in time and place under a baroque baldachin, he seems pitifully out of
scale with the monument surrounding him. But the man Columbus is there
(Fig. 184). Knowing full well that his mighty contrivance had no need for
this forlorn creature in order to function, Melnikov could neither dispense
with Columbus nor construct the monument so as to make him a convinc-
ing part of the whole. Man *should* be the measure of all things, but some-
how he was not.

This pathetic concern to integrate the individual human being into the
technological world he had created was common to many avant-garde Rus-
sian artists of the Revolutionary generation who were trying to orient them-
selves amid the turmoil of the Cultural Revolution. If a few could confi-
dently cheer Maiakovskii's statement that "there are plenty of people
studying the anatomy of man, . . . but we [still] don't know the anatomy of

a steamship,"[21] there were countless others who sympathized deeply each time the actress-heroine of Iurii Olesha's play *A List of Blessings* (*Spisok blagodeianii*) compulsively dusted off her adored portrait of Charlie Chaplin. One to do so was Vladimir Tatlin. High in the gate-tower of Moscow's ancient Novodevichei convent he labored for two years to develop a bentwood and fabric "bird"—the "Letatlin"—that a single man could propel through the air by flapping its graceful wings. Asked by a reporter from *The Evening Moscow* (*Vechernaia Moskva*) why he had gone to such pains, Tatlin explained that it was to give back to mankind the feeling of flight ". . . that we have been robbed of by the mechanical flight of the airplane."[22] But just as Melnikov's Columbus was lost in a world of his own making, so Tatlin's "Letatlin" could not fly.

Both Tatlin's machine and Melnikov's monument dramatically posed the problem of the place of the individual in a collectivized world of technology, but neither resolved it. Nor could this have been done without altering drastically either the individual or his environment. By 1929, the environment was in the midst of the most rapid transformation in history, and few doubted that the results of the upheaval would be irreversible. Aside from those dissidents who persisted in expressing their opposition to the course the country had taken since the initiation of the Five-Year Plan and of collectivization, most public figures came to see the task at hand to be to adapt the citizenry—and themselves—to this changed world.

For many, this process of adaptation entailed profound soul searching. Thus one well-known novelist, Iurii Olesha, penned essays on how "The Necessity of [Self] Reconstruction is Obvious to Me,"[23] while another novelist, Bruno Jasienski, wrote a whole volume on the theme *A Man Changes His Skin* (*Chelovek meniaet kozhu*, 1934). Others, including most planners and architects, framed the problem in the more public form of "How can I facilitate the process of self-reconstruction and skin-changing for others?" So intensively was this task pursued that the most innocent ventures were seized upon and evaluated for their usefulness in accomplishing it. Thus, the development in 1929 of a site plan for Moscow's proposed Central Park of Culture and Rest turned into an exercise in the creation of the "New Soviet Man." When Melnikov and some dozen other leading architects responded to the invitation to submit a proposal, they were exhorted to design the park in such a way that it would: ". . . raise the general culture of the masses and most of all help them to understand the particular issues and tasks of the present stage in the struggle for socialism, . . . propagandize the international meaning of the U.S.S.R., . . . openly demonstrate the growth of our military preparedness, and prepare the laborers for national defense."[24]

A tall order, but not yet one to elicit from Melnikov an answer to the problem of how best to adapt the individual to the new society. His design for the banks of the Moscow River is by no means devoid of interest, with its shell-shaped embankment and formal canals juxtaposed to rustic areas on the slopes of Lenin Hills (Fig. 185). The fountain that he had designed

[21] Akademiia nauk SSSR, *Novoe o Maiakovskom*, *Literaturnoe nasledstvo*, vol. 65, Moscow, 1958, p. 80.

[22] Kornei Zelinskii, "Letatlin," *Vechernaia Moskva*, June 4, 1932, reproduced and translated in Andersen, *Vladimir Tatlin*, pp. 77-80.

[23] Iu. Olesha, "Neobkhodimost perestroiki mne iasna," *30 dnei*, 1932, No. 5, p. 67.

[24] L. B. Lunts, "Tsentralnyi park kultury i otdykha," *Sovetskaia arkhitektura*, 1932, No. 1 (7), p. 35.

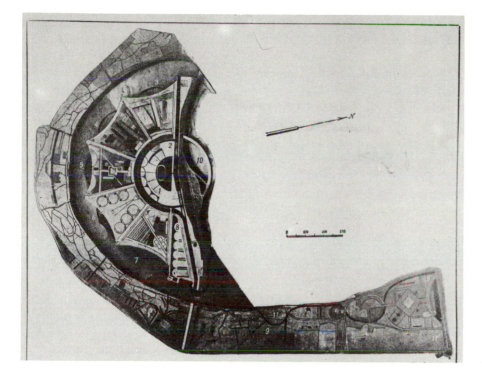

185. Plan for Central Park of Culture and Rest, Moscow, 1929

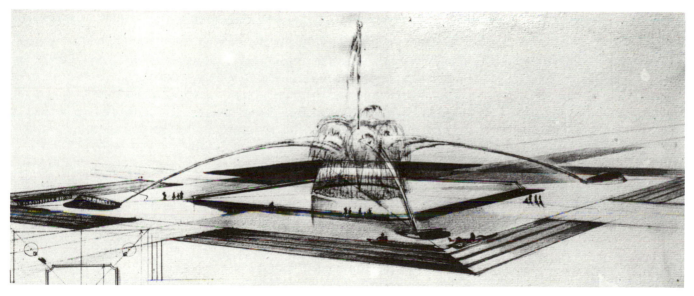

186. Fountain for the Central Park of Culture and Rest, Moscow, 1929

earlier for the same park is also of interest (Fig. 186), with its four jets of water forming an air-purifying arch overhead.[25] But contemporary critics who panned the lack of a clear social program in both projects were not off the mark.[26]

Some months after he had completed his entry to the competition for a monument to Columbus, Melnikov found opportunity for a headlong assault on the problem. The occasion arose when an innocuous proposal to build a resort of one-family dwellings (*dachi*) outside Moscow metamor-

[25] K. S. Melnikov, "Poiasneniia k proektu fontana dlia parka kultury i otdykha im. Gorkogo v Moskve," MS, 1929, 1 p., Melnikov archive.

[26] M. Korzhev and L. Lunts accused Melnikov of adopting a "devil-may-care" attitude and of producing a design "unsuitable for a proletarian park." "Tsentralnyi park kultury i otdykha," *Stroitelstvo Moskvy*, 1931, No. 12, p. 31.

phosed into a grandiose scheme to create an ideal socialist community. The original idea, proposed in *Pravda* in mid-1929, called only for the construction of a garden suburb in a wooded area between the villages of Tarasovka and Reshleino along the Northern Railroad line, fifty kilometers from Moscow.[27] The Moscow trade unions that spearheaded the plan hoped to save the cost of sending members all the way up to the great pre-Revolutionary resorts in the Crimea for vacations, while the regional economic administrations that organized the competition found merit in a project that promised to capitalize on the successful experience of Stockholm, with which it was closely acquainted.[28] Such was the original plan, but scarcely had it been announced than architects turned it into an excuse to elaborate their ideas on the future of cities and on the character of the emerging life of society and of the individual. For them, the competition could not have come at a more opportune moment. Several times during that same year, 1929, architects had mounted the podium at the Communist Academy to debate the need to resettle the entire population in small towns;[29] others were exploring means of reducing the size of large cities at the request of the Supreme Council of the National Economy;[30] while still others were mulling over visionary schemes for agro-cities, ribbon towns, and even portable settlements to be built under the patronage of the Building Section (*Stroisektor*) of the State Planning Commission (*Gosplan*).[31] Suddenly a chance to translate dream into reality had appeared.

The formal requirements of the "Green City" competition were minimal.[32] Except for the stipulations that the town accommodate up to 100,000 people; that it include recreational, cultural, and child-care facilities; that cooking and transportation be collectivized; and that 11,000 of the 15,000 hectares designated for the town be left in forest, the architects were given a free hand. This permitted a select group of leading Moscow architects to air their wildly divergent schemes.

Of all of the entries submitted, three were singled out by the jury and critics alike as being the most worthy of serious study: one by the Constructivist Moisei Ginsburg and his student Mikhail Barshch; another by the formalist theoretician Nikolai Ladovskii; and Melnikov's. Other projects may well have been more workable than these, particularly one received from the Americanophile Daniel Friedman, but they were simply ignored.[33] By general agreement, Ladovskii's elegantly drafted proposal, with its cleverly contrived system of primary rail lines and secondary automobile roads and its handsome residences for two or eight persons each, best met the terms of the competition. Awarded first prize, the plan went immedi-

[27] M. Koltsov, "Zelenyi gorod," *Revoliutsiia i kultura*, 1930, No. 2, pp. 41-42.

[28] L. Vygodskii, "Novosti gradostroitelstva i planirovki," *Kommunalnoe khoziaistvo*, 1929, No. 7-8, pp. 134-37.

[29] See Iu. Larin's presentations on this issue, *Zhilishche i byt*, Moscow, 1931, pp. 6 ff.

[30] L. Sabsovich, *Gorod budushchego i organizatsiia sotsialisticheskogo byta*, Moscow, 1929, pp. 9-10.

[31] S. N. Pokshishevskii, *Promyshlennyi gorod, ego raschet i proektirovaniia*, Moscow, 1932, p. 94. For a review of such projects, see S. Frederick Starr, "Visionary Town Planning During the 'Cultural Revolution.' " *loc.cit.*

[32] "K," "Voprosy planirovki; opyt sotsialisticheskogo goroda-sada," *Stroitelstvo Moskvy*, 1930, No. 5, pp. 450 ff.

[33] One of the few treatments of Friedman's proposal is by L. Nappelbaum, *Iskusstvo v massy*, 1930, No. 6 (14), p. 22.

ately to the builders, who actually erected a number of housing units before the project was dropped.[34]

Far more controversial was Ginsburg and Barshch's scheme for a linear city. Based on the recently expounded theories of the Russian sociologist, M. A. Okhitovich (which were drawn in turn from works by the French economist, Charles Gide), the Ginsburg-Barshch plan would have cut a pair of automobile roads through the territory and strung houses along them, with public facilities at appropriate intervals. The series of buildings planned by Ginsburg and Barshch for their Green City have attracted attention because they are among the better examples of work by Soviet architects in what was to become known as the "International Style," but their implied social outlook is no less striking. Abandoning his earlier passion for functionalism and social engineering on a mass scale, Ginsburg here emerged as the enemy of all compulsion in society. In the plan as a whole he opposed "natural" order to geometric order; in transportation he favored the individualistic private automobile over the scheduled train or bus; in housing, he designed dwelling units for individual families, placing a sliding door between areas designated for husband and wife, so that "ties among people, even among man and wife, will be voluntary. . . . "[35] On all these points, Ginsburg shows himself to have moved squarely into the nineteenth-century anarcho-individualist tradition. His project, like those of his French forebears, was intended not merely to achieve efficiency but also to foster directly the flowering of human personality.[36]

Two different objections were raised to the Ginsburg-Barshch project. On the one hand, the more practical members of the jury were angered because the architects had flaunted the competition rules by not developing public transportation more, by relying excessively on Okhitovich's "unacceptable" ribbon scheme, and by adding a sawmill to the town. On the other hand, their proposal was justly faulted by more radical critics, both for its individualism and also because it told where society was moving but not how to get there—it naïvely assumed that, simply by being moved into such a community, Moscow workers would automatically become integrated into the new socialist way of life. This was precisely the point that bothered Melnikov. It was not enough, he felt, to draft a blueprint for utopia; one had also to draw up a precise map of how to get there. In his own entry to the Green City competition, Melnikov presented both the blueprint and the map, and in the end brought down upon himself such a barrage of indignation as to make the attacks on Ginsburg and Barshch seem mild indeed.

Every aspect of Melnikov's proposal was made to serve an objective that had been muted in the Ginsburg-Barshch and Ladovskii projects, namely, to use planning and architecture as a means of developing in the town's residents a positive orientation towards the collective life of the community. Ginsburg and Barshch did not completely reject this goal, of course, but their project did include several elements that tended in the opposite

[34] Nappelbaum, p. 23; "Voprosy planirovki . . . ," pp. 453-54; for a photograph of one of Ladovskii's housing units, see Leonie Pilewski, "Neuer Wohnungsbau in der Sowjetunion," *Die Form*, 1931, No. 3, p. 102.

[35] "Voprosy planirovki," p. 453.

[36] Quoted by Nappelbaum, p. 18. This important concern of Ginsburg's is ignored in Kopp's well-illustrated but misleading discussion of the project, *Town and Revolution*, pp. 178 ff.

direction. Their linear plan with no central point of assembly, their treatment of the railroad station as a problem in moving people from public to private worlds with a minimum of friction, and their use of one-family dwelling units and multi-family units with separate outside entrances for each—all reflect the thinking of people moving away from the collectivization of life rather than towards it. In the same way, Ladovskii's infatuation with the private automobile, and especially his advocacy of one-family cabins, each equipped with full kitchens, went far towards diluting the impact of the communal facilities he included.[37]

Paradoxically, it was the individualist Melnikov who was now the most uncompromising in his communitarianism. From the minute the visitor arrived by train, he would be swept into the collectivity: "The contemporary station is not only a place for embarkation and debarkation of passengers; it has a large social function. The station is . . . a place for public meetings and possesses cultural and welfare functions. . . ."[38] At a time when literally millions of Russian peasants were shifting aimlessly by train across the land in a desperate attempt to find havens amid the upheavals caused by collectivization, this was, to say the least, an understatement. Whatever the cause, Melnikov's "Vauxhall-Kursaal" looked more like a stadium than a station and was to be equipped with multi-level platforms, rostra, etc., so as to enable some 2,000 people to interact with one another as they entered the collectivized Green City (Figs. 187-188).

Leaving the train, one would have gone by public transport to one of the several large hotels. Automobile roads were included but greatly deemphasized, since electric trains would run everywhere. For recreation, there would be ample hiking trails in the forest southwest of the main transportation ring (Figs. 189-190), but at the same time it was hoped that many visitors would avail themselves of the chance to meet fellow-residents on the promenade running along the top of the peripheral ring like the walk atop the walls of some medieval city. In addition, barge rides on the canal paralleling the transportation ring would provide yet another combination of transportation and social intercourse.

Melnikov projected two types of hotels: district "cottage" hostels and a large central facility. Both surpassed anything Melnikov had done previously in the extent of the collectivization of their amenities, with fully communal kitchens and large common corridors *à la Fourier* providing points at which neighbors could become acquainted (Figs. 191-192). Such arrangements, of course, were common to every collective housing scheme of the time. Thrust onto Russian workers accustomed to very different domestic circumstances, they account for the hostility of many average people to the utopias planned for them by intellectuals who chose to live elsewhere. The distinctive aspect of Melnikov's utopia is the attention he gave to the process of transition from individual to collective existence and the solicitude he showed for the person undergoing it. To this end, he minimized the area within each "cottage" apartment so as to encourage the inhabitants to leave the hearth, but at the same time made them extremely comfortable and secure (Fig. 193). Likewise, while stressing the role of the public galleries, he at the same time provided private entries to each apartment. And rather than force individuals into an undifferentiated sea of col-

[37] Voprosy planirovki . . .," p. 454.
[38] K. S. Melnikov, "K proektu 'zelenyi gorod,' " MS, 1929, Melnikov archive.

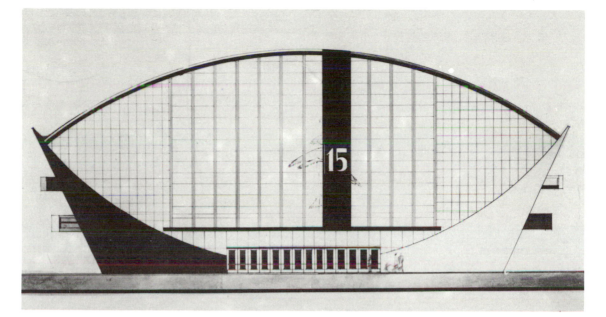

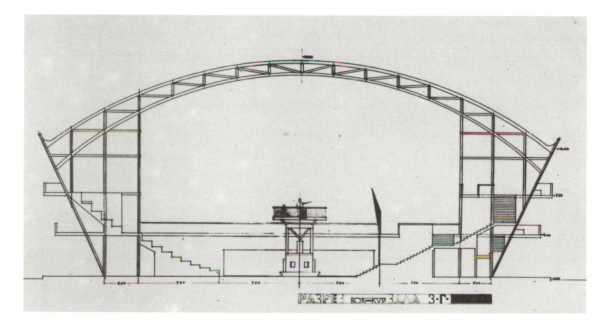

lective life in the vast galleries, he conceived the galleries as being fluid spaces, to be divided up informally by plants, hanging nets, and even portable glass partitions. Through such devices, the individual would gradually become collectivized without being subjected to overt force or to the more subtle coercion of the communal apartments of the day.[39]

Melnikov's commitment to fostering a collectivist mentality in the Russian worker cannot be doubted. The design of the station reflects it, as does the Green City's overall plan, its transportation system, the emphasis on collective recreation and sports, and the regional hotels. But as the individual was being so gently re-programmed for a communal existence, was he also being adapted to live in a technological society? Would the Green City

187. Elevation of main railroad station for the Green City proposal of 1929

188. Section of railroad station, the Green City

[39] K. S. Melnikov, "Proekt korpusa dlia semeino-kholostykh i sotrudnikov 'zelenogo goroda'," MS, 1929, Melnikov archive.

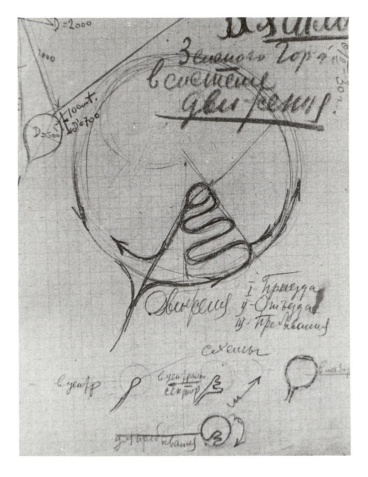

189. Preliminary sketch of site plan for a Green City, 1929, indicating path of movement from the periphery to the center of the settlement

190. Detail of final site plan for a Green City

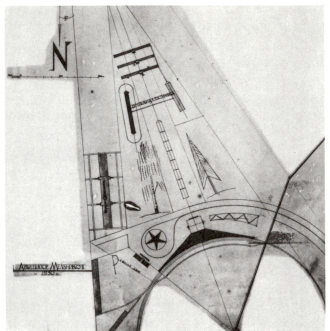

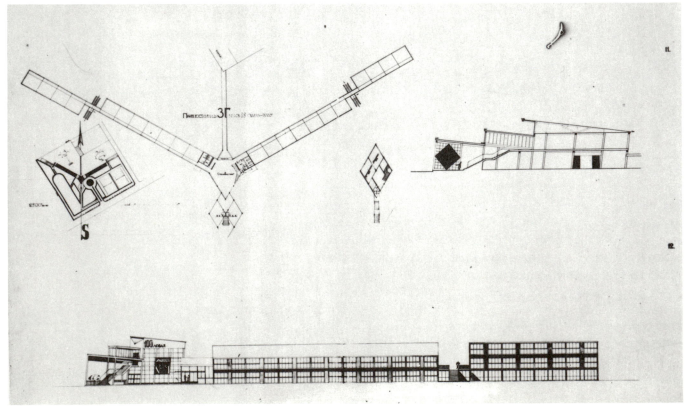

191. Hotel for one hundred guests, a Green City, 1929

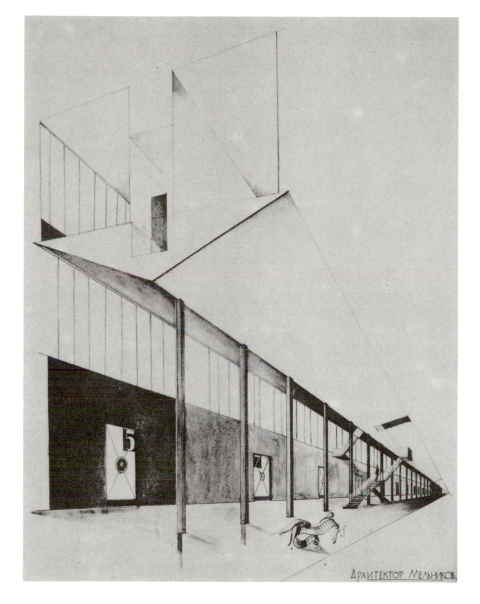

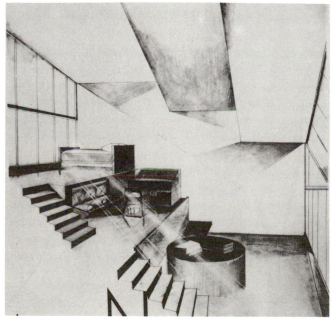

192. Interior corridor of the hotel for one hundred guests, the Green City, 1929

193. Interior of apartment unit in hotel, the Green City, 1929

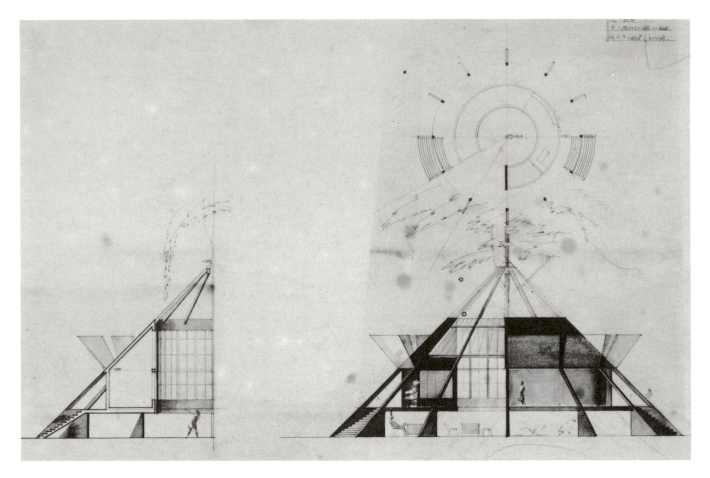

194. Solar pavilion for the Green City, 1929. First variant

harness equally artful techniques to enable Moscow workers to return to the assembly line charged with enthusiasm for the man-made industrial order symbolized by the *Gosplan* garage, the MOSPS theater, and the monument to Columbus? It is this issue, rather than collectivization per se, that dominated Melnikov's thinking about the Green City. To resolve it, he concocted devices far more visionary and, in the eyes of his critics, more outrageous than everything he had done for the sake of promoting a collective consciousness.

Melnikov quite correctly began with the assumption that members of the overworked labor force were exhausted. The recently lengthened working day, combined with the acute housing shortage and the introduction of rationing in 1929, pushed urban workers to the limit of their physical and psychological endurance. When productivity lagged far behind the planners' expectations and job turnover rose to prodigious levels, the social cost of this human crisis became all too apparent.[40] Melnikov was appalled by the situation and he looked on the Green City as a means of meliorating it, not by serving as the opening wedge in some utopian campaign to abolish cities, as Ginsburg and Barshch conceived it, but by providing temporary respite for workers brought there on a rotating basis from teeming Moscow. His Green City would offer relief by placing industrial laborers in a direct and intimate relationship with the primary forces of nature. All forests were to be carefully pruned so as to combine sunlight, shadow,

[40] Alec Nove, *An Economic History of the U.S.S.R.*, London, 1969, pp. 195 ff.

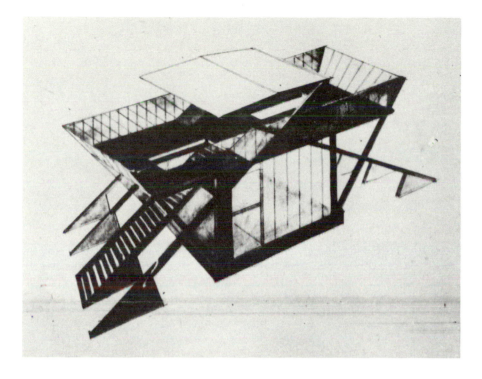

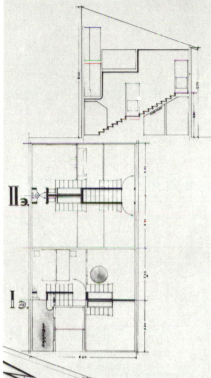

and fresh air in ratios most beneficial for those walking through them. Specially constructed solar pavilions were to be erected in open areas to enable sallow mill-workers to expose their bodies to the concentrated rays of the sun, even in winter (Figs. 194-195). Apartments in the district hotels would be constructed on three levels so as to permit air and light to circulate unimpeded (Fig. 196). Energy for the city's needs would be drawn exclusively from the wind, and, in another allusion to Fourier, animals would be permitted to roam at will through a large sector of the town, so the weary Muscovite could imagine himself once more a primeval man roaming in God's peaceable kingdom.

Not content merely to organize mankind's waking hours for the great cause of relaxation, Melnikov sallied forth to organize sleep into a complete curative system. While Stalin exhorted people to ever greater economic attainments in their work, Melinkov urged them to mightier psychic feats in their sleep. In all, his Green City provided space for 4,000 to take his cure.

The basis of this cure was sleep itself. Recalling the curative power of sleep during the strenuous work on the sarcophagus for V. I. Lenin, Melnikov concluded that: "Today, if I am told that correct food is necessary for health, I reply—'No, sleep is what is needed.' Everyone says fresh air is necessary but again I command that without Sleep fresh air will do little for our health. Expanding this into Architecture, I was amazed at this arithmetic: Man sleeps one third of his lifetime. Taking that to be sixty years, twenty years are spent in sleep, twenty years of lying down without consciousness, without guidance as one journeys into the sphere of mysterious worlds to touch the unexplored depths of the sources of curative sacraments, and perhaps of miracles. Yes, everything is possible, even miracles."[41]

196. Interior of apartment in hotel for the Green City, indicating circulation of light and air

[41] Melnikov, "Arkhitektorskoe slovo . . . ," pp. 52-53. Also K. S. Melnikov, "Proekt 'zelenyi gorod,' " 1929. "Generalnoe planirovanie territorii," MS, 1930, Melnikov archive.

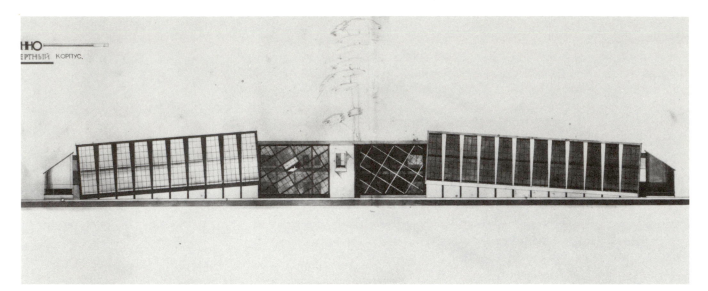

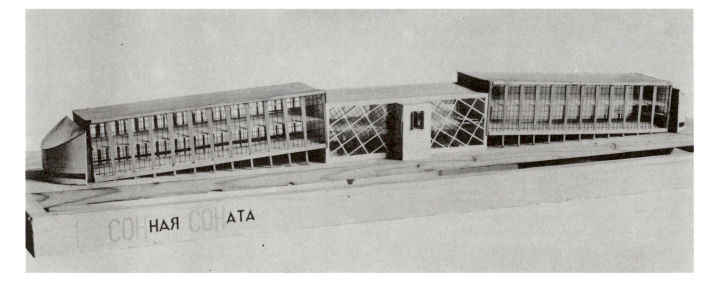

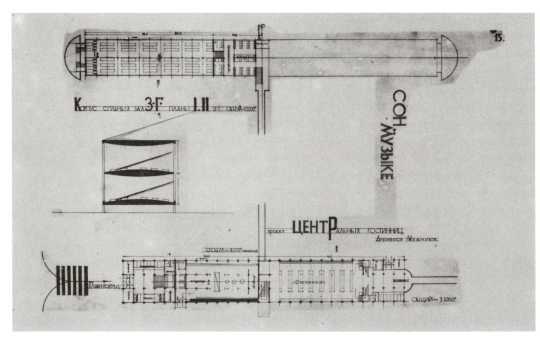

In the central hotel, which was not a hotel in the normal sense but a great "Laboratory of Sleep," the unguided journey of sleep was to be channeled and directed. Here so blissful a slumber would be induced that the several hundred inmates would naturally prefer it to their own isolated bedrooms at home and would long for the day when sleep would be collectivized everywhere (Figs. 197-198). Two large wings radiated from a central corpus, in which were housed rooms for washing, undressing, and preparing oneself for the cure provided in the twin wards at either side. As in the district hotels, all beds here were to be built-in, like laboratory tables; to obviate the need for pillows, the floors sloped gently to the ends of the structure (Fig. 199). The walls were broken with great sheets of glass, for sleep would be encouraged at all times of day and would under some circumstances require sunlight as well as darkness. In short, no effort was spared to attain full control over every aspect of the environment for sleep.

At either end of the long buildings were to be situated control booths, where technicians would command instruments to regulate the temperature, humidity, and air pressure, as well as to waft salubrious scents and "rarefied condensed air" through the halls.[42] Nor would sound be left unorganized. Specialists working "according to scientific facts" would transmit from the control center a range of sounds gauged to intensify the process of slumber. The rustle of leaves, the cooing of nightingales, or the soft murmur of waves would instantly relax the most overwrought veteran of the metropolis. Should these fail, the mechanized beds would then begin gently to rock until consciousness was lost. At this point, the natural sounds might continue or, at the command of trained specialists in the control booths, specially commissioned poems or works of music would be performed so as to obliterate any residual tensions or anxieties from the world of consciousness. Step by step, the worker would relax and his psyche would be rehabilitated by the combined forces of art and technology. Taken together, the building would be a "Sonata of Sleep" or, in Melnikov's pun on *son*, the Russian word for sleep, a *SONnaia SONata*.

The various plans and manifestos that Melnikov submitted with this project suggest just how fine is the line between benevolent fantasy and sinister Promethianism. One may be charmed, for example, by the notion of a forest trimmed so as to let air and light penetrate to the paths beneath. But one grows uneasy at the thought of a wholly artificial environment in which day and night become interchangeable at the will of technicians who, with equal facility, dare to "rationalize the sun."[43] Similarly, the note of whimsy in the idea of poets and musicians performing for sleeping laborers fades quickly with the realization that the purpose of their performance is to manipulate the development of the psyche. In his Green City project, Melnikov emerged as a relatively benign psychological engineer but an utterly determined one. Melnikov and his method permitted of no doubt or contradiction. "Cure through sleep and thereby alter the character," he exhorted in a placard sent to the jury for the competition: "anyone thinking otherwise is sick" (Fig. 200).

Presumably there remained large parts of the population that did think otherwise, however. Scientists, poets, and musicians would in the future have to develop yet more refined techniques for adapting such laggards to

Opposite

197. "Laboratory of Sleep" (The SONnaia SONata) for the Green City, 1929. Elevation

198. Model of the "Laboratory of Sleep" for the Green City

199. Floor plan of the "Laboratory of Sleep" (also called the Central Hotel), indicating placement of beds and circulation of light and air

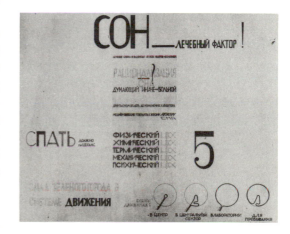

200. Placard submitted to the jury of the Green City competition, proclaiming the principle that "Sleep is the Curative Factor! . . . Anyone Thinking Otherwise is Sick"

[42] K. S. Melnikov, "Generalnoe planirovanie territorii," p. 1.

[43] This phrase of Melnikov's is contained in his brief statement "Gorod ratsionalizirovannogo otdykha," *Stroitelstvo Moskvy*, 1930, No. 3, p. 20.

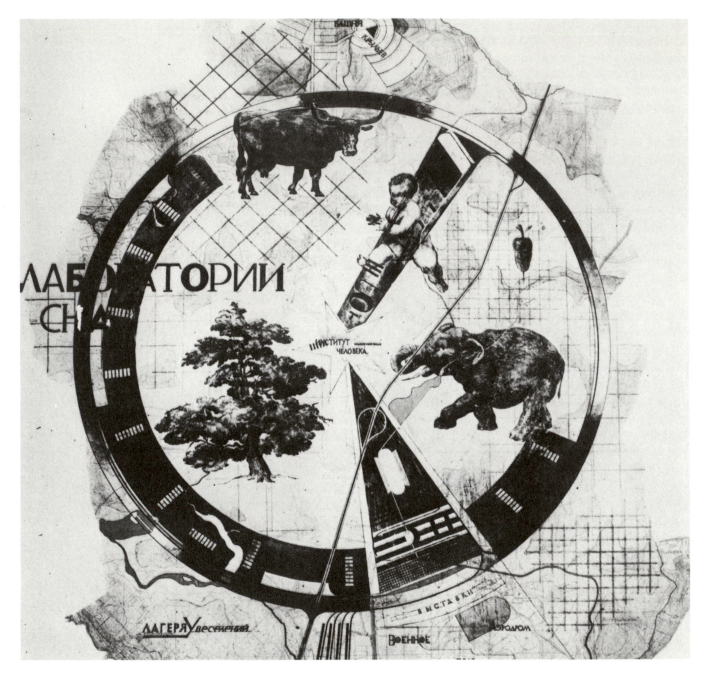

201. General plan of the Green City, 1929

the new order. In recognition of this continuing need, Melnikov proposed to establish at the very center of the circular Green City a large and well-equipped "Institute for Changing the Form of Man"—a fittingly ominous capstone for the behaviorist laboratory through which he hoped to adapt the individual Muscovite to the social and mental world of the Cultural Revolution (Fig. 201).

In 1930, when visionary and apocalyptic notions were widespread in Moscow, it required extraordinary provocation for a critic to claim that an architectural project "breathes romanticism" or "falls into extremism."[44] But this was a common response to Melnikov's much-debated proposal. To be sure, specific buildings and separate elements of the total design

[44] V. N. Simbirtsev, "Zelenyi gorod," *Stroitelstvo Moskvy*, 1930, No. 3, pp. 30-31.

were singled out for praise, but the project's overall reception was strongly negative, with milder critics dismissing the Green City as naïve and more incensed opponents branding it as "anti-socialist" and the work of a "wrecker."[45] How, the jury wondered, could a major architect permit himself to apotheosize sleep at the very time when the nation was gearing up to transform life through work?[46]

The reason for which Melnikov could apotheosize sleep and otherwise engage in such outlandish flights of fancy is that he had every reason to believe that his proposals accorded with scientific truth. He knew, for example, that in 1903 a Russian psychologist by the name of Viazemskii had succeeded in curing children of various undesirable habits through training provided during their sleep.[47] He had heard, also, that American linguists at the Naval Air School in Pensacola had only recently boasted of success in teaching foreign languages to their sleeping students. He had even heard of (but not read) an American science-fiction novel entitled *Ralph-124-C41+*, in which hypnosis and sleep were exploited by pedagogues.[48]

More directly, he was aware of the fact that Soviet psychiatrists were even then conducting extensive experiments in the field of sleep therapy. Hence, Melnikov's use of *hypnopaedia* was by no means as bizarre as it may at first appear, but it was extremely prescient nonetheless. Two years before Aldous Huxley described in detail the "Neo-Pavlovian Conditioning Rooms" in which the sleeping Beta children of his *Brave New World* would be trained, Melnikov had worked out the architecture for such an institution.

One of the few to express unabashed enthusiasm for Melnikov's proposal to manipulate completely both the physical and psychic environment was New York's ebullient showman "Roxy" Roth, who, accompanied by his architect, Wallace Harrison, and several advisors, visited Moscow in the summer of 1931 as part of a continental tour to gain ideas for the proposed Radio City Music Hall. Melnikov recalled meeting with the delegation just as he was completing work on the *SONnaia SONata*. Roth had been directed to Melnikov because of the many auditoriums the Russian had recently designed for workers' clubs, but it was the *SONnaia SONata* that immediately caught Roth's imagination. He recognized at once the theatrical potential of Melnikov's fantastic control booths, and resolved to provide his own technicians with similar facilities for controlling the temperature, atmosphere, sounds, and smells in Radio City Music Hall. Within months, Roth's publicity department was bombarding the American public with the Melnikovian claim that "two hours in the washed, ionized, ozoned, ultra-solarized air [of Radio City Music Hall] are worth a month in the country."[49]

[45] "Gorod ratsionalizirovannogo otdykha," *Iskusstvo v massy*, 1930, No. 6 (14), pp. 20-21.

[46] O. Iu. Schmidt, "Chto reshila rabochaia obshchestvennost o planakh 'zelenogo goroda?' " *Stroitelnaia promyshlennost*, 1930, No. 5, pp. 459-60.

[47] N. B. Viazemskii's full report is to be found in *Trudy Saratovskogo obshchestva estestvoznaniia*, 1903, No. 2.

[48] H. Gernsbeck, "Ralph 124-C41+," was serialized in *Modern Electronics* beginning in June, 1911, and published in altered form in 1921. See F. Rubin, *Learning and Sleep: The Theory and Practice of Hypnopaedia*, Bristol, 1971, pp. 1 ff.

[49] "Debut of a City," *Fortune*, 1933, January, p. 66; also, David Loth, *A City Within a City: The Romance of Rockefeller Center*, New York, 1966, p. 81; and a personal letter to the author from K. S. Melnikov, undated (1974). R. Koolhaas kindly brought the connection of Melnikov and Roth to the author's attention.

Melnikov, of course, knew nothing of the use to which his ideas were to be put and certainly had not conceived them in a frivolous or anti-Soviet spirit. Quite the contrary: he had undertaken the plan with all his accustomed earnestness. And did not the distinctive emphasis that the communal element received at his hands prove beyond doubt that his Green City would promote, rather than retard, the construction of socialism? True enough, he had proposed to change the public's mentality without reference to those productive processes that were the motor force of history, but this was as much the fault of the official sponsors of the competition as of Melnikov. By the same token, the charge that he wished to bring about social change without acknowledging the inevitability of class conflict was certainly true, but, to the extent that it applied to Melnikov, it fit most of the other entrants as well, including the winner, Ladovskii.

Since Melnikov's contemporaries analyzed and criticized so many aspects of his proposal, it is the more surprising that not one of them drew attention to the makeup of the New Soviet Man who would emerge from the Laboratory of Sleep. Yet, because he was the Green City's sole product and the one human type whom Melnikov conceived as being able to thrive in the emerging order, he cannot be ignored. In him, one can readily discern the extent and limits of Melnikov's utopianism.

Upon meeting such a well-rested denizen of the post-Revolutionary world, one would doubtless be impressed by the absence in him of selfish individualism, personal greed, and the like. It would not take long, however, to discern also his utter lack of interest in politics and public affairs, and his complete disengagement from the production of things and the management of people. Not that he would refuse to work, for the Green City alumnus would willingly have returned to his former job in Moscow. But he would take with him no exhortations to greater feats of productivity or to more noble acts of civic responsibility. If he worked hard, it would not be because the Green City had transformed his attitude towards labor but because it would have enveloped the unpleasantness of his job in a private world so serenely beautiful as to render the work endurable. According to this interpretation, Melnikov's Green City did not set out to create *ex nihilo* a New Soviet Man, but to bring out and strengthen in people those creative resources which they already possessed but which their recent lives had nearly obliterated: specifically, a romantic love for nature and a love of music, art, and poetry. Melnikov proposed to solve the problem of the creative personality's alienation in a collectivized world by integrating him with it through communal facilities, but at the time protecting him from it by means of a thick armor of nature and culture.

Each of the diverse elements from which Melnikov's New Socialist Man was constituted had been forged from the architect's personal experience. As a convert to the collectivized life, this New Socialist Man embodied Melnikov's own conversion to the ideals of the Cultural Revolution. As bucolic wanderer in nature, he reflected the architect's idealized memories of his own secure childhood in the Likhabor forest. And the cloak of culture protecting the New Socialist Man from a hostile world of politics and industry is an updated version of the outlook assumed by faculty and students at the Moscow School following their disenchanting encounters with the Revolution of 1905. Far from constituting a Brave New World, then, Melnikov's Green City was to a great extent a revitalized and generalized version of its author's own youthful past.

It is extremely doubtful whether a person thus constituted could easily have survived the difficult years of the 1930s under any circumstances. Amid an industrialized and collectivized world, he would remain part peasant, part aesthete; surrounded by politics, yet alien to it; immersed in selfless labor, yet with his heart elsewhere. All that enabled him to live with himself would have reduced his likelihood of survival, for it offended the priorities of all those who placed economics and politics ahead of nature and culture. Such a person would certainly have been poorly cast for the role of human ant in Melnikov's own drawings for the Palace of Soviets.

The hypothetical new man of the Green City anticipates Melnikov's own dilemma during the 1930s. Having himself accepted many aspects of the Cultural Revolution, he now discovered the extent to which they were in conflict with earlier affirmations that he had never actually rejected. In projects of the later 1930s, he continued to pursue the various impulses that had emerged in his work during the years 1928 to 1932. The technocratic gigantomania and hyper-realism were there, and so was the search for a more human scale and the romantic desire to bring man once again into a close realtionship with nature. But only rarely after the Cultural Revolution did any of these elements coalesce into projects so extravagant in their architectural conception and sweeping in their claims against and for man as the Palace of Soviets or the Green City. When it did happen thereafter, Melnikov would pay a heavy price for it.

VIII. Mass Culture and Megalomania

"To clamor with some people for a new style as if it could be had for the asking . . . is to ignore the whole teaching of history.

"Not so did the great styles of the past come into being."[1]

—THOMAS GRAHAM JACKSON, 1906

MELNIKOV did not build a single major structure after 1934, and after 1936 did not even design one. Those projects which he did create are not lacking in the inventiveness for which he was famous, but they follow no clear sequential order, as if he was grasping now here, now there, for a new principle upon which to ground his work. Gradually his supporters abandoned him. From being the most fashionable and sought-after architect in NEP-era Moscow, he plummeted, within the space of a decade, to the status of a nonentity, excluded from his work and profession and ignored by colleagues and the press.

How is one to account for so profound a change? The easiest way is simply to borrow wholesale the explanation applied to many other artists and writers of Melnikov's generation whose careers were eclipsed during the thirties: that it was Stalin's doing, either directly or indirectly as a consequence of the rise of the "Cult of Personality." In some general way this may well be correct. But until actual links between national politics and the fate of the given artist are identified, it is too facile an explanation. Like a *deus ex machina* in the theater, the invocation of Stalin as The Cause of all change too readily serves to justify the suspension of rational enquiry on the grounds that no further need for it exists. The case is closed. But if obvious prejudice on the part of the judge is grounds for reopening a case, then the verdict against Stalinism must be reexamined. For the strong dislike of most observers for works produced by Soviet artists in the decade before the war has led them to assume that surely Shostakovich, Prokofiev, Malevich, or Melnikov would not have produced such things had they not been compelled to do so. Led along by this logic, they have conjured up a world of Manichean contrasts, in which a powerful realm of Politics eventually achieves full victory over an idealistic but fragile world of Culture.

An appealing picture, this, especially for those who are content when artists manage to carve out for themselves a modest but secure place in their societies. But in making Soviet artists appear as helpless victims of totalitarianism, it distorts reality on several points, both belittling to the artists in question. On the one hand, by implying that works of the thirties that abandon the old avant-garde idiom were created either in the spirit of opportunism or under duress, it denies some very serious artists the strength of their own convictions. It requires us to imagine not one but several dozen practiced flaunters of convention suddenly knuckling under. On the other hand, by regretting the "Stalinist" efforts and reserving praise only for works that perpetuate the older tradition of avant-gardism, this

[1] Thomas Graham Jackson, *Reason in Architecture*, London, 1906, pp. 156-57.

conception makes it damnable to have kept abreast of the times in the 1930s but commendable to have done so a decade before![2]

To a considerable extent, any assessment of Melnikov's life and work in the last half-decade before his fall in 1937 will be colored by one's perspective on such broad issues as these. Two specific points on the architectural environment of the period can be made with some confidence, however, and both are pertinent to Melnikov's situation. First, the move away from the avant-garde styles of the 1920s in favor of a greater monumentality was certainly not unique to the Soviet Union and hence not solely dependent upon its politics. A walk through downtown Washington will turn up dozens of buildings which, were they in Russia, might provide footnotes for those philosophizing on Stalinism in architecture. The similarity exists because Soviet architects, far from being isolated behind an iron curtain in the 1930s, were at least as well-integrated into the world community as they had been in the more openly internationalist era of the 1920s.[3] They might have been seeking something distinctive, but they conducted their search in a world environment in which no less an authority than Sigfried Giedion could also be calling for a "new monumentality" in architecture.

Second, the goal of monumentality may have been pursued with vigor during the period, but Soviet architects did not attain it overnight. Melnikov could design a very un-Stalinist garage for Intourist in 1934 and watch it being built for several years thereafter; Alexander and Leonid Vesnin's eminently Constructivist Palace of Culture for the Stalin Automobile Factory could be the subject of a cover story in the influential journal *The Construction of Moscow* (*Stroitelstvo Moskvy*) late in 1937;[4] while such prominent avant-gardists as Ivan Leonidov and Moisei Ginsburg could continue to follow a fairly independent course in architecture even after Socialist Realism had become the official banner of Soviet literature. This fact, so easily ignored, meant that, at least until the First All-Union Congress of Soviet Architects in 1937, the field was in a state of constant movement, with numerous tendencies contending for hegemony. Indeed, if Stalin or his henchmen ever did "decree" a new architecture (which is doubtful), they were conspicuously inefficient in implementing it, at least before World War II.

This did not mean that the world in which Melnikov moved after 1931 was unchanged from the twenties. After the enthusiasms of the Cultural Revolution had died down, new factors entered the picture and drastically altered the lives of Soviet architects in general and Melnikov in particular. These included, first, the decline in the status of architecture within Soviet society, and, second, the reorganization of architecture as a profession. Each warrants special comment.

[2] On this point, my argument is indebted to the polemical but, it seems to me, sensible rebuttal by A. Ovcharenko of those Western historians of Russian literature who see Socialist Realism purely as something forced upon writers by Stalin. "Sotsialisticheskii realizm v svete mezhdunarodnykh sporov (otvet misteru Maksu Kheiuordu)," *Molodaia Gvardiia*, 1973, No. 9, pp. 265 ff; also 1970, No. 2; 1971, No. 3; 1972, No. 11.

[3] Membership in the League of Nations, the broadening of diplomatic contacts, and the Popular Front with "bourgeois" countries against fascism all contributed to an awareness of developments abroad, even as the concept of "Soviet nationalism" was being worked out at home. In architecture, the presence in the U.S.S.R. of scores of foreign designers through the mid-thirties and tours abroad by leading Soviet architects helped to keep Soviet architects *au courant*.

[4] "Dvorets kultury," *Stroitelstvo Moskvy*, 1937, No. 21, pp. 14-21. The author, D. Aranovich, was critical of the building, but nonetheless described it fully and with the help of numerous illustrations.

The decline of architecture as a high-status profession was occasioned by the rapid rise to prominence of engineers during and after the First Five-Year Plan. As bearers of the skills essential for the construction of factories and dams, engineers could not be neglected by Soviet leaders. Decimated for being politically suspect in 1927, their numbers and prestige rose rapidly once massive industrialization got underway two years later, and by the early thirties engineering had assumed first place among professions offering a path to the top. Architects might still claim that they should plan the future society, but their actual role became increasingly to ornament the grand achievements of the engineers. They might design stations for the Moscow subway, but the engineers built the tunnels; they could create power houses at the Dneprostroi Dam, but they were dependent on the engineers for the specifications.

Most architects accepted this, and focused on the ornamental and ideological side of their work in an effort to redefine their role. Melnikov flatly rejected any suggestion that architects should take a back seat to technicians, or that architecture should serve just a purely ornamental function. Had his own buildings not just been featured in Dziga Vertov's widely heralded films, and had he not been judged one of the world's nine master builders by the jury at the Fifth Milan Triennale in 1933?[5] Clearly, then, his personal status was not declining, and there was no reason why he should act as if it were. Yet, the very grandiloquence of many of his projects of the 1930s suggests that he was more than ever conscious of the need to assert the primacy of architecture.[6]

The second new factor to affect Melnikov after the end of the Cultural Revolution was the reorganization of the architectural profession in 1932. As early as 1924, Ginsburg had concluded that Constructivism and what he termed "formalism" were incompatible, and sharp conflict between them inevitable and desirable.[7] During the late twenties, the timbre of polemics within the field had sharpened. With the Cultural Revolution, Constructivists fell on formalists, formalists fell on Constructivists; classicists and eclectics attacked both and were attacked by both in return; and "proletarian" architects denounced everyone even as they were being denounced and despised. Nikolai Miliutin, the utopian planner who had only recently paid amiable visits to Melnikov's house, now told the world that "extremists" should be purged from architecture, along with "formalist-parasites" who perpetuated styles dating from the epoch of imperialism.[8] Meanwhile, *Pravda* had announced that "utopianism tends to discredit the system," and the Central Committee of the Communist Party had passed stern judgments against the rival evils of idealism and mechanism, i.e., against both formalism and Constructivism.[9] An open season was on.

[5] On the Milan exposition, see K. S. Melnikov, "Arkhitektorskoe slovo v ego arkhitekture," p. 70; and *Cataloge Ufficiale di Milano*, Milan, 1933.

[6] Hence, when in 1935 his students at the newly founded Moscow Architectural Institute asked to be permitted to design a hydroelectric dam, he assented but took great pains to explain to them that as architects they should avail themselves of the engineers' advice, but only as equals or superiors and never as lackeys. K. S. Melnikov, "Gosudarstevennoi kvalifikatsionnoi komissii, ot prof. Melnikova, K. S." MS, 1935, Melnikov archiv, pp. 1-2.

[7] *Wasmuths Monatshefte für Baukunst*, vol. 11, 1927, October, pp. 409-12.

[8] N. A. Miliutin, "Osnovnye voprosy teorii sovetskoi arkhitektury," *Sovetskaia arkhitektura*, 1933, No. 3, p. 4; 1933, No. 6, p. 3.

[9] These confrontations are treated ably by Paul Willens, *loc. cit.*, and especially by Egbert, in "Social Radicalism and the Arts: Russia," pp. v-169 ff.

No tendency was immune from criticism, for the simple reason that no one was sure what position was correct and what was not. It was well and good for the Party to call an All-Union Conference on Propaganda and Agitation in the summer of 1928, but, without clear and specific guidelines for each field, the results could have been only chaotic. Not only did no such official guidelines exist, but the unofficial attempts to spell out the political analogues of architectural systems were hopelessly muddled.

Granted that "formalism"was considered evil, and that Melnikov was by general consensus a "formalist," but what precisely was wrong with formalism? Did it deviate by standing to the left or to the right of Party policy—i.e., was it guilty of Trotskyism or of Bukharinism? The common answer at the time was that formalism erred to the right, in that it evinced less enthusiasm for fundamental economic and social change than for altering the outward trappings of life. Constructivism, by contrast, was perceived as ultra-left, and the radical Marxist rhetoric of Ginsburg seemed to justify this judgment. But with the benefit of hindsight it appears that Melnikov's "formalism," in its impatience with the solid elements of Constructivism and its restless penchant for exhortation through expressive forms, was really the more leftist of the two stances, and that Constructivism, in its enthusiasm for technology as the key to a new world, was guilty of the functionalist and mechanistic thinking associated with the name of Bukharin. The fact that a few commentators perceived this at the time served only to deepen the confusion surrounding the entire polemic.

By 1930, strife among the warring groups had reached such a pitch that projects relating to the Five-Year Plan were being tied up in endless wrangling. The Party, which heretofore had abstained from intervening directly in the controversy but had indirectly fostered it through its support for the slanderous diatribes of the All-Union Organization of Proletarian Architects, now took the profession in hand. First, through the trade-union head, Tomskii, it declared to architects that if they would not voluntarily stop their altercations and organize as a group, it would do so for them. Then, when the loose federation of groups that the architects set up in response to this warning served only to intensify the internecine squabbles, it included architecture among those fields in the arts which it reorganized with a decree of April 23, 1932.[10] In a stroke, all groups and factions were thereby disbanded and their members merged into the single Union of Soviet Architects.

Because Melnikov stood aloof from these intergroup controversies, one would think that he might have been spared the worst criticism. In fact, the opposite was the case. That small modicum of restraint that Moscow's architects felt in attacking one another as members of organized groups was lifted in their dealings with a man who dared to hold aloof from all factions. For his apparent haughtiness, Melnikov became fair game for everyone. In a series of articles appearing between 1929 and 1932, nearly every building he had designed since his return from Paris came under harsh criticism.

It mattered little that no one could agree on just what errors Melnikov had committed. Thus, Leningrad's Mikhail Ilin, well known abroad as a reporter on Soviet architecture, used a critique of the Svoboda Club to make the point that Melnikov's errors consisted of his resort to the

[10] *Pravda*, 1932, 24 April.

"bourgeois" style of formalism.[11] A certain A. Nemov gave voice to precisely the opposite complaint in an article on the Rusakov Club entitled "Against 'Left' Deviations in Club Construction."[12] A piece on the MOSPS theater by Melnikov's contemporary, Aleksei Karra, made several positive points but in the end agreed with Nemov on Melnikov's wild revolutionism.[13] Karra's criticism of Melnikov's MOSPS project for its unseemly boldness is the more unexpected in that only three years before he had praised the Rusakov club for exactly the same quality and had actually copied it in his own proposal for a pavilion for the "Torgpredstvo" show in Paris.[14]

In short, the attacks on Melnikov and the general exchange of recriminations within the field of architecture lacked even that degree of consistency which, for better or worse, informed analogous battles within Soviet literature. Under such circumstances, the architects had every reason to fear one another, for there could be no security against the capricious campaigns being launched for and against every tendency in the field. Given this, the reorganization of the profession had a certain logic. Precisely because it promised to break this untenable situation, the Party's liquidation of all sectarian groupings and its forced gathering of all architects under one nationwide organization was not protested by the field, and in fact gained a surprising degree of support. True, private practices such as Melnikov's were abolished, and a new review agency, the *Arkhplan*, headed by Stalin's henchman, Lazar Kaganovich, was granted power to revise any project submitted. But at the same time, salaries increased and the suburban estate of Sukhanovo was turned over to Moscow's architects as a conference center and resort (1935). Most important, in 1933 the twelve leading architects of the capital were each made director of their own design studio, organized under the Moscow City Council. Melnikov, only recently denounced as a "wrecker," "left deviationist," and "bourgeois formalist," emerged as head of Design Studio Number Seven.

The sense of genuine relief with which Melnikov greeted this fortunate turn of events sets the tone of his first annual report as director: "Conditions for peaceful activity and for belief in the results of creative work have been created, instead of the organizational and adminstrative confusion that frequently prevailed in [the old design agencies]. The very procedure for preparing projects has been significantly simplified and placed in a framework of strict and logical order. No longer are there those fruitless scholastic debates over styles which occupied the lion's share of one's time at the Drafting Agency. No longer are people announcing their commands to architecture, commands that were clear to no one; no longer is there that excessive speechifying, that fruitless waste of valuable time. . . . "[15]

The fact that Melnikov would go on to criticize openly the "prolonged and abnormal organizational period" that the atelier had passed through late in 1933, while responsibility for it was "passed several times from

[11] M. A. Ilin, "Dva novykh kluba," *Stroitelstvo Moskvy*, 1931, No. 10, p. 15.

[12] A. Nemov, "Protiv 'levykh' zagibov v klubnom stroitelstve," *Iskusstvo v massy*, 1930, No. 2 (10), pp. 12-16.

[13] A. Karra, "Arkhitektura teatra. Konkurs na proekt teatra MOSPS," *Stroitelstvo Moskvy*, 1932, No. 7, pp. 16-17.

[14] A. Ia. Karra, V. V. Simbirtsev, "Novye kluby," *Stroitelstvo Moskvy*, 1929, No. 11, pp. 22-23. On Karra's pavilion, see *Stroitelstvo Moskvy*, 1929, No. 7, p. 33.

[15] Konstantin Melnikov, "Tvorcheskoe samochuvstvie arkhitektora," *Arkhitektura SSSR*, 1934, No. 9, p. 43.

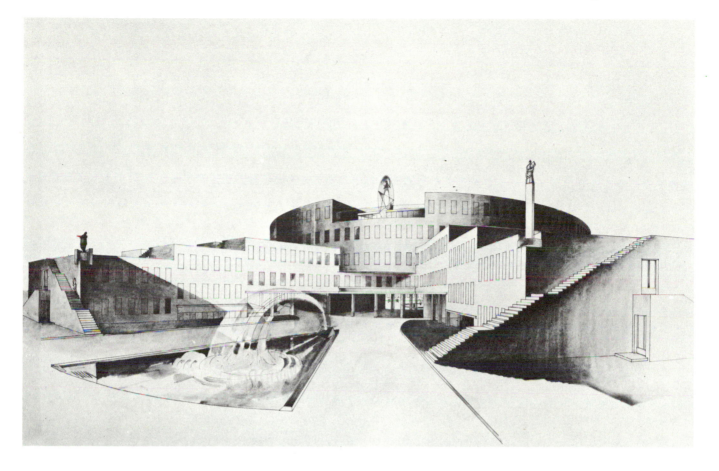

agency to agency," stands as further proof of the new sense of security and self-confidence he enjoyed during 1934.[16]

The dramatic shifts in Melnikov's mood between the end of the Cultural Revolution in 1932 and the new confidence of 1934 correspond roughly to events in the realm of national politics. The First Five-Year Plan had been completed early, but at a cost to the society as a whole that became evident only as the economy dipped sharply in 1933.[17] The recriminations and confusion of which Melnikov complained in architecture coincided with the exile of several leading political figures from Moscow, while the new confidence coincided with the resurgence of the economy late in 1933 and the general "quasi-liberalization"[18] that set in during the interval between the return from exile of Zinoviev and Kamenev in 1933 and the staged assassination of Sergei Kirov in Leningrad on December 1, 1934. The fact that social conditions seemed to have stabilized precisely at the time his own situation did removed many of Melnikov's remaining doubts over the possibility of working in his accustomed way.

His work showed the beneficial influence of these conditions at once. During 1933, the prevailing uncertainty had caused him, in two variant proposals for a Palace of Culture for Tashkent, to retreat to the safe con-

202. Palace of Culture for Tashkent, 1933. First variant

[16] For M. Ginsburg's similar assessment of the situation at this time, see his comments at the discussion staged by the Union of Soviet Architects in 1933, *Arkhitektura SSSR*, 1933, No. 3-4, pp. 12-14.

[17] Alec Nove, *An Economic History of the U.S.S.R.*, London, 1969, p. 224.

[18] The term "quasi-liberal stage" is Isaac Deutscher's (*Stalin, A Political Biography*, 3rd ed., London, 1963, p. 355). For all its usefulness, it surely overstates the case, for precisely during this lull, the Party was being purged of thousands of members.

203. Elevation of Palace of Culture for Tashkent. First variant

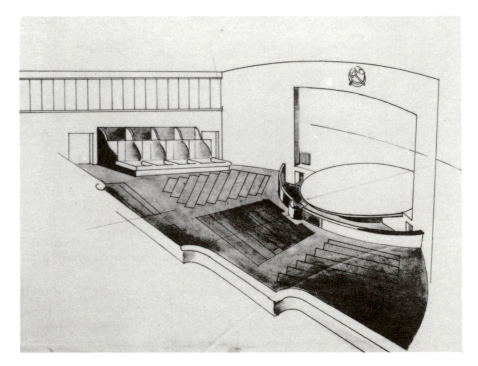

204. Interior of theater, Palace of Culture, Tashkent. First variant

ventionality of updated formulas from the past. The first of these (Figs. 202-204) is by no means without interest, for it marks the beginning of the revival in Melnikov's architecture of the current of Romantic Classicism that had made itself felt throughout the 1920s. As we shall see, this was to constitute one of the main avenues that were explored in the effort to define a socialist style in architecture. The second variant (Figs. 205-208) also merits notice, since in its balconies it introduces exotic motifs of ornamentation that, applied to later buildings, were to bring down upon their author harsh criticism. In presenting this project, he felt obliged to argue that "the forms of architecture are transmitted from age to age and preserve their freshness and the glory of their lines."[19] Yet one year later, in 1934, he produced two projects that in some respects, at least, pick up avant-garde threads as if they had never been severed.

The first of these was a large parking garage for Intourist. Its purpose was to house some 350 vehicles, including buses, and to provide service facilities and office space for Intourist's motor pool. This was achieved by

[19] K. S. Melnikov, "Arkhitekture pervoe mesto," *Stroitelstvo Moskvy*, 1934, No. 1, pp. 9-12.

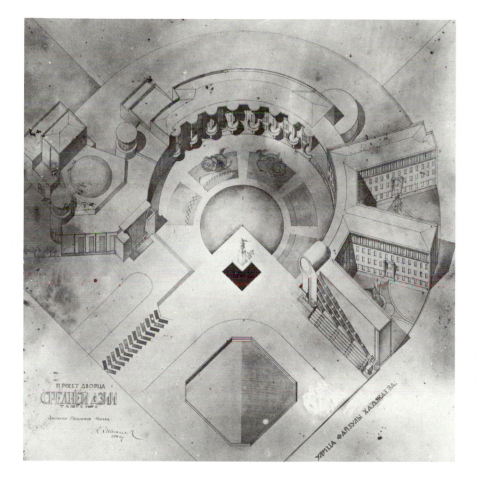

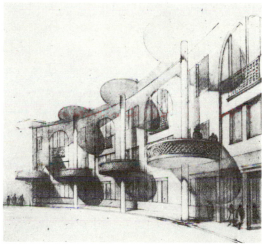

205. Palace of Culture for Tashkent, 1933. Second variant

208. Courtyard facade of Palace of Culture for Tashkent. Second variant

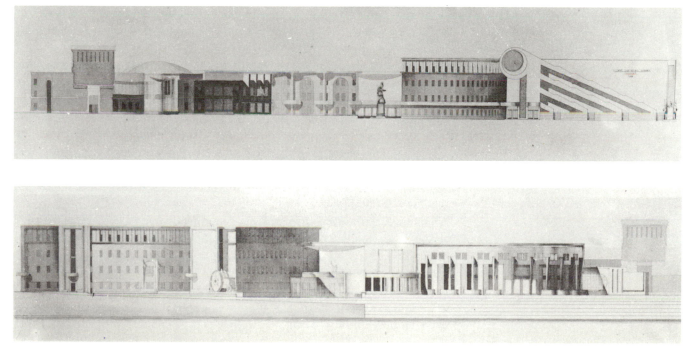

206-7. Elevations of Palace of Culture for Tashkent. Second variant

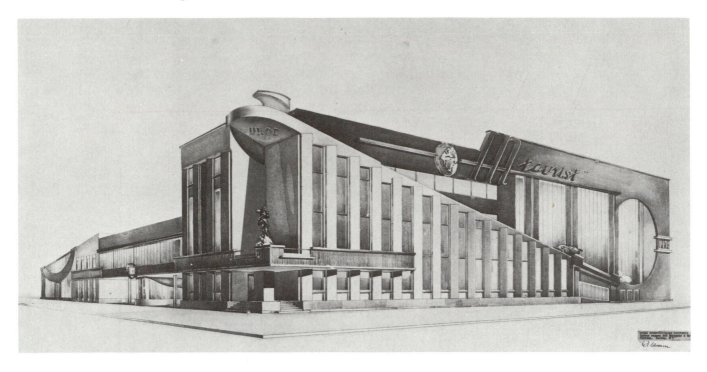

209. Parking garage for Intourist, Moscow, 1934

means of an utterly functional structure built around a reinforced concrete carcass that could well have served as the core of a Constructivist building of the twenties.[20] On the outside, however, Melnikov returned to his old interest in using architecture to depict the mood of dynamism and movement that he felt dominated his own life and that of his society (Fig. 209). The breaking-up of the rectangular main façade of the garage by means of jutting diagonals (Fig. 210) harkens back directly to numerous projects of the 1920s, just as his juxtaposition of that diagonal with strong verticals recalls earlier efforts, notably the Palace of Labor (Fig. 211).

Melnikov was pleased with this design and, in his annual report for 1934, boasted of it as "the most instructive and serious work" done in his atelier that year.[21] His pride is understandable, for the project was actually built—the last building of his to be erected in Moscow, as it turned out. But it is difficult to share his enthusiasm. To be sure, the plan was drastically altered by the design overseer placed in his atelier by Kaganovich, and then again by the *Arkhplan* board of which Melnikov had complained in print.[22] But the real problem with the garage stems not so much from its corruption by others as from its basic conception. Here, unlike Melnikov's romantic revolutionary works of the twenties or his more extravagant efforts at hyper-realism of the era of the Cultural Revolution, the bold effects are superficial and unrelated to the actual workings of the buildings.[23] The image of an automobile racing up the diagonal ramp on the main façade is evocative, to be sure, but hollow in the light of the dissonance between this pictorial representation of the garage's function and the actual working ramps hidden within the building at one end. Given the artificiality of this

[20] Moskovskii sovet rabochikh, krestianskikh i krasnoarmeiskikh deputatov, otdel proektirovaniia, *Sbornik rabot arkhitekturnikh masterskikh Mossoveta za 1934 g.*, 2 vols., Moscow, 1935, vol. I, p. 17.

[21] K. S. Melnikov, "Tvorcheskoe samochustvie arkhitektora," *loc.cit.*

[22] *Ibid.*

[23] These points were made in an unsigned essay, "Falshivyi stil za rulem," *Rabochaia Moskva*, 1936, 15 March, p. 3.

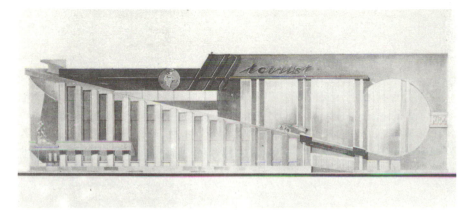

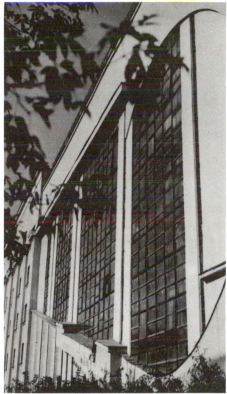

210. Elevation of the Intourist parking garage, 1934

externally applied piece of "formalism," it is the more surprising that such a building could receive official patronage in 1934.

The second major project of the productive year 1934 was linked as closely to the mood of the Cultural Revolution as the Intourist garage was to the twenties. When the XVII Congress of the Communist Party was held in 1934, an exultant mood prevailed. This "Congress of Victors," as Stalin dubbed it, celebrated the achievements of the First Five-Year Plan and pointed optimistically to the day when the U.S.S.R. would be a fully industrialized country. Such a theme drew attention to the central role played by the Commissariat of Heavy Industry (*Narkomtiazhprom*). This burgeoning agency embodied all the government's hopes for the future in that it was at once the organizer, builder, and manager of the giant manufactories that were to transform the economy. The commissariat desperately needed new quarters, and when in 1934 the government assigned it the plot of land commanding Red Square and the Kremlin and designated fully twelve million rubles for construction—equal to half the amount earmarked for the Palace of Soviets and six percent of the sum allocated for all housing in the capital[24]—it was assured a home commensurate with its importance.

211. The Intourist parking garage in Moscow in the 1970s

Those invited to participate in the closed competition were seasoned veterans, most of them avant-gardists like Melnikov, the Vesnins, and Ivan Leonidov, with but one, Ivan Fomin, being of the pre-revolutionary Old Guard.[25] To a man, they seemed to view the project as a rerun of the Palace of Soviets competition. Most saw the two monuments as being part of a single ensemble and attempted to link them with some sort of grand concourse. Some went so far in their desire to create a ceremonial space adjoining the Kremlin and Lenin's tomb as to propose the demolition of both the GUM department store and the sixteenth-century Cathedral of Saint Basil.[26] Melnikov took pains to point out that his proposal would permit these buildings to remain intact, but nonetheless in his aerial drawings did not indicate whether or not the Historical Museum at the south end of Red Square would have to be demolished. Notwithstanding the substantial differences among the various projects, all were set deliberately against the Kremlin, as if that Muscovite fortress was a symbol of the past that had to be overwhelmed and belittled by the great symbol of the present. Mel-

[24] *Stroitelstvo Moskvy*, 1934, No. 1, p. 12. The Palace of Soviets and the Commissariat of Heavy Industry Building together accounted for eighteen percent of the total construction budget.

[25] L. Lisitskii (El Lissitzky), "Konkurs forproektov doma Narkomtiazhproma v Moskve," *Arkhitektura SSSR*, 1934, No. 10, p. 4 ff.

[26] *Sbornik rabot arkhitekturnikh masterskikh Mossoveta, 1934 g.*, Vol. II, p. 5.

nikov's entry dominated Red Square so completely as to make the Kremlin appear as the merest adjunct to the ensemble, an antique backdrop to Lenin's tomb (Fig. 212).

Overwhelming size played a large part in every entry, including Melnikov's. D. Friedman proposed a massively pompous business block in the current American skyscraper style, while the Vesnins worked out several very sophisticated variants consisting of glass towers linked with walkways; the drawings for both were done in such a way that the buildings, if projected to the scale of the human beings on the ground below, would have had to be over a hundred stories in height. Similarly, while Melnikov's tower would actually have stood only forty stories tall (Fig. 213), the drawings depict it as being built at least to the same scale as the Vesnins' (Fig. 214).

Melnikov was not content with having proposed a building that would tower over any other structure ever built in Moscow; he went on to play several visual tricks so as to reinforce his structure's appearance of towering height. First, he proposed to dig out a deep cavity adjacent to the side of the building fronting on Red Square. This cavernous excavation permitted light to penetrate to the windows of the sixteen below-ground stories that were to house an exposition hall and museum of industrialization. At the same time, it would cause Red Square to be reoriented, in the eyes of anyone standing on it, from the Kremlin to the Commissariat building. Most important, he proposed to link the mass of the structure with Red Square by means of two gargantuan exposed stairways (Fig. 215) rising sixteen stories from points at the northern and southern extremity of the parade ground. These stairways, which one would enter through portals in

212. Project for the headquarters of the Peoples' Commissariat of Heavy Industry (*Narkomtiazhprom*), 1934

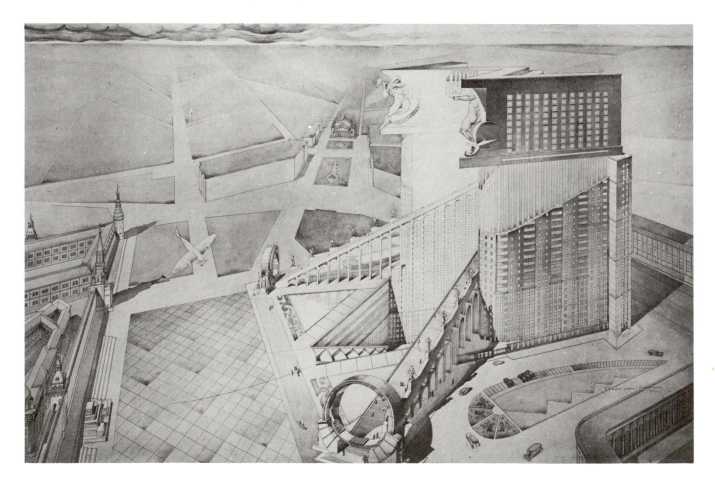

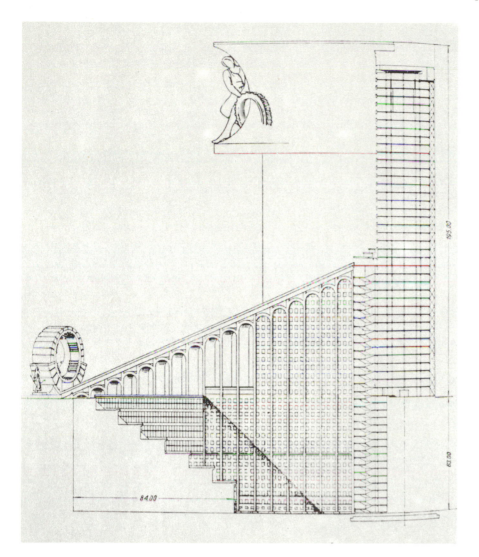

213. Section of *Narkomtiazhprom* building, 1934

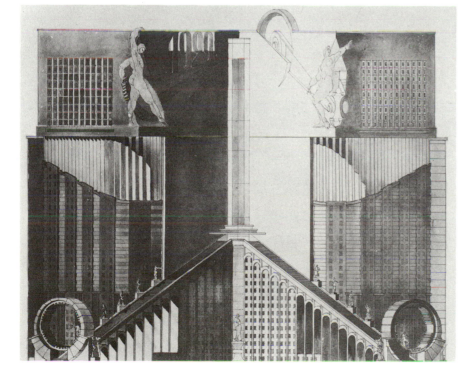

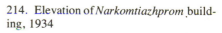

214. Elevation of *Narkomtiazhprom* building, 1934

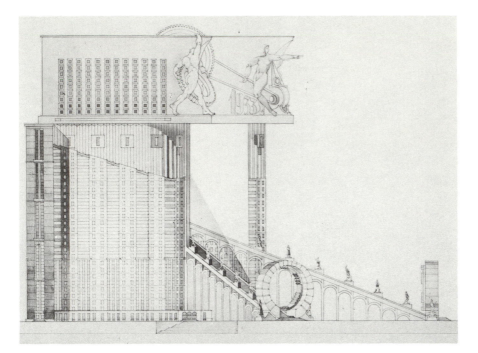

215. Side elevation of *Narkomtiazhprom* building

216. View through portal of *Narkomtiazhprom* building

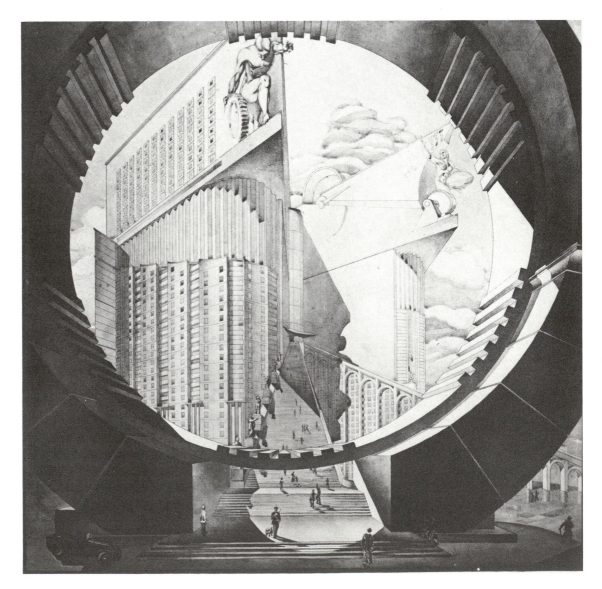

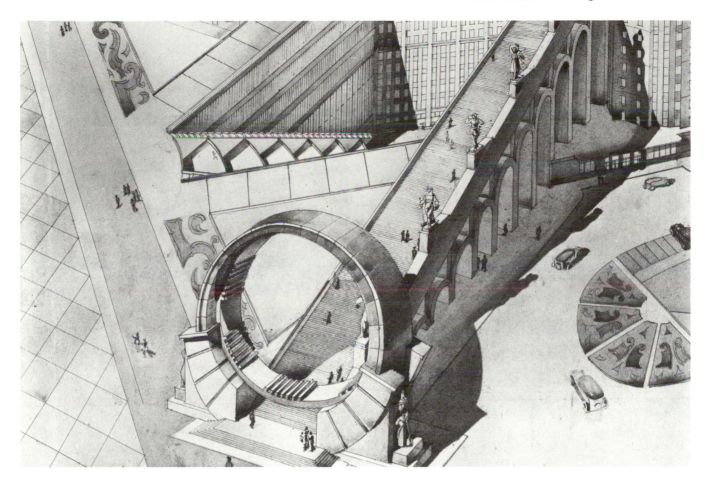

the form of huge roller bearings (Fig. 216), were to be equipped with fast-moving escalators that would sweep the Soviet citizen skyward, just as the entire society was being swept upward through industrialization (Fig. 217).[27] Ascending them, the visitor would confront heroic sculptural figures crowning the ensemble. (Fig. 218).

Here again we encouter Melnikov's passion for a theatricalized *architecture parlante*, for narrative designs that would, as he put it, ". . . bequeath to mankind monuments by which it would be possible to judge the heroism of our times."[28] As in the series of projects undertaken during the Five-Year Plan, he here utilized the visual image of the building's function as the basis for its overall design. In this case, of course, it was not simply heavy industry that was being celebrated, but the Communist Party's First Five-Year Plan, the successful completion of which was hailed by the Congress of Victors. Accordingly, Melnikov considered it quite appropriate to base the plan on the form of the Roman numeral five: "The plan of the building is resolved in the form of two interconnected Roman numeral 'V's,' which, in the view of the author, strengthen in this monumental edifice the pathos of having achieved the objectives of the First Five-Year Plan" (Fig. 219).[29] Melnikov had rejected an earlier variant based on only one Roman numeral five, presumably on the grounds that it did not embody the building's "message" with sufficient precision (Fig. 220). The only

217. View of grand escalators, *Narkomtiazhprom* building

218. Sketches of sculptural figures for *Narkomtiazhprom* building

[27] K. S. Melnikov, "K proektu doma Narkomtiazhproma, 1934, g." (MS, Melnikov archive), p. 1.
[28] *Sbornik rabot arkhitekturnikh masterskikh Mossoveta, 1934 g.*, vol. II, pp. 3-4.
[29] *Ibid.*

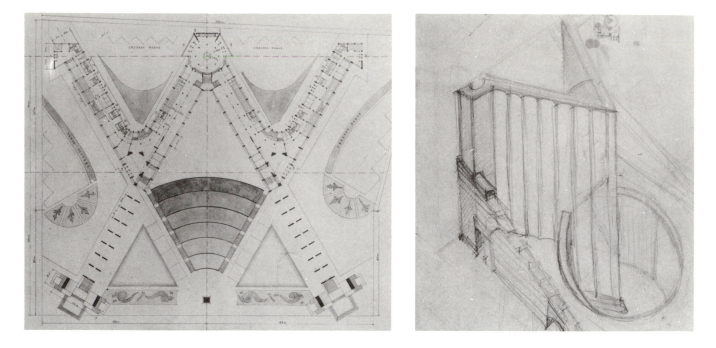

219. Site plan of *Narkomtiazhprom* building in form of two Roman numeral fives

220. Preliminary sketch for *Narkomtiazhprom* building

221. Cartoon from the journal *Krokodil* satirizing *architecture parlante* in 1934

traces of this earlier variant to be found in the final project are the long diagonal wings that reappear in the form of the exposed stairways.

The idea of a structure based on the form of letters or numerals flows naturally from the *architecture parlante* in which Melnikov had worked during the Cultural Revolution, but it had more ancient antecedents as well; whether or not Melnikov was aware of it, the German architect Johann Steingruber, in the 1770s, had taken his patron's initials as the basis for the plan of several palatial structures.[30]

Many critics found all this to be quite outlandish (Fig. 221), including the humor magazine *Krokodil* and the journal *Architecture of the U.S.S.R.* (*Arkhitektura SSSR*), the official mouthpiece of the Union of Soviet Architects. Speaking for the latter publication, V. S. Balikhin at first found the plan to be "a riddle with many unknowns," but then, having unravelled the riddle, concluded that "all this monumental window dressing is in essence shot through with the old-fashioned and primitive forms of modernistic symbolism."[31] The editor of the official volume in which the project was published was yet more blunt in the postscript that he felt obliged to append to Melnikov's essay:

"Many works of the architect K. S. Melnikov have in the past and present brought down upon themselves just criticism (as manifestations of) innovations lacking all ideology, a kind of innovationism that turns into its own object, into acrobatics. The House of Heavy Industry is an example of this formalist fantasy and architectural dynamism, with its abstractly conceived plan, its area excavated in the front of the building to the depth of sixty-three meters, and its external stairway to the height of sixteen storeys. We decisively reject such groundless and individualistic fantasizing of form without reference to reality, such searchings after a formalistic order. . . . In publishing the works and the *Credo* of the architect K. S. Melnikov, the editor suggests that he redesign them on the basis of

[30] Conrads and Sperlich, *Fantastic Architecture*, p. 87.
[31] V. S. Balikhin, "Sintez iskusstv v praktike sovetskoi arkhitektury," *Arkhitektura SSSR*, 1935, No. 7, p. 26.

Socialist Realism so as to be led onto a truly correct path of work and be aided thereby in bringing forth his ample talent."[32] Finally, Melnikov's erstwhile friend El Lissitzky joined the denunciation as well, declaring that "Melnikov has loaded it up with such a quantity of tastelessness and provincialism that I'm embarrassed for the artist."[33]

All three of these attacks, it should be noted, date to 1935, a year after the actual competition and, in terms of the politics of architecture, already another era. In 1934, the architectural public received the House of Heavy Industry project more positively. The prevailing mood of triumph and relative calm could not but influence this, of course, nor could the eagerness of the professionals to view the founding of the Design Studios as marking the end of bitter polemics rather than a new phase in them.

Had architects and architectural critics in 1934 been more certain of their standards of evaluation, the attacks on Melnikov's House of Heavy Industry might have come sooner and harder than they did. But when each of the directors of the twelve design studios of the Moscow Soviet was asked to submit a credo, they thrashed about in confusion and in the end produced the most colorless collection of platitudes imaginable. Melnikov lamented "architecture's lagging behind the general front of Socialist construction," but gave few prescriptions for overcoming it beyond stressing the need to permit the creative talent of the architect to flower.[34] His colleagues did no better. Nikolai Kolli harrumphed against "all theories of non-class and super-class architecture," and Ilia Golosov spoke piously of "an architecture fully reflecting our era."[35] The problem was simply that neither individual architects nor the profession as a whole could yet articulate any clear standards: this in spite of the creation that year of an Academy of Architecture that had as its purpose precisely to set forth a uniform program for the profession.

Considerable pressure to define a common approach to architectural work had been felt for several years. This pressure arose simultaneously from within and without the field as a natural result of the confusion of styles that increasingly prevailed. It took a jump upward in May, 1932, however, when Ivan Gronskii, a Party specialist on literary affairs, declared at a meeting of representatives of Moscow writers that: "The basic demand that [the Party] puts before writers is to write the truth, to reflect reality truthfully. . . . Therefore the basic method of Soviet literature is the method of Socialist Realism."[36] By 1934, the Union of Soviet Writers had convened its first national congress and had succeeded in declaring, as a body, its adherence to this doctrine. It went without saying that architecture should do the same, and without delay.

But for all this prodding, architects did not follow suit at once and in fact required another three years, until 1937, before they could stage a national convention at which to discuss the problem. With hindsight, it is easy to belittle the intervening debate over Socialist Realism as an empty and trivial exercise undertaken to give an air of legitimacy to the inevitable triumph of the Cult of Personality over architecture. But if the evidence of

[32] *Ibid.*, p. 4.

[33] E. Lisitskii, "Forum sotsislisticheskoi Moskvy," *Arkhitektura SSSR*, 1934, No. 10, p. 5.

[34] *Sbornik rabot arkhitekturnykh masterskikh Mossoveta 1934 g.*, vol. ii, pp. 3-4.

[35] *Ibid.*, p. 3.

[36] Quoted by A. Ovcharenko, "Sotsialisticheskii realizm v svete mezhdunarodnykh sporov," pp. 270-71, and by Ermolaev, *Soviet Literary Theories, 1917-1934*, p. 144.

Melnikov's career is any indication, there was in it far more architectural substance than has generally been acknowledged.

What was the social reality that architecture was called upon to reflect? On this there was no disagreement. Every new factory swelled the ranks of Russia's laboring class, and the annual graduation of thousands of "open-admission" students from schools and technical institutes expanded the nation's educated populace. Whatever their differences, both were "new" people, profoundly indebted to the Soviet regime and, many believed, to Stalin for their rapid advancement in society. An architectural style, if it was to succeed in the estimation of such people, had to appeal directly to their sense of pride and accomplishment.

Neither brutal functionalism nor abstract formalism held any appeal for Russians just up from poverty, for in the last analysis both styles assumed a referent in the "high culture" of the past that such people did not possess.[37] Those seeking heroism could only be revolted by the already peeling greyness of Constructivist buildings erected less than a decade before.[38] And technical innovation per se held little fascination either, for its fruits were by no means always so awesome as the Dnieper Dam, nor did they necessarily express qualities unique to the Soviet experience. The architecture of Socialist Realism, then, had above all to be "accessible," to use a term widely in vogue in the mid-thirties.[39] And accessibility implied a robust, straightforward, bombastic and monumental style executed on a scale calculated to awe and at the same time to attract the New Soviet Man.

Melnikov understood this precept, not merely because it was repeatedly expressed by officials, but also because he had independently arrived at a similar conclusion. Most of the projects that he undertook after 1932 reveal his acceptance of the new social environment and his increasing concern to reflect and glorify it in a suitably "accessible" architecture. The resulting designs may be remote from our contemporary taste, just as they were from avant-garde tastes of the 1920s. But to jump from this to the conclusion that his efforts were but cynical attempts at self-preservation is to deny the serious architectural enquiry that lay at the heart of the controversies of the mid-thirties and to ascribe to him motives for which neither his actions at the time nor his later reminiscences provide evidence. On the contrary, thirty years later Melnikov continued to speak of his work of this period with the same pride with which he referred to the Rusakov Club or the Paris pavilion.

Broadly speaking, three different but related styles were put forward by Soviet architects as being the most appropriate for Socialist Realism: a neo-classical *cum* Renaissance revivalism, an eclectic style blended of various Oriental and exotic motifs, and what was taken in Russia to be a New York skyscraper idiom that combined elements of both academic classicism and exoticism. In his last works, Melnikov ventured into all three areas.

Neo-classicism carried the official imprimatur of the government, and

[37] On a related point, Maxim Gorky, in his speech before the 1934 Congress of the Union of Soviet Writers, noted that, "It is hard to imagine Immanuel Kant, barefoot and clothed only in animal skins, wrapped in thought about a Thing-In-Itself." Maxim Gorky, *On Literature: Selected Articles*, Moscow, n.d., p. 229.

[38] Frank Lloyd Wright noticed the shabbiness of the avant-garde buildings of the 1920s during his visit to Moscow in 1937. "Architecture and Life in the USSR," *Architectural Record*, 1937, No. 10, pp. 59-61.

[39] Ehrenburg (*Memoirs, 1921-1941*, pp. 324-25) speaks of "the vogue of 'accessibility.' "

came closer than any other style to dominating Soviet architecture of the times. In 1932, the newspaper *Izvestiia* suggested that "classical (Roman) architecture is closest to us,"[40] presumably because it embodied the ideals of the only multi-national world state ever to rival the size of the U.S.S.R. That same year, Commissar of Enlightenment Lunacharskii argued that "The proletarian has a right to colonnades"[41] and went so far as to cite Marx's admiration for classical Greece in support of his claim. Several editions of the works of Piranesi appeared between 1934 and 1938,[42] Roman theaters were analyzed for their contemporary relevance,[43] and articles on Ledoux and his contemporaries again appeared in print.[44] Though the classicizers included many former avant-gardists, it was the *modus vivendi* that the Union of Soviet Architects struck with such pre-revolutionary academicians as Ivan Fomin and Ivan Zholtovskii that most encouraged this tendency.[45]

On the basis of Melnikov's published *Credo* of 1934, one might conclude that he was unalterably opposed to all this: "Some say that architecture should make room before the comely bazaar of the past. . . . If this is so, then let me be condemned for my furious insistence on moving independently and directly towards a truly distinctive creation. . . ."[46] But what he was opposing here was plagiarism from the past, and not the utilization for original purposes of insights drawn from the classical and Romantic Classical traditions. Thus, the first variant of the Palace of Culture for Tashkent had relied heavily on the assemblage of rectangles and cylinders so beloved by the eighteenth-century Russian architect Kazakov, yet without a hint of literal imitation. Similarly, the style of several of the drawings for the 1934 House of Heavy Industry show the clear influence of Piranesi, though the long exterior stairway is Piranesian in scale and spirit without being indebted to any particular work of the eighteenth-century master.

Later, when Melnikov submitted a design for the Soviet pavilion at the 1937 Paris Exposition, he reverted yet more directly to the notions of Romantic Classicism to which he had first been exposed as a student. Here a series of unornamented round arches (Figs. 222-223) are compiled so as to define a linear space through which the visitor would move in a three-phased procession, passing from an open entryway up a dark passageway by escalator to a light-filled sanctuary in which the exhibits were to be mounted (Figs. 224-225). The building is thus transformed into an ancient temple, in which the public would undergo a rite of purification so as to emerge in the end into the dazzling light of Soviet life. It is not merely fortuitous that this recalls the process of Pamino's purification in Mozart's *The Magic Flute*, for the architect later claimed to have had in mind this work of Romantic Classical theater when he designed the pavilion: "I gave

[40] Cited by Elizabeth Noble, "Architecture in the USSR," *New Masses,* 1938, March 15, p. 30.

[41] Cited by B. Lubetkin, "Soviet Architecture; Notes on Developments from 1917 to 1932," *Architectural Association Journal*, 1956, No. 5, p. 264. A more detailed statement of Lunacharskii's views on this point is to be found in his essay "Arkhitekturnoe oformlenie sotsgorodov," *Revoliutsiia i kultura*, 1930, No. 1, pp. 67-68.

[42] *Cf. Stroitelstvo Moskvy*, 1935, No. 4, p. 35.

[43] Vsesoiuznaia akademiia arkhitektury, *Problemy arkhitektury; sbornik materialov*, A. Ia. Aleksandrov, ed., 1937, No. 2, bk. 2.

[44] D. E. Arkin, "Gabriel i Ledu," *Problemy arkhitektury; sbornik materialov*, Moscow, 1936, No. 1, bk. 1, pp. 71-113.

[45] On the avant-gardists, see the excellent passages by A. G. Chiniakov, "Problema klassicheskogo naslediia," *Bratia Vesniny*, pp. 167-68.

[46] Quoted by Rodionov, "Tvorchestvo arkhitektora K. S. Melnikova," p. 15.

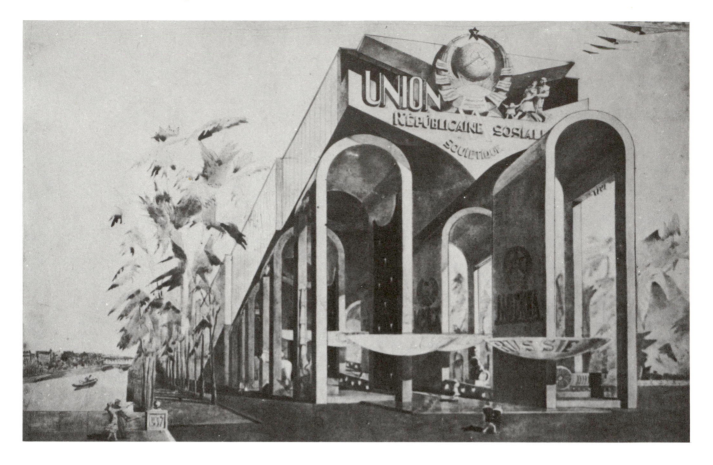

222. Project for Soviet pavilion at 1937 World's Fair, Paris

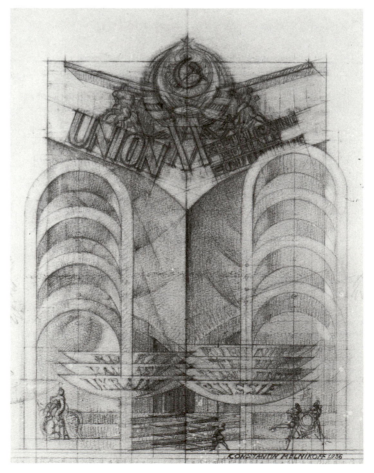

223. Charcoal sketch of facade of Soviet pavilion for 1937 World's Fair

the entrance a deep lead-in, so that visitors would begin their survey of the hall with the pupils of their eyes dilated. The aim of the architecture is to control the vision, as well as the hearing, musically."[47] It is perhaps significant that before selecting this Romantic Classical approach, Melnikov experimented with, but ultimately rejected, several more Expressionistic alternatives (Fig. 226).

Related to the revival of interest in the entire classical legacy was the growing popularity of the so-called "New York style," which became the second alternative prototype for Socialist Realism in architecture. We have already met this variant of the Beaux Arts academic idiom in Friedman's compact project for the Commissariat of Heavy Industry of 1934, but its origins antedate that project by at least half a decade. The decision in 1929 by Aleksei Shchusev to write a foreword to the Russian translation of Neutra's *Wie Baut America?* gave respectability to the already widespread interest in the most recent New World architecture. The successful showing by New Jersey's George Hamilton in the Palace of Soviets competition and

[47] Melnikov, "Arkhitektura moei zhizni," p. 9. For a hostile critique of the various projects submitted, see Ia. Kornfeldt, "Proekty sovetskogo pavilona na Parizhskoi vystavke 1937 g.," *Arkhitekturnaia gazeta*, 1936, No. 33.

224. Side elevation of Soviet pavilion for 1937 World's Fair

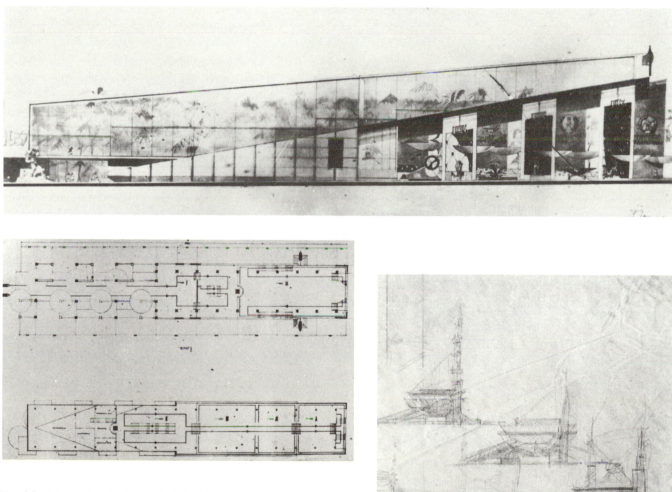

225. Plan of Soviet pavilion for 1937 World's Fair

226. Sketch of early variant for Soviet pavilion at the 1937 World's Fair in Paris

the deliberate decision by the winner, Boris Iofan, to make his winning entry taller than the Empire State Building indicate how rapidly the New York style took hold. It was soon fed by firsthand observations of the United States. In 1934, a former Shchusev aide, Viacheslav Oltarzhevskii, returned from a decade in New York, during which time he had taught architecture at Columbia University.[48] Two years later Iofan himself traveled to America, where he found "a great example of a boldly conceived architecture."[49] When it was recalled that Stalin had included "American efficiency" as part of his definition of Leninism, the last ideological impediments to learning from this otherwise tainted source were removed.[50]

The popularity in Russia of the American variant of the classical academic idiom was exceedingly great throughout the 1930s and 1940s. Its specific contribution was to open to Russian architects a means of building on their academic heritage while unabashedly exploiting the most advanced building technologies. This infatuation ended only in 1955, when the president of the Academy of Architecture, Melnikov's former student Alexander Vlasov, was unexpectedly removed from office because he had praised New York skyscrapers too highly while on an American tour.[51]

Melnikov never acknowledged in writing his interest in, and indebtedness to, American architecture of his era. But a series of three projects pertaining to the reconstruction of the city of Moscow document his steady move away from his old preoccupation with geometric shapes—with "formalism" in the best sense of the word—and his approach towards the less abstract American methods of planning and design. The point of departure was a proposal for the redesign of Moscow's central Arbat Square. Situated only a few blocks from the Kremlin, this irregular-shaped junction of ancient streets had become a major bottleneck that every planner since the teens had sought to alleviate.[52] In 1930, the decision was finally taken to tear down the Church of Saints Boris and Gleb, which had long dominated the square, and to invite major architects to replan the entire area.

Melnikov's approach to this project epitomized his "formalist" method at its best: "I cannot conceive of planning squares without a clear architectural method. For me, there is no architecture without form. That is why the choice of form for the square is so important."[53] In his usual manner, he then proceeded to redefine the square as a triangle (Fig. 227): "The triangle, having a minimum quadrature, nevertheless has a great length, as a consequence of which a large number of streets can have a direct outlet onto the square itself. With a rectangle, for example, many streets could not be joined to it."[54]

Having settled on his basic form, Melnikov went on to exploit the central area that the triangle defined. In place of the church, he proposed to erect an open-air stadium for public assemblies, which he coupled with a parking garage, metro station, taxi stand, and other public facilities; this

[48] V. Aranov, "Stareishii sovetskii zodchii (k 80-letiiu V. K. Oltarzhevskogo)," *Arkhitektura SSSR*, 1960, No. 5, pp. 53-54.

[49] *Arkhitektura SSSR,* 1937, No. 4, p. 13 ff.

[50] Stalin, "Foundations of Leninism," *Leninism*, p. 84.

[51] *New York Times,* 1953, Nov. 10, p. 3; Nov. 18, p. 2. Cited by Egbert, "Social Radicalism and the Arts: Russia," pp. v-378.

[52] S. S. Egorov, N. Beliaev, "Ob uporiadochenii ulichnogo dvizheniia na Arbatskoi ploshchadi," *Kommunalnoe khoziaistvo*, 1929, No. 3-4, pp. 23-24.

[53] K. S. Melnikov, untitled statement to jury of competition for the replanning of Arbat Square, April 4, 1931, p. 2. MS, Melnikov archive.

[54] *Ibid.*, p. 1.

227. Project for the replanning of Arbat Square, Moscow, 1931

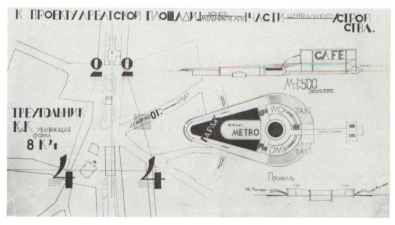

large structure was to be linked with the surrounding streets by a series of tunnels and pedestrian overpasses (Fig. 228). And to give the entire ensemble greater sculptural unity, a series of seven sloping buildings were to bound it on the north and south (Fig. 229).

Favorably received at first,[55] Melnikov's plan was finally rejected in favor of a more bland conception.[56] After this experience, he sought out new sources of inspiration for his urban designs. Following a brief and unsuccessful attempt to apply classical principles to the redesigning of Theater Square in Moscow, Melnikov finally turned to American architecture and planning.

The opportunity to explore this new world was provided by the so-called Stalin Plan for the development of the city of Moscow, on which work commenced in 1933. Specific regions were assigned to the various design studios of the Moscow Council, while coordination among them was provided by a newly created central planning commission. Melnikov's Studio Number Seven was set to work on three sections adjoining the banks of the Moscow River, the Kotelnicheskaia and Goncharnaia Embankments, and the Luzhniki district near the present-day site of Moscow University. Both projects were started during 1934, that very productive year in which Melnikov and his staff was also working on the Intourist garage and the Red

228. Map showing imposition of Melnikov's triangular scheme on the old Arbat square, with details of central structure

[55] Ig. Voblyi described it as "an exceedingly interesting effect, and at the same time being exceptionally desirable in purely functional terms . . . ," "Za planovoe oformlenie Moskovskikh ploshchadei," *Stroitelstvo Moskvy*, 1931, No. 5, pp. 35-36.

[56] "Arkhitektura gorodskoi ploshchadi," *Arkhitektura SSSR*, 1934, No. 2, pp. 10-25 reviews this and other projects actually built.

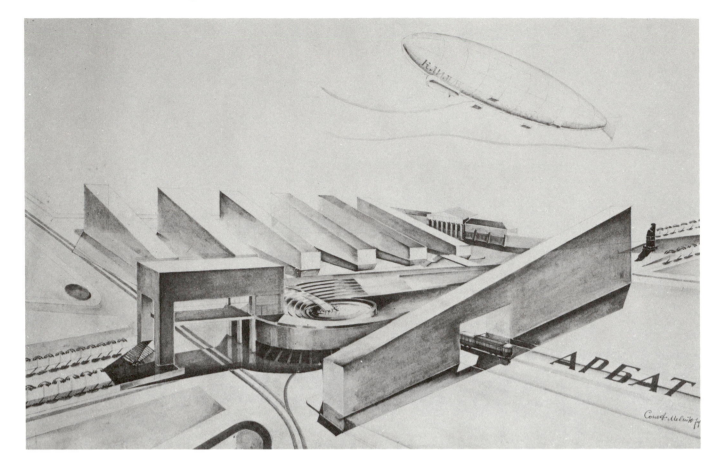

229. Aerial view of proposed Arbat Square reconstruction

Square headquarters for the Commissariat of Heavy Industry. Work continued through 1936.

There were several reasons why the model of New York City was pertinent to the development of the Moscow River embankments. First was the combination of the need to move large volumes of traffic along the river bank and at the same time to preserve the unique topographical features of the area for the enjoyment of residents. Through Viacheslav Oltarzhevskii, Melnikov learned of the Riverside Drive development and its coordination with the West Side Highway, which had been only recently proposed by Robert Moses. His desire to improve on the prototype resulted in the highway along the Goncharnaia Embankment being sunk beneath ground level and the parks being extended down to the river's edge by means of frequent pedestrian overpasses (Figs. 230-231). Second was the need at Luzhniki to carry the traffic over the river on a major bridge high enough so as not to impede river transport. Here he turned to the example of the Hell's Gate bridge on Manhattan's northeastern point, the same bridge, incidentally, which the Russian Futurist émigré David Burliuk had painted in his "radio style" in 1924 (Figs. 232-234). Again, the prototype was not merely copied, but completely reworked to form a fantastic spiral sculpture in the spirit of Iakov Chernikov's *Architectural Fantasies* which had been published two years previously.

Third, and most important, was the need to house some 20,000 Muscovites in a fashion befitting a world capital. Abandoning all his previous notions on public housing, Melnikov turned to an updated version of the

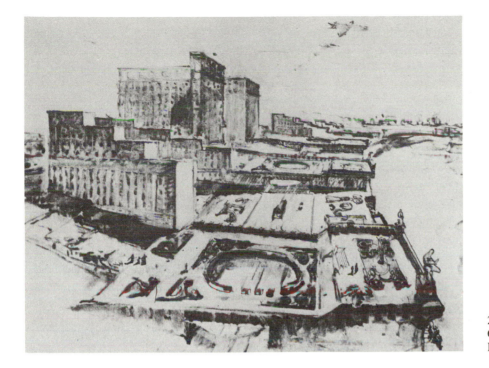

230. Project for the development of the Goncharnaia Embankment of the Moscow River, 1934. First variant

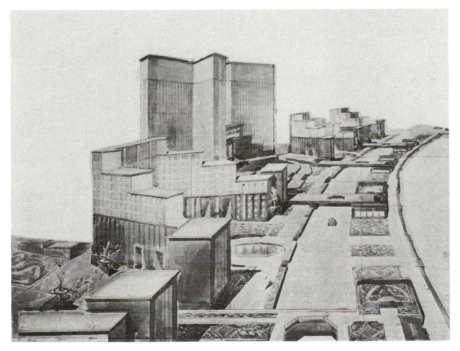

231. Project for the development of the Goncharnaia Embankment. Second variant

turn-of-the-century urban American idiom. The resulting twenty-five-storied apartment blocks (Figs. 235-236) would have been quite at home in upper Manhattan; their pompously imposing façades would have appealed as much to American businessmen as to the new breed of Soviet officials and managers for whom they were intended. But here again, the prototype was extensively reworked. Public ownership of the entire plot enabled Melnikov to concentrate the buildings at some points so as to leave other areas for parks. The careful orientation of the buildings themselves, as well as the numerous rooftop solaria and terraces which the architect included,

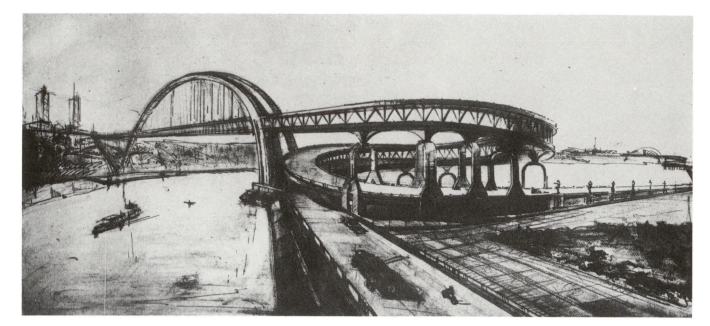

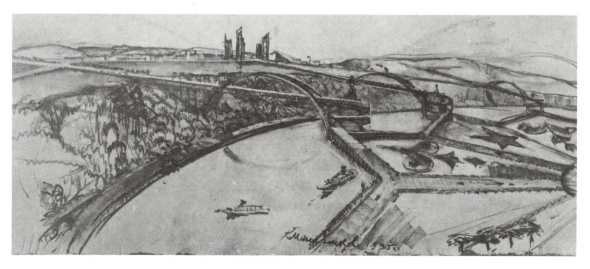

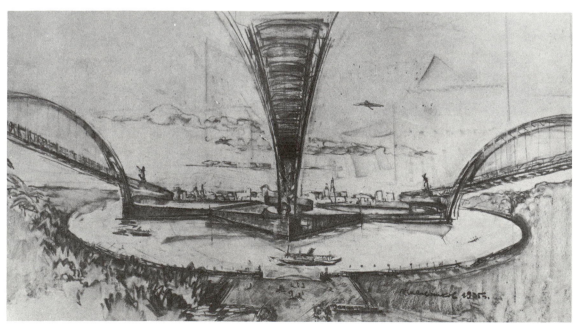

enabled still more fresh air and sunlight to enter the lives of the residents.[57]

In his Moscow River embankments, Melnikov did not slavishly follow American prototypes, but freely adapted them to his needs and the requirements of the situation. Yet the impact of his models is evident throughout and accounts for the sharp differences between this project and both his earlier housing schemes and his more recent planning effort for Arbat Square. The entire undertaking exudes the opulence and the good life that the Five-Year Plans opened to the fortunate. Because the cities of the United States had also been rebuilt to accommodate new mass wealth, their experience became relevant to the debate over Socialist Realism in architecture, notwithstanding the obvious differences between the political and economic systems of the two countries.

[57] K. S. Melnikov, "Proekt zastroiki Kotelnicheskoi i Goncharnoi naberezhnykh," *Arkhitektura SSSR*, 1934, No. 4, pp. 26-27. Also "K proektu zatroiki Kotelnicheskoi i Goncharnoi naberezhnykh," MS, Melnikov archive, p.1. On the work of other architects assigned to replan these and other Moscow River embankments, see N. V. Dokuchaev, "Ansambl naberezhnykh reki Moskvy," *Stroitelstvo Moskvy*, 1936, No. 5, pp. 2-14.

Opposite

232-4. Bridges spanning the Moscow River at Luzhniki, 1935

235-6. Housing for the Goncharnaia Embankment, Moscow, 1934

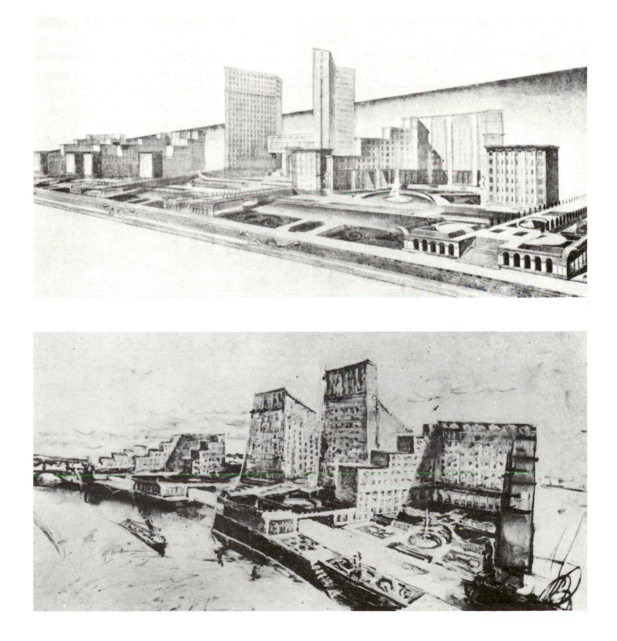

The third major style advanced as a model for Socialist Realism was not a single style at all, but a cornucopia of various exotic motifs. The rise of exoticism in Soviet architecture of the 1930s can be traced to two sources, one domestic and the other international. On the domestic side, it derived from the development under Stalin of a theory of Soviet nationalism that for the first time gave fair emphasis to the numerous Turkic and Caucasian peoples of the Soviet East. As Georgians, Armenians, and Central Asians gained prominence in the official life of Moscow, their indigenous architecture for the first time gained respectability in an all-Soviet context. The Academy of Architecture broke all precedents and began regularly publishing studies on the exotic architectural heritage of Soviet Uzbekistan, Turkmenistan, Georgia, etc., not as antiquarian exercises but as serious contributions to the definition of Socialist Realism in the field.[58] At the same time, buildings in the florid styles of the Islamic and Byzantine worlds began to appear in the major cities where those traditions had once flourished.

As a Great Russian, Melnikov had nothing to do with this current of exoticism, which he considered retrograde and alien. Nor was he attracted to the Russian analogue of that current, the revival of Muscovite architecture that to a more limited extent was also occurring during the early Stalinist era. Having been trained at a time when Russia's leading architects were straining to break with the neo-Muscovite style of the 1880s, he found little to cheer in the Central Committee decree of May 16, 1934, which exhorted Russian historians not to paint their past in too dark colors, or in the renewal of work on Shchusev's Muscovite-style Kazan Station in Moscow, which was a direct result of that decree.[59] Not that Melnikov lacked patriotism. On the contrary, his Russian nationalism was strong to the point of chauvinism, and at its worst had distinct overtones of anti-Semitism as well. But as an architect he was even less capable of associating that nationalism with the neo-Muscovite style than he was of linking it with the revival of the Romantic Classicism of the Napoleonic era in Russia.

Nevertheless, Melnikov was strongly drawn towards exoticism in these years. Unwilling to satisfy that urge by allying himself with either of its domestic variants—Islamic or neo-Muscovite—he turned instead to the ancient Middle East and especially to Pharaonic Egypt. This second strain of exoticism was part of an international tendency. Just as the revival of a heavy classicism in the U.S.S.R. was paralleled in Germany by what Hitler's architect, Albert Speer, referred to as "our Empire style,"[60] and the American urban idiom became an object of study in many places besides Russia, so motifs from the ancient East appeared at that time in the architecture of many countries, especially Germany.

It has been suggested that Egyptian funereal architecture gained popularity in the Third Reich in part because it titillated the Nazi sense of necrophilia.[61] But Melnikov and Soviet architects in general were drawn

[58] This development is analyzed in detail by Iu. Iaralov, *Natsionalnoe i internatsionalnoe v sovetskoi arkhitekture*, Moscow, 1971, Part 3, Ch. 1.

[59] This decree also marked the demise of the school of the historian Pokrovskii and the rehabilitation of such heretofore neglected pre-Revolutionary scholars as Evgenii Tarle. Klaus Mehnert, *Stalin versus Marx: The Stalinist Historical Doctrine*, London, 1952, pp. 11-13.

[60] Albert Speer, *Inside the Third Reich*, New York, 1970, Ch.10.

[61] Barbara Miller Lane, review of Albert Speer's *Inside the Third Reich* in *Journal of the Society of Architectural Historians*, xxxii, No. 4, December, 1973, p. 346.

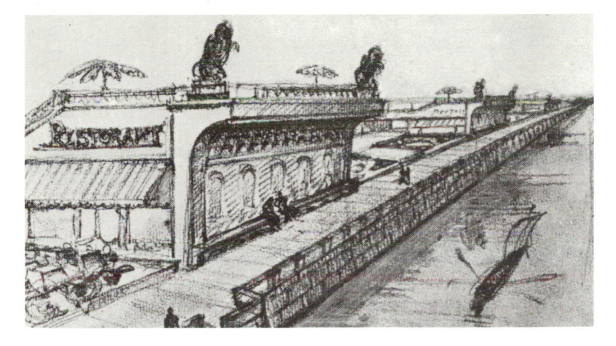

237. Restaurant for the Goncharnaia Embankment of the Moscow River, 1934

towards the architecture of the ancient Middle East not because of any "message" it conveyed but precisely because it did not contain one. Instead, it offered a wealth of exotic but ideologically non-specific motifs that could be placed in the service of any program, including Socialist Realism. At a time when all manifestations of plainness were being rejected in favor of more exuberant and heroic forms, the synthesis of the arts achieved by ancient Egyptians, Assyrians, and Babylonians acquired great relevance.[62]

Melnikov's search for exotic lushness found partial expression in his project for the development of the Moscow River embankments. The new boulevard that he planned to drive from the Kremlin walls southwestward to the river's edge was to end in a park with restaurants and outdoor cafés. Though the actual design of these highly ornamented restaurants exudes as much the air of the Chicago World's Fair as ancient Babylon, they were intended to be "hanging gardens" where Muscovites could bask in Oriental indolence after their labors on the Five-Year Plans (Fig. 237).[63]

In 1935, Melnikov went much further towards adopting exotic motifs in his project for housing for workers at the *Izvestiia* printing plant on Meshchanskaia Ulitsa. No sooner did the government's newspaper announce a competition for housing for its workers than Melnikov and his staff at once seized the opportunity to apply their new ideas. In view of his desire to apply exotic motifs to the project, it is surprising how formal the site plan is. The slightly irregular plot did not permit an absolutely symmetrical arrangement of the seven large apartment blocs (Fig. 238), but by placing them on the perimeter of the site and creating a low, broad entrance stairway (Fig. 239) to the interior courtyard, the illusion of symmetry was achieved. Within the courtyard was to be a promenade laid with black and white diamond-shaped stones, and at the center of the area defined by the promenade was to be a sunken garden crowned by a large fountain (Fig.

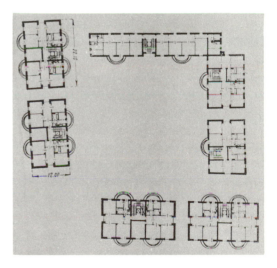

238. Site and floor plan of proposed housing for workers at the *Izvestiia* printing plant, Moscow, 1936

[62] This is the theme of N. Brunov's influential study of ancient Egyptian architecture, "Egipetskaia arkhitektura i problema sinteza iskusstv," *Voprosy arkhitektury*, Moscow, 1935, pp. 11-31.

[63] Melnikov, "Proekt zastroiki Kotelnicheskoi i Goncharnoi naberezhnykh," p. 27.

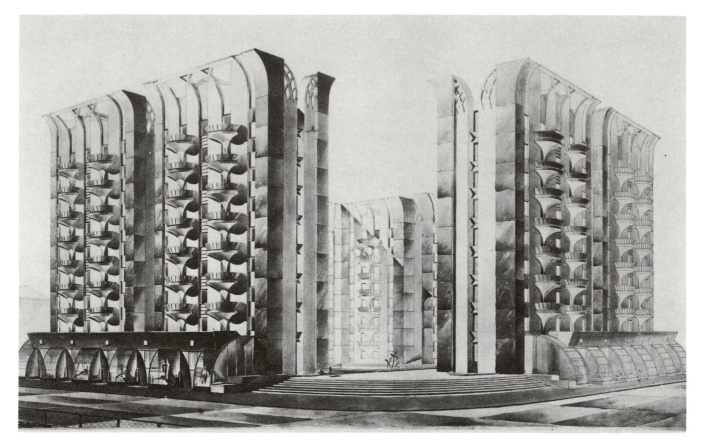

239. Exterior view of the housing complex for *Izvestiia* workers, Meshchanskaia Ulitsa

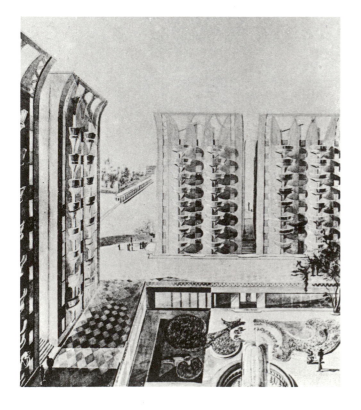

240. View of interior courtyard of housing complex for *Izvestiia* workers

241. Detail of shops at *Izvestiia* housing complex, Meshchanskaia Ulitsa

240). Flashy shops with curving glass windows on the ground floor of each building complete the ensemble (Fig. 241).[64]

It was not in the site plan but in the buildings themselves where Melnikov's orientalism found expression. Massive, unornamented pylons of dark material anchor the four corners of each unit. Towards the top, the weightiness of these primitive megaliths is relieved by an outward flair that creates a slight overhang. This flair is picked up by the elements of the structures between the pylons, but here the cornice-line is perforated to form a kind of open-work pattern in the shape of stylized papyrus flowers (Fig. 242). These "flowers" in turn form the tops of vertical configurations upon which the balconies for each apartment are strung like blossoms or leaves on a stem.

No single element of Melnikov's apartment units bespeaks the oriental influence so blatantly as Walter Gropius' 1936 German embassy in Baghdad, which proclaims that architect's infatuation with Fahtamid architecture. But the ponderous pylons, the stylized floral motif at the cornice, and the balconies in the form of uplifted blossoms—all so atypical of Melnikov's work before 1936—together reflect his new interest in the expressiveness of the ancient East. But however strong his attraction to Pharaonic Egypt, Melnikov did not allow its aesthetics to influence the basic form of his project. In contrast to Albert Speer, who directly imitated Egyptian architectural prototypes, especially the temple at Karnak, Melnikov confined his borrowings largely to ornamental motifs drawn from Egyptian painting and sculpture. This, in the last analysis, marks the limit of his experimentation with the fashionable exoticism of the day.

Between 1932 and 1936, Melnikov participated actively in the effort to define an architectural style worthy of being called "Socialist Realism." He re-examined certain aspects of the heritage of Romantic Classicism, studied closely the recent experience of urban American, and ventured into

[64] Melnikov, K. S., "Proekt zhilogo doma dlia sotrudnikov gazety *Izvestiia* TsIK i VTsIK SSSR v Moskve na uglu ul. Pushkina (b. Dmitrevka) i liniei bulvarov. 1935 god." MS, 1935, 1 p., Melnikov archive. *Cf.* review in *Arkhitekturnaia gazeta*, 1936, No. 9, p. 4.

242. Elevation of workers' housing, Meshchanskaia Ulitsa, Moscow

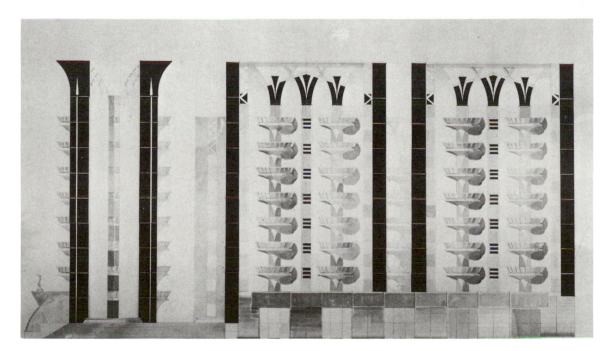

the exotic world of ancient Egyptian art. Yet he never succumbed completely to any one of these modish idioms, and to the extent that he borrowed from them he always freely adapted his sources to bring them into accord with his own inclinations. At the same time, his explorations had a random character, as if he was himself unconvinced of the worth of pursuing any one avenue to its conclusion, as he had done during the 1920s. Not surprisingly, the resulting projects—with the sole exception of the headquarters for the Commissariat of Heavy Industry—lack the firmness and conviction that his friends and enemies alike expected of his work.

Once Melnikov turned his back on the Revolutionary language he had employed in his work since 1919, he found nothing else that could take its place. He devised several dialects, but none was adequate to communicate the grandiose ideals that the Five-Year Plans had inculcated in the new Soviet society. Judged by the standard of grandioseness and accessibility, which he accepted at the time, this phase of Melnikov's career was a failure (Fig. 243).

Measured by the same standards, everyone else had failed too. Notwithstanding the many-sided effort launched by the leading architects of the U.S.S.R. in 1932-1933, no single architectural style appropriate to the emerging Socialist order had been advanced in a convincing manner. Having failed in their ambitions, no one was content. Classicists came to doubt their classicism; the "Americanists" became reticent about the worth of their skyscrapers; exoticists began moving rapidly back to the familiar ground of academism; and the ranks of the Constructivists had long since been thinned by the apostasy of those losing faith in functionalism. The vaunted professional unity instituted in 1932 with the foundation of the Union of Soviet Architects turned out to mask deepening confusion and chaos. As of 1936-1937, there existed nothing in architecture that one could point to confidently as "Socialist Realism."

Construction went forward all the same. Far more than during the 1920s, the silhouette of every major Soviet city prickled with building cranes. The construction industry mobilized Stakhanovite shock-forces to throw up mammoth new offices, apartments, and whole new cities in a vain attempt to keep pace with the rapid development of the country. But this activity brought little credit to architecture. Every construction site proclaimed anew the discipline's internal disagreements over style. Worse, the "grandomania" of all the contending idioms produced cost overruns. So serious had these become by 1936 that the Central Committee of the Communist Party had to intervene with a stern decree to architects on "The Improvement of Construction and the Reduction of Building Costs."[65]

Frustration over the failure to define a program of Socialist Realism in architecture, dissension within the field itself, and mounting criticism from outside the field combined to bring about a major political crisis in the profession. Coinciding as it did with the deepening strains felt elsewhere in Soviet life, this professional crisis came to reflect many of the worst features of the broader struggle that accompanied the rise of Stalin. Of these, two tendencies were of fateful significance for Melnikov: first, the pressure on all organizations, from the Central Committee of the Communist Party down to the most obscure group of librarians in Kazakhstan, to present an appearance of unity and solidarity, even when such unity did not exist;

243. Konstantin Melnikov in 1934

[65] "Iz letopisi sovetskoi arkhitektury," *Arkhitektura SSSR*, 1967, No. 7, p. 12. Also *Arkhitektura SSSR*, 1936, No. 1, p. 1.

and, second, the search for scapegoats mounted within every such group when the requisite consensus did not emerge on its own.

These sinister tendencies had been present in the architectural world even during the 1920s, but in August, 1934, they gained new strength with the convocation of the First All-Union Congress of Soviet Writers. When the writers officially embraced Socialist Realism in literature, it became incumbent upon other artists to follow suit as quickly as possible. Anticipating this, Moscow architects had already held a series of preliminary discussions, the principal statements from which were published in the union's organ, *Architecture of the USSR*.[66] Participants were drawn from most of the factions that had been combined to form the Union of Soviet Architects. Alexander Vesnin and Moisei Ginsburg were there, as were Ivan Fomin, Georgii Golts, and Hans Schmidt, the German architect who was then working in the U.S.S.R. Melnikov was not asked to participate.

An eerie calm hung over these sessions in the autumn of 1934. Recriminations were few, and all participants in the debates displayed an apparent tolerence. Thus, when Ivan Fomin criticized Moisei Ginsburg's "fetishization of materials," the latter responded with nothing more than an earnest essay on "the architectural potentialities of contemporary industry."[67] Encouraged by such shows of moderation, the leaders of the union scheduled the First All-Union Conference of Soviet Architects, to be held at Moscow that same November for the purpose of working out the agenda for the First All-Union Congress of Soviet Architects, which was expected to take place early in 1935.[68] When this conference was convened, Melnikov had again received no invitation. This meeting promptly proved how illusory had been the spirit of good will exhibited by architects only a few months before. Indeed, it utterly dashed whatever hopes may heretofore have existed that the transition to Socialist Realism in architecture would take place without open conflict. A month before the murder of Sergei Kirov in Leningrad—the event generally cited as marking the start of Stalin's large-scale purges—the smell of vindictiveness hung in the air at the conference of Moscow architects. The Constructivists Ginsburg and A. Vesnin both spoke in a conciliatory tone, but were thanked by being berated to their faces as "nihilists."[69] The "Moscow formalists," of whom the absent Melnikov was acknowledged to be the leader, were denounced for advocating "novelty at any cost."[70] Ivan Leonidov, who was also attacked for "formalism," sat through the meeting but was not permitted to speak.[71] Quite unexpectedly, some members of the All-Union Organization of Proletarian Architects (VOPRA) also came in for criticism (for "leftist phrasemongering"), as did the classicists.

Nearly all of this vituperation had one source: the spokesmen for the large delegation of Proletarian Architects from Armenia and Georgia. To be sure, a few attacks were launched by Russians, particularly those who had up to now felt excluded from the affairs of their profession. But the overwhelming majority came from non-Russian architects, who, thanks to

[66] *Arkhitektura SSSR*, 1934, Nos. 4, 6, 7. These exchanges had actually begun in 1933. Cf. *Arkhitektura SSSR*, 1933, No. 3-4, pp. 4-25.

[67] *Arkhitektura SSSR*, 1934, pp. 28-31.

[68] This chronology is set forth in the article "Sovetskie arkhitektory gotoviatsa k sezdu," *Arkhitektura SSSR*, 1934, No. 10, p. 1.

[69] Soiuz sovetskikh arkhitektorov, *Pervoe vsesoiuznoe soveshchanie sovetskikh arkhitektorov, Informationnyi biulleten, No. 2*, Moscow, 1934, p. 16.

[70] *Ibid.*

[71] *Ibid.*, p. 15.

the constitution of the all-union organization, outnumbered the Russians on the conference's praesidium.[72] Resentful of their better-known and more senior colleagues from Moscow and Leningrad, they loosed their attack on the entire Great Russian architectural establishment, scarcely differentiating among its members. The Constructivists were considered odious because they had been notably successful in gaining commissions outside the Russian Republic and at the expense of the "minority" architects. Melnikov and the formalists were equally odious because their emphasis on abstract sculptural forms left no place for ethnic traditions. Melnikov in particular came under their sights because of his much-resented individualism, which they had only recently seen displayed without apology in his published report "On the Creative Self-feeling of an Architect."[73] They mistook his indifference to fraternizing with all colleagues as a specific insult to them as non-Russians, and they loathed the fact that he, a dandified Russian trained under the old school, could have become the leading symbol of Soviet architecture abroad. (Ill. 33) The fact that Melnikov was asked to make a second brief trip to Paris at this time to check the site assigned for the Soviet pavilion at the 1937 fair only intensified this animosity. In this context, one is tempted to revise the characterization of the Stalinist era as the "Revenge of Muscovy,"[74] As it manifested itself at the 1934 conference of architects, Stalinism could more aptly be termed a revenge *against* Muscovy.

However great the discord, the 1934 conference ended by reaffirming its announced objective of developing "a *single* design program for Soviet architecture."[75] This was an ominous sign, for it hinted that greater pressure might be applied against anyone held accountable for the continuing disunity. Melnikov well understood this. That his fears were well founded was confirmed in May, 1935, when a second All-Union Working Conference of Architects was held in Leningrad. Here for the first time the formalists and classicists were grouped as a single enemy and linked with the left-wing heresy of Trotskyism: "Formalism and its ally, restorationism, represent mistakes that are derived above all from the world view of [their] master [i.e., from Trotsky]."[76] Their specific error was to be preoccupied with "paper projects" and "purely declarative work" rather than with the grubby realities of the construction site. The only cure, of course, was for such architects ". . . to be inspired directly by the great leader of the Party, Comrade Stalin, and his most talented co-worker, Comrade L. M. Kaganovich."[77]

It mattered little that Melnikov was not mentioned by name in these latter attacks, and that the lion's share of abuse was heaped on the Leningrad classicist, Ivan Fomin. For there could henceforth be no doubt that Melnikov, as the most prominent of the formalists and the head of a design studio established by Kaganovich himself, had to be brought to heel. The charge linking formalists with Trotsky would have been fatal under any

[72] *Ibid.*, p. 44.

[73] K. S. Melnikov, "Tvorcheskoe samochuvstvie . . . ," *loc.cit.*

[74] James H. Billington, *The Icon and the Axe: An Interpretative History of Russian Culture*, New York, 1966, pp. 532 ff.

[75] "Sovetskie arkhitektory gotoviatsia k sezdu," p. 2. This statement is the more paradoxical in light of the fact that as recently as 1933, *Arkhitektura SSSR* had criticized German architects for attempting to do just this. A. Urban, "Fashizm i arkhitektura," *Arkhitektura SSSR*, 1933, No. 2, p. 34.

[76] *Pravda*, 1936, Jan. 28, p. 3.

[77] *Pravda*, 1936, Feb. 6, p. 3.

circumstances, and the fact that it went unchallenged by the several score architects in the hall only proved that the die had been cast.

Six months later, the situation again began to deteriorate, as Stalin's replacement for the murdered Kirov, the shrewd and vindictive Andrei Zhdanov, launched a general assualt on "formalism" in the arts. On January 28, *Pravda* printed a diatribe against Dmitrii Shostakovich's opera *Lady MacBeth of Mtsensk*, entitled "Noise Instead of Music." The author, apparently Zhdanov, declared the opera to be "un-Soviet, unwholesome, cheap, eccentric, tuneless and Leftist."[78] Shortly thereafter this same work and others by the thirty-two-year-old Shostakovich were declared to be "formalist" as well, thus providing further documentation for the supposed link between formalism and Trotskyism.[79] As part of the same assault, Melnikov and his entire studio came under bitter criticism in articles appearing in the architectural profession's weekly newspaper, *The Architectural Gazette (Arkhitekturnaia Gazeta)*.[80] Granted that these articles added nothing that had not been said before, they nonetheless summarized all the various charges against Melnikov and served him notice that his professional colleagues had not dropped any of them.

On February 18, 1936, Melnikov's enemies succeeded in gaining the backing of the Communist youth movement's authoritative voice, the *Komsomolskaia Pravda*.[81] The anonymous author of this article—clearly a person well acquainted with the architectural world—took note of all the previous criticisms directed against Melnikov, including a comment by the ex-Constructivist M. Barkhin made in the course of a closed jury discussion of the *Izvestiia* housing project. Then he proceeded to unleash a sustained *ad hominem* attack distinguished by such refined argumentation as the following: "Even the most sickly manifestations of the medieval imagination, in the most morose fantasies of [Heironymus] Bosch, pale before his disgusting structures, in which every humane concept of architecture is turned upside down."

Two days later, *Komsomolskaia Pravda* featured two more attacks on Melnikov. The first, by D. Arkin, [82] merely reinforced points that had been made earlier, but the second, by no less authoritative a figure than Melnikov's old supporter, Aleksei Shchusev, indicated that pressure was indeed mounting. While recognizing the younger man's talent, Shchusev warned other architects that Melnikov's "formalism" did not answer the needs of Soviet life.[83] Henceforth, it became unwise for students to study Melnikov's designs.

How far were Melnikov's foes among the architects and their powerful friends prepared to carry their attack? On February 18, the architectural press observed ominously that he was earning far too much money, more even than his former mentors, academicians Zholtovskii and Shchusev.[84]

[78] *Pravda*, 1936, January 28, p. 3.

[79] *Pravda*, 1936, February 6, p. 3.

[80] S. N. Koshin, "K. S. Melnikov i ego kollektiv," *Arkhitekturnaia gazeta*, 1936, 12 January, p. 2. See also "Protif formalizma," *Arkhitekturnaia gazeta*, 1936, February 23, p. 1.

[81] "Lestnitsa, vedushchaia nikuda: arkhitektura vverkh nogami," *Komsomolskaia Pravda*, 1936, February 18.

[82] D. Arkin, "Khudozhestvennoe samodurstvo," *Komsomolskaia Pravda*, 1936, February 20, p. 1.

[83] A. Shchusev, "Igra i 'deiatelnost'," *Komsomolskaia Pravda*, 1936, February 20, p. 4.

[84] "Podgotovka stroitelstva 1937 v Moskve," *Arkhitekturnaia gazeta*, 1936, 23 February, p. 1. Five articles in this issue were devoted to denunciations of Melnikov.

Then on March 2, 1936, the Party's own newspaper, *Pravda*, put in its word. In a long essay (once more apparently by Zhdanov) entitled "On Slovenly Artists," *Pravda* made it clear that no artist guilty of formalism could expect "to gain the patronage of the Soviet people."[85] This signaled the start of a general purge of deviant painters, musicians, and cultural figures, carried out during the spring and summer of 1936. The great Leningrad poster-maker of the revolutionary era, Lebedev, found himself out of work because of the "scribbles" he had done for a children's book; Pasternak was censured; and even the politically adroit Ilia Ehrenburg came in for scathing criticism.

With the net cast so broadly, it was by now inevitable that Melnikov, the acknowledged leader of the formalist tendency in architecture, would soon become ensnared. His position at the Moscow Architectural Institute (where he had been teaching since 1933) had grown steadily more precarious since the Moscow conference of architects in 1934. At the regular meetings of the professoriat, he was warned repeatedly of the need to conform to the norms of "Socialist Realism." Since this term was as yet undefined, such warnings struck him as patently disingenuous, and he stubbornly ignored them. Yet the *Pravda* articles had clarified one point: whatever Socialist Realism in architecture might be, it was incompatible with "formalism." Hence, there was no better way for Melnikov's colleagues to demonstrate their adherence to Socialist Realism than to attack the formalists in their midst. This the former Constructivist, Alexander Vesnin, did not hesitate to do, in an article in the professional press,[86] which was followed by a further round of denunciations by lesser colleagues. Finally, on March 17, 1936, the Council of the Moscow Architectural Institute issued an order dismissing Melnikov from his professorial functions.[87]

Melnikov's expulsion from the Moscow Architectural Institute emboldened his enemies to launch a more personal campaign against him. The first to do so was Karo Alabian, the Armenian architect who had spearheaded the attacks on formalism and Constructivism at the 1934 Moscow conference. In a lead article published by the journal of the Union of Soviet Architects in April, 1936, entitled "Against Formalism, Purism, and Eclecticism," Alabian dropped even that modicum of restraint that he had exercised two years earlier.[88]

Alabian began his essay by contrasting Socialist Realism to all art created solely by and for specialists. Invoking the nation as a whole as the only valid arbiter of taste, he posited that *national* forms were the only ones that the entire society would support. In this, of course, he was merely elaborating the position he and his fellow Armenians had advanced two years earlier in the Moscow meetings. The newspaper *Pravda*, he continued, had quite rightly criticized formalism as being incompatible with this national spirit in art, but it had refrained from specifying precisely how

[85] *Pravda*, 1936, March 2, p. 4; for a similar attack see "Pokroviteli formalizma v arkhitekturnom institute," *Rabochaia Moskva*, 1936, March 15, p. 3. Zhdanov's authorship of these articles is proposed by Juri Jelagin, *Taming of the Arts*, New York, 1951, pp. 151-52.

[86] A. A. Vesnin, "Rech A. A. Vesnina," *Arkhitekturnaia gazeta*, 1936, March 3, p. 1.

[87] "Prikaz Moskovskogo Arkhitekturnogo Instituta No. 43, ot 17 Marta 1936," Melnikov archive.

[88] K. S. Alabian, "Protiv formalizma, uproshchenchestva, eklektiki," *Arkhitektura SSSR*, 1936, No. 3, pp. 1-6.

each field should go about purging itself of the error. This placed on architects the solemn obligation to set their own house in order.

With this introduction, Alabian turned to Melnikov and his most recent work:

"Melnikov is the most clearly expressed formalist in our architecture. His most recent project, the apartment house for Meshchanskaia Ulitsa, is through and through a formalist work. Its architectural conception attests only to Melnikov's desire to 'do whatever would astonish everyone.' Melnikov's architecture is built on striking sensations, on effects hurled at the eyes. He gives no thought to the fact that he is planning a house to be lived in; he pays no heed to assure that the building is maximally comfortable for the inhabitants; that it answer all sanitary demands, and that it be a joyful place inside and out. Melnikov combines completely random elements. The architecture that he passes over from one building to the next reminds one of posters with slogans on them He wants only the exceptionally bold and unusual—he seeks to be original for its own sake. In short, *Melnikov's fundamental and sole aim is to produce an architecture which no one has ever before created.*"[89]

Alabian did not confine his denunciations to Melnikov. Elsewhere in the article he managed to upbraid Ivan Leonidov for his brand of formalism, Moisei Ginsburg and Alexander Vesnin for purism, and two virtually unknown classicists—Nikita Dobrosmyslov and Iurii Shumovskii—for the crime of eclecticism. But most of all it was Melnikov and formalism upon which Alabian poured his vitriol.

Amplifying this diatribe was another essay, "On the Theoretical Roots of Formalism in Architecture," this time by two German Communist critics, L. Rempel and T. Wiener.[90] Rejecting the idea that formalism was simply another "style," they asserted that it constituted ". . . a defined world view" emanating from the era of imperialism and the struggle against realism waged at the turn of the century in the name of so-called artistic consciousness, as against "human consciousness."[91] This scathing attack on modernism touched on everyone from Le Corbusier to von Doesberg, Mies van der Rohe, and Gropius. But, like Alabian's, it singled out Melnikov as the epitome of a movement that, it was claimed, had had its origins in the Munich lectures of Heinrich Wöllflin thirty years earlier. It must be admitted that several of Rempel and Wiener's observations hit the mark, especially their discussion of Melnikov's relationship to Kandinsky, Eric Mendelsohn, and the German Expressionists. But they cannot be taken outside the context of Alabian's vicious attack, which immediately preceded it. In the end, Rempel and Wiener supported Alabian's sinister conclusion that: "Starting from an erroneous position and working with a formalist methodology, Melnikov will never be a leading Soviet Architect. OUR TASK IS TO HELP HIM RECOGNIZE HIS ERRORS."[92]

For some months it almost appears as if Alabian's exhortation to Soviet architects to help Melnikov recognize his errors had gone unheeded. *Komsomolskaia Pravda* continued to vent its spleen on the wayward formalist,

[89] *Ibid.*, pp. 2-3.
[90] L. Rempel, T. Wiener, "O teoreticheskikh korniakh formalizma v arkhitekture," *Arkhitektura SSSR*, 1936, No. 5, pp. 8-13.
[91] *Ibid.*, p. 8.
[92] Alabian, "Protiv formalizma, uproshchenchestva, eklektiki," p. 3.

but otherwise he was left alone through the rest of 1936. There existed no grounds for optimism, however, for it was at this period that the first major trials of Stalin's great purges occurred in quick succession.[93] Foreign architects who had come to work in the U.S.S.R. during the First Five-Year Plan now besieged their embassies for permission to return home. Even Hannes Meyer, who, as a member of Alabian's own Organization of Proletarian Architects, had participated in the press campaign against formalism, pleaded for and received permission to return to Switzerland. At this time, too, the first arrests of architects were taking place. The Armenian poet Gurgen Maari, for example, found himself in a prison cell with two architects and four engineers, and Maari's experience was not unique.[94] Notwithstanding the adoption in November, 1936, of a new Soviet constitution that included extensive guarantees of civil rights, the machine of Stalin's "Great Terror" was grinding away at full fury by year's end.

The reason Melnikov's case was not taken up at once was because the board of the Union of Soviet Architects had finally reached the decision to convene the long-awaited First All-Union Congress in January, 1937. Suddenly an agenda had to be drafted, speakers had to be lined up, programs printed, delegates selected, and housing in the capital for the eight hundred participants and guests had to be arranged. Moscow's architectural world buzzed with the work of preparation. Melnikov was ignored for the time being, as if under quarantine. He was shunned by his colleagues, visited by few friends, and avoided even by most of his staff at Design Studio Number Seven, where he doggedly tried to bury himself in work.

At length, the First All-Union Congress of Soviet Architects opened on January 16, 1937, at the House of Unions. Though it was to mark the final *dénouement* of Melnikov's career, this ten-day convocation had more the appearance of a good-natured and even festive reunion of friends and friendly rivals than an inquisition. On the proscenium sat representatives of nearly all the leading tendencies in Soviet architecture since the Revolution. Melnikov's old patron Shchusev was there, sitting benignly beside former members of the proletarian movement who had only recently attacked him as the worst kind of elitist. The Constructivists Ginsburg and Vesnin were there too, genially pouring glasses of mineral water for the very people whom they had so frequently denounced on the pages of their journal, *Contemporary Architecture*. Enthusiastic architects from each republic read glowing reports on the latest achievements in construction throughout the country. As heads began to nod in the Hall of Columns, choruses from the Red Army's training academy would entertain the delegates with rousing songs. Expeditions to the newly completed Moscow-Volga Canal or to the suburban estate of the Moscow branch of the Union provided occasions for conviviality, as did the banquets held at Moscow's newest hotel. Foreign delegates brought their good wishes to the assembly, and raised their glasses to the words of "Dear Comrade Stalin" that had been taken as the congress' motto: "Concern for man."[95] The prevailing mood of camaraderie must have been infectious. Frank Lloyd Wright, who

[93] In August, 1936, sixteen well-known Old Bolsheviks were found guilty of "wreckerism" at a trial in Moscow, and, in the following months, tens of thousands of others were arrested elsewhere in the country.

[94] Robert Conquest, *The Great Terror: Stalin's Purge of the Thirties*, 2nd ed., New York, 1973, p. 443.

[95] *Arkhitektura SSSR*, 1937, No. 7-8, p. 1.

was being squired around Moscow by Melnikov's adversary, Karo Alabian (now president of the Congress), recorded his impressions of it all in words that must have delighted the organizers: "Who can help loving such liberal, great-hearted fellows? What colleague would not do anything he could do under heaven to help them? . . . There seems nothing but friendly rivalry among them."[96]

Nothing could have been further from the truth. For all the genuine good will that flowed among many delegates and for all the serious and worthwhile points made by many of the speakers, the congress had but one overriding purpose: to define once and for all the principles of Socialist Realism as they applied to architecture and to impose those principles throughout the profession. Since the congress occurred precisely at the moment when seventeen prominent opposition leaders were standing trial for their purported roles in the creation of the "Anti-Soviet Trotskyite Center," it was scarcely to be expected that those architects found by the congress to be flaunting Socialist Realism would be treated kindly.

But the congress had a yet more cynical, irrational, and cruel side, for, as the leaders of the field knew full well, no such principles had as yet been defined, let alone agreed upon. The seasoned polemicist Ivan Matsa acknowledged as much when he reported to the congress on conditions on "the so-called theoretical front": "I say 'so-called' because we have no such front. A 'front' connotes struggle—struggle for something defined, for some definite goal. But in the area of the theory of architecture, no struggle of this sort exists at all at present."[97] Matsa spoke the truth. The congress was, by its own standards, premature. But why, then, was it held at all? It will be recalled that it had been scheduled several years earlier, but then postponed because architects could come to no agreement on the nature of Socialist Realism. It was convoked now because, half a decade before, in 1932, the Seventeenth Conference of the Communist Party had proclaimed that within five years socialism must be achieved within every sphere of Soviet life. This bill came due in 1937, and leaders of the Union of Soviet Architects had no choice but to celebrate the triumph of a program that did not exist. Unsure of what they could affirm, they concentrated their attention instead on what they could most safely deny. Of all the various tendencies in Soviet architecture since 1917, formalism best fit this need, the more so since it had already been linked with Trotskyism. Accordingly, the congress turned into a kind of orgy of denunciation of formalism and of its leading exponent, Melnikov.

Karo Alabian gave the keynote address on the evening of January 16 (Fig. 244). He took the podium with a full career of bitterness against Moscow's architectural elite behind him.[98] A Party member since age twenty, but an architectural student only from his twenty-fifth year (1922), when the Armenian Communist Party sent him on scholarship to Moscow, Alabian had good reason to feel himself an outsider among the sophisticates of the *Vkhutemas*. There he had studied with the high priests of formalism, Ladovskii, Dokuchaev, and—briefly—with Melnikov, but de-

[96] Frank Lloyd Wright, "Architecture and Life in the U.S.S.R.," *Architectural Record*, 1937, October, p. 60. Giorgio Ciucci, "Le Corbusier e Wright in URSS," in *Socialismo, Città, Architektura URSS, 1917-1937*, Manfredo Tafuri, ed., Rome, 1971, pp. 171-94.

[97] *Ibid.*, pp. 31-32.

[98] The only biography of Alabian is L. B. Karlik's effusive *Karo Alabian*, Erevan, 1966; cf. also N. Kolli, "Karo Semenevich Alabian," *Arkhitektura SSSR*, 1959, No. 2, pp. 63-64; and "Pamiati K. S. Alabiana," *Arkhitektura SSSR*, 1967, No. 12, pp. 24-25.

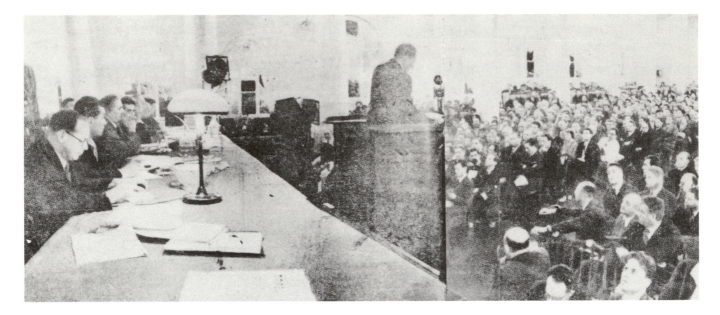

244. Karo Alabian delivering keynote address at the First All-Union Congress of Soviet Architects in 1937

rived from the experience only the conviction, shared by his teachers, that such subtle aesthetics were alien to him. His architectural career foundered, and by 1937 he had built only one building of his own—the Central Theater of the Soviet Army, for the design of which he made self-serving apologies to Wright.[99] His public career flourished, however, as he succeeded in parlaying his leading role in the proletarian group VOPRA into a central position in the new architectural union, whence he launched his purge at the 1935 Moscow conference.

Why did Alabian's resentment focus upon Melnikov? Because Melnikov, more then anyone else, represented achievement of a type inaccessible to him, yet one, at the time he had aspired to it, amply rewarded by the Revolutionary government. On a more personal level, the two had come into conflict as student leader and faculty member at the *Vkhutemas*—leaving Alabian bearing a grudge that he first expressed in the late twenties, when he systematically excluded Melnikov's work from the student publications he edited.[100] Now, in 1937, the moment arrived for Alabian to settle this old score once and for all.

Alabian's speech began with a *pro forma* review of recent achievements in Soviet architecture, contrasting them to the West, where, quoting Wright, he claimed that "architectural initiative had been killed [by the Depression]."[101] Then he lamely attempted a definition of Socialist Realism as that amalgam of "ideology" and "truthfulness" which would meet current demands of technology, culture, and practicality—scarcely a formulation capable of guiding the working architect! After a few more references to the need to produce buildings that would be monuments to the Soviet effort to construct a new society, Alabian turned to the real business of the day, the definition of what Socialist Realism was *not*. At once all

[99] Wright (p. 59) quotes Alabian as saying, "I thought I would put all the columns I would have to use the rest of my life in this one building and have done with it." Alabian had *assisted* in the design of four other projects that were built.

[100] Since Alabian left no memoirs and Melnikov declines to speak in detail of these early confrontations, it is impossible to do more than report the fact that they were cited as factors leading to Alabian's 1937 speech by several retired Moscow architects with whom the author spoke.

[101] Simon Breines, "First Congress of Soviet Architects," *Architectural Record*, 1937, October, p. 63.

uncertainty vanished. Socialist Realism, he asserted, was not Constructivism and it was not formalism. In the rest of his address he elaborated these by-now familiar points. Alabian ridiculed the "extremely freakish" buildings of the post-Revolutionary years, which were not architecture but sculpture, and he spoke contemptuously of Melnikov for his obstinate refusal to come to grips with "Soviet reality."

Alabian's tone was dignified throughout, in keeping with his statesmanly role. To be sure, there was absolutely no need on his part for shrillness, since he could confidently leave to other speakers the task of developing the implications of his pronouncements. This began three days later during a heated debate, not on formalism but on Constructivism. Nikolai Kolli, Wright's closest friend among the Soviet architects, had picked up a theme from Alabian and charged Ginsburg and the Vesnin brothers with moral responsibility for the "faddish" current of Constructivism.[102]

When Viktor Vesnin took the podium to speak in behalf of the accused, he put the proceedings on an unexpected tack. After pointing out parenthetically that Constructivism had at one time enjoyed the support of the highest authorities, Vesnin conceded that it was now a "past phase" in Soviet architecture and that henceforth Socialist Realism would "point out the path for the further development of our socialist architecture." Then Moisei Ginsburg repeated Vesnin's astonishing capitulation, yet in such a way as to divert the attention of the assembly from the past errors of the Constructivists to the present and more sinister evil presented by Melnikov. He deftly accomplished this without so much as mentioning Melnikov by name; he merely rephrased Kolli's criticism so that it would apply more directly to his old foe Melnikov than to himself. How greatly Ginsburg regretted, for example, that workers' clubs had yet to be properly designed; and how contemptible it was when gifted architects allowed their talents to be sullied by self-love and egotism. The talent of an artist must not be directed towards "scraping around in his own soul," Ginsburg declared, "but towards the firm and diligent study of Soviet reality."[103] Aside from the fact that Ginsburg, as a Constructivist, considered the term "artist" to apply largely to formalists who rejected the engineering dimensions of architecture, his inclusion of references to egotism and isolation from Soviet reality pointed directly back to Alabian's incantations against Melnikov. The danger to himself having been averted, Ginsburg returned unscathed to his seat on the presidium.

At this point, Georgii Golts took the podium. Golts' and Melnikov's biographies were deceptively similar. They were contemporaries and had both studied painting at the Moscow School before the First World War. Both had been associated with the Free Workshops, both had been among the "disciples" of Shchusev and Zholtovskii during 1920-1922, and both were among those younger architects who had sought to dent the older generation's monopoly of the field at the Agricultural Exposition in 1923.[104] The similarities are deceptive, however, for at nearly every point in their parallel careers Golts had been relegated to a subordinate role. At the agricultural fair, Golts had plugged away as an assistant to Zholtovskii, while Melnikov built his acclaimed Makhorka pavilion. In 1924, Golts was

[102] *Arkhitektura SSSR*, 1937, No. 7-8, p. 28.

[103] *Ibid.*, p. 29.

[104] Iu. Savitskii, "G. P. Golts," *Arkhitektura SSSR*, 1940, No. 7, p. 39; cf. also Golts' autobiographical statement, "G. P. Golts," *Arkhitektura SSSR*, 1935, No. 5, pp. 17-20. As a painter, Golts was probably more avant-garde than Melnikov, having worked for both Goncharova and Larionov before their emigration.

granted an ordinary study tour to Italy, while Melnikov was soon to travel in triumph to Paris. As a classicist during the Cultural Revolution, Golts, in his own words, had gone "unrecognized,"[105] while Melnikov added new triumphs to his record. Once more, Melnikov's apparent success had unwittingly fed a colleague's sense of failure, and once again that colleague seized the chance to bring low the cause of his humiliation.

In his speech, Golts transformed the problem of formalism from a question of principles to one of personalities: "When talk turns to the subject of formalism, it is Melnikov and [Ivan] Leonidov who are usually accused. But between these two there is one essential difference. Leonidov is an honest man. He loves his art. If he has committed errors . . . it can be explained by the fact that he has been pulled away from our reality. Hence we must not only criticize him but also help him. Melnikov, though, is another matter entirely, for in him one does not sense the quality of honesty. He is a talented man, but he has no real love for his art. Melnikov is quite contented with himself and when a person falls into self-satisfaction he leaves life behind."[106]

This indictment made it clear that not all formalists were to be treated equally. Some were capable of being redeemed while others—i.e., Melnikov—were not. In order to draw such distinctions, the thesis advanced during 1935 and 1936 that formalism was a form of Trotskyism had to be dropped. Indeed, Trotskyism was scarcely mentioned at the congress, no doubt because of an agreement made informally among members of the Council of the Union of Soviet Architects.[107] This ideological sleight-of-hand meliorated somewhat Leonidov's sentence—he was at least allowed to continue architectural practice—but it sealed Melnikov's fate irrevocably.

From Melnikov's standpoint, everything that followed Golts' pronouncement was anticlimactic. Little did it matter that Frank Lloyd Wright took the floor to denounce both the "left" and "right" wings of post-revolutionary Soviet architecture.[108] By now, further concurring opinions were redundant. The critic David Arkin, who had already denounced Melnikov in print, gave voice to the obvious in his concluding remarks to the congress: "It is completely obvious that at this Congress the architecture of formalism went down to total defeat in all its forms and manifestations, whether of the home-grown *Vkhutemas* variety based on every manner of spatial abstractions and the most naive architectural stunts, or the more refined, but nonetheless contentless and fruitless purism of the 'Western' type . . . or finally, of the openly formalistic features in the work of a series of architects of the 'classical' line."[109]

And so it had. But thanks to the tidy distinctions introduced by Georgii Golts, some formalists were to suffer more than others, and Melnikov more than any. *Izvestiia* singled him out for attack in its coverage of the congress.[110] Henceforth, Melnikov was not simply avoided but placed under

[105] Golts, "G. P. Golts," p. 17.

[106] *Arkhitektura SSSR*, 1937, No. 7-8, p. 30.

[107] It is difficult to avoid the hypothesis that Ginsburg lay behind this, for there is no one in the upper echelons of the Union of Soviet Architects who had more compelling reasons than Ginsburg for drawing a distinction between his close friend and protégé, Leonidov, and Melnikov in order to meliorate the sentence of the former.

[108] *Ibid.*, p. 50. Wright also declared that town-planning was impossible in America and that the American skyscraper was "a victory for engineering and defeat for architecture."

[109] D. Arkin, "Problemy sovetskoi arkhitektury na sezde," *ibid.* p. 51 ff.

[110] "Pervyi vsesoiuznyi sezd sovetskikh arkhitektorov," *Izvestiia*, 1937, June 21, p. 3.

virtual house arrest. As the purges ground on around him, he remained at home, unvisited and treated as a pariah even by long-time associates. Within the year, he was forced to give up his position as director of the Design Studio Number Seven and to sever all association with the architectural collective he had organized.

Convinced that by now Melnikov was ready to capitulate, leaders of the Union of Architects approached him with the suggestion that he submit to them a thorough critique of his own work as a condition for renewing his active career. Melnikov refused, claiming that he was far too busy, and then countered with the suggestion that the Union should fund an exhibition of his work, publish a monograph on him, and arrange an evening colloquium on his architecture.[111] Goaded by this rejoinder, the Union of Architects severed all relations with the wayward Melnikov and denied him the right to practice or even to teach in the field to which he had devoted his life. His career was finished.

* * *

Having followed the steps by which Melnikov was purged from the profession of architecture, we should review the causes of that development, not just to understand his personal tragedy but also in order to determine which of the ideals that Melnikov had served during the 'twenties accounted for his fall in the 'thirties.

The most obvious factor, of course, was that his foes had found him to be a formalist, and formalism was agreed to be incompatible with Socialist Realism. But before this is permitted to stand as the main cause, it must be noted that in actuality the congress' purge of formalists was far from complete. If Melnikov's crime consisted only in formalism, how can one account for the fact that Ivan Fomin could go forth from the congress to produce some of the most uncompromisingly formalist buildings of his career and to see this same type of classical formalism adopted as the official style for post-World War II reconstruction from Stalingrad to Minsk? Why was the leading theoretician of formalism, N. V. Dokuchaev, allowed to deliver a long speech at the congress, even after Alabian's and Golts' addresses?[112] And how could Ivan Leonidov, after initially having been bracketed with Melnikov, be permitted to continue work at the Academy of Architecture, to publish projects,[113] and even (in 1937-1938) to build a purely formalistic stairway at the Ordzhonikidze Sanatorium in Kislovodsk—the first design of his ever constructed?[114] If formalism was really the main evil, then the Union of Soviet Architects should have been punished for laxity. Both Golts and Alabian should have been purged forthwith, for both had designed buildings that were acknowledged at the time to be squarely within the bounds of that very classicizing formalism that the congress condemned.[115]

[111] L. O. Bumazhnyi, "Sostoianie i zadachi Moskovskoi organizatsii soiuza,"*Arkhitekturnaia gazeta*, 1937, No. 37, June 10, pp. 1-2.

[112] *Arkhitektura SSSR*, 1937, No. 7-8, p. 41.

[113] Ivan Leonidov, "Proekt Bolshogo Arteka," *Arkhitektura SSSR*, 1938, No. 10, pp. 61-64.

[114] Aleksandrov and Khan-Magomedov, *Ivan Leonidov*, p. 99 ff.

[115] Elizabeth Noble, reporting on the congress in the American pro-Soviet journal *New Masses*, was quite right in referring to "formalism of the expressionist school that had found expression in Alabian's Red Army Theater of 1934 in Moscow," even if she erred in thinking that that particular architect had been purged. "Architecture in the U.S.S.R.," *New Masses*, 1938, March 15, p. 30. On Golts' classicism, see V. Bykov, "Konstantin Melnikov i Georgii Golts," *Sovetskaia arkhitektura*, 1969, No. 18, pp. 59-67.

Melnikov's formalism did not alone account for his fall, nor did any other factors arising directly from his practice of architecture. Nor was it due to his politics, or to political attitudes imputed to him by others. As we have seen, the charges of "Trotskyism" and "wreckerism" had been applied to all formalists in 1935 and 1936 but were dropped at the congress itself, where very little political mudslinging in fact occurred. The main reason for which Melnikov was treated differently from the accused formalists and from the entire group of Constructivists is that, of all the most prominent architects in the U.S.S.R., he had the fewest "connections" in the field and could hence be made the Union's scapegoat with the least fear of upsetting the status quo.

Mention has been made of Melnikov's individualism, his distaste for factional groupings, and for the polemics to which such groupings give rise. During the 'twenties, this attitude no doubt shielded him from much time-consuming controversy. But by not being squarely aligned with any one group in 1932, he fell outside the imposed truce through which all such groups were merged to form the Union of Soviet Architects. Hence, his place in the new national union was from the outset even more peripheral than it had been during the 'twenties. Moreover, he had failed to found a school of admirers and former students who could rally to his support in time of need. Most of his students disappeared into anonymous posts in the building field. Of the few who rose higher, Iakov Kornfeld turned back to the more conservative paths of Shchusev and Fomin and criticized his former mentor for failing to follow suit.[116] Another early student, Alexander Vlasov, went over to the proletarian group VOPRA even before graduating from the *Vkhutemas* and by the mid-1930s had become one of Alabian's co-workers.[117] Still another student and colleague, A. Trankvilitskii, who had worked with Melnikov on several of the major projects of 1933-1936, so adroitly disassociated himself from his mentor that before the end of 1937 he could see his work back on the pages of a leading journal.[118] The only colleague at the Design Studio Number Seven who attempted to speak out was the Party member V. I. Kurochkin, but he was denied access to all public media.[119]

The most serious effort in Melnikov's behalf came from an architect with whom he shared little in common, namely, the Constructivist critic and polemicist R. Khiger. In the winter of 1934-1935—just as word of Alabian's impending campaign began to pass around Moscow—it was Khiger who dared to publish in the union's journal a lengthy essay entitled "In the Studio of the Architect Melnikov."[120] Khiger could scarcely be considered a friend of Melnikov, having twice denounced him in print, once going so far as to call the Green City project "anti-Soviet."[121] Now,

[116] Ia. Kornfeld criticized Melnikov's clubs in "Rabochie kluby, dvortsy kultury," *Arkhitektura SSSR*, 1933, No. 2, p. 28.

[117] See Aleksandr V. Vlasov, "Tvorcheskii otchet," *Arkhitektura SSSR*, 1935, No. 4, pp. 55-58, as well as his speech at the 1937 Congress, *Arkhitektura SSSR*, 1937, No. 708, pp. 23-25.

[118] Trankvilitskii's *dacha*, executed in a "safe" folk idiom, is published in *Stroitelstvo Moskvy*, 1937, No. 11, pp. 6-7.

[119] As recalled by Viktor Stepanovich Melnikov.

[120] R. Ia. Khiger, "V masterskoi arkhitektora Melnikova," *Arkhitektura SSSR*, 1935, No. 1, pp. 30-34.

[121] R. Khiger, "Formalizm, ideologiia upadochnichestva v sovetskoi arkhitekture," *Sovremennaia arkhitektura*, 1929, No. 4, pp. 142-46. Khiger's assessment of other post-revolutionary movements as well as formalism is set forth in his *Puti arkhitekturnoi mysli 1917-1932*, Moscow, 1933, especially p. 30 ff.

however, as if feeling guilt over his earlier attacks, he spoke of Melnikov admiringly as "our innovator *par excellence*," who was doing for architecture what Picasso and Kandinsky had done for painting. Like those artists, he had made numerous mistakes, for which he had been justly criticized. Such shortcomings led some to ask: "In what measure does the formalistic dynamic and fantasy of Melnikov's work coincide with the general tendency of the growth of Socialist Realism? Are there any elements of Socialist Realism to be found in his work? Shouldn't Melnikov simply forget about his individualism?"

To this, Khiger replied bluntly that: "It would be sad indeed if this were to occur. It would be sad for Soviet architecture to be denied Melnikov's unique creative gifts. Socialist Realism in architecture signifies not some repetition of the style of the Parthenon, of the Baths of Caracalla, or the Pitti Palace, but movement forward brought about by reworking our treasures, movement towards different creative peaks, above which will rise up yet newer and newer summits. Along this difficult and joyous path the creative exercises of Melnikov will greatly serve us."[122]

After this brave sally, however, Khiger left the task of defending Melnikov to others, who, as we have seen, chose instead the security of silence.

Without supporters, Melnikov's case was probably lost before it opened. But whatever hope still remained on the eve of the congress was certainly dashed by his decision not to attend any of the meetings at which his work was to be denounced and then, following the attacks, his adamant refusal to issue any acknowledgment of his own guilt. And why should he have done so? One very compelling reason was that it might have enabled him to save the last remnants of his architectural career. The composer Dmitrii Shostakovich, driven nearly to suicide by the attacks on him in 1936, came to appreciate this, and went far toward mollifying those who had branded him a formalist by subtitling his 1938 Fifth Symphony "A Soviet Artist Replies to Just Criticism."[123] So did the Constructivist Viktor Vesnin, whose confession at the congress enabled him to be elected to the board of the Union of Soviet Architects.

Melnikov flatly refused to do this. He was absolutely convinced that he was the victim of a campaign of vilification that lacked the slightest artistic basis, and hence that any "confession" on his part would be equivalent to groveling before the enemies of architecture. He did not even denounce his critics, as the producer Meierhold did in 1939—and for which he was sent to death in Siberia. Instead, Melnikov simply abandoned the world in which he had figured so prominently for nearly two decades and, with no means, no position, and few friends to sustain him, quietly withdrew into the private realm of his family.

[122] Khiger, "V masterskoi arkhitektora Melnikova," pp. 32-33.
[123] Robert Conquest considers this phenomenon in the political trials in his chapter "On the Problem of Confessions," *The Great Terror*, Ch. 5.

IX. Retrospection and Introspection, 1938-1974

"And he grew grayer and grayer, older and older, not by the days but by the hours."—ALEXANDER HERZEN, on the exiled architect Alexander Vitberg, 1834 [1]

DURING the thirty-seven years between his forced retirement from the practice of architecture in 1937 and his death in the late autumn of 1974, Melnikov remained on the sidelines of Soviet architectural life. While he did not perish at the hands of the Cult of Personality as many of his contemporaries did, neither did he benefit from the full and unqualified rehabilitation that many other victims of the terror received. Suspended for a generation in a kind of professional limbo, he devoted his time to painting, teaching, drafting projects that were never to be realized, systematizing his earlier work—and fantasizing.

The first seven years were the hardest. Until 1944, he had no regular employment at all. During this grim phase of his life he returned to his easel, executing sketches for a series of large canvases on such orthodox themes as "The Meeting of Minin and Pozharskii," "Barricades on Dolgorukov Street," and even "A Meeting of the Ministers of the U.S.S.R." None gained official approval. More successful were his endeavors as a portraitist, which earned him a few commissions through the Moscow League of Artists. He took time out from this work only to design a bizarrely eclectic "Russian dacha" (Fig. 245) and to do a series of visionary architectural sketches. Among the latter, the drawing of a fantastic "Capital of the World" perhaps best reveals his state of mind at the time, for, on the one hand, it reflects the strong nationalism evoked in him by the war and, on the other, it acknowledges Stalin's absolute authority by placing the world capital "in the Caucasus" (Fig. 246).

If the war brought immense suffering to millions of Russians, it also forced the government to accept the cooperation of numerous domestic forces that had heretofore been considered suspect. Hundreds of parish churches were reopened and greater diversity was tolerated in art and music, on the reasonable grounds that relative freedom would be translated into loyal support for the defense effort. Earlier in the war Melnikov had to eke out a living building stoves, often in highly sculptural forms. But with the policy of internal détente, the Academy of Architecture in 1944 nominated him for an honorary doctorate and permitted him to return to a limited teaching role at the Moscow Architectural Institute. In gratitude, Melnikov designed a monumental entrance gate for the Moscow Union of Architects' suburban estate of Sukhanovo (Fig. 247).

This situation did not last, however, and the degree for which he had been nominated was not confirmed under Andrei Zhdanov's postwar reign as arbiter of all cultural matters. Melnikov was out of work. During the last

[1] A. I. Gertsen, *Sochineniia v deviati tomakh*, Moscow, 1956, IV, p. 278.

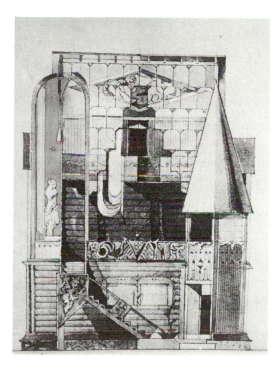

245. Project for a Russian *dacha*, 1944

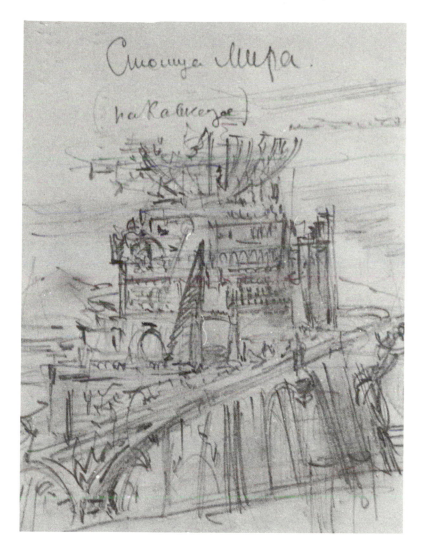

246. Fantasy sketch depicting "The Capital of the World (in the Caucasus)"

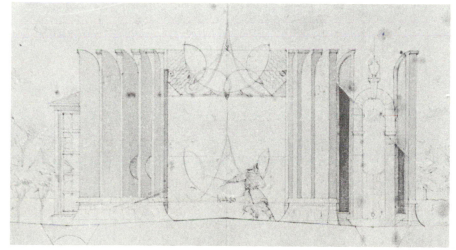

247. Project for formal entry to the estate of Sukhanovo, 1947

years of Stalinism, he confined himself to working out a few modest projects for the Saratov Highway Institute, a body that was somewhat more generous in its interpretation of his uncertain status than were his former employers in Moscow. This did not last, however; soon even the opportunity to teach in Saratov was denied him.

The death of Stalin on March 5, 1953, brought Melnikov's first efforts to bring about his own rehabilitation. No sooner was the "leader of humanity" dead than Melnikov assigned himself the job of designing a new mausoleum for Stalin and Lenin, to be built on an artificial island in the middle of the Moscow River (Fig. 248). Even though the design met the most pompous definitions of Socialist Realism, the government did not even consider it, Stalin's remains having already been interred alongside Lenin's on Red Square. Whether because of this effort or in spite of it, however, Melnikov was given back his professional title, though not his full curricular role at the architectural institute. Indeed, he did not find employment again until he received an appointment at the All-Union Civil Engineering Correspondence Institute in Moscow.

Thanks to this degree of reinstatement, Melnikov at last felt himself able for the first time to review his earlier work without anguish. In a series of

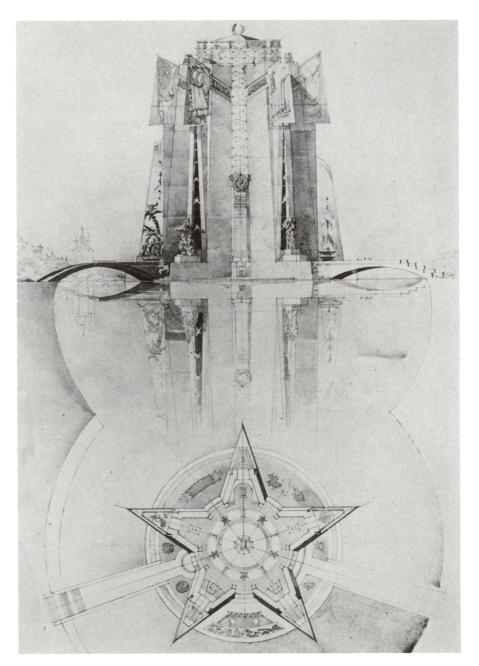

248. Project for a Lenin-Stalin Mausoleum, to be built on an artificial island in the Moscow River, 1953

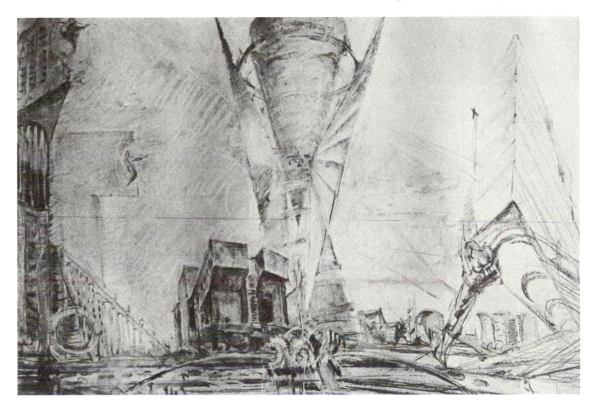

sketches, he grouped all of his earlier buildings into grand and fantastic ensembles, as if inviting the public once more to come forth and view them (Fig. 249). In the same spirit, too, he began to devote great amounts of time to systematizing the general conclusions about architecture to which his earlier practice had led him and presenting these conclusions in the form of a pedagogical system.

249. An architectural fantasy, ca. 1955

The manuscript *cum* scrapbook that resulted from this effort is so chaotic as to defy categorization.[2] At points it rises to the level of abstraction of Malevich's or Ladovskii's theoretical treatises of the 1920s, but just as often it consists of little more than a very earthbound discussion of construction problems. For whole sections, it appears as a history of world architecture, but then it will change abruptly into the author's unblushing *apologia pro vita sua*, replete with citations from Melnikov's own architecture and writing. In short, his effort at systematization was in the end not so much a sustained argument as a collection of extended jottings, the work of a man eager to resume an active life, but, in his mid-sixties, anxious also to justify his life's work in terms of the history and theory of his discipline. There are moving passages, to be sure, but all of the main points had been made already in one or another of Melnikov's earlier essays or project descriptions.

It is impossible to say to what extent Melnikov's efforts to revive his active career might have succeeded, for by the time his campaign began to bear fruit he was already beyond the age of retirement. At any rate, there remained significant opposition to his own efforts and to those of his friends, as became apparent on the occasion of his seventieth birthday in 1960. Normally, such an anniversary would have provided an appropriate

[2] Untitled autobiographical and theoretical work, including scrapbook, MS, Melnikov archive, 4 vols., 1955.

moment to right old wrongs. Melnikov's friends realized this and, with his cooperation, planned a retrospective exhibit of his work and the publication of a monograph on him. They were encouraged in this by recent events on the artistic front. In February of that year, a Russian translation of John Rewald's *The History of Impressionism* was announced,[3] while a month after that, in connection with a visit by Khrushchev to Paris, a large show of late-nineteenth-century French art opened in Moscow, featuring many of the heretofore neglected painters considered in Rewald's book. If the reviled movement of Impressionism could be rehabilitated, they reasoned, was it not likely that Melnikov could be as well? After all, only a year before Khrushchev had called on Soviet writers and artists to put an end to their internecine quarrels and to launch a new era inspired by the "angels of reconciliation."[4]

In the end, however, the exhibition did not open and the monograph was not published. Apparently, well-placed old rivals and enemies were still able to intervene successfully against both enterprises, offsetting the support that the idea of a monograph on Melnikov had won within the Academy of Sciences and that the exhibition enjoyed among younger architects.[5]

Though this episode ended in failure, Melnikov could not help but be heartened by the actions of those numerous friends and admirers who had spoken out in his behalf. Reverential visitors began appearing in great numbers at his cylindrical house; he was invited to participate in discussions with young architects; and he came gradually to be accepted as one of the most prominent living reminders of the era that had so recently ended. Accordingly, when the government in the following year announced its intention of participating in the New York World's Fair planned for 1964, Melnikov was emboldened to present himself to the Central Committee as the most appropriate architect to design the exposition hall.

He based his case on the then fashionable Cold-War proposition that "a tremendous battle was being waged between two systems, and it will be advantageous for us at this exposition to demonstrate visually the superiority of our system." As he explained in his letter to the Central Committee:

"I was the author of the building of the U.S.S.R. pavilion in Paris in 1925. That was the year that we appeared abroad for the first time. The architecture of that pavilion was in sharp contrast to most of the buildings of the other states, which contributed to the success of our pavilion. . . . I sincerely desire to try my hand again at making a pavilion that will cause the Americans to regard us as the only creators of contemporary works of architecture, and request a chance to participate in the closed competition for the USSR pavilion. . . . I pledge to produce for the jury and Government my plan by the set date and without compensation, once I have been provided with a plan of the site and the program for the project."[6]

Melnikov claimed that his resulting proposal was built around the notion of two contending systems, capitalism and Communism, but this political theme is not clearly evident in the drawings themselves.[7] On the contrary,

[3] Egbert, v-507.

[4] *Pravda*, 1959, May 23.

[5] Melnikov, "Arkhitektorskoe slovo v ego arkhitekture," p. 73. Also, personal conversation with the author, May, 1967.

[6] K. S. Melnikov to the Central Committee of the Communist Party of the U.S.S.R., *Otdel stroitelstva*, 25 November, 1961, Melnikov archive.

[7] K. S. Melnikov, "Poiasnenie proekta pavilona SSSR na Niu-Iorkskoi Mezhdurarodnoi Vystavke 1964-1965 g.g.," MS, Melnikov archive.

they show a large rectangular structure broken into a series of interior rooms and halls at two levels and dominated by a sweeping free-formed concrete roof (Figs. 250-251) that is very close in its expressionism to Saarinen's Trans-World Airways terminal or his Ingles Hockey Rink at Yale University. This undulating roof, and particularly the dramatic sculptural entry, evoke memories of Melnikov's earlier exposition halls, not in their form but in their intended impact on the viewer (Figs. 253-255). As Melnikov described it:

"The planned entry hall is not high and the project is in fact quite modest. The exit, though, is triumphal. The movement of the visitor is in proportion to the height of the premises. The farther one goes, the higher the halls. Entering at the bottom, the visitor is carried by escalator up to the brightly lighted halls with the huge height up to 18 meters, an unusual and enigmatic form for the New World."[8]

Like all of Melnikov's other post-1934 projects, however, this one was not to be built, for the Soviet Union withdrew its support from the fair even before a final decision had been taken on the architect for its pavilion.

Domestic and international problems accompanying Khrushchev's last

[8] *Ibid*., Melnikov subsequently accused the Moscow architect Posokhin of having pirated the essentials of his New York pavilion for the Soviet exposition hall at the Montreal Expo, a charge difficult to sustain in the light of the much simpler curvature of the roof at Montreal. Melnikov, "Arkhitektorskoe slovo . . .," p. 58.

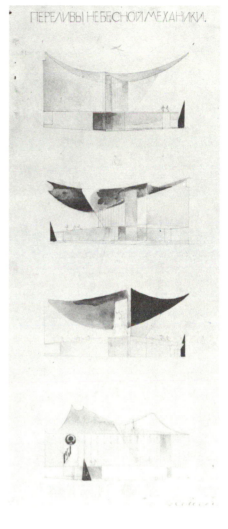

252. Sketches of final variant of roof of the Soviet pavilion at the 1962 New York World's Fair

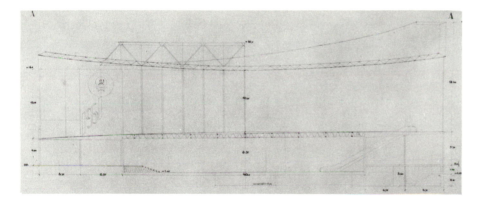

250. Section of Soviet pavilion at the 1962 New York World's Fair

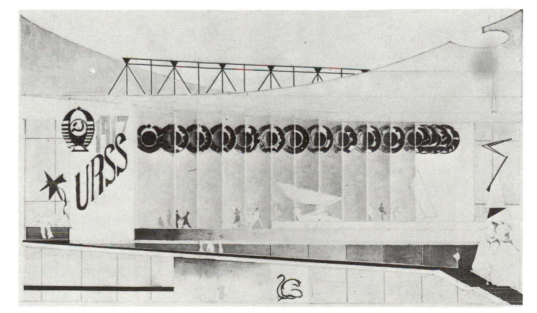

251. Elevation of proposed pavilion for the 1962 New York World's Fair

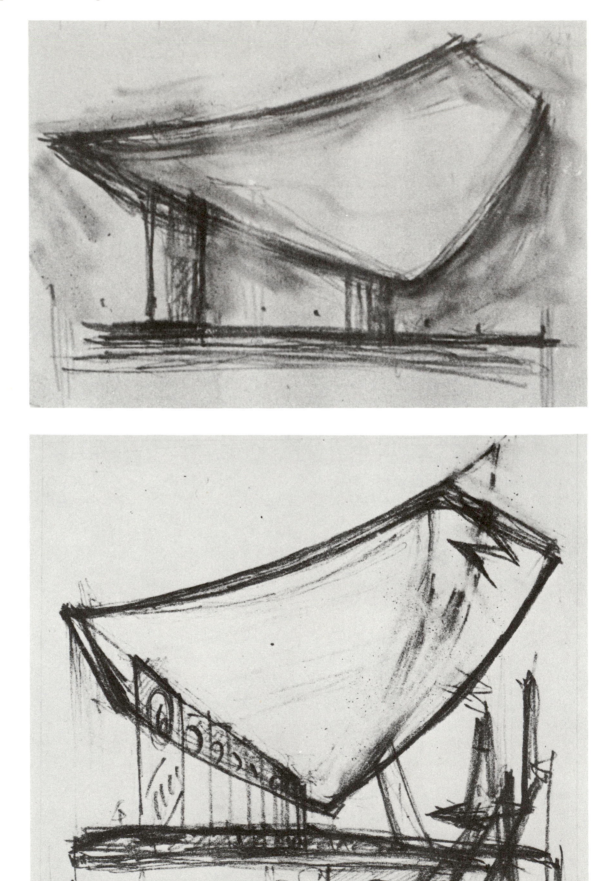

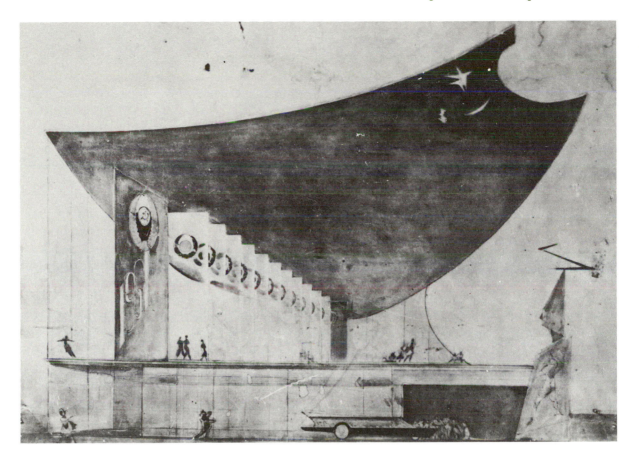

255. Main entrance to Soviet pavilion at the 1962 New York World's Fair

Opposite

253-4. Preliminary sketches of roof of the Soviet pavilion at the 1962 New York World's Fair

year in power threatened in 1962 to nullify the meager progress towards rehabilitation that Melnikov had made over the last half-decade. Tension with China had been increasing for some while already, and at the Twenty-Second Congress of the Communist Party in October, 1961, it burst into the open with a series of charges and countercharges between the Soviet and Chinese representatives. As if to counter the Chinese accusation that the Soviet Union had abandoned its own principles, a large art exhibit staged simultaneously with the congress featured only works in a correctly Socialist Realist mold. This renewed hostility towards modernism in all its aspects was expressed by Khrushchev himself in December, 1962, when he attended the opening of an exhibition of works by Moscow artists at the old Imperial Stables. Speaking off-the-cuff, the General Secretary declared that the paintings before him were good for nothing but to cover urinals, that their authors should have their pants taken down and be seated in nettles, etc., etc.[9]

Leonid Ilichev, head of the Ideological Commission of the Central Committee, soon translated Khrushchev's vulgarities into a systematic attack on that old bogey "formalism."[10] This might not have had any importance for Melnikov had not sympathic colleagues finally risen to defend innovation. But no sooner had Ilichev presented his views than the outstanding architectural critic Selim O. Khan-Magomedov countered with a ringing defense of innovation, which he published in an essay entitled "In-

[9] *Encounter*, 1963, April, reproduced in *Khrushchev and the Arts: The Politics of Soviet Culture, 1962-1964*, Priscilla Johnson, ed., Cambridge, Mass., 1965, pp. 101-105.
[10] *Pravda*, 1962, December 22. Translated in Johnson, *Khrushchev and the Arts*, pp. 105-20, especially p. 117.

novation and Conservatism in the Work of the Architect."[11] About the same time, too, Stalinist traditionalism came under severe criticism in no less authoritative a body than the Union of Soviet Architects.[12] Khrushchev had surely not anticipated that his pronouncements would meet with published criticism, but once that criticism appeared he showed himself more than ready to join battle. This was proved by his inclusion of architecture among the arts that he subjected to withering criticism in a lengthy speech on March 8, 1962.[13] After reaffirming his loathing for the excesses of Stalinism and then attacking both Ilia Ehrenburg and Evgenii Evtushenko for stating similar views on their own, Khrushchev turned abruptly to Melnikov's Rusakov Club, ridiculing it as "an ugly and uncomfortable building, as ugly as sin."[14] In an unintentional stroke of irony, he next turned on the Red Army Theater, a classical temple in the form of a star designed by Melnikov's old foe, Karo Alabian. Having lumped together these two unlikely works under the heading of formalism, Khrushchev concluded: "It is inconceivable why, and for what purpose sensible, educated people play the fool, give themselves airs, and present the most absurd products as works of art, while life around them is full of natural and thrilling beauty."[15]

In a desperate attempt to set matters straight with the General Secretary, Melnikov addressed an appeal directly to Khrushchev,[16] but received no response. The entire episode came as a blow to the seventy-two-year-old Melnikov, whose health began rapidly to give way in the face of a prolongation of what he termed his "artificial lethargy."

Only with his seventy-fifth birthday, in 1965, did events take a new turn. True, the year did not start auspiciously. Melnikov's letter to the Construction Division of the Central Committee, asking that "my name as a person be restored," was not answered.[17] But within months, the long postponed exhibition of Melnikov's works was permitted to open, not at the architectural museum but at the House of the Architect, the headquarters of the Moscow branch of the Union of Soviet Architects. The exhibit was stunning, with plans, drawings, and photographs displayed before a large and receptive audience. At a banquet in Melnikov's honor, Ilia Ehrenburg averred that, not being the Minister of Culture, he could not apologize for the long and difficult years that Melnikov had been forced to endure, years in which Soviet architecture had descended to a style appropriate only to "second-rate countries with second-rate taste."[18]

No less stunning than the adulation of friends was the continuing irony of the situation. The exhibition took place in the rooms of the very organization that had destroyed Melnikov's career twenty-eight years before.

[11] S. O. Khan-Magomedov, "Novatorstvo i konservatizm v tvorchestve arkhitektora," *Voprosy sovremennoi arkhitektury*, 1962, No. 1, pp. 31-48.

[12] A. V. Vlasov, "Otchetnyi doklad pravleniia Soiuza arkhitektorov SSSR," *Tretii vsesoiuznyi sezd sovetskikh arkhitektorov*, Moscow, 1962, pp. 10 ff.

[13] *Pravda*, 1962, March 10. Translated in Johnson, *Khrushchev and the Arts*, pp. 147-86.

[14] *Ibid.*, p. 171.

[15] *Ibid.*

[16] K. S. Melnikov, "Tovarishchu Nikite Sergeevichu Khrushchevu," June, 1963, MS copy, Melnikov archive.

[17] K. S. Melnikov, "V otdel stroitelstva, TsK KPSS," 1965, January 9, MS copy, Melnikov archive.

[18] "Moskovskoe otdelenie soiuza arkhitektorov SSSR," *Stenogramma vechera, posviashchennogo tvorcheskoi, nauchnoi i pedagogicheskoi deiatelnosti professora K. S. Melnikov, 28 Dek., 1965*, p. 3.

Melnikov's own family had had to bear the major responsibility for mounting the show. When Moscow television sought to cover the event, permission was denied on the grounds that the exposition was not officially sanctioned. And only four days after it opened, the exhibition was closed, ostensibly because the hall was needed for other purposes. No wonder that Melnikov, viewing the great Soviet film production of Shakespeare's *Hamlet*, was struck by the parallel to his own life: "They are calling me prince," he wrote bitterly, "yet they do not allow me to enter my kingdom."[19]

Nonetheless, with the decision by the Union of Architects to exhibit his work, the restraints that had heretofore prevented others from entering Melnikov's kingdom were removed, with the result that within months a number of serious articles and essays brought his work once more to the attention of the Soviet public at large. The organ of the Union of Architects, *Architecture of the U.S.S.R.*, presented an overview of his career;[20] the journal *Decorative Art* (*Dekorativnoe iskusstvo*) published an appreciation of his views on the design of workers' clubs;[21] and *Izvestiia* devoted a major article in its Sunday supplement, *The Week* (*Nedelia*) to the aging master.[22] The latter two of these important publications were the work of the same critic, Khan-Magomedov, who had led the campaign against Khrushchev's vulgar abuse three years earlier.

Even after such tributes, Melnikov continued to feel a compulsive need to explain and justify his views to friends and visitors—and not without reason. As late as 1970, at the age of eighty, he was denied permission to accept an invitation to a birthday celebration in his honor at the University of Milan.[23] Given actions such as this, it is not surprising that when the magazine *Amerika* published an article on modern architecture, he penned a letter to the editors, reminding Western readers of the innovative role once played by Soviet architects in general and by Melnikov in particular.[24] Over the years between the late 1950s and his death in 1974, he went so far as to write his own life story, not once but several times, in variants of increasing length and polemical heat. There exists no more poignant testimony to his determination to demonstrate once and for all the relevance of his architecture to an uncomprehending world than his return to the drawing boards at the age of seventy-six to design a children's theater for a vacant lot near his own home (Figs. 256-257).[25]

The belated but sincere tributes that Melnikov received in his last years arose from many quarters and from several generations. On the one hand, seasoned architects turned to him, sensing that his bold vision of the architect's mission could help to rejuvenate their own routinized practices. As a group of Moscow architects wrote in Melnikov's guest book: "An

[19] Melnikov, "Arkhitektorskoe slovo . . . ," p. 71.

[20] Gerchuk, "Arkhitektor Konstantin Melnikov."

[21] S. O. Khan-Magomedov, "Kluby segodnia i vchera," *Dekorativnoe iskusstvo SSSR*, 1966, No. 9, pp. 2-6.

[22] S. Khan-Magomedov, "Konstantin Melnikov, arkhitektor," *Nedelia*, 1966, No. 7, 6-12 December; see also Irina Uvarova, "Razgovor s Konstantinom Melnikovym," *R.T.*, 1967, No. 5.

[23] Invitation of 23 June, 1970, from the Faculty of Architecture, University of Milan, signed "Portogesi," MS, Melnikov archive.

[24] K. S. Melnikov, undated letter to editors of *Amerika* magazine, MS, Melnikov archive, 3 pp.

[25] Iu. Gnedovskii, "Konkurs na proekt detskogo kinoteatra," *Stroitelstvo i arkhitektura Moskvy*, 1968, No. 7, pp. 22-27.

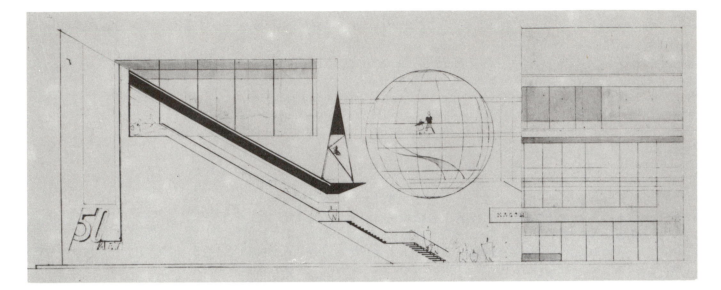

256-7. Project for a childrens' theater, Moscow, 1961

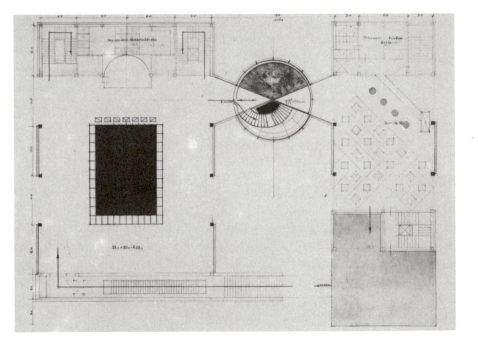

unexpected and new world of ideas, thoughts, and feelings has opened before our eyes."[26] On the other hand, he was idolized by many members of a new and hopeful generation of students from various fields who sought him out in the hope that he could somehow impart to them that freshness of vision which their society had possessed in the 1920s. Partly under the inspiration of this renewal of interest within the U.S.S.R. and partly as a result of their own research, various persons in France, Italy, England, and America were also becoming acquainted with Melnikov's achievement. So far as the world was concerned, then, he had been successfully "rehabilitated" before his death in the autumn of 1974.

Yet for all this burst of recognition, Melnikov to his last days felt himself to be an outsider, sharing little in common with the world to which his longevity had condemned him. Many visitors to his house sensed this in

[26] *Avtografy* (Melnikov archive), p. 7.

the aloofness with which he received them. The more obtuse among them, such as the writer Victor Nekrasov, laid this to Melnikov's wounded vanity and therefore went out of their way to lavish obsequious praise and flattering professional gossip on the aging architect.[27] To this he would respond with outright coldness, causing the visitors to retreat in a confusion of indignation and sadness (Fig. 258).

Melnikov was certainly cut off from the world around him, an "alien in his own country," as he had once described the house in which he was born. His wounded vanity, however, was only one of several factors that contributed to this feeling. No less significant was his long isolation from the life about him, which left him in old age like Ivan Prisypkin, the hero of Maiakovskii's play *The Bedbug*, the romantic enthusiast from the Revolutionary era whom scientists preserved in limbo for a generation, only to be resuscitated in a cold and more rationalistic world that could exhibit him but not appreciate him fully on his own terms.

Beyond this, one might ask whether there were not more fundamental factors arising from Melnikov's own beliefs that contributed to the gulf that he perceived between himself and the architectural world at large. After all, it would be inaccurate to attribute his isolation solely to the hostility of his Soviet colleagues when that sense of distance endured long after many of the best Soviet architects and scholars came once more to appreciate and esteem him as an innovator. Nor would it be reasonable to ascribe Melnikov's feeling of isolation to purely local issues, when he repeatedly indicated that he was no less disenchanted with architecture abroad than with Russian architecture. Finally, it would be erroneous to claim that the causes of his alienation were rooted in conditions unique to the middle third of the century, when we know that he had felt himself to be no less isolated from his professional colleagues at the very height of his success during the 1920s.

What was it that cut Melnikov off from foes and friends alike, and that endured through both the active and inactive phases of his career? To answer this question we must consider the architect's life and thought as a whole, and seek the underlying principles both of his architecture and of his personal philosophy.

[27] Victor Nekrasov, "How I Met a Dinosaur and What Happened," Michael Glenny, transl., *Times Literary Supplement*, 1975, March 21, pp. 314-15.

258. Konstantin Melnikov at the age of seventy-five

X. Architecture Against Death: The System of Melnikov's Art

Man lives in order not to die, for he was created for immortality.
—NIKOLAI FEDOROV *ca*. 1885[1]

MELNIKOV was the very antithesis of a systematic thinker. He wrote no full exposition of his views on architecture and life, and he was quick to condemn his various attempts to do so as utterly unsatisfactory. In conversation, he warned against relying too heavily on his various and brief autobiographical sketches, and he was sufficiently displeased with his longer treatise *cum* scrapbook as to oppose its publication in any form. The several short statements on his work which he published in the 1920s and 1930s were all written to satisfy specific tactical demands, and lack both candor and breadth.

The most adequate guides to Melnikov's views are a number of disconnected jottings that he made during the last decades of his life and a series of conversations that he conducted with various persons, among them the present author. To be sure, these constitute no real corpus of his thought and are in fact shot through with *lacunae* that can only frustrate anyone searching for more comprehensive statements. Nonetheless, they provide tantalizing glimpses into Melnikov's turn of mind. When considered in the context of the far more extensive and detailed statements that he made in his architecture itself, they provide a basis, however tenuous, for generalizing about the architect's thought. Specifically, they make possible the partial reconstruction of his principles of design and, beyond that, of his views on the more basic ends that architecture exists to serve.

Reviewing Melnikov's various statements on architecture, one is struck by the fact that most of them are cast in the negative. Over the years, he had much more to say about those tendencies and beliefs to which he was opposed than about the positive ideals that impelled him. The statements are nonetheless important, because they add up to a systematic attack on all the principal forms of positivism and determinism in which the leading approaches to architecture of the twentieth century have been grounded.

"I consider any dogma to be the enemy of my work,"[2] declared Melnikov. So often and so vehemently did he repeat this that one cannot doubt that he meant it. He shrank from being identified with any philosophical or aesthetic "system," and the political and cultural "isms" that come close at times to dominating writings of Le Corbusier, Mendelsohn, and Ginsburg figure in his jottings only when he attacks them. Melnikov's refusal to become identified with any ideology of the day was due not so much to his opposition to their substance as to his belief that they were all

[1] Nikolai Fedorov, cited in *Vselenskoe delo, sbornik II*, Riga, 1934, p. 100.
[2] Melnikov, "Arkhitektorskoe slovo . . . ," p. 68.

irrelevant to architecture. He professed himself unable to derive from any of the contending "isms" an adequate architectural method, let alone a satisfactory conception of the ultimate purposes of architecture.

First among the deterministic systems that Melnikov rejected was functionalism. Since in various forms this current commanded broad allegiance among many of his professional rivals, he denounced it with particular gusto. Can function really serve as the basis for a method of design, he asked?

"Who decides on the function of a cello? The function of that instrument might tell us that it should be made of wood, although maybe nylon cellos will be created someday. The function tells us that the cello should have four strings, though I have heard that there used to be six-string cellos. Beyond this, 'function' merely means a particular person's taste. Suppose, for example, that I am designing a house for you. You are a certain age now, but in twenty years you will be that much older. Your life will have changed and the 'functional' needs will have changed with it, yet you will still want to live in the same house. No, function cannot provide all the answers."[3]

A second form of determinism that was widespread during Melnikov's career held that the materials and technologies available to the architect would provide the necessary basis for his work. Again, he flatly disagreed. In the introduction to his attempt at a treatise on architecture, he denied that there was any need at all "to enumerate the methods of building."[4] A short memorandum that he penned in 1961 made clear his basic hostility to technological determinism:

"The pianist Lev Oborin is here now. 'Lev, tell me whether you are interested in knowing what kind of wood the keys are made of? Are you able to tell me the chemical formula for the metal alloy in the strings of your instrument?' No? But you are nonetheless able to speak precisely of your desires with regard to the selection of the instrument. A Steinway, perhaps For my part, I am purely an architect. Why, therefore, should I know from what materials the panels I use are made? Today one type is in fashion and tomorrow another will be. We might as well ask Lev Oborin to play the trumpet! What? He cannot? I will tell you plainly: The only materials needed for the construction of my architectural works are light, air, and water."[5]

Having eliminated both the function of a building and the materials of which it is constructed as sources of principles of design, Melnikov might perhaps be expected to have embraced a kind of environmental determinism. Nature, after all, in the climate, light, and terrain, provides a series of "objective" conditions with which buildings could be designed to harmonize. This form of determinism has had eloquent partisans in the twentieth century, notably Frank Lloyd Wright, Hugo Haring, and the later Alvar Aalto. But Melnikov never so much as considered it in his search for a principle of design, nor did any other major figure in the modern movement in Russia. Such disinterest is not surprising in a country where nature has traditionally been viewed as an unpredictable enemy to be overcome rather than as a steady and benign force. Melnikov's reasoning on the issue

[3] Conversation with Nancy H. Starr, Spring, 1967.

[4] Untitled autobiographical and theoretical MS with autobiography, I, p. 1.

[5] K. S. Melnikov, "Moi obsuzhdeniia i perezhivaniia v khudozhestvennykh sferakh stroitelstva," MS, Melnikov archive, p. 1. Note of 14 September 1961.

reflects these circumstances, although the final conclusion is distinctly his own:

"I met [the poet Evgenii] Evtushenko a while back at the architects' club and he asked me whether I had read Frank Lloyd Wright's book. I told him I had not (though I read it soon afterwards). Soon he was telling me all about its contents. Wright says that a building must be closely related to the land, that it must seem to GROW from it. But look at the weather today. It's sunny. Tomorrow it may rain. And then the season will change, and it will be bright but wintry, then dark and gloomy. Don't such considerations leave the question of the building's relation to the land back where it always was, in the mind of the architect?"[6]

With this, Melnikov had turned his back on all of the "objective" forces from which many twentieth-century architects have attempted to derive a method of work. Social and economic circumstances can do no more than set forth broad programs that are subject to infinite numbers of interpretation in practice; function depends ultimately on taste; technology opens up so many avenues as to throw the choice among them back into the hands of the individual architect; and the environment is too capricious a guide. And if these "objective" forces were incapable of providing inadequate principles of design, they were of even less value in defining the ultimate purposes that architecture serves. In his search for both the means and the ends of architecture, then, Melnikov had to turn elsewhere.

Melnikov was left with but two possibilities: he could either fall back on a received tradition and define his work in terms of it, or turn inward to his own self. As we have noted, he did not reject the first of these out of hand. On the contrary, having been steeped in the canons of beaux-arts architecture and in the tradition of Romantic Classicism, he reverted repeatedly to these precepts during his career as an innovator. His penchant for the theatrical, his tendency to create designs by assembling sculptural elements, and his deep commitment to architecture as an art rather than a craft—all bespeak the influence of his training at the Moscow School of Painting, Sculpture and Architecture during the final years of the old regime.

Yet the 1917 Revolution created an environment in which the more active architects of Melnikov's generation could not have developed the old tradition further, even had they wished to do so; the few who tried were either misfits or provincials. Nor is there any evidence that Melnikov suppressed a desire to continue along the lines in which his mentors had worked. On the contrary, from the beginning of his post-Revolutionary activity in 1919 down to his expulsion from the Union of Soviet Architects in 1937, he was guided not by tradition but by his own intuition. This, in the last analysis, was the ground in which he rooted all his architectural practice.

In 1933, Melnikov was asked by the new journal *Architecture of the USSR* to submit a statement on his method of formulating a project. In the brief respite between the hysteria of the Cultural Revolution and the brutality of the purges, he drafted a statement that on one point is remarkable for its candor: "At the first stage of work on a project there is no *a priori* law governing the creative process to which one is subject. A great deal depends on intuition and on what is commonly called the 'creative impulse.' "[7] Architecture is the undetermined product of subjective per-

[6] Conversation with the author, Spring, 1967.

[7] K. S. Melnikov, "Oformlenie proekta," *Arkhitektura SSSR*, 1933, No. 5, p. 35.

ceptions, rather than the inevitable end-product of the interaction of objective forces. It is *for* society, but it is not *by* society. And since the "creative impulse" of individuals is central to its existence, architecture is inescapably an art in the fullest sense of the word.

Intuition as such could be guided by many elements, and Melnikov accordingly laid great stress on the importance in architecture of rigorous training. He could speak with pride of the "New Academy" that he and Ilia Golosov founded at the *Vkhutemas* and contrast its rigor to what he considered to be the excessively psychological approach of his friends Ladovskii and Dokuchaev. But, for all this, Melnikov had no doubt that the intuitions from which design emerges have their source in the subjective world of feeling. As he explained in the introductory paragraph to his scrapbook: "The main aim of my book is to present Architecture, but not some Architecture that is made up from well-known recipes and illusions that cannot be realized, but rather an architecture [that embodies] those rare intimations of the unseen but real world of our own feelings."[8] Architecture is right or wrong according to the extent to which it accurately translates impulses gleaned from the realm of feeling into compositions of masses and voids.

With this, Melnikov set down a principle by which one could judge a work of architecture. He employed it unhesitatingly when he spoke—usually negatively—of the works of others. Hence, he objected to the buildings of Mies van der Rohe, not because they were ugly, unworkable, poorly constructed, or inappropriate to their surroundings, but because they seemed to him to be "emotionally frigid"; he considered that the Constructivists erred not by their infatuation with function per se, but because that infatuation led them to design buildings that were "soul-less."[9]

How does Melnikov's own architecture measure up to this standard which he applied so confidently to others? In the course of this study we have had occasion to speak in some detail of specific buildings and projects. We have seen how from 1919 onward he strove to communicate through his work the spirit of dynamism that he felt within himself and in the society around him. As part of this effort he successfully transformed the Sukharevka Market into a pattern of swirling avenues to be activated by teeming throngs of peasant tradesmen. This same passion for vital movement was embodied in building after building, notably in the four exposition pavilions and the parking garages.

Melnikov strove to express his feelings of dynamism in abstract forms as well, and in the course of a decade and a half he experimented with a broad range of possible alternatives to the static cube and rectangle so beloved by the Constructivists. In the bar-administration building for the Sukharevka Market he employed a triangular ground plan, and in his Palace of Soviets he attempted to activate the pyramid. The dynamic potential of the cylinder is essayed in his own home, in the Burevestnik Club, and in his unrealized projects for the Zuev Club and the Frunze Military Academy; rhomboid forms figure prominently in his pavilion at Paris; and in the Santo Domingo monument to Columbus he turned once more to the spirals of Boccioni and Tatlin.

Not satisfied with creating buildings that moved (the *Leningradskaia*

[8] Melnikov, Untitled autobiographical and theoretical MS, with autobiography, Vol. I, p. 1.
[9] Melnikov, "Arkhitektorskoe slovo . . . ," p. 59.

Pravda office) or that were set in motion by moving crowds, and impatient with activated and politicized abstract forms, Melnikov also experimented with the most literal expressions of a building's activity. The result was a series of projects that communicated their essence through the direct language of *architecture parlante*. Beginning in the mid-1920s and reaching a peak in the Gosplan garage and the MOSPS theater, he developed an exuberant *hyper-realism* that threatened finally to obliterate architecture as such and to replace it with theatricalized representations of the activities it served.

Since each of Melnikov's buildings and projects has already been considered in some detail, it is not necessary here to review them all. Suffice it to say that his passion for dynamism and motion, both mechanistic and vitalistic, found expression in nearly all of them. But does this adequately comprehend the full range and depth of his concern when he spoke of architecture presenting "intimations of the unseen but real world of our own feelings?" There are are strong reasons to believe that it does not. Why, if Melnikov had no further aims in his architecture, did he emphasize in his letter to the editors of *Amerika* magazine that "architecture, like all other arts, serves only the spiritual side of human life."[10] Why, if he recognized ends other than to communicate his infatuation with dynamism, would he have emphasized that architects have a deep obligation "to communicate the agitation of their own spirit to others?"[11]

Just what were the "agitations of spirit" that Melnikov endeavored to communicate through his architecture? The question is of central importance to the problem of his alienation and also to the problem of his architecture as a whole. Once again, his written *œuvre* is frustrating in its near complete silence. Neither the various manuscript drafts of the autobiography nor his *Credo* contains one sentence that addresses the question directly. In conversation, Melnikov would often shift abruptly from architecture to the realms of philosophy, psychology, and metaphysics, and his later reminiscences reflected this broader interest. But even here he preferred to pose questions rather than to volunteer his own answers. Whether through reticence, a heightened sense of privacy, or because of his belief that such things should become apparent through his architecture or not at all, Melnikov left little from which to discover the nature of those deeper "agitations of spirit" that impelled him.

And yet, there are a few promising leads. While visiting his daughter in Tashkent in September, 1961, Melnikov set down the following autobiographical note. So important did he consider it that six years later he was still alluding to it in conversation and having multiple copies typed for posterity: "Certain feelings have come to me several times during my life. *Dwelling upon them, I would, for seconds at a time, arrive at the sensation of a total emptiness of the spirit.* [At such times] *there existed no world at all, and there existed nothing for me to replace it with, and this 'nothingness' shook my entire being.* I do not know whether I have described it adequately, but I definitely remember and know for a fact that I have had moments of feeling that the end of the universe was at hand."[12]

How should this be interpreted? Melnikov was over seventy when he wrote these words, and, when asked, he confessed that they were oc-

[10] K. S. Melnikov, letter to *Amerika* magazine, p. 2.
[11] *Ibid.*, p. 1.
[12] Melnikov, "Moi rassuzhdeniia . . . ," p. 1, 15 September 1961.

casioned by his reading of Dostoevsky. But the note cannot be dismissed as the morose literary rumination of an old man, for he took pains to point out that the fear to which it alludes had beset him throughout his life. Rather, it must be treated as Melnikov himself regarded it, namely, as a record of his profound and enduring preoccupation with the problem of death.

It is easier to affirm that Melnikov dreaded nothingness and death than it is to explain why. There is nothing remarkable about his having experienced such fears during the post-1937 period, of course, since his involuntary idleness transformed him into a kind of artist-corpse among the living. But Melnikov insisted that his preoccupation with the problem of mortality antedated his professional demise and in fact had existed even during the years of his greatest success.

It is tempting to look to some pivotal event in his boyhood or young manhood. There can be no doubt that he had been profoundly shaken by the death in 1916 of the loving aunt who had cared for him as a child and by the death of his father during the darkest moments of the Civil War. He spoke movingly of both people during his later years and lingered over his description of both deaths in his autobiographical sketches. Nowhere, however, did he specifically link his own spiritual crisis with these or with any other identifiable events in his early life.

If one can only surmise about the personal sources of Melnikov's fascination with the problem of death, it is possible to speak with some confidence on the extent to which this same issue commanded the attention of certain of his Russian contemporaries, many of them close to the circles in which he moved. A lurid absorption in the problem of death, of course, was widespread in *fin de siècle* Europe, and Russia was no exception. There it gave rise to the necrophilic paintings of Borisov-Musatov and to the morbid verse of the symbolist poet Briusov. As in the rest of Europe, this concern sprang in good measure from the waning of faith, among the intelligentsia, in the Christian cosmology and specifically in the Resurrection. In Russia, where the drama of Easter had always taken precedence over all other Christian holidays, the vacuum created by this shift in belief was especially acute, and was reflected in the work of many leading writers. Turgenev, for example, had written a poem in prose about a death-bearing *Insect* that youth itself could not resist, while Tolstoy in his *Confession* had identified death as the one great human problem upon which all others turned. During Melnikov's student days the Orthodox Church was being rocked by a band of zealots claiming that Christianity had needlessly capitulated before death;[13] at least two journals were founded for the explicit purpose of addressing the issue of man's mortality;[14] and the physicist P. Bakhmetev had taken matters into his own hands by conducting research into anabiosis, the process of resuscitating life from death.[15]

All these currents were under the direct or indirect inspiration of the obscure, late-nineteenth-century Moscow librarian and mystic, Nikolai

[13] Peter Scheibert, "Die Besiegung des Todes—ein theologisches Programm aus der Sowjetunion (1926)," *Glaube-Geist Geschichte; Festschrift für Ernst Benz*, Gerhard Müller, Winfried Zeller, eds., Leiden, 1967, pp. 441 ff.

[14] *Novoe vino* was founded and existed briefly in Moscow during 1908, while the first collection of *Vselenskoe delo* appeared in Odessa in 1914.

[15] Bakhmetev's research involved the use of extremely low temperatures to bring about anabiosis, an idea which has most recently been explored in southern California. See "Vselenskoe delo v proshlom," *Vselenskoe delo, sbornik II*, pp. 107 ff.

Fedorov, the decennial of whose death was celebrated in 1913.[16] Revered by Tolstoy and Dostoevsky alike, Fedorov spoke of the advent of a new universal brotherhood among mankind. He believed this to be unrealizable as long as man was mortal, and so he proclaimed an all-out war by science against death and indeed against all other natural impediments to human freedom. The lives of the living were to be indefinitely prolonged and the dead were to be resurrected. Through such visions, the notion of wedding social radicalism, scientism, and Christianity was made plausible to scores of Russians in places as diverse as Odessa, Moscow, Vernyi (Alma-Ata), and, within a few years, Riga, and Kharbin in China.[17]

Such discussions by no means ended with the Bolshevik Revolution. Indeed, they reached something of a climax in 1919-1920, the winter of Melnikov's father's death and the year in which Melnikov drafted his project for a crematorium in Moscow. The Moscow painter V. N. Chekrygin was working feverishly at the time on a series of sketches for a vast canvas entitled "The Resurrection of the Dead."[18] The futurist poet Vladimir Maiakovskii, obsessed with his own mortality and recently introduced to Fedorov's ideas by the critic Osip Brik,[19] confided to a friend that he was "absolutely convinced that there will be no death [and that] the dead will be raised." The friend recalled, "At this moment I discovered a quite new Maiakovskii, who was dominated by the desire for victory over death."[20] And in the same year, too, Lenin's Commissar of Enlightenment, Anatolii Lunacharskii, wrote a long play entitled *The Magi* on the theme of becoming "younger than birth" and reissued a second play, *Faust and the City*, which dealt directly with the theme of death and resurrection.[21] Both works called on the new social order to achieve immortality, whether through the enduring memory of the people (*Faust and the City*) or through an outright victory over time (*The Magi*).[22]

How did Melnikov relate to this exotic current in the cultural life of Revolutionary Russia, and how important was this current to his actual work as architect? Like Lunacharskii, Maiakovskii, and the artist Checkrygin, all of whom he knew and admired, Melnikov had begun his reflections from a thoroughly Christian concern for eschatology. He was a communicant of the Orthodox Church throughout his life and was surrounded by a family of impressive piety—his sister-in-law was a nun. But in spite of this, his Orthodox Christianity was evidently not sufficiently strong to provide him, through the sacraments of the church, with a fully satisfactory antidote to the sense of utter void that oppressed him. Hence, he could write that "[At such times] there existed no world at all *and there existed nothing for me to replace it with*" [Emphasis added].[23]

Had he been a natural scientist, it is likely that Melnikov would have carried out research on a means to extend life and thereby to push back the

[16] The main publication of Fedoroviana was Nikolai Fedorovich Fedorov, *Filosofiia obshchego dela*, V. A. Kozhevnikov, N. P. Peterson, eds., Moscow, 1913.

[17] For a lively review of some of these currents, see Peter Wiles, "On Physical Immortality," *Survey*, 1965, July, pp. 125-43; October, pp. 142-61.

[18] *Vselenskoe delo, sbornik II*, p. 183.

[19] Strobe Talbott, *Mayakovsky Agonistes: The Myth of the Self in the Poetry of Vladimir Mayakovsky*, unpubd. B.Litt. thesis, Oxford University, 1971, p. 116.

[20] Roman Jakobson, "O pokolenii, rastrativshem svoikh poetov," *Smert Vladimira Maiakovskogo*, Berlin-Petropolis, 1930, p. 25. Cited by Talbott, *loc.cit.*

[21] A. V. Lunacharski, *Three Plays*, L. A. Magnus, K. Walter, transl., London, 1923.

[22] *Ibid.*, pp. 134, 209.

[23] Melnikov, *Moi rassuzhdeniia . . .*, p. 1.

void that so terrified him. He was not a scientist, however, and could wage his struggle against death only with that weapon most readily at hand: his art. Like Schiller and the Romantic poets before him, Melnikov realized that his own creative activity came closer to filling the abyss than did anything else available to him; hence, architecture came to be that "something" with which he could stave off his own terrifying sense of nothingness. "Architecture," he said, "is the best means available to a person to prove to himself and to the world that, yes, he exists."[24] In the same vein, he wrote that "Creation exists when one can say—THIS IS MINE."[25]

These, then, were some of Melnikov's persistent concerns and the interests of a number of people in the world of the former Moscow School of Painting, Sculpture, and Architecture in which he moved. Turning now to his project for the Moscow crematorium, we have noted already that it was eclectic to the point of confusion, with its expressionistic tower and its west front deriving from German industrial architecture. Against the background of the demology espoused by Lunacharskii, Maiakovskii, and Chekrygin, however, its underlying program is quite clear. Cremation having been banned by the Orthodox Church, the construction of a crematorium within the precincts of the holy monastery of Saint Dmitrii Donskoi was an act of utter defiance of the Christian conception of immorality by the new state. Melnikov apparently accepted this. Like the positivist Physician in Lunacharskii's play, *Faust and the City*, he was quite willing in 1919 to pronounce physical death as final and irreversible—hence the cremation of the body—but, like the Archangel Gabriel in that same play, he clearly envisioned a new kind of immortality, to be celebrated by the people and enshrined in its memory through the elaborate civic ceremonies orchestrated by the very plan of the crematorium. Thus, we see Melnikov for the first time setting forth that "something" with which mankind might replace the emptiness of death. And architecture gave it form.

Melnikov (and his patrons) "solved" the problem of death in 1919 by abandoning hope in physical resurrection and by setting forth instead the means through which the good deeds of people could attain a form of eternity by being preserved in the civic memory. Five years later he found the opportunity to return to the problem of death in a most dramatic way when he was commissioned to design a sarcophagus for the body of V. I. Lenin. This time he went far beyond the compromise solution embodied in the crematorium.

The decision to exhibit Lenin's body was rich in symbolic significance for an Orthodox Christian population and inevitably brought to the surface much of the discussion on death and resurrection that had been going forward over two decades. That Lenin could die and yet, in some sense, continue to live held out the possibility of a new kind of immortality in a post-Christian Russia. This is not the place to analyze the intentions of the commission charged with carrying out the task, which would be impossible under any circumstances since the bulk of its papers are closed.[26] What can be done is to note the views of a number of people in the capital and of Melnikov himself on the task at hand.

[24] Conversation with the author, Spring, 1967.

[25] "Kredo," MS, Melnikov archive, p. 1.

[26] These materials are preserved, however, and certain of them are cited by A. N. Kostyrev in his *Mavzolei V. I. Lenina*, and by S. O. Khan-Magomedov in his *Mavzolei Lenina: Istoriia sozdaniia i arkhitektury*, Moscow, 1972.

In the period between the crematorium project and the death of Lenin, the problem of death had been advanced on several fronts. In 1920 the sponsors of the last pre-revolutionary publication to address the issue had regrouped in Moscow and published a manifesto[27] calling for a full and open discussion of means for overcoming the finitude of man. It culminated with an astonishing plea: " . . . we again call everyone without distinction of sex, age, race, class or faith and world view to the struggle with an enemy that is age-old and mighty but conquerable, and vanquishable. THE DEAD OF ALL LANDS, UNITE!" The Marxist historian M. N. Pokrovskii, now an aide to Lunacharskii in the Commissariat of Enlightenment, was among many who lent a receptive ear to this campaign.[28] Figuring that Christianity derived its strength from its *spiritual* victory over death, Pokrovskii saw that the task of the Communist state was to use science to achieve a *physical* victory over death, thereby causing the collapse of religion. Still another participant in this campaign, Valerian Muraviev, trumpeted from his post as translator in the Commissariat of Foreign Affairs that the day was at hand when "Chemical discoveries will not kill people but rather will give them rebirth and resurrection." This was written in December, 1923, a month before Lenin's death. Muraviev, an ex-Constitutional Democrat saved from the firing squad by Trotsky's intervention, had become ardently pro-Communist by the time he wrote this, on the grounds that the October Revolution promised the total regeneration of man.[29] At the same time, he remained close to various Orthodox groups in Moscow exploring the mysticism of the twelfth-century ascetic, St. Gregory Palamas. Widely circulated in manuscript during the winter of 1923-1924, Muraviev's tract was already in press when its publication was blocked. Melnikov recalled having read it in manuscript, however, even before the same arguments appeared in a longer essay by Muraviev entitled *The Mastery of Time*, which was actually printed by the author in 1924.[30]

Hence, when Melnikov set to work on the sarcophagus, the possibility of the physical resurrection of the dead was actively being discussed in various quarters known to him and by people with whom he was acquainted either personally or through their writings. We know, further, that those who were answering Fedorov's "heroic call to battle against death" considered the decision to preserve Lenin's body in the light of their campaign and concluded shortly thereafter that it constituted a positive step towards the achievement of their program.[31] Finally, there is evidence to suggest that the Commissar of Foreign Trade, Leonid Krasin, the chairman of the state commission charged with planning the Lenin sarcophagus and hence the person to whom Melnikov was directly responsible, also subscribed to certain articles of the Fedorovian faith. Invited to deliver an oration at the funeral of a minor Communist official, Krasin publicly stated his belief that science would achieve the resurrection of the dead.[32] It is Krasin whom

[27] The text of this manifesto is partially reproduced in *Vselenskoe delo, sbornik II*, pp. 113-15.

[28] "Nashi poteri (nekrologi)," *ibid.*, p. 184.

[29] The only biographical sketch of Muraviev is in "Nashi poteri (nekrologi)" *ibid.*, pp. 181-82.

[30] V. Muraviev, *Ovladenie vremenem* (izdanie avtora), Moscow, 1924.

[31] *Cf.* essay by N. A. Skii, "O smerti i pogrebenii," *Vselenskoe delo, sbornik II*, p. 145. "The embalming and preservation of the body of V. I. Lenin . . . can only be explained by the idea of the necessity and inevitability of resurrection."

[32] *Proletarskaia revoliutsiia*, CVIII, p. 149n-50n, cited by S. Utechin, "Bolsheviks and Their Allies After 1917: The Ideological Pattern," *Soviet Studies*, 1958, October, p. 130, 135n. When Krasin died, Melnikov designed an elaborate catafalque; unfortunately, no photograph or drawing survives.

Melnikov identified as having conceived the "general idea" of putting Lenin's body permanently on view.[33]

Such circumstantial evidence can neither establish Melnikov's relationship to the Fedorovians nor prove the influence of their thinking on his project for the sarcophagus of Lenin. It does, however, provide a context in which several otherwise anomalous points in the project can be explained. First, as we have noted, Melnikov claimed to have been inspired in his work by the folk tale of the Sleeping Princess.[34] It will be recalled that the Princess had appeared dead but was only sleeping, lying in uncorrupted beauty on her royal bed until the Prince would enter the room, kiss her, and bring her back to life. Forty years after Lenin's death, Melnikov still affirmed to visitors that he intended this comparison to be taken literally.[35] Who, then, is the Prince who will steal through the oaken door of Lenin's mausoleum in order to bring the sleeper back to life? It is, of course, the revolutionary Russian people, who possess the power of resurrection and will exercise it by endowing their leader with immortality. Melnikov "solved" the problem of Lenin's mortality by denying that he was dead. In the words of a poster issued by Alexander Rodchenko in the same month in which Melnikov designed the sarcophagus, the entire mausoleum would be a monument "To the Living Ilich!"[36]

Second, in the same memoir Melnikov referred to the glass cover for the sarcophagus as a "crystal."[37] Once again, his choice of terms was deliberate and, given his interpretation of the project, particularly appropriate. As we have noted, the Moscow architectural world had become acquainted with German Expressionism between 1919 and 1923. Melnikov neither spoke nor read German, but he professed great interest in Expressionism and in fact had already applied certain of its leading notions in the Palace of Labor competition. Melnikov's celebration of crystalline forms in the sarcophagus for Lenin is another borrowing from the language of Expressionism. Crystals figure prominently in Expressionist writings as symbols of an eternal and perfect order. Hence, an Expressionist hymn (of which Melnikov owned a Russian translation in manuscript) culminated in the following utopian image:

> "The Light suffuses the Universe
> And comes alive in the crystal. . . ."[38]

Against this background one can detect Melnikov's intention to show that Lenin, the light that illuminated the Revolutionary order, would forever appear to the people through the undying perfection of a crystal.

For the Orthodox Christian, as for Christians generally, death marks the end of one's corrupt physical existence and the potential beginning of a perfect spiritual being. Resurrection therefore stands as the central point of history, but its function and meaning depend utterly on one's recognizing man's present state of corruption. Nikolai Fedorov and his early disciples

[33] K. S. Melnikov, "V komisiiu po postroike mavzoleia V. I. Lenina," 1924, July 15 (Melnikov archive): *cf.* Khan-Magomedov, *Mavzolei Lenina,* p. 29.

[34] Melnikov, "Postroika sarkofaga dlia sokhraneniia na vechnye vremena tela V. I. Lenina," p. 1.

[35] Conversation with the author, April, 1967.

[36] Karginov, *Rodcsenko*, p. 152.

[37] Melnikov, *Postroika sarkofaga*, p. 1.

[38] Paul Scheerbart, *Glasarchitektur*, Berlin, 1914, p. 21. For a perceptive analysis of Scheerbart's and other Expressionists' views on crystalline forms, see Rosemarie Haag Bletter, "Bruno Taut and the Scheerbartian Style: Utopian Aspects of German Expressionist Architecture," unpublished Ph.D. dissertation, Columbia University, 1973, ch. 4.

placed particular stress on this, but held out the possibility of mankind's achieving rebirth through advances in science and society that would eliminate the sources of evil. In this respect they came surprisingly close to viewing resurrection in the same way that secular utopians view revolution. Thanks to this implied parallel, disseminated in late Imperial Russia by Fedorovians and non-Fedorovians alike, it required little imagination to conceive of the Revolution of 1917 as that awesome event which would liberate mankind from the sins of its past.

In the same year in which Melnikov designed the sarcophagus for Lenin, he was given the chance to elaborate this vision in his design for the Soviet pavilion at the Art Deco exposition in Paris. We have examined the process by which Melnikov took up and ultimately rejected the image of a world spanned by Communism as the basis for the pavilion's design. Taken out of context, the final proposal could appear as little more than a cleverly executed experiment in the manipulation of abstract forms. But it is more. Comparing the final design of the pavilion with the "crystalline" variant for the Lenin sarcophagus—the variant that Melnikov himself preferred—we see the close relationship between the two. The trapezoidal ground plan of the exposition pavilion would have been inappropriate for the sarcophagus, of course, and the intricately interwoven planes of the sarcophagus unsuited for a simple wooden pavilion. But both involve a static ground plan rendered dynamic by means of a bold diagonal, and in both cases this diagonal transformed the single mass into a pair of faceted crystalline forms.

With this, the inner program of the Paris pavilion becomes clear. The structure is nothing less than Melnikov's rejected sarcophagus of Lenin writ large. The French populace, corrupted by the moribund order in which it lived, was invited to enter into the living spirit of the Russian Revolution. By visiting this exposition pavilion *cum* tomb, the French people would receive a new life as a revolutionary proletariat. Leaving the pavilion, the Frenchman would quite literally be turned red, "whether or not he wanted to be,"[39] for this was the purpose of the latticework of crimson-painted beams over the stairway. The rite of revolutionary rebirth would culminate at the moment when each visitor to the pavilion would emerge from the exhibits and be bathed in the reflected red light. Paraphrasing Saint Paul, Melnikov's pavilion seemed to proclaim to a degenerate and death-ridden West that it could be born again—through Lenin.

Melnikov did not leave any written testament spelling out the symbolic program of the Paris pavilion as he did in the case of the Lenin mausoleum. He did, however, speak of the relationship between the design of the sarcophagus and the exhibition pavilion, noting that "they were linked, at least intuitively, however little it may be obvious to my learned visitors today."[40] Within four years he returned to the same theme when he was called upon to design the workers' club for the "Pravda" factory at Dulevo, outside Moscow. As we have noted, the ground plan of the Dulevo Club is based on the human form, with functions assigned to their logical place in the anthropomorphic structure. Thus, the place of the brain is occupied by the back-stage area of the club's theater. The theater's proscenium is situated where the mouth would be, as if to stress that from here would flow the club's message to the workers from the china factory. The

[39] Melnikov,"Arkhitektura moei zhizni," p. 12.
[40] Conversation with the author, 1967.

workers themselves were to be seated in an auditorium situated in the building's "chest cavity," suggesting perhaps their proximity to its "heart."

Whose is the body that the Dulevo workers were invited to enter? What transfiguration was to occur through the rites celebrated in the building's "head"? Several pieces of evidence point directly back to the Paris pavilion and to the figure of V. I. Lenin. Within yards of the Dulevo Club stood a large, conspicuous, and, by 1929, deconsecrated Orthodox church. Since there existed ample free space in the neighborhood at the time, the choice of the plot next to this church for a spot on which to build a workers' club can scarcely have been fortuitous. Clearly, the union that sponsored the construction of the club sought to juxtapose this modern community center to the crumbling church, the community center of the past.

Before turning to Melnikov's club, we should note that the Orthodox Christian, like the Catholic, accepts the architecture of the place of worship as a symbolic representation of the body of Christ. Just as Bernini's projects for Saint Peter's in Rome are based upon his sketches of the body of Christ crucified,[41] so the Orthodox cathedral or church is looked upon as representing, however abstractly, Christ's living presence in the sacrament of communion administered therein. The reconsecration of the edifice as part of the Easter Mass each year is done in recognition of this doctrine, and quite logically culminates in the communion of the faithful in the body of the church.

Melnikov, the former choir-boy from Petrovsko-Razumovskoe and a veteran of years of the usual Russian theological instruction, knew this ritual well. Indeed, its essential elements are to be found in the design for the workers' club at Dulevo, albeit in reworked form. The messianic figure—in this case Lenin—is present symbolically in the form of the edifice itself, and this edifice exists so as to provide a setting for a communion of the faithful with the living spirit of their messiah. In the case of both the church and the club, this ritual was to be presented in dramatic form by priests or actor-lecturers who appear in front of the congregation. Important segments of the Orthodox Mass are celebrated at some distance removed from the congregation, behind the Holy Doors; similarly, in the Dulevo Club the transforming rites were to be celebrated on a proscenium visible to the congregation but whose backstage area was inaccessible and obscured by curtains.

Well before the design of the Dulevo Club in 1929, the problem of death and rebirth had evidently become a passion with Melnikov, finding expression in the most diverse and unlikely assignments. How else, for example, can one interpret the particular enthusiasm he showed for designing automobile garages? To some extent, of course, his initial involvement with vehicular parking was the chance result of his patron's requirements. But only once before had he shown any particular interest in "machine romanticism"—in his design for the Leningrad *Pravda* office—and then only because it held out the possibility of transforming a metal and glass structure into a vital and richly symbolic mechanism responsive to human will. The parking garages, however, engaged Melnikov's imagination from the outset and retained it, as we have noted, down to his death. Many a person who had crossed the European continent to hear the aging Mel-

[41] *Cf.* Rudolf Wittkower, "A Counter-Project to Bernini's Piazza di San Pietro," *Journal of the Warburg and Courtauld Institutes*, London, 1939-1940, Vol. 3, pp. 88 ff.

nikov expound on architecture was astonished to hear him hold forth instead on his theories of vehicular movement and parking!

The link between Melnikov's preoccupation with parking garages and his profound absorption with the problem of death and rebirth are to be sought in the analogy the architect conceived between the automobile—"a heroic, self-directed, vital little machine"[42]— and living beings; in speaking of the Bakhmetevskaia Ulitsa garage, he referred to Leyland buses as "horses."[43] Like living beings, automobiles from time to time undergo periods of complete idleness during which their motion and power cease, as in sleep or death. In his preferred variant for the garage over the Seine, Melnikov created an elaborate and highly visible system of entry and exit ramps, along which vehicles would pass on their way to and from such periods. Theatricalizing the process of parking, Melnikov arranged that each vehicle would disappear into the garage and "die" in the place assigned to it by his system of vehicular movement. Some time later—*mirabile dictu!*—the same machine would return to life and emerge triumphantly from the garage, sweeping on suspended ramps over an awed Parisian public and astounding onlookers with its renewed vitality. A similar drama would be performed at every one of the Moscow garages. As in the Paris pavilion, the miraculous rebirth would have been programmed and staged not by some high priest but by the architect, Melnikov.

If some echo of the theme of death and rebirth is to be detected in the Melnikov garages, the closely related theme of extending life indefinitely was elaborated explicitly in the design of his own house on Krivoarbatskii Pereulok. For the Fedorovians, the physical resurrection of the dead constituted a maximal program, but they were prepared to settle for a minimal program that would bring about the indefinite prolongation of existing life.[44] Working under their direct influence, a group of Russian doctors and biologists in Kiev, Moscow, and Paris founded the scientific study of gerontology.[45]

By the late twenties Melnikov was living a life for which neither his upbringing nor education had prepared him. The acclaim that had been lavished on him brought worrisome social obligations, while the more he dressed himself up in felt hat and spats, the further he moved from the simple life he had hitherto always lived. None of this sat well with Melnikov's innate austerity, and he was later to recall having come gradually to fear for his own corruption. Meanwhile, he had reached his late thirties, and the strains of his professional life were for the first time leaving him fatigued and conscious of the limits of his own physical energy.

In this mood he set about to build himself a house. Passing over those aspects of the structure that we have already considered, we find our attention caught by the bedrooms, and particularly by the beds themselves. Prior to their reconstruction to repair damages inflicted during World War II, these had a very different character than they do today. Far from being beds in the usual sense, they resembled nothing so much as biers.[46] Con-

[42] Conversation with the author, April, 1967.
[43] K. S. Melnikov; "Stroitelstvo i arkhitektor," in *Arkhitekturnaia kompozitsiia; sovremennye problemy,* Moscow, 1970, p. 20.
[44] George L. Kline, "Soviet Russian Promethianism," unpublished lecture delivered at the Kennan Institute for Advanced Russian Studies of The Wilson Center on 17 December 1975.
[45] P. Wiles, Part II, on A. A. Bogomolets, etc.
[46] The description here pertains to the bedroom as it was originally constructed, not in the altered form in which it exists today, because of the damage it suffered during World War II.

structed of marbleized plaster over brick and containing no springs, they were as much a part of the bedroom as Lenin's sarcophagus is of the tomb chamber. Like the tomb chamber, the walls of the bedroom were of polished stone. No ornament existed. The only color present was a pale yellow-green wash on the walls, symbolizing new life. In the surviving photograph, the bed clothes are arranged with geometric precision, as if for eternity.

What was to take place here? For once, Melnikov expressed his intentions quite fully, first in his autobiographical sketch and then in greater detail in the course of interviews with the author.[47] Briefly, the bedroom was designed as a kind of machine to enable its inhabitants to be rejuvenated daily. Wearied from the cares of daily life and worn down by time, the architect would lay himself down here at night. He would lose consciousness and become, so to speak, dead to the world: in this suspended state, mysterious processes would envelop him and, in the course of the night, give him new strength in the struggle against death. The next day he would awaken reborn and renewed, his *Youth Restored*, to quote the title of a novel by Melnikov's contemporary and acquaintance Mikhail Zoshchenko. The use of sleep for this end was not original with Melnikov, and he freely admitted to the inspiration of a volume by the Russian emigré biologist Elie Metchnikoff entitled *The Prolongation of Life*.[48] What was distinctive was Melnikov's translation of this Fedorovian hope into architectural terms. By devising a system to retard the process of physical decay in himself, he in effect used his art to "create time," as Valerian Muraviev proposed in his volume *The Mastery of Time*.[49]

Up to now we have been grouping together diverse projects in order to show the extent of Melnikov's apparent preoccupation with the problem of man's mortality and his need for rebirth. However, a sharp distinction must be drawn between those projects of the late NEP period (1925-1928) and those immediately before and after. Whereas the Lenin sarcophagus and the Paris pavilion both linked regeneration with society and the political order, the garages and Melnikov's private house completely ignored politics and civil society as a whole. Only with the *Pravda* club at Dulevo, built at the height of the Cultural Revolution in 1929, do we see the problem once more stated in public terms. This time the change in focus was to be permanent. From that date onward Melnikov concentrated exclusively on the analogy that he perceived between social revolution and the physical resurrection of the dead.

Before turning to the two projects in which this analogy was most thoroughly explored, we may note a further aspect of Fedorov's vision, namely, its equation of individuality with death and of collectivity with life. Societies in which the principle of individuality reigned were inescapably under the hand of death, while societies in which collectivity or brotherhood (*bratstvo*) were most highly developed were nearest to achieving immortality. After the Revolution such notions were developed by a number of thinkers, among them Valerian Muraviev. After explaining that physical resurrection had already become a scientific possibility, Muraviev set out to describe the "new culture" in which it would actually be accomplished:

"If the old culture had as its basis the dogma of biological rivalry, the

[47] Melnikov, "Arkhitektura moei zhizni," p. 9.

[48] Elie Metchnikoff, *The Prolongation of Life: Optimistic Studies*, New York, 1907, p. 120 ff. The Russian translation appeared in 1915 in Moscow.

[49] Muraviev, *Ovladenie vremenem*, p. 120.

egoistic struggle of the individual for physical self-preservation—often against the interests of other people and of society at large—the new culture must be derived from the recognition of a profound principle as the mover of life, namely the symbiosis or collaboration of all living organisms. . . . Such a new culture, guided by the united effort of humanity, will for the first time actually accomplish the common task of all living beings: the work of life against death. . . ."[50]

When Muraviev wrote this in 1923, it was increasingly difficult for the Fedorovians to maintain that the Revolution had brought about the anticipated apocalypse. Whatever progress had occurred in Russia's social life, it was insignificant in comparison to their grandiose hopes. As a result, the most apocalyptic expectations of 1917 were packed away, the embarrassing reminder of an unfulfilled past. With the promulgation of the First Five-Year Plan and the start of the Cultural Revolution in 1928, however, the Fedorovians' expectations revived, this time finding expression in publications as diverse as the authoritative literary journal *Red Virgin Soil* (*Krasnaia nov*) and the earnest *News* (*Izvestiia*) of the Central Institute of Technology. It was at this critical moment, shortly after the Cultural Revolution began, that Melnikov set to work on his entry for the Green City competition. Not surprisingly, he used his project as a means of expressing his own apocalyptic hopes.

Since we have already considered Melnikov's Green City in some detail, we may turn directly to those specific aspects of the proposal which relate to the problem of regenerating or transfiguring humanity. First among these is the "Sonata of Sleep" pavilion, wherein Moscow workers were to submit themselves to symbolic death (sleep) in order to undergo the transformation that would enable them to emerge as citizens of a socialized community. In conception the pavilion is less a sanitorium than a laboratory or assembly line, as befits so scientistic a form of Promethianism. As a whole, it closely resembles a passage in a story of 1928 by Boris Pilniak, in which the battle to eliminate death was to be waged from shining new "Factories of Health" scattered across the Soviet landscape.[51]

We have noted that the collectivization of the resurrected citizenry was to be less than thoroughgoing in this project, and that the process of social transformation is conceived in the Green City as simply the process of individual transformation writ large. To this extent, the project is a step back from the Paris pavilion, which stressed far more forcefully the collective character of the transfiguring experience. But the "Laboratory of Sleep" embodies but one dimension of Melnikov's vision for the Green City. For the other we must turn to his "Institute for Changing the Form of Man."

It will be recalled that this behaviorist laboratory was to have been situated at the very center of the Green City, a placement that is indicative of the importance Melnikov ascribed to the institute's function. In spite of this, however, it is not so much as mentioned in any published discussion of the project as a whole, nor did Melnikov himself elaborate on it in any extant manuscript. Why the peculiar silence?

Melnikov's own explanation was that, since the terms of the competition called for no such institute, it would have been inappropriate of him to make much of it in his written explanations. "Then too," he would add,

[50] Muraviev, "Vseobschchaia proizvoditelnaia matematika," *Vselenskoe delo, sbornik II*, p. 138.
[51] Boris Pilniak, "Shtoss v zhizn," *Krasnaia nov*, 1928, No. 10, pp. 3-32.

"the very conception of the 'Institute' would perhaps have been unacceptable to some of my audience."[52] This is a gross understatement. Melnikov's Green City project accepts the revolutionary injunction to transform human society, but it goes far beyond it. In essence, the "Institute for Changing the Form of Man" denies that the radical objectives of revolutionary politics can be achieved through social and economic changes alone, or by any other scheme that would leave the human organism in the flawed form in which it had existed for ages. In order for man to achieve his ultimate dominion and to triumph over the individualism, poverty, and disease that signify the presence of death, the human species would have to be totally remade—it would have to be perfected through eugenics.

Returning to the Soviet disciples of Nikolai Fedorov in the 1920s, we find them profoundly dissatisfied with human beings as such and intent upon mobilizing all the resources of science to remake them. Thus, Valerian Muraviev, in his tract on a *General Productive Mathematics*, had declared that:

"We have passed beyond those periods of human history when it was possible to think only of the psychic alteration of man, of developing in him one or another set of ideas or moral inclinations. Along with this necessary task of perfecting man internally there stands before us the problem of his more thorough transfiguration and renewal, of the alteration of mankind as a physical type. . . . This creates the need for a special art bound up with a perfected anthropology—for an *anthropotechnics* or even an *anthropo-urgy*. We already have a series of applied sciences that are working out a practical approach to this problem. . . . The pinnacle of [such work in the field of medicine] is the discovery of the possibility of rejuvenation, which constitutes a genuine step in the scientific struggle for longevity. Alongside medicine stands experimental biology, which is going still further. In various experiments in that field (which, to be sure, are not yet definitive) methods are being devised for achieving a victory over death by means of vitalizing and resuscitating organs after anabiosis. [When these are perfected], a genuine and complete victory over death will have been attained. At such a time, naturally, the field of anthropotechnics will have a partner in the field of anastatics, the art of resurrecting lost life."[53]

Similar thoughts were stated or implied in the works of such prominent Soviet scientists as the eugenicist Koltsov, the biologist Voronov, and others.[54] Similar thoughts, too, lie behind the very conception of Melnikov's "Institute for Changing the Form of Man." The discoveries of this institute, once applied, were to be the ultimate expression of the political revolution.

All of Melnikov's earlier proposals for bringing about mankind's victory over social corruption and death had assumed that architect-activists would plan and guide the process. By contrast, the "Institute for Changing the Form of Man" turned the entire work over to scientists. Revolutionaries in all other spheres of endeavor—including architecture—were relegated to secondary roles, and the exhortatory function that had figured so prominently in such earlier projects as the Paris pavilion was dropped entirely.

[52] Conversation with the author, 1968.
[53] Muraviev, "Vseobshchaia proizvoditelnaia matematika," pp. 131-32.
[54] N. K. Koltsov, "Uluchshenie chelovecheskoi porody," cited in Muraviev, "Vseobshchaia . . . ," pp. 130 ff. *Cf.* also Metchnikoff, *The Prolongation of Life*, Ch. IV.

So retiring a role was not for Melnikov, however, and within a year after completing the Green City plans he had drafted another proposal in which architecture and politics were again thrust to the center stage. Here, in his entry to competition for the Palace of Soviets, he retained the conception of death as a biological event, but he firmly subordinated science to politics. In the process, he stated more forcefully than ever before the social nature of the battle being waged.

In the series of explanatory drawings that accompany the project, Melnikov once again presented the image of a society on its deathbed. To represent the *ancien régime,* as we have seen, he employed the funereal form of the pyramid, stretching it horizontally in order to emphasize its immobility and lifelessness. Against this pyramid he brought down the vertical knife of revolution, which split the old régime in half and overturned it, transforming it into a dynamic, upward-thrusting form. Unfortunately, Melnikov left no record as to whether he intended in this scenario to evoke Fedorov's equation of horizontality with death and verticality with resurrection and life.[55] But the results are clear: after the apocalypse of revolution, the first were put last and the last were put first, with the result that society as a whole was transfigured. Instead of the dying and reborn god of world mythology, it is society that dies and is reborn. From start to finish, Melnikov's entry to the competition for the Palace of Soviets celebrates the passion of society as a whole; it is an architectural liturgy of *demotheism.*

This was to be Melnikov's furthest development of the theme with which he had been preoccupied since 1919. After the Palace of Soviets competition, Melnikov addressed the problem of death and transfiguration only one more time, when he drafted a project for the Soviet pavilion at the 1937 fair in Paris. Here, as we have noted already, he used the model of Mozart's *Magic Flute* to propose the regeneration of a moribund French society by moving its members from the illusory daylight of Paris through a state of disorienting darkness into the light of Soviet life—by escalator. But this was to be his last attempt to engineer the triumph of life over death through architecture. From 1936 until his own death in 1974, he abandoned the theme entirely. When, in 1953, he drew up plans for a joint mausoleum for Lenin and Stalin to be built on an artificial island in the middle of the Moscow River, he provided no mechanism for bringing them back to the world or for transforming the world through their deaths.

In this final stage of his life Melnikov finally came to accept the reality, and indeed the necessity, of corruption and death. In the last draft of his brief autobiography, completed in the autumn of 1971, he acknowledged the evil of this life without suggesting that there existed any means by which it could be permanently overcome. On the contrary, he came to view it as absolutely essential to the existence of those few things that make life endurable: "If hostility, hate, evil and envy should die, we would no longer see the beauties of honor and manfulness, nor the qualities of individual personality."[56] So slight a hope could not and did not sustain him, however (Fig. 259). Just as earlier he had lost his hope that death might be a prelude to life, so now he abandoned this dialectic rationalization of evil. Without it, of course, life's darker shades became yet more pronounced. Tired and embittered, like a modern prophet out of *Ecclesiastes*, he averred

[55] Fedorov, "Gorizontalnoe polozhenie i vertikalnoe—smert i zhizn," *Filosofiia obshchego dela,* II, p. 260.
[56] Melnikov, "Arkhitektorskoe slovo . . . ," p. 77.

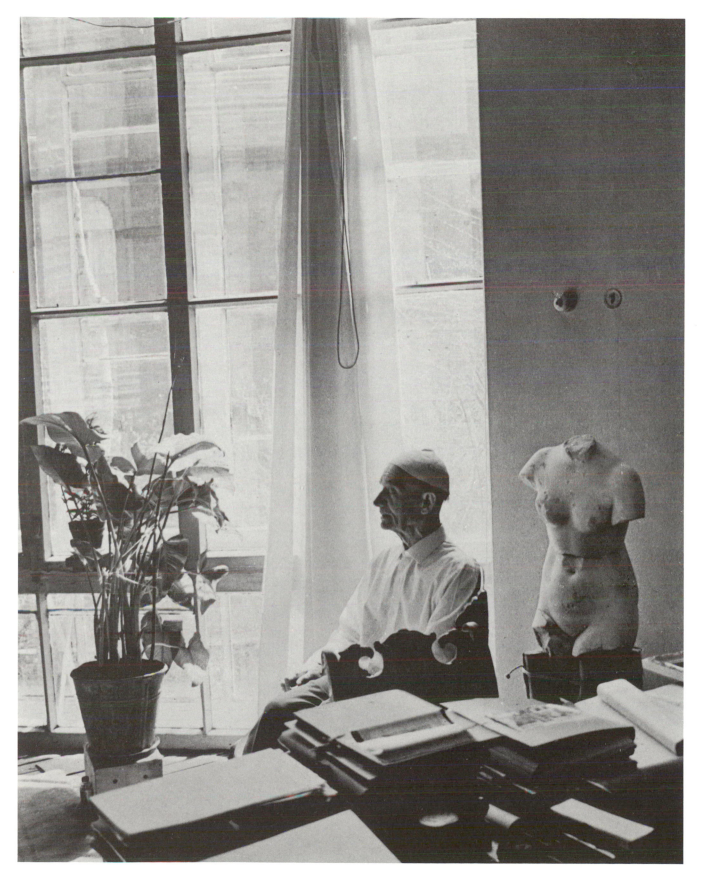

259. Konstantin Melnikov at the age of eighty-one

that: " . . . the children of the Earth are mad, there are few among them who are sober and still fewer who are good. The more scientific and hence brazen they become, the less Love there remains on earth and the power of beauty weakens. . . . "[57]

Having lost his faith in any future salvation, individual or social, and having been taught by his own experience to be skeptical about the power of good over evil in this life, Melnikov was left with but one possible affirmation: that art might not be as ephemeral as the rest of human existence. He desperately clung to this thin hope, claiming finally of his own art, architecture, that "its laws are eternal and do not depend on time, the social order, on human prosperity, or on culture."[58] No longer sustained by a belief in the possibility of immortality for the human soul, Melnikov placed his last hope in the immortality of art—specifically, of his own art. He expressed this hope not long before he died, using the precise image that we have followed thus far through his work as an architect. In an addendum to the last draft of his autobiographical sketch, he addressed his own buildings and especially his many unrealized projects: "This is not the end, it is a beginning . . . some day they will build You, who were not built in the 1930s. My projects will be realized, all by themselves and with no pressure from the author. Like some old wine that has been kept forty years in the basement and nonetheless maintains its intoxicating strength, you have preserved your honor, the freshness of novelty, and your secret. . . . "[59]

[57] *Ibid.*, p. 77.
[58] *Ibid.*, p. 78.
[59] *Ibid.*, p. 58.

Résumé

1926	**Bus garage, Bakhmetevskaia Ulitsa, Moscow
	*Baldachin for funeral of Leonid Krasin, London, November, 1926
1927	*Soviet pavilion, Salonika, Greece
	**House for K. S. Melnikov, Krivoarbatskii Pereulok, Moscow
	**Rusakov factory, workers' club, Moscow
	Zuev factory, workers' club, Moscow
	**Frunze factory, workers' club, Moscow
	**Kauchuk factory, workers' club, Moscow
1927-28	Svoboda (now Gorkii) factory, workers' club, Moscow (two variants)
	Administrative center, Ulianovsk
	**Pravda factory, workers' club, Dulevo
1928	*Kauchuk factory cafeteria
1929	**Burevestnik factory, workers' club, Moscow
	Layout, Gorkii Park of Culture and Rest, Moscow (partially realized)
	Fountain in Gorkii Park, Moscow
	Public housing, Moscow (two variants)
	Monument to Christopher Columbus, Santo Domingo
	**Parking garage, Novo-Riazanskaia Ulitsa, Moscow (two variants)
	**_Gosplan_ parking garage, Moscow (with V. I. Kurochkin)
1930	"Green City," near Moscow
	**Reconstruction of Moscow Chamber Theater
1930-31	Frunze Military Academy, Moscow (two variants)
1931	Theatre of the Moscow Regional Council of Professional Unions (MOSPS), Moscow
	Reconstruction of Arbat Square, Moscow
1931-32	Palace of Soviets, Moscow
1932	Reconstruction of Theater Square, Moscow
1932-33	Palace of Culture, Tashkent (two variants)
1934	School, Moscow
	Replanning of Goncharnaia Embankment, Moscow
	**Intourist Garage, Moscow
	Narkomtiazhprom Building, Red Square, Moscow (at least two variants)
1935	_Izvestiia_ living quarters, Moscow
	Replanning of Luzhniki district, Moscow
1936	Southwestern region of Moscow
	Soviet pavilion, 1937 Paris Exposition (at least two variants)
1937	Hospital, Moscow
	Workers' village, Vanikov factory, Lopasnaia Station
1938	Pedestrian crosswalks, Novinskii Boulevard, Moscow
1944	Russian bath
1945	Free-standing "dacha" of wood
1947	Interior, _Miasokombinat_ Building, Moscow
	Gate of estate of Sukhanovo, owned by the Moscow branch of the Union of Soviet architects
1947-48	Pedestal for statue to a Hero of the Soviet Union, Moscow
1949	**Interior of the central department store, Saratov
1950	Village of Viazovka, near Saratov
1951	Central square of Saratov

1954 Tractor station at Volokolomsk
 Monuments to the 300th anniversary of the union of Russia and
 the Ukraine
1955 Lenin-Stalin mausoleum, Moscow, "The Pantheon"
1958 Palace of Soviets, Moscow
1962 Soviet pavilion, New York World's Fair
1967 Children's theater, Moscow

Bibliography

Manuscripts by Konstantin S. Melnikov (All in possession of the architect's family in Moscow unless otherwise indicated)

"Akusticheskie svedeniia dlia zdaniia kluba imeni Rusakova," 1927

"Arkhitektorskoe slovo v ego arkhitekture," 2 variants, 1967-1974

"Arkhitektura moei zhizni," 3 variants, 1961-1967

"Gosudarstvennoi kvalifikatsionnoi komissii, ot prof. Melnikova, K.S.," 1935

"K proektu doma Narkomtiazhproma, 1934,g.," 1934

"Kredo," n.d. (1934?)

"K proektu zelenyi gorod," 1929

"Katalog zhivopisei K.S. Melnikova," undated

"Moi rassuzhdeniia i perezhivaniia v khudozhestvennykh sferakh stroitelstva," n.d. (1960s)

"Na shchet doma," 1953

"Opisanie konstruktsii sobstvennogo doma," 3 pp., 1927

"Opredelenie ekonomicheskikh soobrazhenii k proektu zdaniia kluba imeni Rusakova," 1927

"Parizhskaia vystavka 1925g. v arkhitekture." Speech delivered on 5 March 1926, Moscow. Central State Archive of Literature and Art of the USSR (TsGALI SSSR), f. 941, op. 3, d. 47

"Poiasneniia k proektu fontana dlia Parka kultury i otdykha im. Gorkogo v Moskve," 1929

"Poiasnenie k proektu teatra im. MOSPS v Moskve," 1931

"Poiasnenie proekta pavilona USSR na Niu-Iorkskoi Mezhdunarodnoi Vystavki 1964-1965 gg.," 1936

"Postroika sarkofaga dlia sokhraneniia na vechnye vremena tela V.I. Lenina," undated

"Proekt korpusa dlia semeino-kholostykh i sotrudnikov 'zelenogo goroda,'" 1929

"Proekt pavilona gazety *Leningradskaia Pravda* v Moskve," 1924

"Proekt 'zelenyi gorod'; generalnoe planirovanie territorii," undated

"Tovarishchu Nikite Sergeevichu Khrushchevu," 1963, June, 3 pp.

"V kommissiiu po postroike mavzoleia V.I. Lenina ot arkhitektora K.S. Melnikova," 1924, December 15

"V kommissiiu po postroike mavzoleia V.I. Lenina," 1924, December 14

"V otdel stroitelstva TsK KPSS ot K.S. Melnikova," 1965, January 9

"Zapiski," six small notebooks from the 1960s

"Zdaniia klubov," undated

Correspondence with S. F. Starr, 1967-1974; owned by S. F. Starr

Letter to the Central Committee of the Communist Party, *Otdel stroitelstvo*, 1961, November 25

Letter to the editor of the journal *Amerika*, n.d.

Untitled memorandum of 1971, October 30
Untitled autobiographical/theoretical work with scrapbook, 4 vols., 1955

Published Articles by Konstantin S. Melnikov

"Arkhitekture pervoe mesto," *Stroitelstvo Moskvy*, 1934, No. 1, pp. 9-13
"Arkhitekturnoe osvoenie novykh materialov," *Arkhitektura SSSR*, 1934, No. 4, p. 37; No. 3, pp. 5-8
"Estakada ili podem po spirali," *Arkhitekturnaia gazeta*, 1935, September 3
"Gorod ratsionalizirovannogo otdykha," *Iskusstvo v massy*, 1930, No. 6 (14), pp. 20-21
"Gorod ratsionalizirovannogo otdykha," *Stroitelstvo Moskvy*, 1930, No. 3, pp. 20, 24, 25
"Konstantin Stepanovich Melnikov" (various articles), *Mastera sovetskoi arkhitektury ob arkhitekture*, Tsagarelli, I. Ia., ed., 2 vols., Moscow, 1975, vol. II, pp. 154-185
"Oformlenie proekta," *Arkhitektura SSSR*, 1933, No. 5, p. 35
"Printsipy arkhitekturnogo tvorchestva," *Raboty arkhitekturnykh masterskikh*, 2 vols., Moscow, 1937, vol. II, pp. 3-4
"Proekt arbatskoi ploshchadi," *Sovetskaia arkhitektura*, 1931, No. 3, pp. 41-46
"Proekt zastroiki Kotelnicheskoi i Goncharnoi naberezhnykh," *Arkhitektura SSSR*, 1934, No. 4, pp. 26-27
"Razvivat svoiu tvorcheskuiu liniiu, *Stroitelstvo Moskvy*, 1933, No. 9, p. 8
"Stroitelstvo i arkhitektor," *Arkhitekturnaia kompozitsiia; sovremennye problemy*, Moscow, 1970, pp. 20-23
"Tvorcheskoe samochuvstvie arkhitektora," *Arkhitektura SSSR*, 1934, No. 9, pp. 10-11

Soviet Works (published and unpublished) Touching on the Works of K. S. Melnikov and Written during His Active Career

Alabian, K. S., "Protiv formalizma, uproshchenchestva, eklektike," *Arkhitektura SSSR*, 1936, No. 4, pp. 1-6
Angarov, A., "Protiv formalizma, uproshchenchestva, eklektiki!," *Arkhitekturnaia gazeta*, 1936, March 8, p. 1
Aranovich, D., "Dvorets kultury," *Stroitelstvo Moskvy*, 1937, No. 21, pp. 14-21
Arkin, D., "Khudozhestvennoe samodurstvo," *Komsomolskaia Pravda*, 1936, February 20, p. 4
L'Art décoratif et industriel de l'U.R.S.S., Edition du comité de la section du l'U.R.S.S. à l'exposition internationale des arts décoratifs, Moscow, 1925
"Avtografy lits, posetivshikh sobstvennyi dom K.S.M.," MS, Melnikov family archive, Moscow
Babitskii, "Klubnoe stroitelstvo tekstilshchikov," *Stroitelstvo Moskvy*, 1928, No. 7, pp. 5-10
Bumazhnyi, L. O., "Sostoianie zadachi Moskovskoi organizatsii Soiuza," *Arkhitekturnaia gazeta*, 1937, June 10, pp. 1-2
Dokuchaev, N. V., "Ansambl naberezhnykh reki Moskvy," *Stroitelstvo Moskvy*, 1936, No. 5, pp. 2-14
First Agricultural and Home Industries Exhibition of the USSR Foreign Department: Guide to the Exhibition, Moscow, 1923
"Garazhnaia sistema arkhitektora Melnikova," *Nasha gazeta*, 1926, May 18, p. 4
Gnedovskii, Iu., "Konkurs na proekt detskogo kinoteatra," *Stroitelstvo i arkhitektura Moskvy*, 1968, No. 7, pp. 22-27

"God raboty proektnykh i planirovochnykh masterskikh Mossoveta," *Arkhitektura SSSR*, 1934, No. 9, pp. 8-17

"Iz letopisi sovetskoi arkhitektury," *Arkhitektura SSSR*, 1936, No. 1, p. 1

"Voprosy planirovki; opyt sotsialistischeskogo goroda-sada," *Stroitelstvo Moskvy*, 1930, No. 5

Prof. V. K., "Arkhitektura na Parizhskoi khudozhestvennoi promyshlennoi vystavke 1925 g.," *Stroitelnaia promyshlennost*, 1925, No. 9

Karra, A., "Arkhitektura teatra. Konkurs na proekt teatra MOSPS," *Stroitelstvo Moskvy*, 1932, No. 7, pp. 16-17

Karra, A., "Dva klubnykh zdaniia," *Stroitelstvo Moskvy*, 1930, No. 8-9, pp. 24-28

Karra, A., and Smirnov, V., "Novye kluby Moskvy," *Stroitelstvo Moskvy*, 1929, No. 11, pp. 21-27

Karra, A., and Smirnov, V., "Besprintsipnyi eksperiment," *Stroitelstvo Moskvy*, 1929, No. 10, p. 20

Khiger, R. Ia., "Formalizm, ideologiia upadochnichestva v sovetskoi arkhitekture," *Sovremennaia arkhitektura (SA)*, 1929, No. 4, pp. 142-46

Khiger, R. Ia., *Puti arkhitekturnoi mysli 1917-1932*, Moscow, 1933

Khiger, R. Ia., "Arkhitektor K. S. Melnikov," *Arkhitektura SSSR*, 1935, No. 1, pp. 30-34

Khrushchev, N. S., "Rech tovarishcha N.S. Khrushcheva," translated and reproduced in Johnson, Priscilla (ed.), *Khrushchev and the Arts: The Politics of Soviet Culture, 1962-1964*, Cambridge, Mass., 1965, pp. 101-105

"Klub kommunalnikov na Stromynke," *Stroitelstvo Moskvy*, 1927, No. 11, pp. 3-5

Kogan, P. S., "O Parizhe i Parizhskoi vystavke," *Iskusstvo trudiashchikhsia*, 1925, No. 14

Kolli, N. Ia. "Osnovnye etapy razvitiia sovetskoi arkhitektury," *Arkhitekturnaia gazeta*, 1937, June 20, p. 1

Koltsov, M., "Zelenyi gorod," *Revoliutsiia i kultura*, 1930, No. 2, pp. 41-42

Kornfeld, Ia., "Povysit kulturu klubnogo stroitelstva," *Revoliutsiia i kultura*, 1930, No. 11, pp. 42-46

Kornfeld, Ia., "Proekty sovetskogo pavilona na Parizhskoi mezhdunarodnoi vystavke 1937 g.," *Arkhitekturnaia gazeta*, 1936, No. 33

Kornfeld, Ia., "Rabochie kluby, dvortsy kultury, *Arkhitektura SSSR*, 1933, No. 2

Koshin, S.N., "Melnikov i ego kollektiv," *Arkhitekturnaia gazeta*, 1936, No. 9

Korzhev, M., and Lunts, L., "Tsentralnyi park kultury i otdykha," *Stroitelstvo Moskvy*, 1931, No. 12

Lavrov, F., "Moskovskii krematorii i ego znachenie," *Stroitelstvo Moskvy*, 1926, No. 5, pp. 5-7

Lisitskii, E., "Forum sotsialisticheskoi Moskvy," *Arkhitektura SSSR*, 1934, No. 10, p. 5

Lisitskii, E., "Konkurs forproektov doma Narkomtiazhproma v Moskve," *Arkhitektura SSSR*, 1934, No. 10, p. 4ff

L-nov, "Neudachnye konstruktsii," *Stroitelstvo Moskvy*, 1929, No. 10, pp. 19-20

Lukhmanov, N., *Arkhitektura kluba*, Moscow, 1930

"Lestnitsa, vedushchaia nikuda; arkhitektura vverkh nogami," *Komsomolskaia Pravda*, 1936, February 18

Lukhmanov, N., "Prazdnik sovetskoi arkhitektury," *Nasha gazeta*, 1926, May 14, p. 1

Lukhmanov, N., "Tsilindricheskii Dom," *Stroitelstvo Moskvy*, 1929, No. 4, pp. 16-22

Lukomskii, G.K. "SSSR na khudozhestvennoi vystavke v Parizhe," *Krasnaia niva*, 1925, No. 7

Lunts, L.B. "Tsentralnyi park kultury i otdykha," *Sovetskaia arkhitektura*, 1932, No. 1(7), p. 35

"M," "Krupnye postroiki tekushchego sezona," *Stroitelstvo Moskvy*, 1927, No. 9, 1-5, No. 11, pp. 1-7

"M," "Novye kluby u khimikov," *Stroitelstvo Moskvy*, 1928, No. 1, pp. 18-21

Matsa, I., "Arkhitekturnaia pravda i ee formalisticheskie izvrashcheniia," *Arkhitekturnaia gazeta*, 1936, February 23

Mikhailov, A., *Grupirovki sovetskoi arkhitektury*, Moscow and Leningrad, 1932

Minkus, M.M., and Shass, Iu. E., "Proektirovanie krasnoznamennoi voennoi akademii im. M. V. Frunze," *Sovetskaia arkhitektura*, 1933, No. 5, pp. 60-62

Mordvinov, A.G., "Dvorets truda MOSPS v Moskve," *Sovetskaia arkhitektura*, 1933, No. 1, pp. 56ff

Moskovskii sovet rabochikh, krestianskikh i krasnoarmeiskikh deputatov, otdel proektirovaniia, *Sbornik rabot arkhitekturnikh masterskikh Mossoveta za 1934 g.*, 2 vols., Moscow, 1935

Nemov, A., "Protiv 'levykh' zagibov v klubnom stroitelstve," *Iskusstvo v massy*, 1930, No. 2(1), pp. 12-16

"Parizhskaia mezhdunarodnaia dekorativnaia vystavka," *Bakinskii rabochii*, 1925, No. 154, June 12

"Pavilon SSSR na Solonikskoi vystavke," *Vecherniaia Moskva*, 1926, November 15

"Pervaia Meshchanskaia," *Arkhitekturnaia gazeta*, 1936, February 12, p. 3

"Pervyi vsesoiuznyi sezd sovetskikh arkhitektorov," *Izvestiia*, 1937, June 21, p. 3

Petrov, V., "ASNOVA za 8 let," *Sovetskaia arkhitektura*, 1931, No. 1-2, pp. 48-51

"Plan novogo rynka," *Vecherniaia Moskva*, 1924, October 3, p. 2

"Podgotovka stroitelstva 1937 v Moskve," *Arkhitekturnaia gazeta*, 1936, February 23

"Pokroviteli formalizma v arkhitekturnom institute," *Rabochaia Moskva*, 1936, March 15, p. 3

"Proekt kluba kommunalnikov," *Vercherniaia Moskva*, 1927, April 4, p. 4

"Protiv formalizma," *Arkhitekturnaia gazeta*, 1936, February 23, p. 1

"Protiv formalizma v arkhitekture," *Sovetskoe iskusstvo*, 1936, February 29, p. 4

"Rabota 7-oi arkhitekturnoi proektnoi masterskoi Mossoveta," *Arkhitekturnaia gazeta*, prilozhenie k No. 3, 1936

Rechmedinov, K., "O garazhnom stroitelstve," *Vestnik inzhenerov*, 1927, June, pp. 244-48

Schmidt, O. Iu., "Chto reshila rabochaia obshchestvennost o planakh 'zelenogo goroda'?" *Stroitelnaia promyshlennost*, 1930, No. 5, pp. 459-60

Shafran, I.L., "Formalisticheskii uchebnik," *Arkhitekturnaia gazeta*, 1936, April 23, p. 3

Shcherbakov, V., "Konkurs na zdaniia tipivykh klubov," *Stroitelstvo Moskvy*, 1927, No. 5, pp. 8ff

Shchusev, A., "Igra i genialnost," *Komsomolskaia Pravda*, 1936, February 20, p. 4

Simbirtsev, V.N. "Zelenyi gorod," *Stroitelstvo Moskvy*, 1925, No. 3, pp. 30-31

Soiuz arkhitektorov SSSR, Moskovskoe otdelenie, *Stenogramma vechera posviashchennogo tvorcheskoi, nauchnoi i pedagogicheskoi deiatelnosti professora K.S. Melnikova, 28 Dekabria, 1965*, typescript, 1965

Soiuz sovetskikh arkhitektorov, *Pervoe vsesoiuznoe soveshchanie sovetshikh arkhitektorov*, Moscow, 1934

SSSR; Parizhskaia vystavka 1925 g., Moscow, 1925

Taut, Bruno, "Novaia arkhitektura v SSSR, *Stroitelnaia promyshlennost*, 1925, No. 8, p. 562

Tugendhold, Ia., "Prazdnik arkhitektury," *Izvestiia*, 1923, September 2

Tugendhold, Ia., "Stil 1925 g.," *Pechat i revoliutsiia*, 1925, No. 7

"V masterskoi K.S. Melnikova," *Rabis*, 1930, No. 46, p. 8

"Vosmidesiatiletie Konstantina Stepanovicha Melnikova," *Arkhitektura SSSR*, 1970, No. 11, pp. 68-69

Vygodskii, L., "Novosti gradostroitelstva i planirovki," *Kommunalnoe khoziaistvo*, 1929, No. 7-8, pp. 134-37

Zapletin, N. "Dvorets sovetov SSSR," *Sovetskaia arkhitektura*, 1932, No. 2-3, p. 10

Zheits, V., "O tsilindricheskom dome arkhitektora Melnikova," *Stroitelstvo Moskvy*, 1929, No. 10, pp. 18-19

Zheits, V., "10 rabochikh klubov (sbornik statei)," Moscow, 1932

Selected Western Publications Touching on K. S. Melnikov and Written During His Active Career

Aranovitz, D., "Baukunst der Gegenwart in Moskau," *Wasmuths Monatshefte für Baukunst*, 1929, No. 13, pp. 112-28

Barkhine, G., "Architecture Russe," *Cahiers de Belgique*, 1928, p. 228

Breines, Simon, "First Congress of Soviet Architects," *Architectural Record*, 1937, October, p. 63

"Dans la cité des architectes," *Les Annales*, 1925, April 19

"L'exposition des arts décoratifs," *Art et Décoration*, 1925, September

"L'exposition des arts décoratifs–la participation de l'URSS," *France et Russie*, 1925, March 15

Eugene, Marcel, "L'exposition des arts décoratifs; Les 'palaces' bourgeois et la 'maison' des Soviet," *Claré*, 1925, April 1

Faraut, L., "Quatre-vingts danseurs Russes . . .," *Petit Parisien*, 1925, April 7

Franklyn, W., "Industrial and Decorative Art in Paris," *Architectural Record*, 1925, No. 4, pp. 376-79

Galtier-Boissiere, Jean, "L'exposition des arts décoratifs." *Le Crapouilot*, 1925, June 1

George, Waldemar, "Les sections étrangères," *L'amour de l'art*, 1925, No. 8, pp. 290-91

Ilyine, Michel (Mikhail Ilin), "L'Architecture du club ouvrier en U.R.S.S.," *L'Architecture d'Aujourd'hui*, 1931, November, pp. 17-19

———, "L'Architecture moderne en U.R.S.S." *L'Architecture d'Aujourd'hui*, 1931, January-February, pp. 126-29

———, "L'Expressionisme en architecture," *L'Architecture d'Aujourd'hui*, 1930, December, pp. 29-34

Kelsey, Albert, ed., *Program and Rules of the Competition for the Selection of an Architect for the Monumental Lighthouse . . . to the Memory of Christopher Columbus, Together with the Report of the International Jury*, 2 vols., Washington, 1928-1930

"Kunstgewerbe-Austellung in Paris," *Der Querschnitt*, 1925, No. 7

Laphin, André, "Une maison pour un escalier," *L'Intransigeant*, 1925, May 9

Lissitzky, El, *Russland, Die Rekonstruktion der Architektur in der Sowjetunion*, Vienna, 1930

Rambosson, Yvanhoe, "La Participation Étrangère," *La Revue de L'Art*, XLVIII, 1925, Sept. 26

The Machine Age Exposition, New York, 1927

"Paris 1925; A General View," *Architectural Review*, 1925, July, pp. 3-6

Pilewski, Leonie, "Neue Bauaufgaben in der Sowjet-Union," *Die Form*, 1930, No. 9

"Spetsialnoe izdanie o mezhdunarodnoi uystavke decorativnykh iskusstv," *Parizhskii vestnik*, 1925, May 6

"URSS," *La Russie nouvelle*, 1925, No. 6

Voyce, Arthur, *Russian Architecture Trends in Nationalism and Modernism*, New York, 1948

Short notices:

Akademisk Tidshrift, 1926, No. 10, pp. 134-35. Reprinted in Anderson, Troels, *Vladimir Tatlin*, Stockholm, 1968, p. 13

Concordia, 1925, July 19

France et Russie, 1925, March 15

Poslednye novosti, 1925, February 1

Le Quotidien, 1925, April 1

Wasmuths Monatshefte für Baukunst, 1925, No. 1, p. 394

Retrospective Studies Touching on the Works of K. S. Melnikov (Soviet and Non-Soviet)

Afanasiev, K. N. (ed.), *Iz istorii sovetskoi arkhitektury 1917-1925, dokumenty i materialy*, Moscow, 1963

——— (ed.), *Iz istorii sovetskoi arkhitektury 1926-1932, dokumenty i materialy*, Moscow, 1970

Aizenshtat, O., "Khudozhnik A.M. Rodchenko," *Dekorativnoe iskusstvo*, 1962, No. 7, pp. 23-28

Aleksandrov, V., "Dom Melnikova," *Zhilishchnoe stroitelstvo*, 1972, May, pp. 14-15

Baba, Edward, "Dom Melnikowa," *Projekt*, 1974, No. 6, pp. 50-51

Barkhin M. G., Tsagarelli, I. Ia., "Konstantin Stepanovich Melnikov," *Sovetskaia arkhitektura*, Moscow, 1975, vol. II

Benedetti, Carlo, "Architetti degli anni venti a Mosca," *L'Unita*, 1975, March 9, p. 3

Bliznakov, Milka T., "The Search for a Style: Modern Architecture in the U.S.S.R., 1917-1932," unpubd. Ph.D. diss., Columbia University, 1971

Bourgeois, Victor, "Salut au constructivisme," *Zodiac*, 1957, No. 1, pp. 193-95

Bykov, V., "Konstantin Melnikov i Georgii Golts," *Sovetskaia arkhitektura*, 1969, No. 18, pp. 59-67

Caldenby, Claes, "Konstantin Melnikov-arkitekt," *Rysk Kulturrevy*, 1974, No. 2, pp. 6-11

Egbert, Donald Drew, *Communism and the Arts in Russia*, unpubd. MS, Princeton, N. J.

Eliasoph, Philip I., "Melnikov's Paris Pavilion," unpubd. M.A. thesis, State University of New York at Binghamton, 1975

Feo, Vittorio de, *U.R.S.S. Architettura 1917-1936*, Rome, 1963

Frampton, Kenneth, "Notes on a Lost Avant-Garde: Architecture USSR, 1920-1930," *Art News Annual*, vol. 34, New York, 1968

Gerchuk, Iu., "Arkhitektor Konstantin Melnikov," *Arkhitektura SSSR*, 1966, No. 8, pp. 51-55. Translated in Shvidkovsky, O.A. (ed.), *Building in the USSR 1917-1932*, London, 1971

Gray, Camilla, *The Great Experiment: Russian Art 1863-1922*, New York, 1962

Hlavova, Zdena, "Konstantin Stepanovic Melnikov," *Domov*, 1967, No. 5, pp. 2-8

Karshan-Esselier, Françoise; Ciucci, Giorgio; Dal Co, Francesco, eds., "L'Architecture et avant-garde artistique URSS de 1917 à 1934," *VH-101*, Paris, 1972, No. 7-8

Khan-Magaomedov, S. O., "Konstantin Melnikov: arkhitektor," *Nedelia*, 1966, No. 7, pp. 6-12

———, "Kluby segodnia i vchera," *Dekorativnoe iskusstvo SSSR*, 1966, No. 9, pp. 2-6

———, "Arkhitektor K.S. Melnikov," *Mosproektovets*, 1965, December 17, p. 4

———, *Mavzolei Lenina; istoriia sozdaniia i arkhitektury*, Moscow, 1972

———, "Ratsionalnoe i emotsionalnoe v tvorchestve arkhitektora," *Mosproektovets*, 1965, August 13, p. 2

Khazanova, V. E., *Sovetskaia arkhitektura pervykh let Oktiabria, 1917-1925*, Moscow, 1970

Khlebnikov, I., "Rabochie kluby 20-ykh godov," *Zhilishchnoe stroitelstvo*, 1968, No. 8, pp. 22-23

"Konstantin Melnikov," (obituary), *The New York Times*, 1974, December 5, p. 50

Kopp, Anatole, *Changer la vie: de la vie nouvelle aux problèmes urbains; U.R.S.S. 1917-1932*, Paris, 1975

———, *Ville et révolution, Architecture et urbanisme soviétiques des années vingt*, Paris, 1967.

Kostyrev, An. N., *Mavzolei V. I. Lenina: Proektirovanie i stroitelstvo*, Moscow, 1971

Kroha, Jiří, and Hrůza, Jiří, *Sovetská architektonická avantgarda*, Prague, 1973

Lison, Peter, *The Palace of the Soviets; Change in the Direction of Soviet Architecture*, unpubd. Ph.D. diss., University of Pennsylvania, 1971

Listov, V., "Neskolko strok dvadtsatogo goda," *Sovetskaia kultura*, 1970, November 3, p. 2

Lubetkin, Berthold, "Soviet Architecture: Notes on Developments from 1917 to 1932," *Architectural Association Journal*, vol. 71, 1956, May

Nekrasov, Viktor, "How I Met a Dinosaur and What Happened," Michael Glenny, transl., *Times Literary Supplement*, 1975, Mar. 21, pp. 314-15

Noever, Peter, "Was ist Design?," *Die Presse*, 1975, November 15-16, p. 19

Oorthuys, Gerret, and Koolhaas, Remmert, *Ivan Leonidov*, London, 1977

Quilici, Vieri, *L'architettura del Construttivizmo*, Bari, 1969

Rodionov, V. G., "Tvorchestvo arkhitektora Melnikova," unpubd. *studentcheskaia rabota*, Leningrad State University, Kafedra istorii iskusstv, 1966

Senkevitch, Anatole, *Soviet Architecture, 1917-1956: A Bibliographical Guide to Source Material*, Charlottesville, Va., 1973

———, *Soviet Architecture: The Evolution of the Contemporary Idiom*, Brownsville (privately printed), 1967

Shvidkovsky, O.A. (ed.), *Building in the U.S.S.R. 1917-1932*, London, 1971

Solovieva, N., "Dom Narkomtiazhproma," *Na stroikakh Rossii*, 1968, No. 6

Starr, S. Frederick, "Konstantin Melnikov," *Architectural Design*, 1969, No. 7, pp. 367-73

———, "Konstantin Melnikov: A Soviet Expressionist?" *Lotus International*, 1977, October

———, "L'urbanisme utopique pendant la révolution culturelle soviétique," *Annales*, 1977, Jan.-Feb., pp. 87-105

———, "Visionary Town Planning During the Cultural Revolution," in Fitzpatrick, Sheila (ed.), *The Cultural Revolution of 1928-1932 in the USSR*, Bloomington, 1977.

Strigalev, Anatolii A., "Proekty kineticheskikh sooruzhenii v tvorchestve K.S. Melnikova," MS., 6 pp, 1975

———, "Konstantin Melnikov," *Architecture, Forms, Functions*, 1968, No. 14

Tafuri, Manfredo (ed.), *Socialismo, Città, Architettura URSS 1917-1937, Il contributo degli architetti europa*, Rome, 1971

Teige, Karel, and Kroha, Jiří, *Avantgardni architektura*, Prague, 1969

Uvarova, Irina, "Razgovor s Konstantinom Melnikovym," *R.T.*, 1967, No. 5

Veronesi, Giulia, *Style 1925: Triomphe et chute des "Arts-Deco,"* Lausanne, 1968

Willen, Paul L., "Soviet Architecture in Transformation: A Study in Ideological Manipulation," unpubd. M.A. thesis, Columbia University, 1953

Zhadova, L., "Sovetskii otdel na mezhdunarodnoi vystavke dekorativnykh iskusstv v Parizhe v 1925 godu," *Tekhnicheskaia estetika*, 1966, No. 16, p. 4

Zhukov, Konstantin, "K.S. Melnikov—arkhitektor (Moskovskie osobniaki)," *Moskva*, 1967, No. 5., pp. 216-18

Index

Index of Buildings and Projects by K. S. Melnikov

Library of Congress Cataloging in Publication Data

Starr, S. Frederick.
 Melnikov.

 Bibliography: p.
 Includes index.
 1. Mel'nikov, Konstantin Stepanovich, 1890-
2. Architects—Russian Republic—Biography.
NA1199.M37S7 720'.92'4 [B] 77-85566
ISBN 0-691-03931-3